CREATIVITY AWARDS ANNUAL

40

CREATIVITY AWARDS ANNUAL

CREATIVITY 40

Copyright © 2011 by CREATIVITY INTERNATIONAL AWARDS

For additional information, or to learn how your work may be submitted to the CREATIVITY INTERNATIONAL AWARDS
for possible inclusion in subsequent Annuals, please address inquiries to:

CREATIVITY INTERNATIONAL AWARDS
2410 Frankfort Avenue
Louisville, KY 40206
PHONE: 502.893.7899
FAX: 502.896.9594
EMAIL: info@creativityawards.com.
WEBSITE: www.creativityawards.com

First published in 2011 by:
CREATIVITY INTERNATIONAL AWARDS
2410 Frankfort Avenue
Louisville, KY 40206
PHONE: 502.893.7899
FAX: 502.896.9594
EMAIL: info@creativityawards.com
WEBSITE: www.creativityawards.com

Distributed throughout the world by:
Harper Design an imprint of HarperCollinsPublishers
10 East 53rd Street
New York, NY 10022
Fax: (212) 207-7654
HarperCollins books may be purchased for educational, business, or sales promotional use. For information, please write:
Special Markets Department, HarperCollinsPublishers, 10 East 53rd Street, New York, NY 10022.

Book design by SW!TCH Studio • www.switchstudio.com
Copywriting services provided by Lee Copywriting & Editing, Louisville, KY
Photography, scanning & pre-press services provided by FCI Digital • www.fcidigital.com

Library of Congress Control Number: 2011924322
ISBN: 9780062101143

Printed in Indonesia by Charta Global, Inc.
First Printing, 2011

CONTENTS

CONTENTS

FOREWORD

Huh!

The power to move someone's intellect or emotions.

Challenging them to think and see something in a way they weren't expecting.

To anyone who's chosen to make a living practicing the art of visual communication the "Huh" moment signifies a job well done or it can send us back to the drawing board (the dreaded Huh? moment).

As a judge for the 40th Creativity Awards Annual, I was inspired by the global scope of the work and the insights shared with my fellow judges. The work reinforced the thought that in this ever changing, social networking world we live in, design is more than just making something look good. It has the power to make us stop, think and say, "I never thought of it that way."

Enjoy.

Wayne Carey
SVP Director of Design
Draftfcb Chicago

ACKNOWLEDGMENTS

Thank you to the Creativity 40 judging panels for donating their time and expertise:

2010 Media Judges
Robby Berthume – Eclyptix, CA, USA; Can Bizer – 2Fresh, Istanbul, Turkey; Monica Ciarli – NBC Universal, Rome, Italy; Matt Davis – Davis Design Partners, OH, USA; Jeff Gilligan – NY, USA; Nick Iannitti & Sean Macphedran – Fuel Industries, Ontario, Canada; Claire Ragin – Red Beret Designs, NC, USA; Chris Sereno – Cisco Systems, CA, USA; Deborah Shea – Hellbent Marketing, CA, USA

2010 Print Judges
Brent Almond – Design Nut, MD, USA; Greg Bernstein – Made by Gregg, GA, USA; Jeff Bockman – NY, USA; Wayne Carey – Draftfcb Chicago, IL, USA; Marcie Carson – IE Design + Communications, CA, USA; Rene Galindo – Signi, Mexico; Bridgid McCarren – HOW/F+W Media, OH, USA; Chuck Miller – Combined Technologies, IL, USA; Robert Mitchell – Zed Communications, Dubai, UAE; Charlie Van Vechten – Jacob Tyler Creative Group, CA, USA

I would also like to thank Diana Falvey & Shaney Rogers – assistants extraordinaire without whose help I would be entirely lost and Sarah Yingst for her photography & videography skills. Thank you ladies!

MEDAL DESIGNATIONS

 This symbol designates a PLATINUM AWARD winning design. Our most prestigious award is reserved for the best in category. Only one design is awarded per category.

 This symbol designates a Gold award winning design. The top 10% of designs in each category are selected for the gold award.

 This symbol designates a Silver award winning design. The top 25% of designs in each category are selected for the Silver award.

CREATIVITY
INTERNATIONAL AWARDS

REGISTER ONLINE AT
creativity awards.com

PRINT

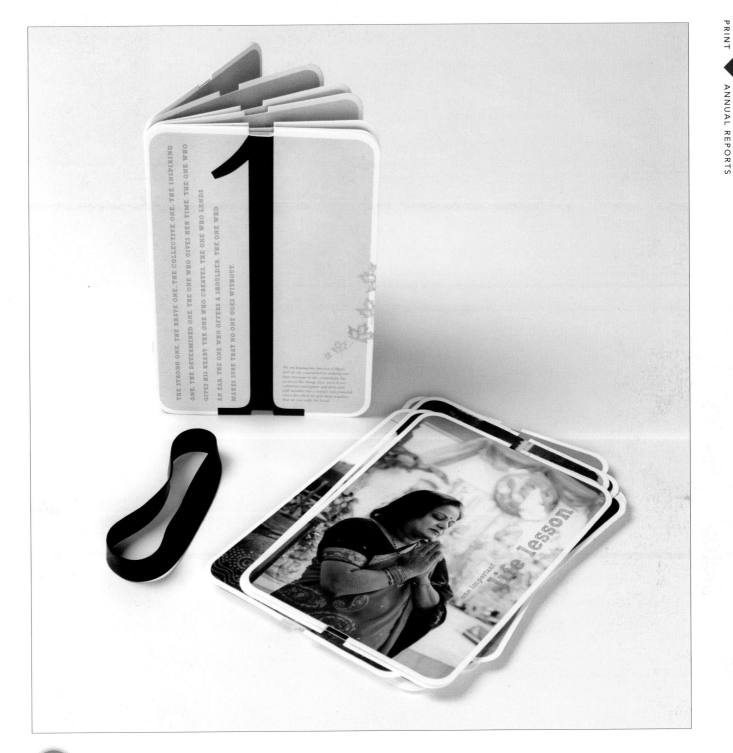

CREATIVE FIRM: FOUNDRY CREATIVE – CALGARY, AB, CANADA

CREATIVE TEAM: ZAHRA ALHARAZI – CREATIVE DIRECTON;
KYLIE HENRY – DESIGN; MELANIE WOYTIUK – EDITORIAL; FRITZ
TOLENTINO – PHOTOGRAPHY; BLANCHETTE PRESS – PRINTER;
DAVE DELIBATO – WRITER

CLIENT: IMMIGRANT SERVICES CALGARY

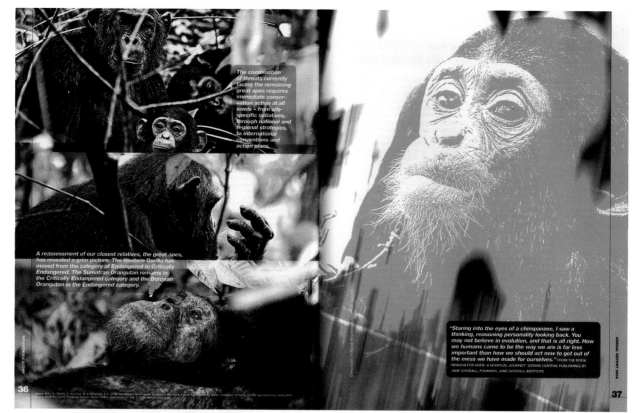

CREATIVE FIRM: EMERSON, WAJDOWICZ STUDIOS – NEW YORK, NY, USA

CREATIVE TEAM: JUREK WAJDOWICZ – ARTISTIC DIRECTOR/DESIGNER/PHOTOG-RAPHER; LISA LAROCHELLE – ARTISTIC DIRECTOR/DESIGNER; YOKO YOSHIDA – SR. DESIGNER; MANUEL MENDEZ – DESIGNER; ANTONIN KRATOCHVIL – PHOTOGRAPHER; CAROL SNAPP – EDITOR

CLIENT: ARCUS FOUNDATION

CREATIVE FIRM: NESNADNY + SCHWARTZ – CLEVELAND, OH, USA

CREATIVE TEAM: MARK SCHWARTZ – CREATIVE DIRECTOR; GREG OZNOWICH, GINA ZIMMERMAN – DESIGNERS; LISA MCGREAL, CYNTHIA SCHULZ, RONALD RICHARD – WRITERS

CLIENT: THE CLEVELAND FOUNDATION

CREATIVE FIRM: INC DESIGN – NEW YORK, NY, USA

CREATIVE TEAM: ALEJANDRO MEDINA – CREATIVE DIRECTOR;
ALEXANDRA BABRINA – DESIGNER

CLIENT: TRANSATLANTIC HOLDING, INC

CREATIVE FIRM: SIGNI – MEXICO

CREATIVE TEAM: RENE GALINDO – ART DIREC-
TOR; FELIPE SALAS – DESIGNER

CLIENT: CORPORACIÓN GEO

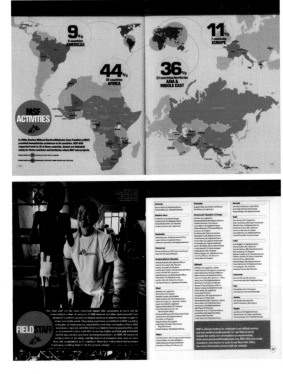

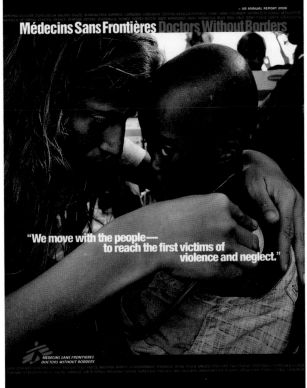

CREATIVE FIRM: EMERSON, WAJDOWICZ STUDIOS – NEW YORK, NY, USA

CREATIVE TEAM: JUREK WAJDOWICZ – ARTISTIC DIRECTOR/DESIGNER; LISA LARO-
CHELLE – ARTISTIC DIRECTOR/DESIGNER; YOKO YOSHIDA – SR. DESIGNER; MANUEL
MENDEZ – DESIGNER

CLIENT: MEDECINS SANS FRONTIERES / DOCTORS WITHOUT BORDERS

CREATIVE FIRM: FOUNDRY CREATIVE – CALGARY, AB, CANADA

CREATIVE TEAM: ROTH AND RAMBERG PHOTOGRAPHY – PHOTOGRAPHER; ZAHRA ALHARAZI – CREATIVE DIRECTOR; KYLIE HENRY – DESIGNER; KATHRYN WARD, SEBASTIEN WILCOX, NEXEN – WRITERS; BLANCHETTE PRESS – PRINTER

CLIENT: GALLERY5

CREATIVE FIRM: SMART MEDIA – THE ANNUAL REPORT COMPANY – COLOMBO, SRI LANKA

CLIENT: DIMO PLC

CREATIVE FIRM: GREENFIELD/BELSER LTD. – WASHINGTON, D.C., USA

CREATIVE TEAM: MARGO HOWARD – DESIGNER; MARK LEDGERWOOD – ART DIRECTOR; KAREN COKER – COPYWRITER; GENE SCHAFFER – PRODUCTION ARTIST

CLIENT: BODMAN

CREATIVE FIRM: ZYNC – TORONTO, ON, CANADA
CREATIVE TEAM: MARKO ZONTA – CREATIVE DIRECTOR
CLIENT: CASEY HOUSE

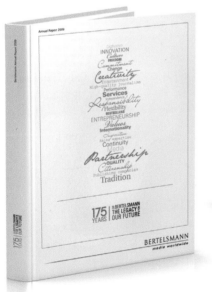

CREATIVE FIRM: BERTELSMANN AG – GUTERSLOH, GERMANY
CREATIVE TEAM: CLAUDIA WEITHASE – ART DIRECTOR
CLIENT: BERTELSMANN AG
URL: HTTP://REPORTS2.EQUITYSTORY.COM/BERTELSMANN/ANNUAL

Please do not read this report without wearing a helmet

TEPE İNŞAAT

Under Construction

Annual Report 2009 40.YEAR

CREATIVE FIRM: FINAR KURUMSAL – ISTANBUL, TURKEY
CREATIVE TEAM: TEOMAN FIÇICIOGLU – CREATIVE DIRECTOR; ALI FAIK YILMAZ, FERHAT GÜZEL – GRAPHIC DESIGNERS; BEGÜM BERKMAN – COPYWRITER
CLIENT: TEPE CONSTRUCTION

管理層討論與分析

2009年重要里程碑

CREATIVE FIRM: MONOPOLY DESIGN LIMITED – CENTRAL, HONG KONG
CREATIVE TEAM: RACHEL YU – CREATIVE DIRECTOR; JEROME BEDIONES – DESIGNER
CLIENT: CHINA MERCHANTS HOLDINGS (INTERNATIONAL) COMPANY L
URL: WWW.CMHI.COM.HK

HESS CORPORATION

CREATIVE FIRM: INC DESIGN – NEW YORK, NY, USA
CREATIVE TEAM: ALEJANDRO MEDINA – CREATIVE DIRECTOR; ALEXANDRA BABRINA – DESIGNER
CLIENT: HESS CORPORATION

CREATIVE FIRM: DESIGN NUT – KENSINGTON, MD, USA

CREATIVE TEAM: BRENT ALMOND – ART DIRECTOR/DESIGNER; ANNA BILLINGSLY – COPY EDITOR

CLIENT: UNIVERSITY OF MARY WASHINGTON

CREATIVE FIRM: MAD DOG GRAPHX – ANCHORAGE, AK, USA

CREATIVE TEAM: KRIS RYAN–CLARKE – ART DIRECTOR/DESIGNER

CLIENT: THE ALASKA COMMUNITY FOUNDATION

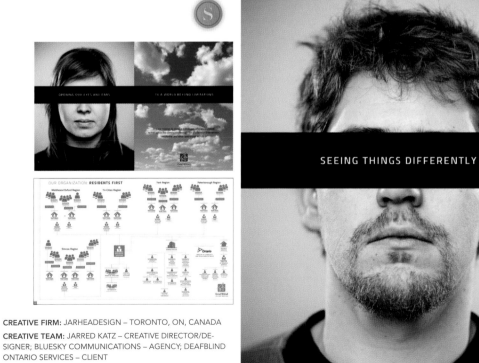

CREATIVE FIRM: JARHEADESIGN – TORONTO, ON, CANADA

CREATIVE TEAM: JARRED KATZ – CREATIVE DIRECTOR/DE-SIGNER; BLUESKY COMMUNICATIONS – AGENCY; DEAFBLIND ONTARIO SERVICES – CLIENT

CLIENT: DEAFBLIND ONTARIO

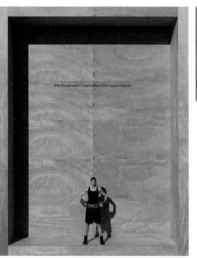

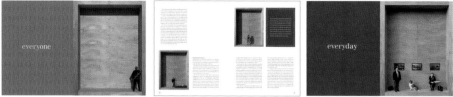

CREATIVE FIRM: NESNADNY + SCHWARTZ – CLEVELAND, OH, USA

CREATIVE TEAM: MARK SCHWARTZ – CREATIVE DIRECTOR; MICHELLE MOEHLER, CINDY LOWREY, KEITH PISHNERY – DESIGNERS; COKE O'NEAL – PHOTOGRAPHER; GLENN RENWICK – WRITER

CLIENT: THE PROGRESSIVE CORPORATION

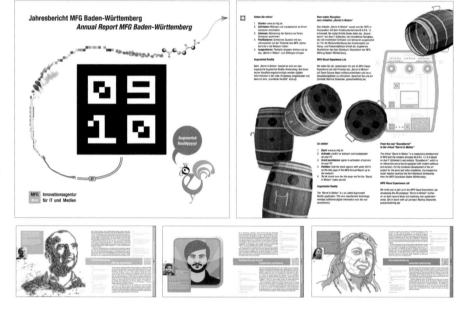

CREATIVE FIRM: MFG BADEN–WÜRTTEMBERG MBH – PUBLIC INNOVATION AGENCY FOR ICT AND MEDIA – STUTTGART, GERMANY

CREATIVE TEAM: KLAUS HAASIS – CEO, MFG BADEN–WÜRTTEMBERG; SILKE RUOFF – MANAGER COMMUNICATION, MFG BADEN–WÜRTTEMBERG; JÜRGEN GERHARDT – GRAFICAL DESIGNER, XX DESIGN PARTNER; TOM PHILIPPI – PHOTOGRAPHER; HANNAH FESSELER – PROJECT MANAGER MARKETING, MFG BADEN–WÜRTTEMBERG; ANDREA SCHLODER – IL-LUSTRATION

CLIENT: MFG BADEN–WÜRTTEMBERG MBH

URL: HTTP://WWW.MFG–INNOVATION.COM/1280.HTML

CREATIVE FIRM: LEVINE & ASSOCIATES – WASHINGTON, D.C., USA

CREATIVE TEAM: GREG SITZMANN – ART DIRECTOR

CLIENT: UNITED BROTHERHOOD OF CARPENTERS

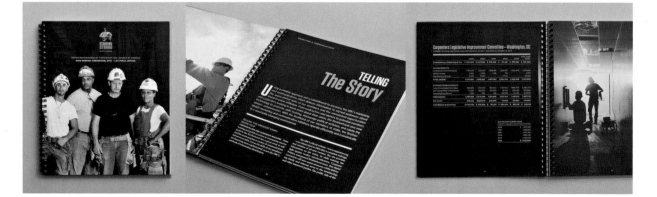

CREATIVE FIRM: SPLASH PRODUCTIONS PTE LTD – SINGAPORE

CREATIVE TEAM: NORMAN LAI, STANLEY YAP – ART DIRECTORS; TERRY LEE – COPYWRITER; ARI (WWW.PERICRAFT.COM) – IL-LUSTRATOR; COLORSCAN CO PTE LTD – PRINTER

CLIENT: MEDIA DEVELOPMENT AUTHORITY OF SINGAPORE

URL: HTTP://WWW.SPLASH.SG/MAIN/INDEX.PHP?/LAUGH/PIXELAT

CREATIVE FIRM: SMART MEDIA – THE ANNUAL REPORT COMPANY – COLOMBO, SRI LANKA

CLIENT: DIPPED PRODUCTS PLC

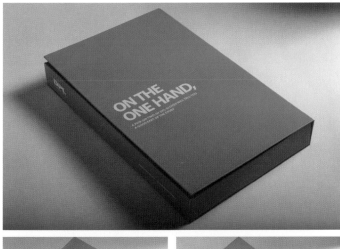

CREATIVE FIRM: FINAR KURUMSAL – ISTANBUL, TURKEY

CREATIVE TEAM: TEOMAN FIÇICIOGLU – CREATIVE DIRECTOR; ÖZLEM FIRAT, TALHA HOSGÖR – GRAPHIC DESIGNERS

CLIENT: SEKERBANK

CREATIVE FIRM: TAYLOR DESIGN – STAMFORD, CT, USA

CREATIVE TEAM: DANIEL TAYLOR – CREATIVE DIRECTOR; MARK BARRETT – ART DIRECTOR/DESIGNER; LARRY KAUFMAN, ROB WALLACE – WRITERS

CLIENT: KEEP AMERICA BEAUTIFUL

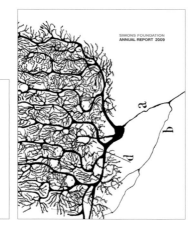

CREATIVE FIRM: IRIDIUMGROUP, INC – NEW YORK, NY, USA

CREATIVE TEAM: YISON KO – CREATIVE DIRECTOR

CLIENT: SIMONS FOUNDATION

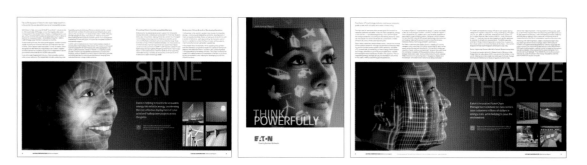

CREATIVE FIRM: NESNADNY + SCHWARTZ – CLEVELAND, OH, USA

CREATIVE TEAM: MARK SCHWARTZ – CREATIVE DIRECTOR; GREG OZNOWICH, GINA ZIMMERMAN – DESIGNERS; FRANK OSWALD – WRITER; DESIGN PHOTOGRAPHY, INC. – PHOTOGRAPHER

CLIENT: EATON CORPORATION

CREATIVE FIRM: SMART MEDIA – THE
ANNUAL REPORT COMPANY – COLOMBO,
SRI LANKA

CLIENT: BANK OF CEYLON

CREATIVE FIRM: IRIDIUMGROUP, INC – NEW YORK, NY, USA

CREATIVE TEAM: YISON KO – CREATIVE DIRECTOR

CLIENT: UNITED NATION FEDERAL CREDIT UNION

CREATIVE FIRM: SMART MEDIA – THE ANNUAL
REPORT COMPANY – COLOMBO, SRI LANKA

CLIENT: SEYLAN BANK PLC

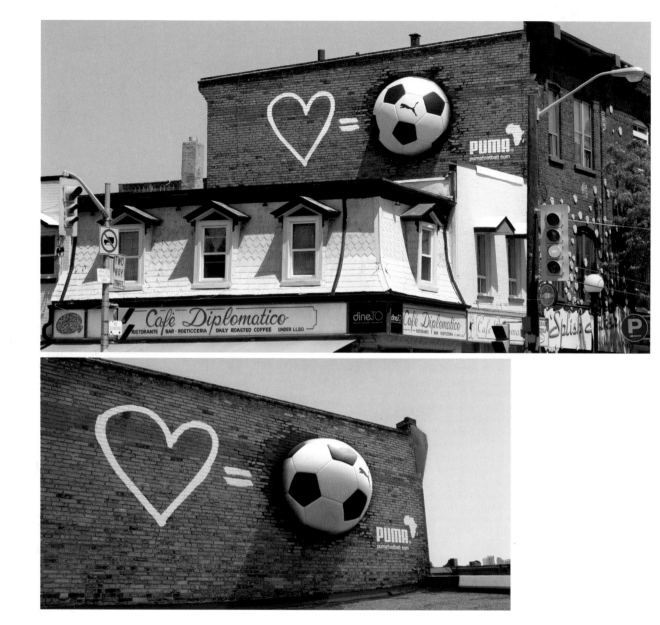

PLATINUM

LOVE = FOOTBALL

CREATIVE FIRM: ZULU ALPHA KILO – TORONTO, ON, CANADA

CREATIVE TEAM: ZAK MROUEH, JOSEPH BONNICI – CREATIVE DIRECTORS; MARK FRANCOLINI – ART DIRECTOR; GEORGE AULT – COPYWRITER; GRANT CLELAND – DESIGNER; MICHAEL FELLINI – ILLUSTRATOR

CLIENT: PUMA CANADA

Some consider Italy to be one of the world's most romantic places, and Italians love soccer–er, football. To promote PUMA's "Love = Football" campaign in Canada and generate buzz around the athletics company's sponsorship of the Italian team, Toronto agency Zulu Alpha Kilo created a massive wall mural featuring a 3D football appearing to smash through a brick wall. Erected above a popular intersection in Toronto's Little Italy, the mural captured the heart and soul of Canada's football–crazed Italian community.

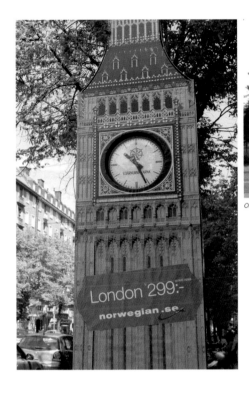

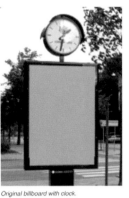

CREATIVE FIRM: VOLT AB – STOCKHOLM, SWEDEN

CREATIVE TEAM: KATARINA WIDMAN – MARKETING MANAGER SWEDEN; PETTER NYLIND – COPYWRITER; KARL ANDERSSON – ART DIRECTOR; LOUISE WALLGREN – AC-COUNT MANAGER; STAFFAN KJELLVESTAD – RETOUCH; ÅSA STJÄRNQUIST – FINAL ART

CLIENT: NORWEGIAN

Original billboard with clock.

CREATIVE FIRM: MTV NETWORKS – NEW YORK, NY, USA

CREATIVE TEAM: NIGEL COX–HAGAN – EVP CREATIVE & MARKETING; PHIL DELBOURGO – SVP BRAND & DESIGN; TRACI TERRILL – VP EDITORIAL; JIMMY WENTZ – VP OFF–AIR CREATIVE; ALLISON SIERRA – DIRECTOR PROJECT MANAGEMENT; JESSE RAKER – DESIGNER; DAN TUCKER – WRITER

CLIENT: VH1

CREATIVE FIRM: VOLT AB – STOCKHOLM, SWEDEN

CREATIVE TEAM: KATARINA WIDMAN – MARKETING MANAGER SWEDEN; PETTER NYLIND – COPYWRITER; KARL ANDERSSON– ART DIRECTOR; LOUISE WALLGREN – ACCOUNT MANAGER; STAFFAN KJELLVESTAD – RETOUCH; ÅSA STJÄRNQUIST – FINAL ART

CLIENT: NORWEGIAN

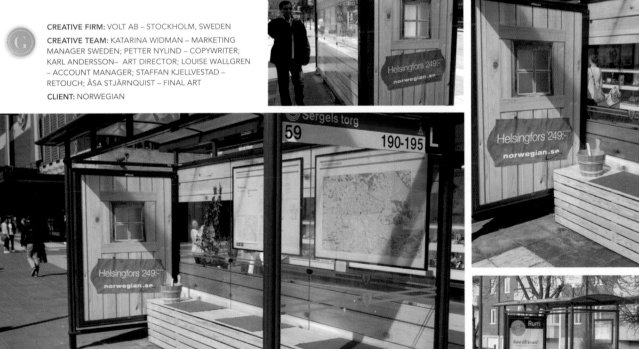

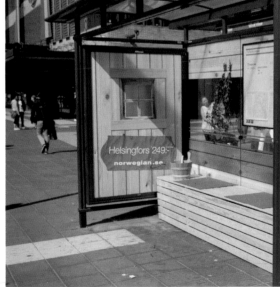

The original bus shelter.

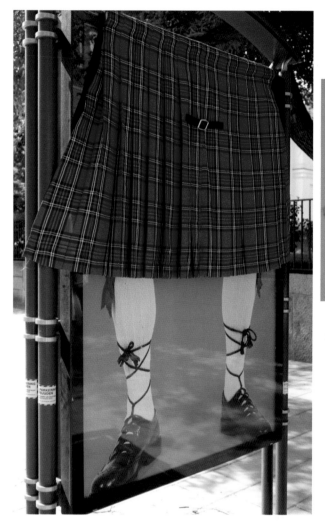

CREATIVE FIRM: VOLT AB – STOCKHOLM, SWEDEN

CREATIVE TEAM: KATARINA WIDMAN – MARKETING MANAGER SWEDEN; PETTER NYLIND – COPYWRITER; KARL ANDERSSON – ART DIRECTOR; LOUISE WALLGREN – ACCOUNT MANAGER; STAFFAN KJELLVESTAD – RETOUCH; ÅSA STJÄRNQUIST – FINAL ART

CLIENT: NORWEGIAN

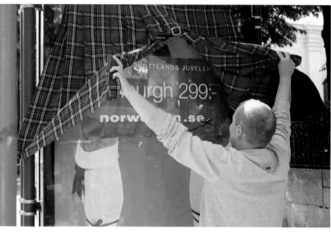

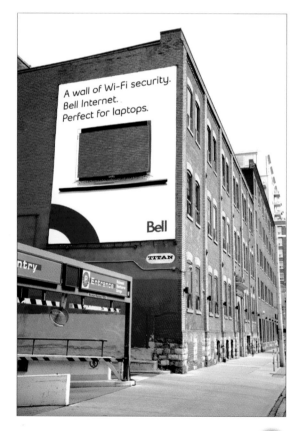

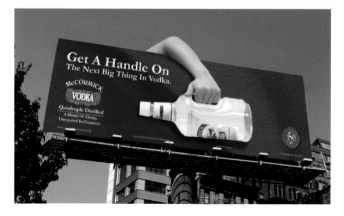

CREATIVE FIRM: SAGON/PHIOR – LOS ANGELES, CA, USA

CREATIVE TEAM: PATRICK FEE – CREATIVE DIRECTOR

CLIENT: MCCORMICK DISTILLING

CREATIVE FIRM: ZULU ALPHA KILO – TORONTO, ON, CANADA

CREATIVE TEAM: MATT PROKAZIUK, GEORGE AULT – COPYWRITERS; ZAK MROUEH, JOSEPH BONNICI – CREATIVE DIRECTORS; MARKETA KRIVY, SIMON AU – ART DIRECTORS; MOOREN BOFILL – DESIGNER

CLIENT: BELL CANADA

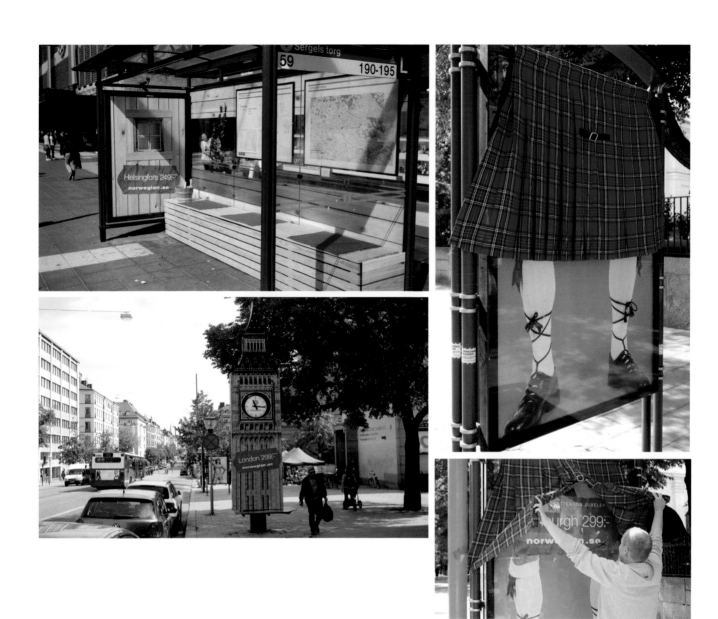

PLATINUM

NORWEGIAN – NEW DESTINATIONS

CREATIVE FIRM: VOLT AB – STOCKHOLM, SWEDEN
CREATIVE TEAM: KATARINA WIDMAN – MARKETING
MANAGER SWEDEN; PETTER NYLIND – COPYWRITER;
KARL ANDERSSON – ART DIRECTOR; LOUISE WALLGREN –
ACCOUNT MANAGER; STAFFAN KJELLVESTAD – RETOUCH;
ÅSA STJÄRNQUIST – FINAL ART
CLIENT: NORWEGIAN

How do you bring a bit of Britain or Finland to everyday, inner–city Stockholm? To get Stockholmers to pay special attention to Norwegian Air's low prices on flights to London, Edinburgh and Helsinki, Stockholm–based agency Volt took an unusual approach.

Volt turned local bus shelters into visual representations of Finnish saunas (complete with birch benches), while those with clocks became five–meter–high versions of the Big Ben clock tower. To invite curious would–be visitors to Edinburgh, a liftable kilt on cheekily covered a Scotsman's…special price. (The tagline?

"Discover the jewels of Scotland.") "The Edinburgh ad immediately gained the attention of a group of camera–equipped Japanese tourists as soon as the kilt was in place," says art director Karl Andersson. Adds copywriter Petter Nylind, "Norwegian is always open to try new solutions to get their message out, and this was something both they and, it would turn out, the residents of Stockholm really appreciated." To paraphrase the old joke about a Scotsman and his kilt, it looks like the presentation not only won first prize but also took home the Platinum.

This is not a legless cripple from Calcutta.
This is a defender of the rights of untouchables.

POORER COUNTRIES DESERVE MORE THAN OUR OUTDATED STEREOTYPES
SHOW YOUR SUPPORT BY BACKING LOCAL INITIATIVES

CREATIVE FIRM: EURO RSCG C&O – PARIS, FRANCE
CREATIVE TEAM: OLIVIER MOULIERAC, JÉRÔME GALINHA – CREATIVE DIRECTORS; CATHERINE LABRO – ART DIRECTOR; CAPUCINE LEWALLE – COPYWRITER; CORINNE DUTOIT–COSTA – AGENCY PRODUCER; AGATHE BOUSQUET – AGENCY COMMUNICATION DIRECTOR
CLIENT: CCFD – TERRE SOLIDAIRE

Susan Boyle

She Dreamed A Dream.
LIVE YOUR DREAMS
Pass It On.
VALUES.COM

CREATIVE FIRM: THE FOUNDATION FOR A BETTER LIFE – DENVER, CO, USA
CREATIVE TEAM: BERNIE HOGYA – CREATIVE DIRECTOR; RON WACHINO – WRITER
CLIENT: FOUNDATION FOR A BETTER LIFE

Greg Mortenson

Built 131 schools. Rebuilt 58,000 lives.
PURPOSE
Pass It On.
VALUES.COM

Albert Lexie

Donated $100,000 in tips to help kids.
CHARITY
Pass It On.
VALUES.COM

Mister Rogers

Won't you be my neighbor?
FRIENDSHIP
Pass It On.
VALUES.COM

CREATIVE FIRM: MTV NETWORKS – NEW YORK, NY, USA
CREATIVE TEAM: NIGEL COX–HAGAN – EVP CREATIVE & MARKETING; PHIL DELBOURGO – SVP BRAND & DESIGN; TRACI TERRILL – VP EDITORIAL; JIMMY WENTZ – VP OFF–AIR CREATIVE; KESIME BERNARD – CREATIVE DIRECTOR; ALLISON SIERRA – DIRECTOR PROJECT MANAGEMENT; JULIE RUIZ – ART DIRECTOR; JESSE RAKER – DESIGNER; KIM NGUYEN – WRITER; TRISTAN EATON – ILLUSTRATOR
CLIENT: CENTRIC

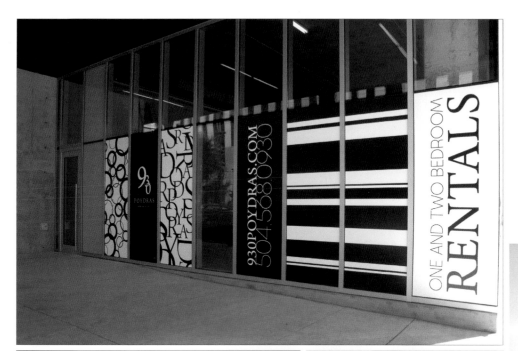

PLATINUM

CREATIVE FIRM: SQUARE FEET DESIGN – NEW YORK, NY, USA

CREATIVE TEAM: LAUREN MARWIL – PRINCIPAL/CREATIVE DIRECTOR; MARCELLA KOVAC, MICHELLE SNYDER, ROBYN HALPER – DESIGNERS

CLIENT: BRIAN GIBBS DEVELOPMENT LLC

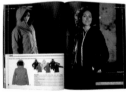

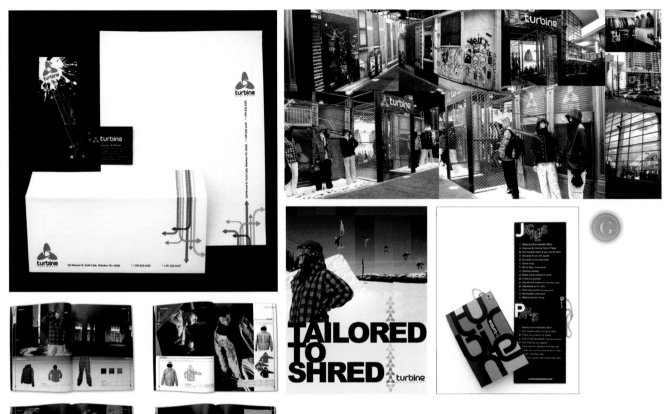

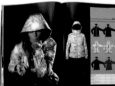

CREATIVE FIRM: TAIPEI, TAIWAN

CREATIVE TEAM: YU FEN (TRACY) LIN – ART DIRECTOR

CLIENT: TURBINE BOARDWEAR

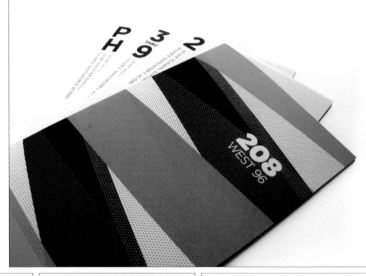

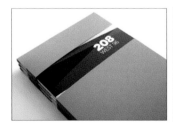

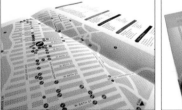

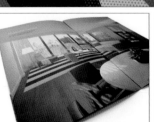

CREATIVE FIRM: SQUARE FEET DESIGN – NEW YORK, NY, USA

CREATIVE TEAM: LAUREN MARWIL – PRINCIPAL/CREATIVE DIRECTOR; MARCELLA KOVAC, ROBYN HALPER – DESIGNERS

CLIENT: MANOR PROPERTIES GROUP LLC

URL: HTTP://208W96.COM/

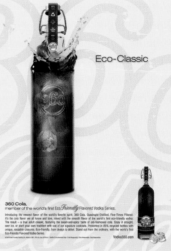

CREATIVE FIRM: SAGON/PHIOR – LOS ANGELES, CA, USA
CREATIVE TEAM: CANDY SAGON – SENIOR WRITER; GLENN SAGON – CREATIVE DIRECTOR; PATRICK FEE – CO–CREATIVE DIRECTOR
CLIENT: MCCORMICK DISTILLING

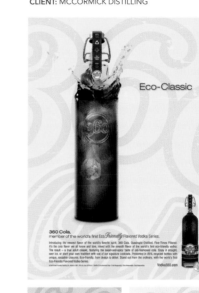

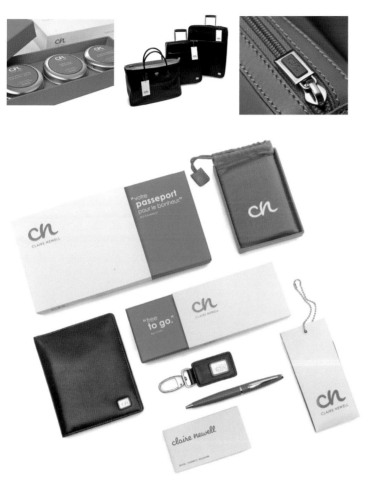

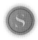

CREATIVE FIRM: BRAND ENGINE – SAUSALITO, CA, USA
CREATIVE TEAM: TOM DAVIDSON, WILL BURKE – ART DIRECTORS; TOM DAVIDSON, MIKE JOHNSON, MEEGAN PEERY, BILL KERR, CORALIE RUSSO – DESIGNERS
CLIENT: CLAIRE NEWELL

CREATIVE FIRM: STEPHEN LONGO DESIGN ASSOCIATES – WEST ORANGE, NJ, USA
CREATIVE TEAM: STEPHEN LONGO – ART DIRECTOR
CLIENT: EKKO RESTAURANT

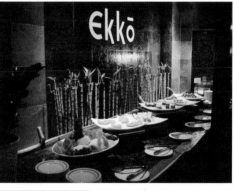

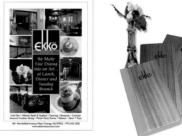

CREATIVE FIRM: AD PLANET GROUP – SINGAPORE
CREATIVE TEAM: JAMES TAN – PRODUCTION MANAGER; KELVIN TAY – ACCOUNT DIRECTOR; LEO TECK CHONG – EXECUTIVE CREATIVE DIRECTOR; ALFRED TEO – ASSOCIATE CREATIVE DIRECTOR
CLIENT: SINGAPORE PRESS HOLDINGS

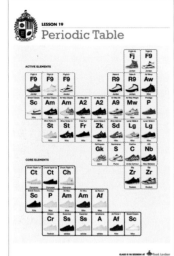

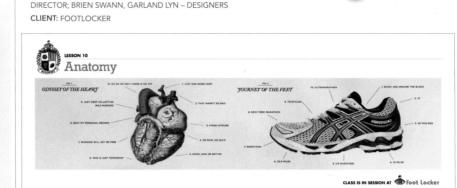

CREATIVE FIRM: SAPIENTNITRO – MIAMI BEACH, FL, USA

CREATIVE TEAM: NATHAN AVILA, BRAD BLONDES – DESIGNERS; KATHY DELANEY – CHIEF CREATIVE OFFICER; SARA GALKIN – SENIOR MANAGER, CREATIVE SERVICES; JOHN KUNICHIKA – DESIGN DIRECTOR; TODD FEITLIN – CREATIVE DIRECTOR; BRIEN SWANN, GARLAND LYN – DESIGNERS

CLIENT: FOOTLOCKER

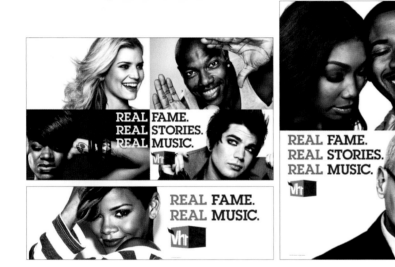

CREATIVE FIRM: MTV NETWORKS – NEW YORK, NY, USA

CREATIVE TEAM: NIGEL COX–HAGAN – EVP CREATIVE & MARKETING; PHIL DELBOURGO – SVP BRAND & DESIGN; TRACI TERRILL – VP EDITORIAL; JIMMY WENTZ – VP OFF–AIR CREATIVE; ALLISON SIERRA – DIRECTOR PROJECT MANAGEMENT; JULIE RUIZ – ART DIRECTOR; ADAM VOHLIDKA – DESIGNER; PIOTR SIKORA – PHOTOGRAPHER/ DIRECTOR OF PHOTOGRAPHY; BETH WAWERNA – DIRECTOR EDITORIAL; KIM NGUYEN – WRITER

CLIENT: VH1

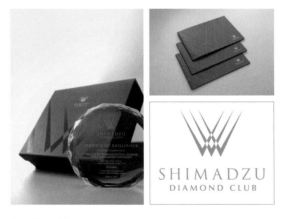

CREATIVE FIRM: OCULUS DESIGN PTE LTD – SINGAPORE

CREATIVE TEAM: JONATHAN ENG – DESIGN DIRECTOR; HUIMIN LIN – DESIGNER

CLIENT: SHIMADZU (ASIA PACIFIC) PTE LTD

CREATIVE FIRM: HANGAR 18 – VANCOUVER, BC, CANADA

CREATIVE TEAM: CASSIE PLOTNIKOFF – PROJECT MANAGER; SEAN CARTER – CREATIVE DIRECTOR; TODD CHAPMAN, SEAN CARTER – DESIGNERS; JOANNE HENDERSON – PRODUCTION MANAGER; JOAN HUNTER – PRODUCTION ARTIST

CLIENT: HANGAR 18 CREATIVE GROUP

URL: HTTP://WWW.H18.COM/

CREATIVE FIRM: MSDS – NEW YORK, NY, USA

CREATIVE TEAM: RYAN REYNOLDS – DESIGN DIRECTOR/ILLUSTRATOR; MATTHEW SCHWARTZ – CREATIVE DIRECTOR; PAUL CHAMBERLAIN – PRODUCTION DIRECTOR; NATHAN MANIRE – DESIGNER; JAMES PROVOST – ILLUSTRATOR

CLIENT: ELECTRIFICATION COALITION

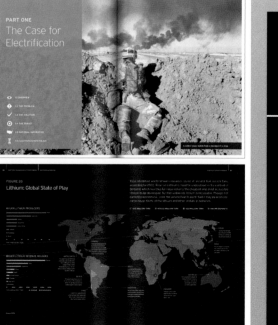

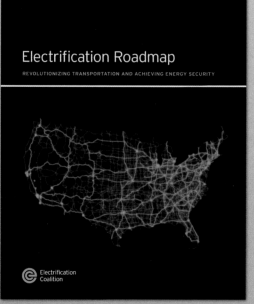

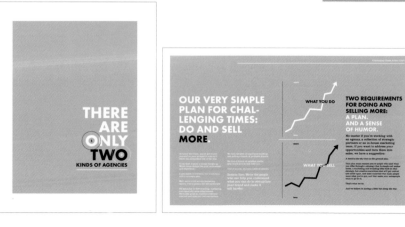

CREATIVE FIRM: MODO MODO AGENCY – ATLANTA, GA, USA

CLIENT: MODO MODO AGENCY

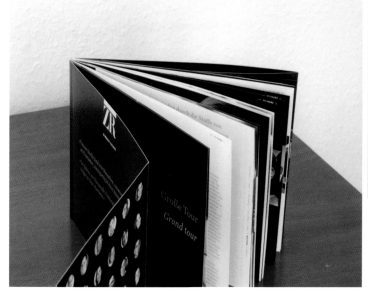

CREATIVE FIRM: SPELL INC. – NEW YORK, NY, USA

CREATIVE TEAM: NICI VON ALVENSLEBEN – CREATIVE DIRECTOR; LUCA VIGNELLI – PHOTOGRAPHER; CORNELIA KNAPP, SANDRA NEUHAUSEN – MARKETING

CLIENT: ZIMMER + ROHDE

CREATIVE FIRM: SIGNI – MEXICO

CREATIVE TEAM: RENE GALINDO – ART DIRECTOR; ODETTE EDWARDS – DESIGNER

CLIENT: GRUPO EXPANSION

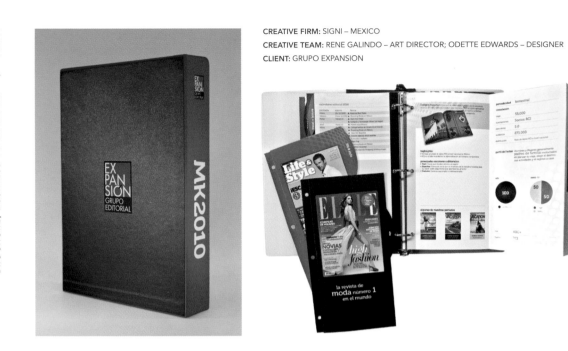

CREATIVE FIRM: FRANKE+FIORELLA – MINNEAPOLIS, MN, USA

CREATIVE TEAM: CRAIG FRANKE – PRINCIPAL/CREATIVE DIRECTOR; TODD MONGE – SENIOR DESIGNER; LISA PEMRICK, JILL MAKI – COPYWRITERS

CLIENT: THE VALSPAR CORPORATION

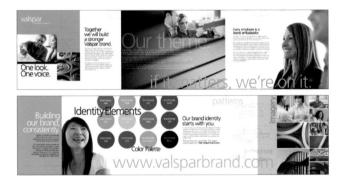

CREATIVE FIRM: PARETO – TORONTO, ON, CANADA

CREATIVE TEAM: EGON SPRINGER – CREATIVE DIRECTOR; LORI HONEYCOMBE – ART DIRECTOR; MAURICE YOUNG – COPYWRITER; JANE THEODORE – STUDIO MANAGER; JENNIFER TRUONG – MAC ARTIST; ANDRE VAN VUGT – PHOTOGRAPHER

CLIENT: SELECTED COMPANIES

CREATIVE FIRM: LEVINE & ASSOCIATES – WASHINGTON, D.C., USA

CREATIVE TEAM: MARCO JAVIER – CREATIVE STRATEGIST

CLIENT: CHILDREN'S NATIONAL MEDICAL CENTER

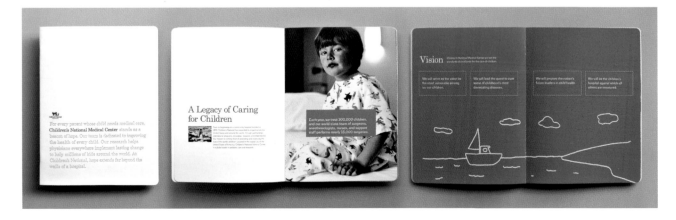

CREATIVE FIRM: MTV NETWORKS – NEW YORK, NY, USA

CREATIVE TEAM: SCOTT WADLER – SVP CREATIVE SERVICES, SENIOR CREATIVE DIRECTOR; CHERYL FAMILY – SVP/BRAND STRATEGIST; NICK GAMMA – DESIGN DIRECTOR; ANTHONY CARLUCCI – SENIOR DESIGNER; TORY MAST – COPYWRITER

CLIENT: VIACOM

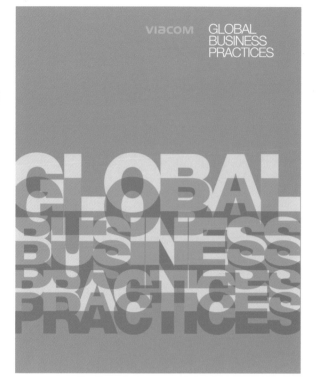

CREATIVE FIRM: FRANKE+FIORELLA – MINNEAPOLIS, MN, USA

CREATIVE TEAM: CRAIG FRANKE – PRINCIPAL/CREATIVE DIRECTOR; TODD MONGE – SENIOR DESIGNER; GREG MCCULLOUGH – COPYWRITER

CLIENT: THE MOSAIC COMPANY

CREATIVE FIRM: FINAR KURUMSAL – ISTANBUL, TURKEY

CREATIVE TEAM: TEOMAN FIÇICIOGLU – CREATIVE DIRECTOR; TALHA HOSGÖR, ÖZLEM FIRAT, FERHAT GÜZEL, ALI FAIK YILMAZ – GRAPHIC DESIGNERS

CLIENT: FINAR KURUMSAL

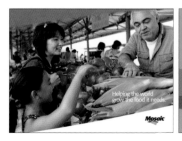

CREATIVE FIRM: FRANKE+FIORELLA – MINNEAPOLIS, MN, USA

CREATIVE TEAM: CRAIG FRANKE – PRINCIPAL, CREATIVE DIRECTOR; TODD MONGE – SENIOR DESIGNER; LISA PEMRICK – COPYWRITER

CLIENT: THE MOSAIC COMPANY

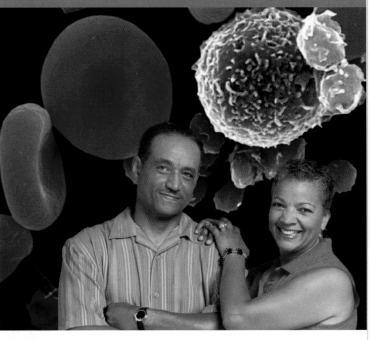

What If I Need Blood?
Understanding Your Blood Transfusion Options

+ **American Red Cross**

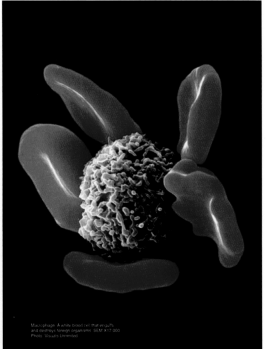

Macrophage: A white blood cell that engulfs
and destroys foreign organisms. SEM X17,000
Photo: Visuals Unlimited

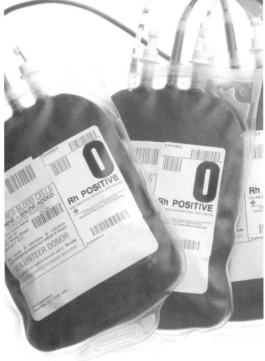

P PLATINUM

CREATIVE FIRM: AMERICAN RED CROSS – POMONA, CA, USA

CREATIVE TEAM: DONNA ANAYA – GRAPHIC ARTIST; MARC
JACKSON – DIRECTOR

CLIENT: AMERICAN RED CROSS

CREATIVE FIRM: ZYNC – TORONTO, ON, CANADA

CREATIVE TEAM: MARKO ZONTA – CREATIVE DIRECTOR; LEE BOULDEN – DESIGNER; ANNIE NAVALEZA–PARADIS – PRODUCTION DESIGNER

CLIENT: FRAGILE X RESEARCH FOUNDATION OF CANADA

CREATIVE FIRM: TOTH – CAMBRIDGE, MA, USA

CREATIVE TEAM: MIKE TOTH – CHIEF CREATIVE OFFICER; ROBERT VALENTINE – CREATIVE DIRECTOR; JACK WHITMAN – DESIGNER; DIANNA EDWARDS – COPYWRITER; GEOF KEARN, FRANCOIS HALARD, ANDREW ZUKERMAN – PHOTOGRAPHERS

CLIENT: INTERFACE FLOR

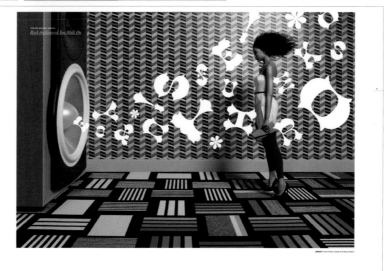

CREATIVE FIRM: E–GRAPHICS COMMUNICATIONS – YOKOHAMA, JAPAN

CREATIVE TEAM: TOMOHIRA KODAMA – EXECUTIVE CREATIVE DIRECTOR; SEIICHI YAMASHITA – CREATIVE DIRECTOR; CHIEKO IZUMI – ART DIRECTOR; NOBUHIRO YAMAGUCHI – COPYWRITER; KOJI BABA – PHOTOGRAPHER

CLIENT: NISSAN MOTOR COMPANY

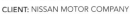

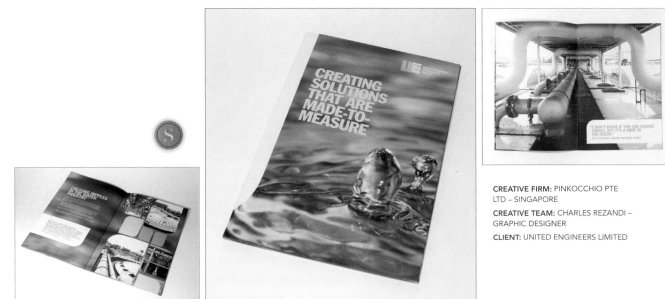

CREATIVE FIRM: PINKOCCHIO PTE LTD – SINGAPORE

CREATIVE TEAM: CHARLES REZANDI – GRAPHIC DESIGNER

CLIENT: UNITED ENGINEERS LIMITED

CREATIVE FIRM: E–GRAPHICS COMMUNICATIONS – YOKOHAMA, JAPAN

CREATIVE TEAM: TOMOHIRA KODAMA – EXECUTIVE CREATIVE DIRECTOR; YASUYUKI NAGATO – CREATIVE DIRECTOR; JUNICHI YOKOYAMA – ART DIRECTOR; NAOYA MIKI – DESIGNER; HIROYUKI ARAI – COPYWRITER; KOJI BABA – PHOTOGRAPHER

CLIENT: NISSAN MOTOR COMPANY

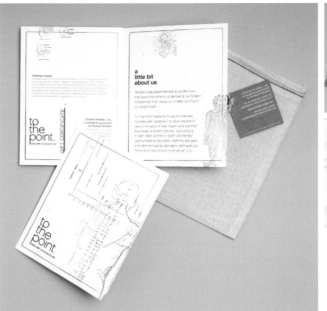

CREATIVE FIRM: BEX BRANDS – SAN DIEGO, CA, USA

CREATIVE TEAM: BECKY NELSON – CREATIVE DIRECTOR/DESIGNER

CLIENT: TO THE POINT ACUPUNCTURE

URL: WWW.BEXBRANDS.COM

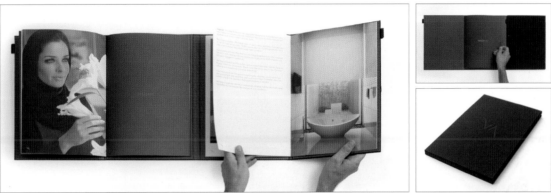

CREATIVE FIRM: TMH – DUBAI, UAE

CREATIVE TEAM: JAMES WOOD – CREATIVE DIRECTOR/DE-SIGNER; MORTEZA KASHANI – PRODUCTION MANAGER

CLIENT: INNOVARC

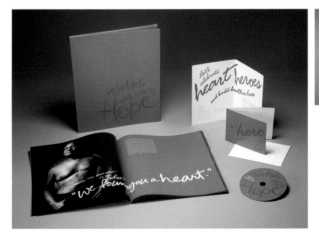

CREATIVE FIRM: CLINE DAVIS AND MANN LLC – NEW YORK, NY, USA

CREATIVE TEAM: GLENN BATKIN – GROUP CREATIVE DIRECTOR, ART; RITA CALIENDO – ART SUPERVISOR; JOE KREISBERG – COPY SUPERVISOR

CLIENT: AMERICAN HEART ASSOCIATION

CREATIVE FIRM: GREENFIELD/BELSER LTD. – WASHINGTON, D.C., USA

CREATIVE TEAM: AARON THORNBURGH – DESIGNER; JAIME CHIRINOS – PRODUCTION ARTIST

CLIENT: STEPTOE & JOHNSON

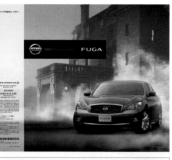

CREATIVE FIRM:
E–GRAPHICS COMMUNICA-
TIONS – YOKOHAMA, JAPAN

CREATIVE TEAM: TOMOHIRA
KODAMA – EXECUTIVE CRE-
ATIVE DIRECTOR; YASUYUKI
NAGATO – CREATIVE DIREC-
TOR; JUNICHI YOKOYAMA
– ART DIRECTOR; NAOYA
MIKI – DESIGNER; TAKANORI
UTSUMI – COPYWRITER; KOJI
BABA – PHOTOGRAPHER

CLIENT: NISSAN MOTOR
COMPANY

CREATIVE FIRM: PINKOCCHIO PTE
LTD – SINGAPORE

CREATIVE TEAM: TRACY TOH –
SENIOR GRAPHIC DESIGNER; TEW SUN
NE – CREATIVE DIRECTOR

CLIENT: UNITED ENGINEERS LIMITED

CREATIVE FIRM: E–GRAPHICS COMMUNICATIONS – YOKOHAMA, JAPAN

CREATIVE TEAM: TOMOHIRA KODAMA – EXECUTIVE CREATIVE DIRECTOR;
YASUYUKI NAGATO – CREATIVE DIRECTOR; RYUJI ISHIMATSU, JUNICHI KANBARA
– ART DIRECTORS; HIROYUKI ARAI – COPYWRITER; MAMORU ATSUTA –
PHOTOGRAPHER

CLIENT: NISSAN MOTOR COMPANY

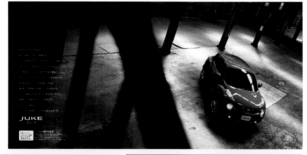

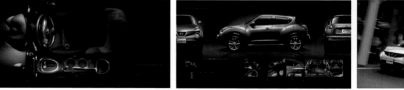

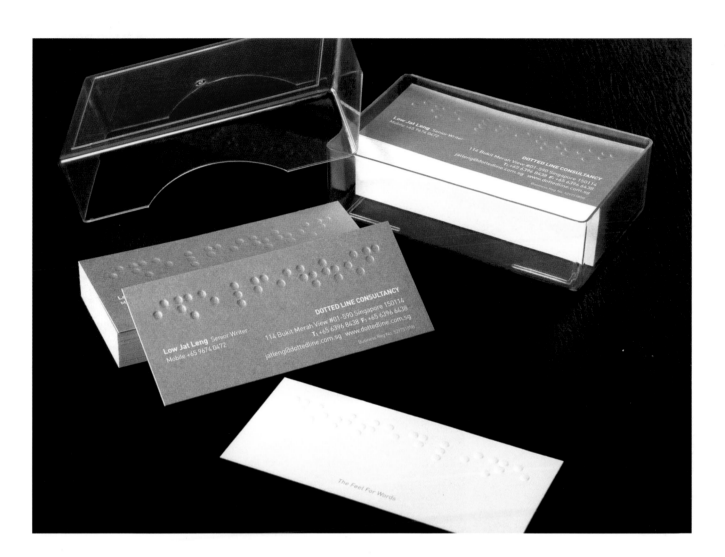

PLATINUM

DOTTED LINE

CREATIVE FIRM: SPLASH PRODUCTIONS PTE LTD –
SINGAPORE

CREATIVE TEAM: NORMAN LAI – ART DIRECTOR; JAT
LENG LOW, TERRY LEE – COPYWRITERS; NATALIE LOW –
DESIGNER

CLIENT: DOTTED LINE CONSULTANCY PTE LTD

URL: HTTP://WWW.SPLASH.SG/MAIN/INDEX.PHP?/
THINK/THE–FEE

Anyone trying to learn English as a second (or third, or fourth) language can tell you that it's not the simplest tongue to master—but that doesn't mean there's not elegance to be found within its forms. For a business card concept for Dotted Line Consultancy, Splash Productions in Singapore made an effort to illustrate the minimalist elegance of the English language. "The client wanted us to convey the feel for words and have the cards be highly accessible to everyone who can read, even the visually challenged," says art director Norman Lai. The challenge, however, was telling the Dotted Line story with the least amount of details while still communicating multiple layers of meaning through, as Lai says, "accessibility, sensibility, universality, and flair."

Splash elegantly included all of those elements in the metallic silver cards; the embossed dots form the company name in Braille. "These spell accessibility," says Lai. "Artfully connected, the line connotes ideas forming into insights, and insights into persuasions." The backs of the cards further drive home the power of the consultancy with the line, "The Feel For Words."

CREATIVE FIRM: INKUBATOR IDEJA D.O.O. –
ZAGREB, CROATIA
CREATIVE TEAM: ANTONIO TEPIC – DESIGNER
CLIENT: ADA UVOZ–IZVOZ D.O.O.
URL: HTTP://PAKIRANJEPOKLONA.COM/

CREATIVE FIRM: ZUAN CLUB – TOKYO, JAPAN
CREATIVE TEAM: AKIHIKO TSUKAMOTO –
DESIGN/ART DIRECTION
CLIENT: JEWERY FOUR C, LTD.

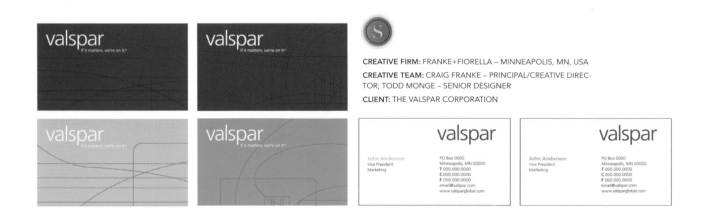

CREATIVE FIRM: FRANKE+FIORELLA – MINNEAPOLIS, MN, USA
CREATIVE TEAM: CRAIG FRANKE – PRINCIPAL/CREATIVE DIREC-
TOR; TODD MONGE – SENIOR DESIGNER
CLIENT: THE VALSPAR CORPORATION

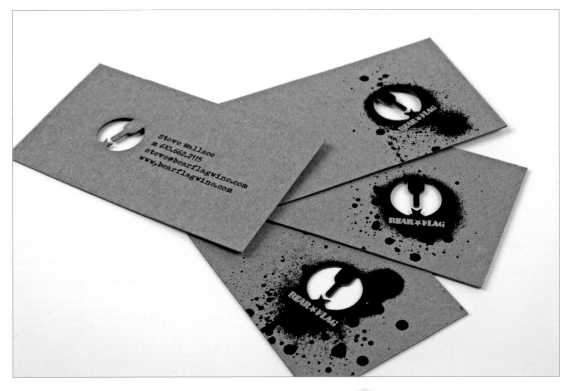

CREATIVE FIRM: HUNTER PUBLIC RELATIONS – NEW YORK, NY, USA
CREATIVE TEAM: LOUISA CARAGAN – CREATIVE DIRECTOR; FREDDY LOPEZ – DESIGNER
CLIENT: BEAR FLAG WINE

CREATIVE FIRM: IGH SOLUTIONS – INVER GROVE HEIGHTS, MN, USA
CREATIVE TEAM: JORDAN FALK – CREATIVE MANAGER
CLIENT: VIRTUAL IMAGES

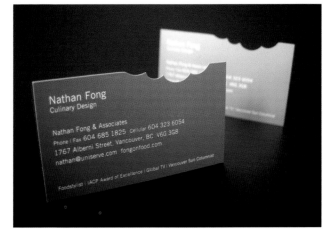

CREATIVE FIRM: HANGAR 18 – VANCOUVER, BC, CANADA
CREATIVE TEAM: VIDA JURCIC – CONCEPT & DESIGN;
JOANNE HENDERSON, JOAN HUNTER – PRODUCTION
CLIENT: NATHAN FONG

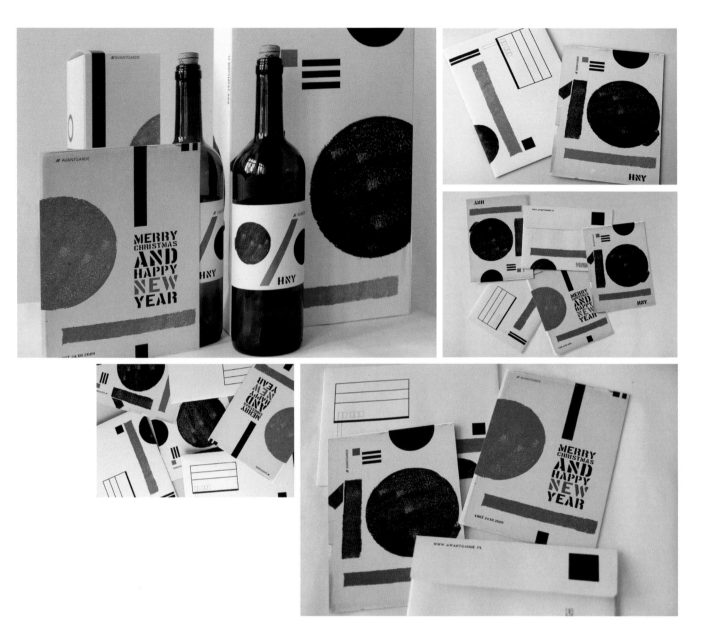

PLATINUM

CREATIVE FIRM: GRAFIKA AWANTGARDA – LODZ, POLAND
CREATIVE TEAM: AGNIESZKA ZIEMISZEWSKA – GRAPHIC DESIGNER
CLIENT: GRAFIKA AWANTGARDA
URL: WWW.ZIEMI.ART.PL

HNY FROM LODZ

The winter holidays may mean less business for many agencies, but many strive to let clients know that they're not forgotten–and that they make the rest of the year's business possible. Grafika Awantgarda in Lodz, Poland drew on its city's design traditions in devising a non–religious Christmas/New Year's card for clients, friends, and acquaintances. "Because Christmas is for me a tradition, the project of the card refers to the design traditions of the city of Lodz," says graphic designer Agnieszka Ziemiszews-

ka. "Lodz has a rich constructivist avant–garde tradition, which was created by such artists as Wladyslaw Strzemisnki and Henryk Berlewi, who had and still have a strong influence on many designers from Lodz." The project adapted current avant–garde interpretations in order to pay homage to the graphic tradition while emphasizing the identity of its source. The set, composed of a card and a custom–labeled bottle of wine with which to toast the New Year, were designed especially for the occasion.

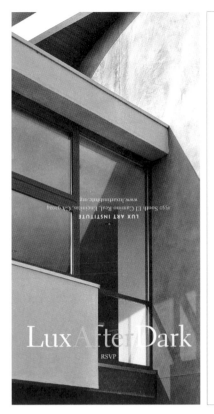

CREATIVE FIRM: MIRESBALL – SAN DIEGO, CA, USA
CREATIVE TEAM: JOHN BALL – CREATIVE DIRECTOR;
BETH FOLKERTH, GALE SPITZLEY – SENIOR DESIGNERS
CLIENT: LUX

CREATIVE FIRM: FOUNDRY CREATIVE – CALGARY, AB, CANADA
CREATIVE TEAM: ZAHRA ALHARAZI – CREATIVE DIRECTOR; KYLIE
HENRY – D`ESIGNER; SIGNATURE PRESS – PRINTER
CLIENT: NEXEN

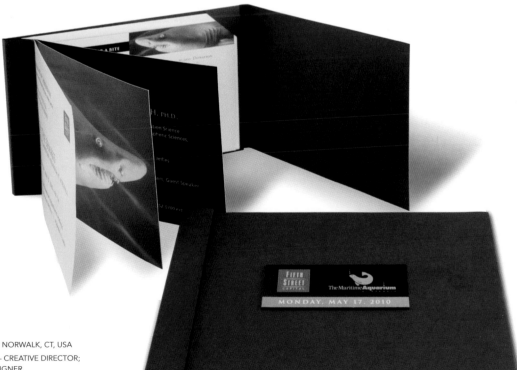

CREATIVE FIRM: TFI ENVISION, INC. – NORWALK, CT, USA
CREATIVE TEAM: ELIZABETH P. BALL – CREATIVE DIRECTOR;
BRIEN O'REILLY – ART DIRECTOR/DESIGNER
CLIENT: THE MARITIME AQUARIUM AT NORWALK

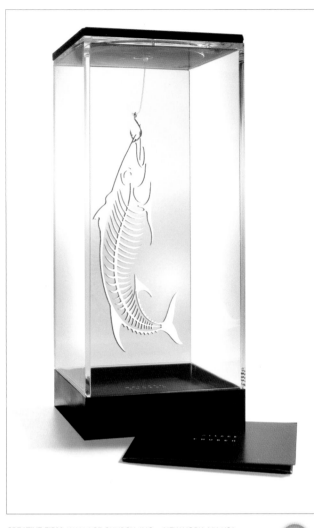

CREATIVE FIRM: WALLACE CHURCH, INC. – NEW YORK, NY, USA

CREATIVE TEAM: STAN CHURCH – CREATIVE DIRECTOR; TIPHAINE GUIL-LEMET, BECCA REITER, KIM YOUNG – DESIGNERS

CLIENT: WALLACE CHURCH, INC

URL: WWW.WALLACECHURCH.COM

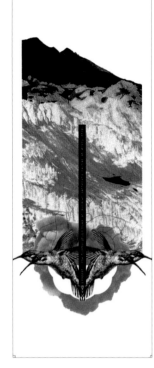

Kantorwassink invites you and a guest to be our guests at the UICA Live Coverage Event.

3 13 2010

DRINKS BEFORE DRINKS
Pub 43
43 Division Avenue South
5:00pm – 6:20pm

ART AND AUCTION AND DRINKS
Urban Institute for Contemporary Arts
41 Sheldon Boulevard SE
6:30pm – 11:00pm

Tickets, tabs and cabs are on Kantorwassink

Help us help keep the creative arts promising and prominent in Grand Rapids.

CREATIVE FIRM: KANTORWASSINK – GRAND RAPIDS, MI, USA

CREATIVE TEAM: DAVE KANTOR, WENDY WASSINK, JASON MURRAY – CREATIVE; AMY MARINARI – PRODUCTION

CLIENT: KANTORWASSINK

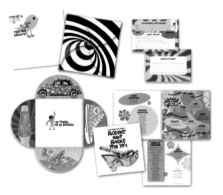

CREATIVE FIRM: RANDI WOLF DESIGN – GLASSBORO, NJ, USA

CREATIVE TEAM: KIM CREAMER – CLIENT DIRECTOR; THOMAS SOMMER – CLIENT DIRECTOR OF DEVELOPMENT; RANDI WOLF – GRAPHIC DESIGNER; DONNA MIDILI – CLIENT PRODUCTION MANAGER

CLIENT: ROBINS' NEST INC.

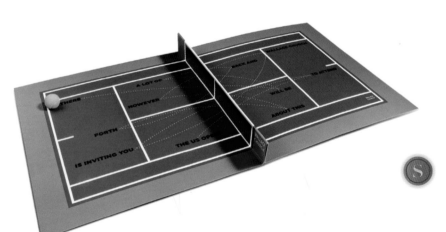

CREATIVE FIRM: WALLACE CHURCH, INC. – NEW YORK, NY, USA

CREATIVE TEAM: STAN CHURCH – CREATIVE DIRECTOR; TIPHAINE GUILLEMET – DESIGNER

CLIENT: WALLACE CHURCH, INC

URL: WWW.WALLACECHURCH.COM

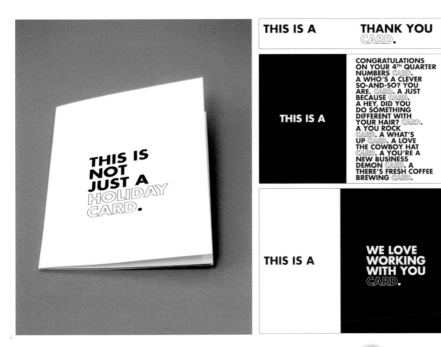

THIS IS A THANK YOU CARD.

THIS IS A CONGRATULATIONS ON YOUR 4TH QUARTER NUMBERS CARD. A WHO'S A CLEVER SO-AND-SO? YOU ARE. CARD. A JUST BECAUSE CARD. A HEY, DID YOU DO SOMETHING DIFFERENT WITH YOUR HAIR? CARD. A YOU ROCK CARD. A WHAT'S UP CARD. A LOVE THE COWBOY HAT CARD. A YOU'RE A NEW BUSINESS DEMON CARD. A THERE'S FRESH COFFEE BREWING CARD.

THIS IS A WE LOVE WORKING WITH YOU CARD.

CREATIVE FIRM: MODO MODO AGENCY – ATLANTA, GA, USA
CREATIVE TEAM: JENNIFER WATSON – CREATIVE DIRECTOR; KIRK WELLS – ART DIRECTOR
CLIENT: MODO MODO AGENCY

CREATIVE FIRM: MERCHAN–DESIGN – SAO PAULO, BRAZIL
CREATIVE TEAM: MARCELO LOPES – DESIGNER/DESIGNER DIRECTOR
CLIENT: THAMIREZ

CREATIVE FIRM: PARETO – TORONTO, ON, CANADA
CREATIVE TEAM: LORI HONEYCOMBE – ART DIRECTOR/COPY-WRITER/DESIGNER; BRIAN BURCH – PRINT PRODUCTION; EGON SPRINGER – CREATIVE DIRECTOR
CLIENT: SUZANNE DUFFIN

CREATIVE FIRM: HICKOK COLE ARCHITECTS – WASHINGTON, D.C., USA
CREATIVE TEAM: JENNIFER MURPHY – GRAPHIC DESIGNER; SARAH BARR – ART DIRECTOR; MARILYNN MENDELL – STRATEGIC PLANNING
CLIENT: HICKOK COLE ARCHITECTS

CREATIVE FIRM: DESIGN NUT – KENSINGTON, MD, USA
CREATIVE TEAM: BRENT ALMOND – DESIGNER/PHOTOGRAPHER/COPYWRITER
CLIENT: DESIGN NUT, LLC

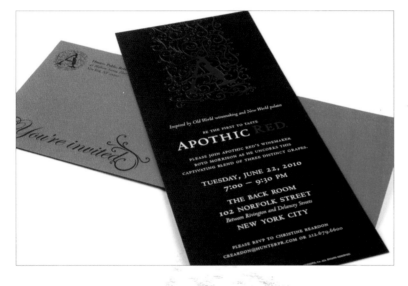

CREATIVE FIRM: HUNTER PUBLIC RELATIONS – NEW YORK, NY, USA
CREATIVE TEAM: LOUISA CARAGAN – CREATIVE DIRECTOR; LAURA DESILVIO – DESIGNER
CLIENT: APOTHIC RED WINE

CREATIVE FIRM: HICKOK COLE ARCHITECTS – WASHINGTON, D.C., USA
CREATIVE TEAM: SARAH BARR – ART DIRECTOR/GRAPHIC DESIGNER; MARILYNN MENDELL – STRATEGIC PLANNING
CLIENT: HICKOK COLE ARCHITECTS

CREATIVE FIRM: TFI ENVISION, INC. – NORWALK, CT, USA
CREATIVE TEAM: ELIZABETH P. BALL – CREATIVE DIRECTOR/ART DIRECTOR/DESIGNER
CLIENT: TFI ENVISION, INC.

CREATIVE FIRM: CHASE CREATIVE – ST. PETE BEACH, FL, USA
CREATIVE TEAM: GEORGE CHASE – OWNER
CLIENT: STUART SOCIETY

CREATIVE FIRM: DENISE BOSLER LLC – DOUGLASSVILLE, PA, USA
CREATIVE TEAM: DENISE BOSLER – DESIGNER; TRACY KRETZ –
PHOTOGRAPHY
CLIENT: DENISE BOSLER & ROBERT WEINMANN

CREATIVE FIRM: DESIGN NUT – KENSINGTON, MD, USA
CREATIVE TEAM: BRENT ALMOND – DESIGNER
CLIENT: THE CHORAL ARTS SOCIETY OF WASHINGTON

CREATIVE FIRM: PINKOCCHIO PTE LTD – SINGAPORE
CREATIVE TEAM: TRACY TOH – SENIOR GRAPHIC DESIGNER; TEW SUN NE – CREATIVE DIRECTOR
CLIENT: MINISTRY OF MANPOWER

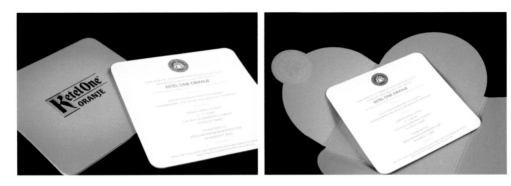

CREATIVE FIRM: HUNTER PUBLIC RELATIONS – NEW YORK, NY, USA
CREATIVE TEAM: LOUISA CARAGAN – CREATIVE DIRECTOR/DESIGNER
CLIENT: DIAGEO NORTH AMERICA

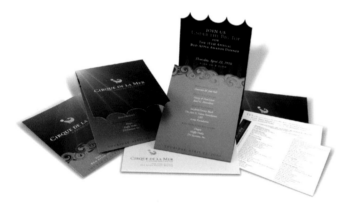

CREATIVE FIRM: TFI ENVISION, INC. – NORWALK, CT, USA
CREATIVE TEAM: ELIZABETH P. BALL – CREATIVE DIRECTOR; BRIEN O'REILLY – ART
DIRECTOR/DESIGNER
CLIENT: THE MARITIME AQUARIUM AT NORWALK

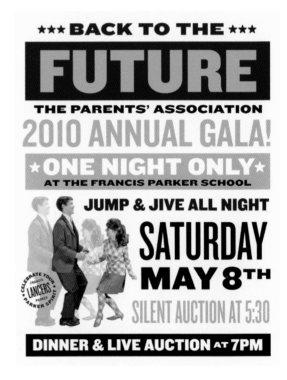

CREATIVE FIRM: MIRESBALL – SAN DIEGO, CA, USA
CREATIVE TEAM: SCOTT MIRES – CREATIVE DIRECTOR; DYLAN JONES –
SENIOR DESIGNER; ASHLEY KERNS, MARGARET HURLBUT – DESIGNERS
CLIENT: FRANCIS PARKER

CREATIVE FIRM: HUNTER PUBLIC RELATIONS – NEW YORK, NY, USA
CREATIVE TEAM: LOUISA CARAGAN – CREATIVE DIRECTOR; LAURA DESILVIO – DESIGNER
CLIENT: BAREFOOT WINE

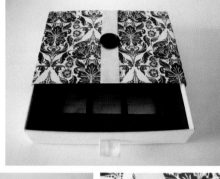

CREATIVE FIRM: BRIGHT RAIN CREATIVE – ST. LOUIS, MO, USA
CREATIVE TEAM: MATT MARINO – DESIGNER
CLIENT: ROBERT CLARK

CREATIVE FIRM: NATOOF – DUBAI, UAE
CREATIVE TEAM: MARIAM BIN NATOOF – FOUNDER & CREATIVE DIRECTOR
CLIENT: SUAAD & SAEED

CREATIVE FIRM: NATOOF – DUBAI, UAE
CREATIVE TEAM: MARIAM BIN NATOOF – FOUNDER &
CREATIVE DIRECTOR
CLIENT: NATOOF
URL: HTTP://WWW.NATOOF.COM

CREATIVE FIRM: STUDIO TWO – LENOX, MA, USA
CREATIVE TEAM: AMANDA BETTIS – GRAPHIC DESIGNER;
KEVIN SPRAGUE – CREATIVE DIRECTOR
CLIENT: IS183 ART SCHOOL
URL: HTTP://IS183.ORG/

CREATIVE FIRM: SBC ADVERTISING –
COLUMBUS, OH, USA

CREATIVE TEAM: LANCE DOOLEY –
V.P. CREATIVE DIRECTOR; STEPHANIE
YOUNG – ASSOCIATE CREATIVE
DIRECTOR; KATIE DIRKSEN – ART
DIRECTOR; JIM SMITH – SR.
COPYWRITER; MARK HOLTHUESEN –
PHOTOGRAPHER

CLIENT: BED BATH & BEYOND

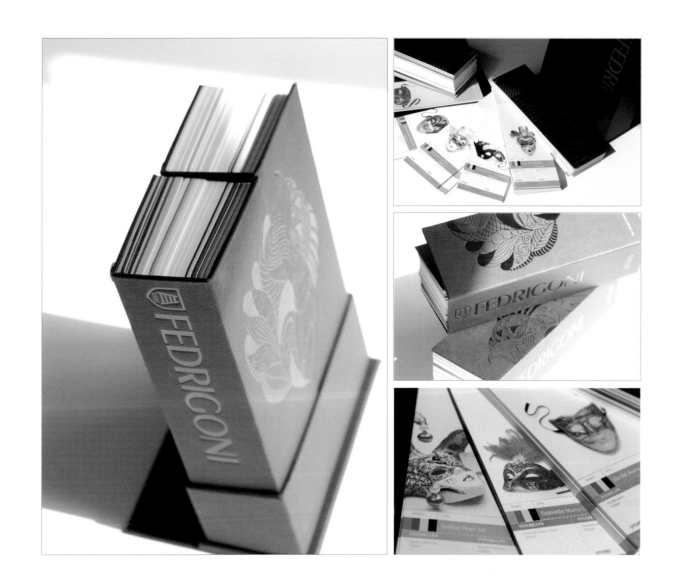

 PLATINUM

DESKTOP SWATCH BOOK

CREATIVE FIRM: TMH – DUBAI, UAE
CREATIVE TEAM: JAMES WOOD – CREATIVE DIRECTOR/
DESIGNER; MORTEZA KASHANI – PRODUCTION MANAGER;
SRINIVAS SHENOY – HEAD OF ARTWORK
CLIENT: FEDRIGONI

Gorgeous paper demanded a gorgeous showcase, and Italian paper manufacturers Fedrigoni had TMH, an agency in Dubai, create a beautiful desktop swatch book. "It needed to be a piece of collateral that fellow designers and art directors would enjoy using day to day," says creative designer and director James Wood, "keeping the papers of Fedrigoni 'front of mind' as the stock of choice."

However, finding a unifying theme that could be successfully deployed over 300 wildly different colors, textures, and finishes of paper (as well as shipping it all over the world) was a bit of a challenge. TMH drew its inspiration from the vivid colors and intricate details of Venetian masks, reflecting the opulent brand values of Fedrigoni's Italian heritage, punctuating it with a tagline, "The people behind fine Italian paper." "The masquerade theme provided great opportunities to display exotic images, and high–end production techniques such as CYMK overprinting on debossed hot foil maximized and enhanced the qualities

of the paper," Wood reports. To aid with portability, a "flip and stand" display format was a simple yet stylish solution to the problem of shipping the finished units, which end users could then easily convert to a sturdy desktop dispenser.

"I believe successful creative solutions are born out of developing a strong collaborative relationship between the client and the creative agency," says Wood. "We are very fortunate to enjoy such a relationship, and I think the result speaks for itself."

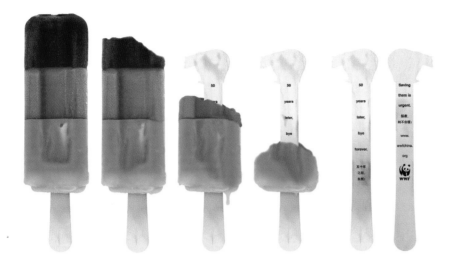

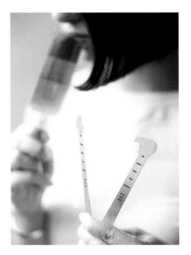

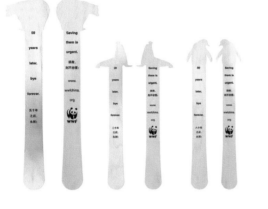

CREATIVE FIRM: ERIC CAI DESIGN CO. – BEIJING, CHINA

CREATIVE TEAM: CAI SHI WEI, ERIC – CREATIVE DIRECTOR/ART DIRECTOR/
DESIGNER; TAN YAN, ESTHER – WRITER; DUAN LIAN, DENNY – DESIGNER

CLIENT: WWF CHINA

CREATIVE FIRM: SHERMAN ADVERTISING/MERMAID,
INC. – NEW YORK, NY, USA

CREATIVE TEAM: SHARON MCLAUGHLIN – CREATIVE
DIRECTOR; STEPHEN MORSE – RETOUCHER

CLIENT: HUDSON HARBOR

 CREATIVE FIRM: PLUMBLINE STUDIOS, INC – NAPA, CA, USA

CREATIVE TEAM: DOM MORECI – CREATIVE DIRECTOR/
PHOTOGRAPHER; ROBERT BURNS – DESIGN DIRECTOR;
ERIC BALL – DESIGNER

CLIENT: MARIN HISTORY MUSEUM

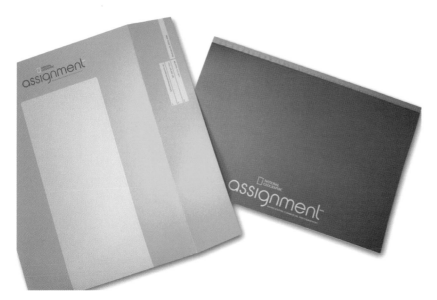

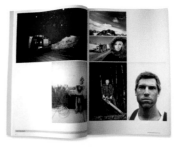

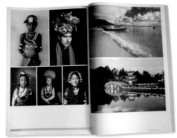

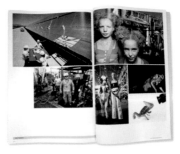

CREATIVE FIRM: NATIONAL GEOGRAPHIC IMAGE SALES – WASHINGTON, D.C., USA

CREATIVE TEAM: NADINE STELLAVATO BROWN – DESIGNER

CLIENT: NATIONAL GEOGRAPHIC ASSIGNMENT

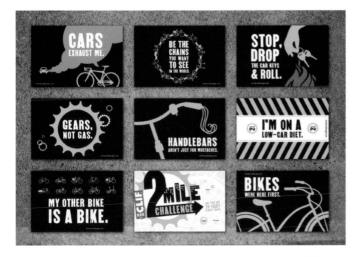

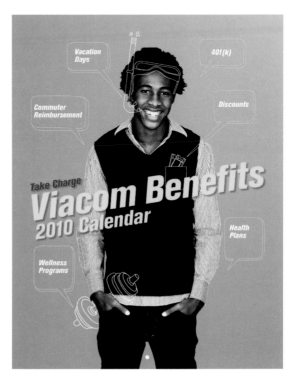

CREATIVE FIRM: CLIF BAR & COMPANY – EMERYVILLE, CA, USA

CREATIVE TEAM: MARK BOEDIMAN – SENIOR DESIGNER; CHRISTO-
PHER SWANNER – COPYWRITER; ELLY CHO – PRODUCTION; MATTHEW
LOYD – CREATIVE DIRECTOR

CLIENT: CLIF BAR & COMPANY

CREATIVE FIRM: MTV NETWORKS – NEW YORK, NY, USA

CREATIVE TEAM: SCOTT WADLER – SVP CREATIVE SERVICES, SENIOR CREATIVE DIRECTOR;
CHERYL FAMILY – SVP/BRAND STRATEGIST; NICK GAMMA – DESIGN DIRECTOR; ANTHONY CAR-
LUCCI – SENIOR DESIGNER; PATRICK O'SULLIVAN – COPY DIRECTOR; TORY MAST – COPYWRITER

CLIENT: VIACOM

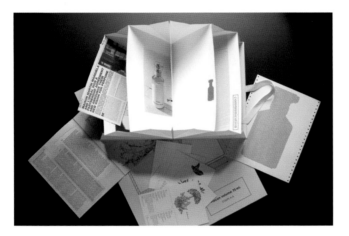

CREATIVE FIRM: RYSWYCK – PARIS, FRANCE
CREATIVE TEAM: RYSWYCK, MAISON MARTIN MARGIELA PARFUMS – CREATIVE DIRECTORS; GILLES ESTEVE – ART DIRECTOR
CLIENT: MAISON MARTIN MARGIELA PARFUMS
URL: WWW.MAISONMARTINMARGIELA–PARFUMS.COM

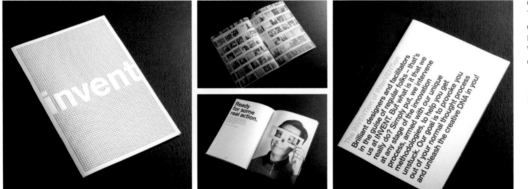

CREATIVE FIRM: SPLASH PRODUC-
TIONS PTE LTD – SINGAPORE
CREATIVE TEAM: STANLEY YAP – ART
DIRECTOR; SERENE SEE – COPY-
WRITER
CLIENT: NATIONAL LIBRARY BOARD

CREATIVE FIRM: COGNETIX – CHARLESTON, SC, USA
CREATIVE TEAM: WILSON BAKER – PHOTOGRAPHER; KATIE KERN – PROJECT MANAGER; HEATHER MUELLER – COPYWRITER; JESSICA CROUCH – ART DIRECTOR/DESIGNER
CLIENT: BISHOP GADSDEN

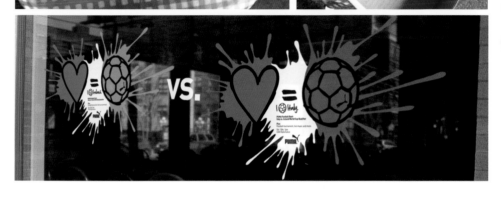

We checked with the kitchen, this pizza is regulation.

PUMA Football Bash
Italy vs. Ireland World Cup Qualifier

Plus
Football tournament, live music and more.
Oct. 10th, 1pm
Café Diplomatico

Café Diplomatico
RESTAURANT & PIZZERIA

♥ = ⚽

⚑ No Jersey
👟 No Cleats
🚫 No Service

♥ = ⚽

CREATIVE FIRM: ZULU ALPHA KILO – TORONTO, ON, CANADA

CREATIVE TEAM: ZAK MROUEH – CREATIVE DIRECTOR; MARK FRANCOLINI – ART DIRECTOR; GEORGE AULT – COPYWRITER; GRANT CLELAND – DESIGNER; JAY LOLLI, ROB SGRIGNOLI – PHOTOGRAPHERS

CLIENT: PUMA CANADA

♥ = ⚽ VS. ♥ = ⚽

CREATIVE FIRM: PINKOCCHIO PTE LTD – SINGAPORE

CREATIVE TEAM: TRACY TOH – SENIOR GRAPHIC DESIGNER; TEW SUN NE – CREATIVE DIRECTOR

CLIENT: LHN GROUP

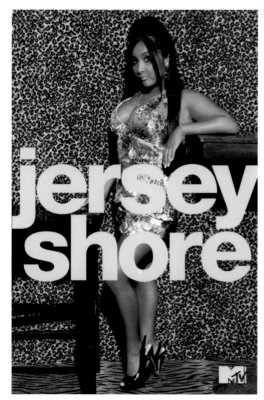

jersey shore

CREATIVE FIRM: MTV NETWORKS – NEW YORK, NY, USA

CREATIVE TEAM: JEFFREY KEYTON – SVP, DESIGN AND OFF–AIR CREATIVE; JIM DEBARROS – VP, OFF–AIR CREATIVE; LANCE RUSOFF – DESIGN DIRECTOR; ERHAN ERDEM – COPY DIRECTOR; ISABELLE RANCIER – DESIGNER; FRAN SIZEMORE – COORDINATING PRODUCER

CLIENT: MTV

CREATIVE FIRM: SHERMAN ADVERTISING/MERMAID, INC. – NEW YORK, NY, USA

CREATIVE TEAM: SHARON MCLAUGHLIN – CREATIVE DIRECTOR; STEPHEN MORSE – RETOUCHER

CLIENT: 40 WALL STREET

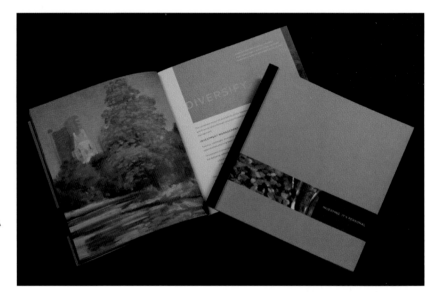

CREATIVE FIRM: SKIDMORE – ROYAL OAK, MI, USA

CREATIVE TEAM: GARY SPONDIKE – SENIOR ACCOUNT DIRECTOR; LAURA LYBEER–HILPERT – DESIGNER; STEVE MAGSIG – ILLUSTRATOR; SARA FREY – WRITER

CLIENT: TELEMUS CAPITAL

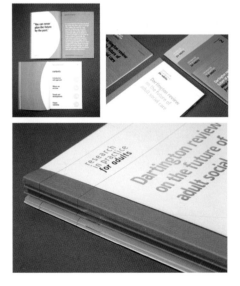

CREATIVE FIRM: PATRICK HENRY CREATIVE PROMO- TIONS, INC. – STAFFORD, TX, USA

CREATIVE TEAM: HOLLY MCALLISTER – SR. ART DIREC- TOR; TIM TURNER – PHOTOGRAPHER

CLIENT: INTERSTATE HOTELS & RESORTS`

CREATIVE FIRM: BELIEVE IN LIMITED – EXETER, UK

CREATIVE TEAM: TISH ENGLAND – DESIGN DIRECTOR; BLAIR THOMSON – CREATIVE DIRECTOR

CLIENT: RESEARCH IN PRACTICE FOR ADULTS (RIPFA)`

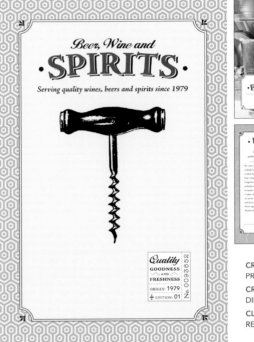

CREATIVE FIRM: PATRICK HENRY CREATIVE PROMOTIONS, INC. – STAFFORD, TX, USA

CREATIVE TEAM: HOLLY MCALLISTER – SR. ART DIRECTOR; RALPH SMITH – PHOTOGRAPHER

CLIENT: MCCORMICK & SCHMICK'S SEAFOOD RESTAURANTS

CREATIVE FIRM: SPLASH PRODUCTIONS PTE LTD – SINGAPORE

CREATIVE TEAM: TERRY LEE – COPYWRITER; CAILING LIM – DESIGNER; DOMINIE PTE LTD – PRINTER

CLIENT: ACI

CREATIVE FIRM: ALCONE MARKETING – IRVINE, CA, USA

CREATIVE TEAM: RENATA CARROLL, JULIA CADAR – ART DIRECTORS; NICK ROOTH – CREATIVE DIRECTOR; KEVIN KLEBER – VP CREATIVE DIRECTOR; LUIS CAMANO – CHIEF CREATIVE OFFICER

CLIENT: THE WD–40 COMPANY

CREATIVE FIRM: SHERMAN ADVERTISING/MERMAID, INC. – NEW YORK, NY, USA

CREATIVE TEAM: SHARON MCLAUGHLIN – CREATIVE DIRECTOR; STEPHEN MORSE – RETOUCHER

CLIENT: LIBERTY LUXE / LIBERTY GREEN

CREATIVE FIRM: MERCHAN–DESIGN – SAO PAULO, BRAZIL
CREATIVE TEAM: MARCELO LOPES – DESIGNER/DESIGNER DIRECTOR
CLIENT: EMAR BATALHA

CREATIVE FIRM: GRAIN CREATIVE CONSULTANTS – SURRY HILLS, NSW, AUSTRALIA
CREATIVE TEAM: JURE LEKO – CREATIVE DIRECTOR/TYPOGRAPHER; JEREMY TOMBS – SENIOR DESIGNER
CLIENT: SARA LEE AUSTRALIA

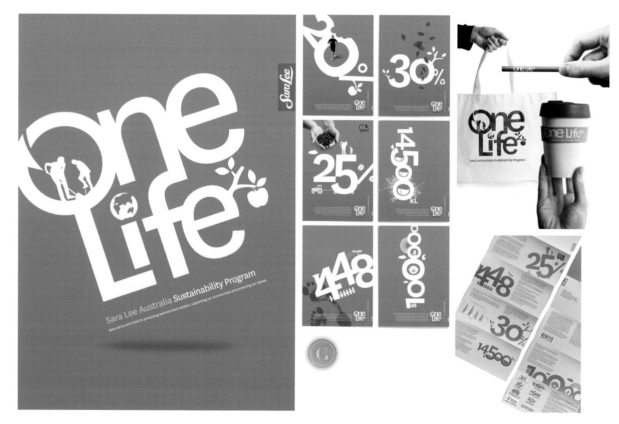

CREATIVE FIRM: PURPLE FOCUS PVT. LTD. – INDORE, INDIA

CREATIVE TEAM: VALLAN ANTONY, PRAVEEN KARPE – ASSOCIATE CDS; NILESH KULKARNI – ART DIRECTOR; MAHENDRA NAGVANSHI – SENIOR VISUALISER

CLIENT: CHIMC

CREATIVE FIRM: FRANKE+FIORELLA – MINNEAPOLIS, MN, USA

CREATIVE TEAM: CRAIG FRANKE – PRINCIPAL/CREATIVE DIRECTOR; SHARON MAZUREK, BRETT BACON – DESIGNERS; KATRIN LOSS – PRODUCTION/DESIGNER; DAWN GRAN – COPYWRITER

CLIENT: 3M, SKIN AND WOUND CARE DIVISION

CREATIVE FIRM: SBC ADVERTISING – COLUMBUS, OH, USA

CREATIVE TEAM: JOE & MARY VAN BLERK, PETE COE, ALEC HEMER – PHOTOGRAPHERS, HOW BOOK; MARK HOLTHUESEN – PHOTOGRAPHER, WOW BOOK; LANCE DOOLEY – V.P. CREATIVE DIRECTOR; STEPHANIE YOUNG – ASSOCIATE CREATIVE DIRECTOR; KATIE DIRKSEN – ART DIRECTOR; JIM SMITH – SR. COPYWRITER

CLIENT: BED BATH & BEYOND

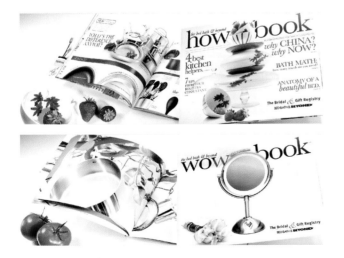

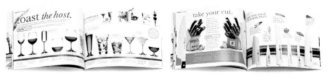

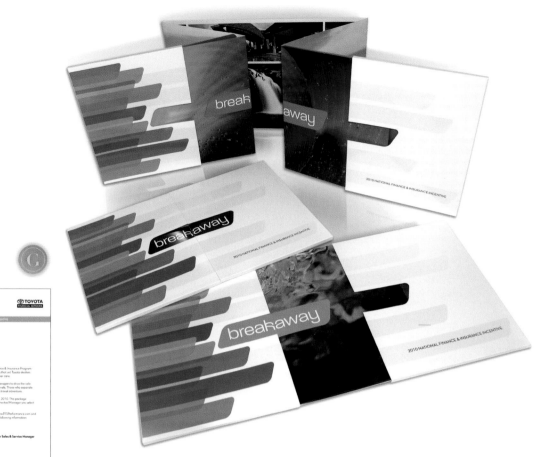

CREATIVE FIRM: TOYOTA FINANCIAL SERVICES – TORRANCE, CA, USA

CREATIVE TEAM: DANIEL KO, DOUG YASUDA – ART DIRECTORS; ALAN WIESNER – DESIGN MANAGER;
JESSAMINE MERRILL – MARKETING MANAGER

CLIENT: TOYOTA FINANCIAL SERVICES

CREATIVE FIRM: OCULUS DESIGN PTE LTD – SINGAPORE

CREATIVE TEAM: JONATHAN ENG – DESIGN DIRECTOR; CHIN YONG NG – DESIGNER; THE EUROPEAN UNION
DELEGATION TO SINGAPORE; SWEDISH EMBASSY

CLIENT: EUROPEAN UNION DELEGATION TO SINGAPORE

URL: HTTP://WWW.CITIES2050.SG/

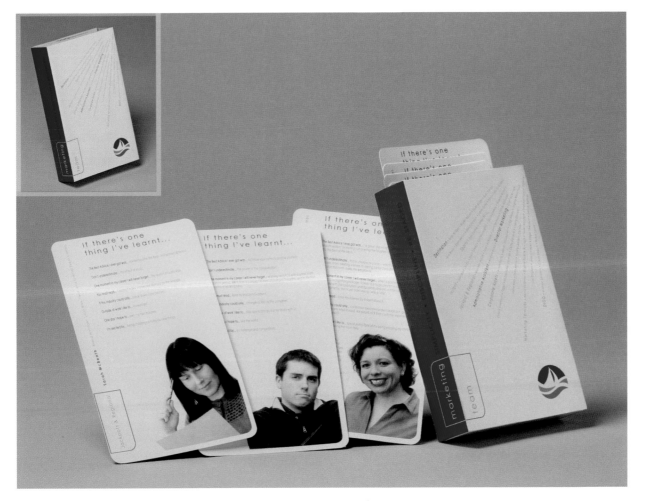

CREATIVE FIRM: ATLANTIC LOTTERY – MONCTON, NB, CANADA
CREATIVE TEAM: NATALIE BOUDREAU – GRAPHIC DESIGNER
CLIENT: ATLANTIC LOTTERY

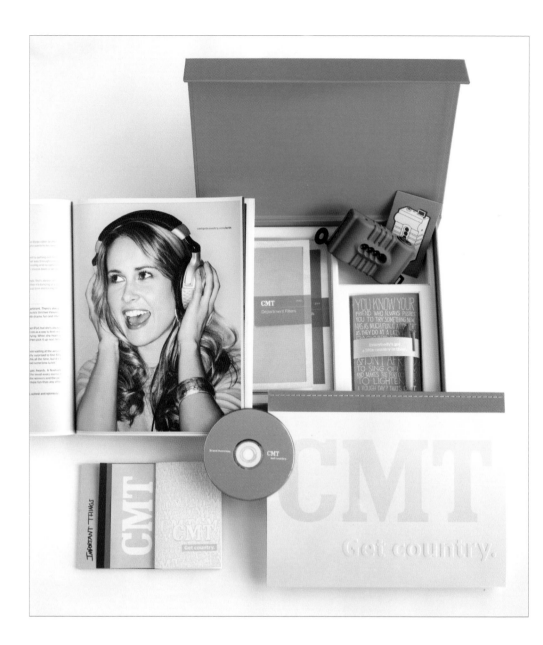

PLATINUM

CMT BRAND BOOK

CREATIVE FIRM: MTV NETWORKS – NEW YORK, NY, USA
CREATIVE TEAM: BRETT WARREN – DESIGNER; ERICA MYERS, JUDSON AIKENS – PROJECT MANAGERS; MICHAEL WARREN – PHOTOGRAPHER; WEBB MASON – PRINTER; DEE MCLAUGHLIN, JEFF NICHOLS – CREATIVE DIRECTORS; JASON SKINNER – ART DIRECTOR; NORA GAFFNEY, MATT LEHMAN, BRAD DAVIS – DESIGNERS
CLIENT: CMT

Remember The Brady Bunch? The TV family–cum–singing group sang, "When it's time to change, you've got to rearrange who you are into what you want to be." Says CMT, "Who knew all you ever needed to know about branding you could learn from The Brady Bunch? Sounds simple–until

you are the ones given the task to figure all that out AND be able to communicate it to everyone who needs to know."

Taking its inspiration from the Brady kids, CMT put together a colorful, eye–catching box that could have come right out of 1970. The invitation was to open it up and discover the world of the new CMT, including new colors, new textures, a new tagline, new brand font (the awesomely named Stag), new graphic standards, and more.

"All of these elements support our new Brand Filters of Genuine, Independent, Rooted, Spirited, Giving, Uncomplicated,

Inviting, and Optimistic," says CMT. "It's who our audience is, and how they want us to be. So we listened." Rooting the colors and textures in the natural world, CMT also kept the font simple and flexible and the overall feel optimistic. "The messaging is clear and straightforward," the in–house agency says. "The executions are simple and uncluttered, just like 'our people.'"

Simple, but not quiet. Admits the creator: "The real reason for the oversized, bright orange box is so it would stand out on bookshelves and desks, screaming 'Look at me, I am CMT!'"

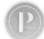

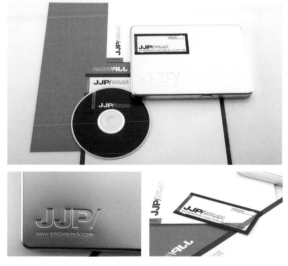

CREATIVE FIRM: PLUMBLINE STUDIOS, INC – NAPA, CA, USA

CREATIVE TEAM: DOM MORECI – CREATIVE DIRECTOR; ROBERT BURNS – DESIGN DIRECTOR; ERIC BALL, AARON PEDROZA – DESIGNERS

CLIENT: FOLGER LEVIN LLP

CREATIVE FIRM: COASTLINES CREATIVE GROUP – VANCOUVER, BC, CANADA

CREATIVE TEAM: BYRON DOWLER – CREATIVE DIRECTOR; ANGIE LAU – DESIGNER

CLIENT: JORDAN JUNCK PHOTOGRAPHY

URL: WWW.JORDANJUNCK.COM

CREATIVE FIRM: COASTLINES CREATIVE GROUP – VANCOUVER, BC, CANADA

CREATIVE TEAM: BYRON DOWLER – CREATIVE DIRECTOR; HENRY CHEN – BRAND STRATEGIST/DESIGNER; ANGIE LAU – DESIGNER

CLIENT: AUDACIOUS INTERIORS LTD.

URL: WWW.AUDACIOUSINTERIORS.CA

CREATIVE FIRM: KNOCK INC. – MINNEAPOLIS, MN, USA

CREATIVE TEAM: MEENAL PATEL – DESIGNER; TODD PAULSON – CHIEF CREATIVE OFFICER; SARA NELSON – DESIGN DIRECTOR; CREIGHTON KING – PRODUCTION ARTIST; JAKE NASSIF – WRITER

CLIENT: ARTSPACE

CREATIVE FIRM: BELIEVE IN LIMITED – EXETER, UK

CREATIVE TEAM: BLAIR THOMSON – CREATIVE DIRECTOR/DESIGNER

CLIENT: BELIEVE IN™

URL: WWW.BELIEVEIN.CO.UK

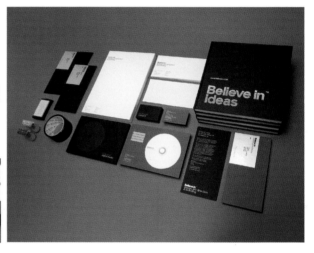

CREATIVE FIRM: FRANKE+FIORELLA – MINNEAPOLIS, MN, USA

CREATIVE TEAM: CRAIG FRANKE – PRINCIPAL/CREATIVE DIRECTOR; TODD MONGE – SENIOR DESIGNER; JILL MAKI, LISA PEMRICK – COPYWRITERS

CLIENT: THE VALSPAR CORPORATION

CREATIVE FIRM: ZYNC – TORONTO, ON, CANADA

CREATIVE TEAM: MARKO ZONTA – CREATIVE DIRECTOR; PETER C WONG – DESIGNER

CLIENT: PARALUCENT

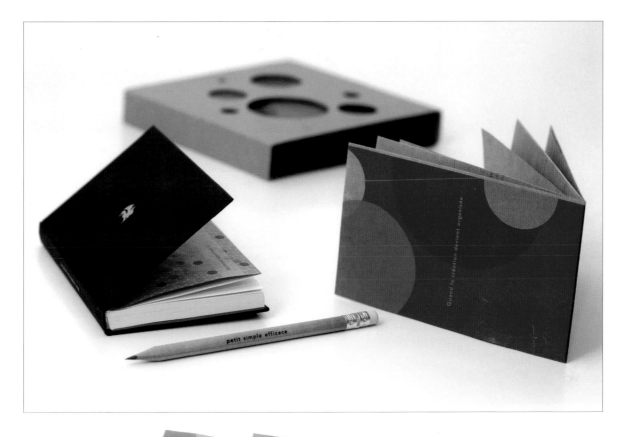

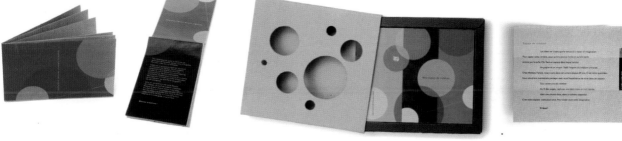

PLATINUM

MON ESPACE DE CREATION (MY CREATIVE SPACE)

CREATIVE FIRM: MATTEAU PARENT GRAPHISME ET COMMUNICATION INC. – QUEBEC, QC, CANADA

CREATIVE TEAM: HELENE MATTEAU – ART DIRECTOR; MARIE–JOSEE BLOUIN, MARTIN HUDON, PIERRE PARENT – GRAPHIC DESIGNERS

CLIENT: MATTEAU PARENT GRAPHISME ET COMMUNICATION INC.

After a quarter century of being creative, Matteau Parent graphisme et communication is still in touch with its roots, and to celebrate its 25th anniversary, the Quebec graphic design studio wanted to share the experience with its clients. "As we have lived in this universe for the past 25 years, we wanted to touch them personally, inspire them in their everyday lives," says art director Helene Matteau. "The idea of a little notebook with ques-

tions such as 'Am I a creative person?' 'What importance do I give to my creativity?' 'What could I create this week, just for the pure pleasure of creating?' came up. For clients it would be their creative space—theirs alone."

First, the creatives had to brainstorm about the tools for creativity. "It had to be more than just a notebook," Matteau says. "Would it come in a pocket? In a box? With a pen attached? Would there be something else about creativity?" But the efforts seemed fruitless until the gathered designers took a look at the gathered sketches on the conference room table. As the French might say, Voilà. "We

looked at the pile and said, 'That's it!'" Matteau added a foldout "mind map" to help clients organize their creativity and shape "their wildest dreams and most serious projects."

The agency intended to reduce costs by assembling the kits in house, but there were problems even before the materials made it to the table: splitting cover stock, poorly glued notebooks, typos on the pens. The project was delayed two months, but eventually Matteau's creative epiphany came to fruition. "Finally, after a lot of sweat and 100 notebooks less than anticipated, the kit was ready to be given to our clients," she reports. "Success!"

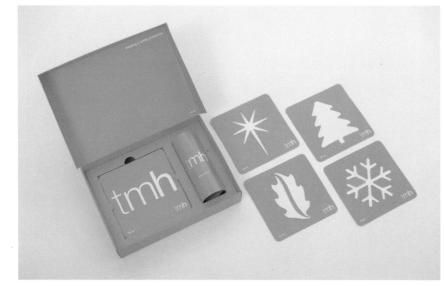

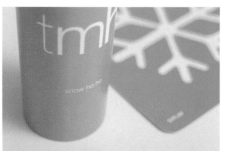

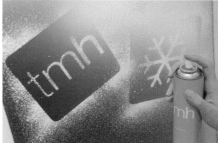

CREATIVE FIRM: TMH – DUBAI, UAE

CREATIVE TEAM: JAMES WOOD – CREATIVE DIRECTOR/DESIGNER; MORTEZA KASHANI – PRODUCTION MANAGER; SRINIVAS SHENOY – HEAD OF ARTWORK

CLIENT: TMH

CREATIVE FIRM: MAZE INC – ROSELLE, IL, USA

CREATIVE TEAM: BETH KELLER STEIN – CREATIVE DIRECTOR/PRINCIPAL

CLIENT: MAZE INC

URL: MAZEDESIGNSOLUTIONS.COM

CREATIVE FIRM: KENTLYONS – LONDON, UK

CREATIVE TEAM: JON CEFAI – CREATIVE DIRECTOR

CLIENT: SELF PROMOTION

CREATIVE FIRM: SPLASH PRODUCTIONS PTE LTD – SINGAPORE

CREATIVE TEAM: JAT LENG LOW – SENIOR COPYWRITER; FARID KASNOEN – ART DIRECTOR; STANLEY YAP – PHOTOGRAPHER

CLIENT: SPLASH PRODUCTIONS PTE LTD

CREATIVE FIRM: WALLACE CHURCH, INC. – NEW YORK, NY, USA

CREATIVE TEAM: STAN CHURCH – CREATIVE DIRECTOR; AKIRA YASUDA – DESIGNER

CLIENT: WALLACE CHURCH, INC

URL: WWW.WALLACECHURCH.COM

CREATIVE FIRM: WALLACE CHURCH, INC. – NEW YORK, NY, USA

CREATIVE TEAM: STAN CHURCH – CREATIVE DIRECTOR; TIPHAINE GUILLEMET, BECCA REITER, KIM YOUNG – DESIGNERS

CLIENT: WALLACE CHURCH, INC

URL: WWW.WALLACECHURCH.COM

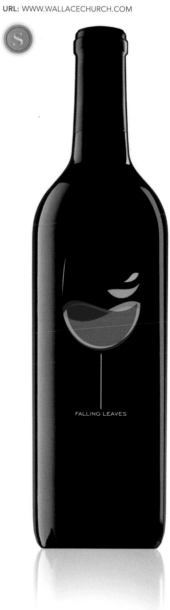

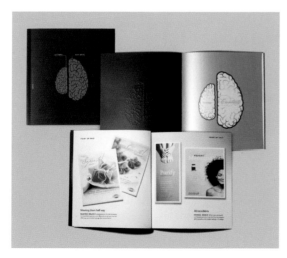

CREATIVE FIRM: PARETO – TORONTO, ON, CANADA

CREATIVE TEAM: EGON SPRINGER – CREATIVE DIRECTOR; LORI HONEYCOMBE – ART DIRECTOR; MAURICE YOUNG – COPYWRITER; JANE THEODORE – STUDIO MANAGER; JENNIFER TRUONG – MAC ARTIST; ANDRE VAN VUGT – PHOTOGRAPHER

CLIENT: PARETO

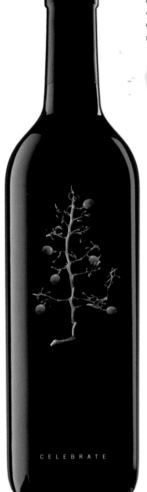

CREATIVE FIRM: WALLACE CHURCH, INC. – NEW YORK, NY, USA

CREATIVE TEAM: STAN CHURCH – CREATIVE DIRECTOR; LOU ANTONUCCI – DESIGNER

CLIENT: WALLACE CHURCH, INC

URL: WWW.WALLACECHURCH.COM

CREATIVE FIRM: HUNTER PUBLIC RELATIONS – NEW YORK, NY, USA

CREATIVE TEAM: LOUISA CARAGAN – CREATIVE DIRECTOR; LAURA DESILVIO, FREDDY LOPEZ – DESIGNERS

CLIENT: HUNTER PUBLIC RELATIONS

CREATIVE FIRM: INTERROBANG DESIGN COLLABORATIVE, INC. – RICHMOND, VT, USA

CREATIVE TEAM: MARK SYLVESTER – CREATIVE DIRECTOR/DESIGNER/WRITER; BOB PACKERT – PHOTOGRAPHER; MICHAEL ALBOR – LEAD HAIR STYLIST; MARIOLGA PANTAZOPOULOS – MAKE–UP; RINA STENIS – WARDROBE STYLIST; JENNIFER DUNLEA – PROP STYLIST

CLIENT: PACKERT PHOTOGRAPHY/INTERROBANG DESIGN CLLBTV.

CREATIVE FIRM: TAYLOR DESIGN – STAMFORD, CT, USA

CREATIVE TEAM: DANIEL TAYLOR – CREATIVE DIRECTOR; HANNAH FICHANDLER – ART DIRECTOR/DESIGNER; JOHN RUDOLPH – DESIGNER; STACEY RESNIKOFF – WRITER

CLIENT: TAYLOR DESIGN

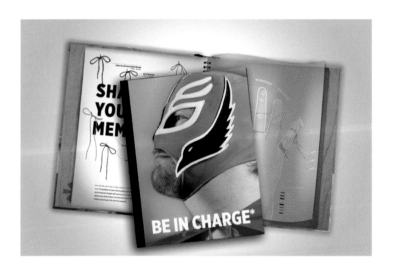

Ⓟ PLATINUM

CREATIVE FIRM: RULE29 – GENEVA, IL, USA

CREATIVE TEAM: JUSTIN AHRENS – PRINCIPAL/CREATIVE DIRECTOR; TIM DAMITZ, SUSAN HERDA, KARA AYARAM – DESIGNERS; KERRI LIU – SENIOR DESIGNER

CLIENT: RULE29

BE IN CHARGE

Most people make New Year's resolutions with the best of intentions, but without encouragement, most are destined to fail. Rule29 Creative, in Geneva, Illinois, collaborated with a variety of creative partners to produce the "Be in Charge" calendar and motivate people every day of the year. "The project was inspired by our numerous experiences in mundane office environments," explains principal and creative director Justin Ahrens. "We believe that work is often taken too seriously and we wanted to offer an alternative perspective to the daily grind."

With the design, colors, and images arranged in a way to break the beige cubicle mold and rethink what's possible in the workplace–including a flexible start date–Ahrens and company tested some of their own limits. "While working with a large team"– MacDonald Photography, Todd McQueen Illustration, Utopia Paper, O'Neil Printing, Roswell Bookbinding, and copywriter Nina Khan–"can often be an obstacle in and of itself, our team decided to practice what we preached and embrace the creative possibilities via collaboration." And whether that collaboration involves encouragement, minimizing distractions, or engaging in playful mischief (including wrapping a coworker in plastic wrap, dressing as a Mexican wrestler, or unleashing live poultry in the office), the Rule29 team invites everyone to be creative in "being in charge" (of themselves).

AT FIRST, IT'S REALLY SOUR, BUT THEN, THERE'S A GREASY AFTER-TASTE...

Jacques

CREATIVE FIRM: FELT DESIGN GROUP – COSTA MESA, CA, USA
CREATIVE TEAM: ALLISON DEFORD – TRAILBLAZER; LORI SALLEE – IDEA WRANGLER; BETSY SMITH – COPYWRITER; WENDY VALENZUELA – PHOTOGRAPHER
CLIENT: FELT DESIGN GROUP
URL: HTTP://WWW.FELTEVERYWHERE.COM

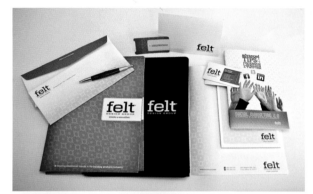

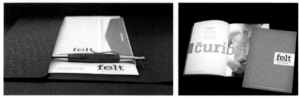

CREATIVE FIRM: MARC ATLAN DESIGN, INC. – VENICE, CA, USA
CREATIVE TEAM: MARC ATLAN – CREATIVE DIRECTOR
CLIENT: MARC ATLAN DESIGN, INC.

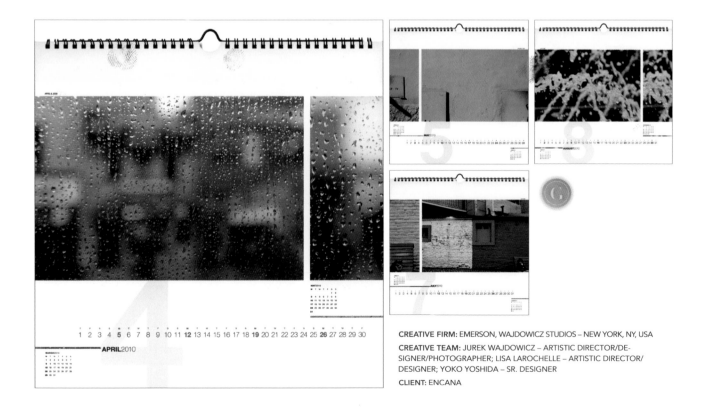

APRIL2010

CREATIVE FIRM: EMERSON, WAJDOWICZ STUDIOS – NEW YORK, NY, USA
CREATIVE TEAM: JUREK WAJDOWICZ – ARTISTIC DIRECTOR/DESIGNER/PHOTOGRAPHER; LISA LAROCHELLE – ARTISTIC DIRECTOR/DESIGNER; YOKO YOSHIDA – SR. DESIGNER
CLIENT: ENCANA

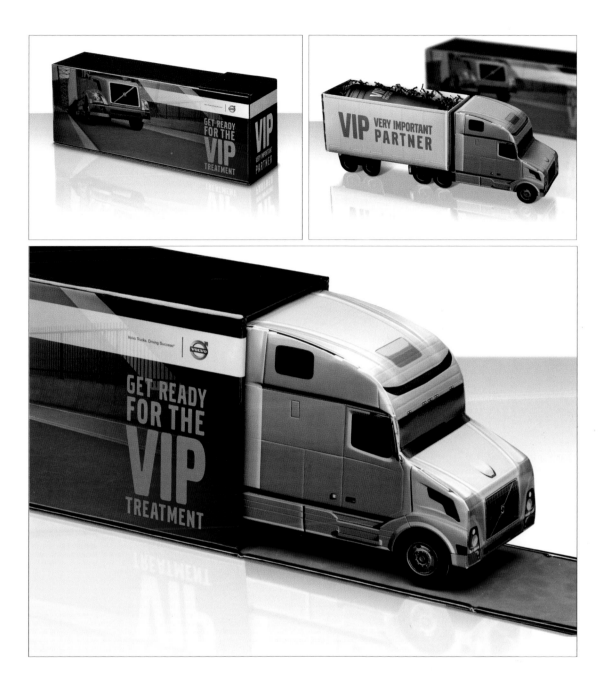

 PLATINUM

VOLVO VIP KIT

CREATIVE FIRM: THOMPSON CREATIVE – GREENSBORO, NC, USA

CREATIVE TEAM: GARY THOMPSON – CREATIVE DIRECTOR; MIRANDA YOUNG – DESIGNER

CLIENT: VOLVO TRUCKS OF NORTH AMERICA

Want to impress a client? Send around a car to pick up him or her. Or, better yet, if you're Volvo Trucks North America, you can send a truck to the front door. When the company developed their VIP (Very Important Partner) initiative, they turn to Thompson Creative in Greensboro, N.C. to design packaging for a kit that would make the recipient truly feel very important.

The exterior box features a magnetic closure that when opened forms a red carpet for the paper truck inside. The trailer of the truck holds the VIP welcome letter, membership card, and complimentary insulated travel cup. "Most of the credit for this piece belongs to PBM Graphics," says creative director Gary Thompson of his agency's design partner. "The complex printing process demanded flawless attention to detail."

CREATIVE FIRM: ECHO TORRE LAZUR – EAST HANOVER, NJ, USA

CREATIVE TEAM: TOM WEID – PRODUCTION; JUAN RAMOS – EVP, EXEC. CD; BILL LEE – VP, MANAGEMENT SUPERVISOR; STEVE GOURLEY – VP, GROUP CREATIVE DIRECTOR, ART; GARRY HICKMAN – SR. ART DIRECTOR; JENNIFER RODRIGUEZ – VP, GROUP CREATIVE DIRECTOR, COPY; MELINDA MILOVIC – COPY SUPERVISOR; BRYAN MINOGUE – COPY SUPERVISOR; JACK KELLEHER – ACCOUNT SUPERVISOR

CLIENT: GALDERMA

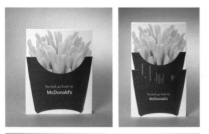

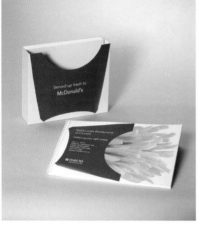

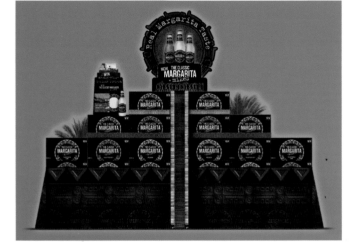

CREATIVE FIRM: ALCONE MARKETING – IRVINE, CA, USA

CREATIVE TEAM: SCOTT LITTLEJOHN – ASSOCIATE CREATIVE DIRECTOR; PAUL ULLOA – ART DIRECTOR; NICK ROOTH – CREATIVE DIRECTOR; KEVIN KLEBER – VP CREATIVE DIRECTOR; LUIS CAMANO – CHIEF CREATIVE OFFICER

CLIENT: MIKE'S HARD LEMONADE

CREATIVE FIRM: PARETO – TORONTO, ON, CANADA

CREATIVE TEAM: EGON SPRINGER – CREATIVE DIRECTOR/DESIGNER; CARRIE MACNAUGHTON – SENIOR PROJECT MANAGER; CATHY SCHUELER – DIRECTOR, SALES OPERATIONS; LORI HONEYCOMBE – ART DIRECTOR; BRIAN BURCH – PRINT PRODUCTION

CLIENT: MCDONALD'S

CREATIVE FIRM: FOODMIX – ELMHURST, IL, USA

CREATIVE TEAM: FOODMIX CREATIVE AND PRODUCTION TEAMS

CLIENT: KELLOGG'S FOOD AWAY FROM HOME

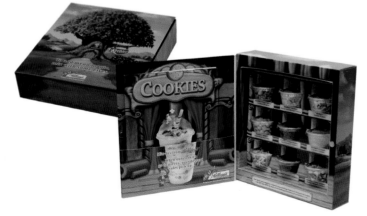

CREATIVE FIRM: PARETO – TORONTO, ON, CANADA

CREATIVE TEAM: EGON SPRINGER – CREATIVE DIRECTOR/ART DIRECTOR/DESIGNER; JOHN HITZROTH – PRINT PRODUCTION MANAGER; DENIS GENDRON – GENERAL MANAGER

CLIENT: CADBURY

PLATINUM

CREATIVE FIRM: JURCZYK DESIGN – LODZ, POLAND
CREATIVE TEAM: IZABELA JURCZYK – GRAPHIC DESIGNER
CLIENT: MAP POLAND

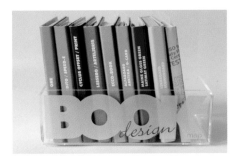

PROMOTION OF EDITORIAL PAPER SWATCH BOOKS MADE FOR MAP POLAND

BOOK DESIGN is more than just…book design. The campaign breaks down the expression into its most organic, thoughtful element, taking the observer back to basics. "BOOK DESIGN is a promise of more," says Izabela Jurczyk of Jurczyk Design in Lodz, Poland. Created in response to an elemental need of the publishing market, the collection of booklet–bound papers introduces the wide range of ecological papers and cardstocks available from book printing company Map Poland.

"BOOK DESIGN is a proposal for those solution seekers who are looking for papers varied in whiteness and transpar-

ency," says Jurczyk. "The papers can be easily compared and fit to a particular use and editorial conception." With slipcovers made of pure binder's board–a traditional printers' material–and a clear, modular shelving unit, Jurczyk says that "surprisingly, the conception is an enchanting solution that shows once again that simple is beautiful." Even the collection as a whole is an attractive marketing aspect, as a booklet–filled shelf is a colorful attention getter with room to grow. "BOOK DESIGN is something like an unfinished tale," says Jurczyk. "Everyone can write its end on his own. The choice is up to users."

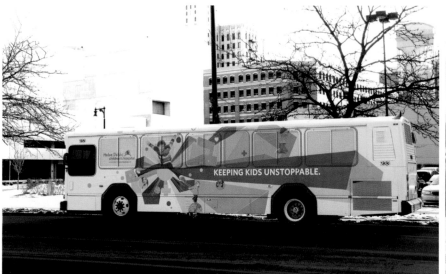

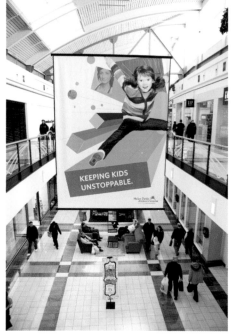

CREATIVE FIRM: KANTORWASSINK – GRAND RAPIDS, MI, USA

CREATIVE TEAM: JENNIFER JOHNSTON, AMY MARINARI – PRODUCTION; DAVE KANTOR, WENDY WASSINK, JASON MURRAY, TIM CALKINS, CHRIS EMMER – CREATIVE

CLIENT: HELEN DEVOS CHILDREN'S HOSPITAL`

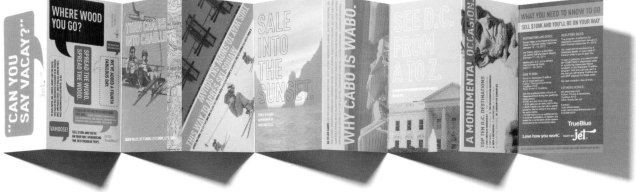

 PLATINUM

STEELCASE READY. SET. JET. 2010

CREATIVE FIRM: KANTORWASSINK – GRAND RAPIDS, MI, USA

CREATIVE TEAM: WENDY WASSINK, DAVE KANTOR, CHRIS EMMER, JOHN FERIN, JASON MURRAY – CREATIVE; AMY MARINARI – PRODUCTION

CLIENT: STEELCASE

Despite the name, Steelcase still sells wood furniture, and they believe that it's a good thing Grand Rapids design firm Kantorwassink created a personality–packed, fully branded rewards program for Steelcase, from "Ready. Set. Jet." tagline, logo, and collateral required to get the program going. An accordion–folded brochure showing all the wonder-ful places wood can take Steelcase sellers goes against the grain of ordinary office promotional materials, but what really ex-cites creatives Wendy Wassink and David Kantor are the results. "Since the program began, it's resulted in thousands of dealer vacations, years of award–winning work from Kantorwassink, and millions in sales for Steelcase."

CREATIVE FIRM: ZED COMMUNICATIONS – DUBAI, UAE

CREATIVE TEAM: ROBERT MITCHELL – CREATIVE DIRECTOR; PEARL PACHECO – ART DIRECTOR; JUAN CARLOS DEL MUNDO – COPYWRITER; RAJEEV ADVANI – PRODUCTION MANAGER

CLIENT: UAE RED CRESCENT

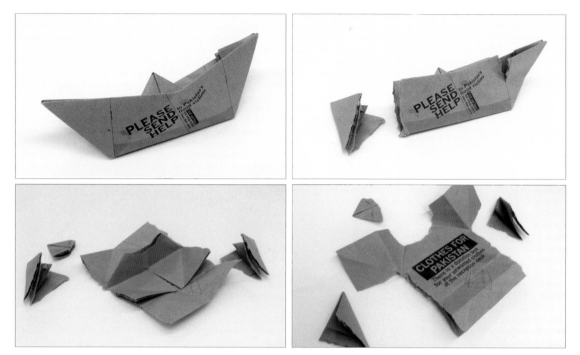

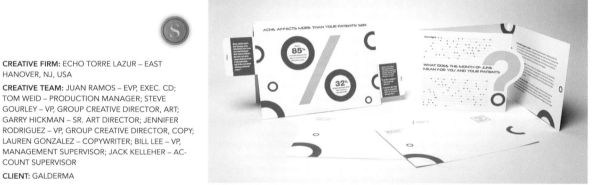

CREATIVE FIRM: ECHO TORRE LAZUR – EAST HANOVER, NJ, USA

CREATIVE TEAM: JUAN RAMOS – EVP, EXEC. CD; TOM WEID – PRODUCTION MANAGER; STEVE GOURLEY – VP, GROUP CREATIVE DIRECTOR, ART; GARRY HICKMAN – SR. ART DIRECTOR; JENNIFER RODRIGUEZ – VP, GROUP CREATIVE DIRECTOR, COPY; LAUREN GONZALEZ – COPYWRITER; BILL LEE – VP, MANAGEMENT SUPERVISOR; JACK KELLEHER – AC-COUNT SUPERVISOR

CLIENT: GALDERMA

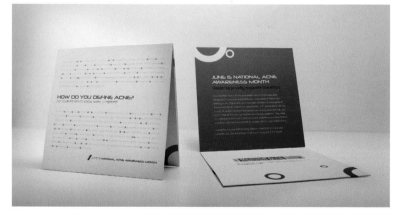

CREATIVE FIRM: ECHO TORRE LAZUR – EAST HANOVER, NJ, USA

CREATIVE TEAM: BILL LEE – VP, MANAGEMENT SUPERVISOR; JUAN RAMOS – EVP, EXEC. CD; TOM WEID – PRODUCTION MAN-AGER; STEVE GOURLEY – VP, GROUP CREATIVE DIRECTOR, ART; GARRY HICKMAN – SR. ART DIRECTOR; JENNIFER RODRIGUEZ – VP, GROUP CREATIVE DIRECTOR, COPY; MELINDA MILOVIC, BRYAN MINOGUE – COPY SUPERVISORS; JACK KELLEHER – ACCOUNT SUPERVISOR

CLIENT: GALDERMA

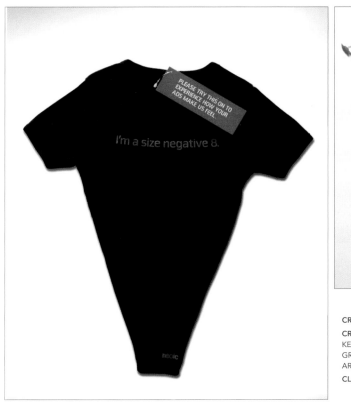

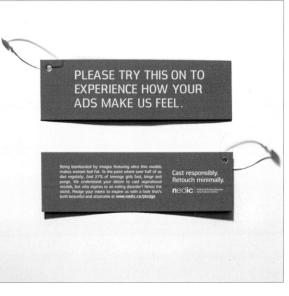

CREATIVE FIRM: ZULU ALPHA KILO – TORONTO, ON, CANADA

CREATIVE TEAM: ZAK MROUEH – CREATIVE DIRECTOR; MARKETA KRIVY – ART DIRECTOR; TROY MCCLURE – COPYWRITER; GRANT CLELAND – DESIGNER; MIKE THOANG – PRODUCTION ARTIST; EILEEN SMITH – PRODUCTION MANAGER

CLIENT: NATIONAL EATING DISORDER INFORMATION CENTRE

CREATIVE FIRM: Y&R SOUTH AFRICA – WOODMEAD, SOUTH AFRICA

CREATIVE TEAM: MICHAEL BLORE – CHIEF CREATIVE OFFICER; LIAM WIELOPOLSKI – EXECUTIVE CREATIVE DIRECTOR; ANITA MODI – HEAD OF DESIGN; BRADLEY STAPLETON – DESIGNER; SEBASTIAN SCHNEIDER – COPYWRITER; MBUSO NDLOVU – ART DIRECTOR

CLIENT: UNICEF

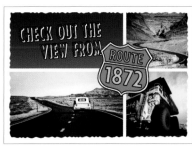

CREATIVE FIRM: PENSARÉ DESIGN GROUP – WASHINGTON, D.C., USA

CREATIVE TEAM: MARY ELLEN VEHLOW – CREATIVE DIRECTOR; LAUREN EMERITZ – DESIGNER

CLIENT: JOHN FRANZÉN / PEW CAMPAIGN FOR RESPONSIBLE MINING

Thanks

*Thanks for helping
to make me such
a successful anorexic.*

CREATIVE FIRM: ZULU ALPHA KILO – TORONTO, ON, CANADA

CREATIVE TEAM: ZAK MROUEH – CREATIVE DIRECTOR; MAR-KETA KRIVY – ART DIRECTOR; TROY MCCLURE – COPYWRITER; GRANT CLELAND – DESIGNER; MIKE THOANG – PRODUCTION ARTIST; EILEEN SMITH – PRODUCTION MANAGER

CLIENT: NATIONAL EATING DISORDER INFORMATION CENTRE

CREATIVE FIRM: FOODMIX – ELMHURST, IL, USA

CREATIVE TEAM: FOODMIX CREATIVE AND PRODUCTION TEAMS

CLIENT: WOW SALES

CREATIVE FIRM: PARETO – TORONTO, ON, CANADA

CREATIVE TEAM: JACQUELINE GOODFELLOW – PRINT PRODUCTION; EGON SPRINGER – CREATIVE DIRECTOR; LORI HONEYCOMBE – ART DIRECTOR; MAURICE YOUNG – COPYWRITER; JANE THEODORE – STUDIO MANAGER; JENNIFER TRUONG – MAC ARTISIT; ANDRE VAN VUGT – PHOTOGRAPHER

CLIENT: RANGE OF CLIENTS

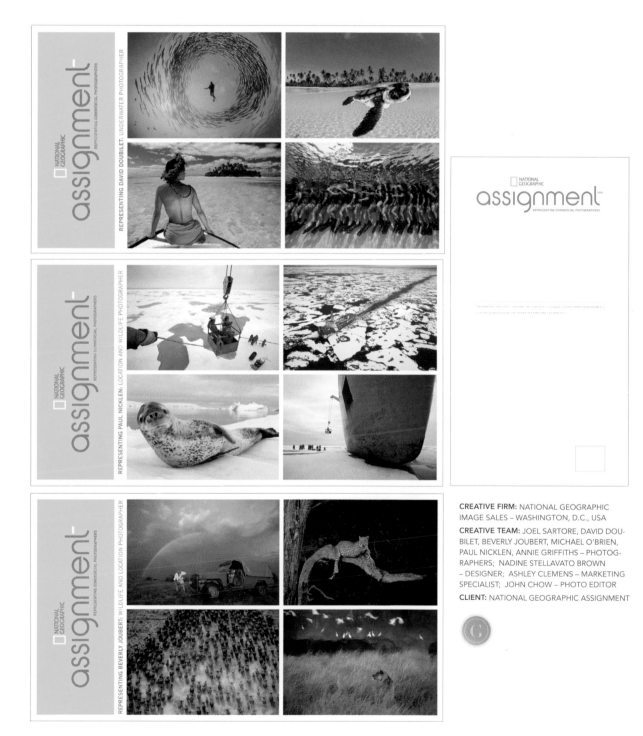

CREATIVE FIRM: NATIONAL GEOGRAPHIC
IMAGE SALES – WASHINGTON, D.C., USA

CREATIVE TEAM: JOEL SARTORE, DAVID DOU-
BILET, BEVERLY JOUBERT, MICHAEL O'BRIEN,
PAUL NICKLEN, ANNIE GRIFFITHS – PHOTOG-
RAPHERS; NADINE STELLAVATO BROWN
– DESIGNER; ASHLEY CLEMENS – MARKETING
SPECIALIST; JOHN CHOW – PHOTO EDITOR

CLIENT: NATIONAL GEOGRAPHIC ASSIGNMENT

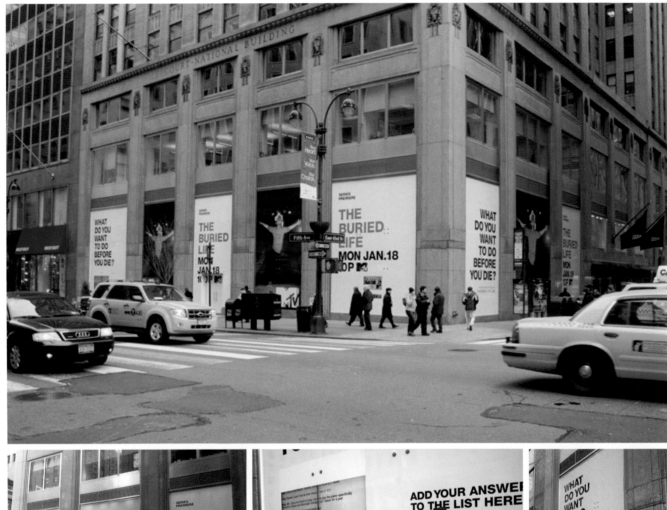

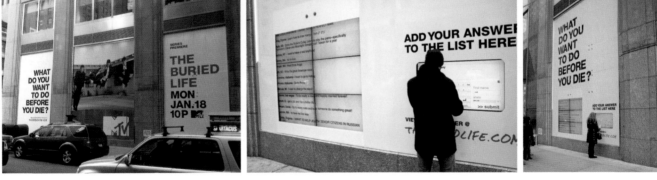

 PLATINUM

CREATIVE FIRM: MTV NETWORKS – NEW YORK, NY, USA

CREATIVE TEAM: JEFFREY KEYTON – SVP, DESIGN
AND OFF–AIR CREATIVE; JIM DEBARROS – VP, OFF–AIR
CREATIVE; RICHARD BROWD – ASSOCIATE ART DIRECTOR;
JINNIE LEE – COORDINATING PRODUCER; MARC KLATZKO
– MANAGING DIRECTOR, CREATIVE / MAUDE; BRETT
SPIEGEL – PROJECT MANAGER / MAUDE

CLIENT: MTV

CREATIVE FIRM: PERKINS+WILL – CHICAGO, IL, USA

CREATIVE TEAM: ERIN HUTTAS – DESIGNER; PATRICK GRZYBEK – TECHNICAL DEVELOPMENT; EILEEN JONES – DESIGN PRINCIPAL; BRIAN WEATHERFORD – BRAND STRATEGIST/CREATIVE DIRECTOR; KAY LEE – PROJECT MANAGER; SAM STUBBLEFIELD – SENIOR GRAPHIC DESIGNER; KJ KIM – GRAPHIC DESIGNER; SMITA MODI – WAYFINDING+SIGNAGE DESIGNER

CLIENT: NEW YORK UNIVERSITY, LEONARD N. STERN SCHOOL OF BUSINESS

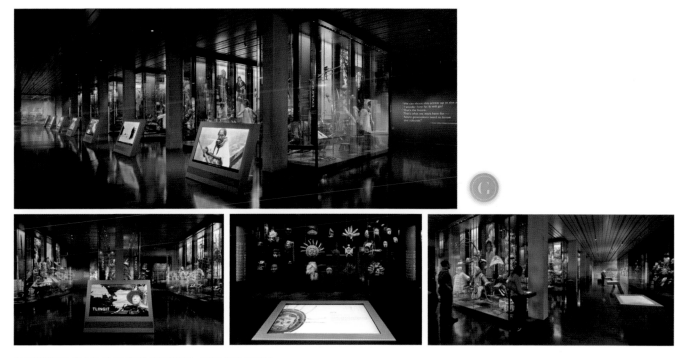

CREATIVE FIRM: RALPH APPELBAUM ASSOCIATES – NEW YORK, NY, USA

CREATIVE TEAM: ANNE BERNARD – CONTENT DEVELOPER; DIANA GREENWOLD, MAGGIE JACOBSTEIN – CONTENT COORDINATORS; NIKKI AMDUR – COPY EDITOR; GEORGE SEXTON ASSOCIATES – EXHIBIT LIGHTING DESIGN; AUDIO, VIDEO AND CONTROLS, INC. – EXHIBIT AUDIO VISUAL SYSTEMS DESIGN; MAGNUSSON KLEMENCIC ASSOC., INC AND BBFM ENGINEERS – EXHIBIT STRUCTURAL; RSA ENGINEERING, INC. – EXHIBIT MECHANICAL; DAVID CHIPPERFIELD ARCHITECTS – DESIGN ARCHITECTS; KUMIN ASSOCIATES INC – ARCHITECT; ALCAN GENERAL CONSTRUCTION – GENERAL CONSTRUCTION; KUBIK/MALTBIE – EXHIBIT FABRICATION; CLICK NETHERFIELD – CASEWORK; ELY INC AND BENCHMARK – MOUNTMAKING; DONNA LAWRENCE PRODUCTIONS – MEDIA PRODUCER – FILM; SECOND STORY INTERACTIVE – MEDIA PRODUCER – INTERACTIVES; CHARLIE MORROW PRODUCTIONS – MEDIA PRODUCER – SOUNDSCAPE; RALPH APPELBAUM – PRINCIPAL IN CHARGE; TIM VENTIMIGLIA – PROJECT DIRECTOR/LEAD DESIGNER; JENNIFER WHITBURN – PROJECT MANAGER/SENIOR EXHIBIT DESIGNER; NIKKI SHAH–HOSEINNI – 3–D DESIGNER; CAROLINE BROWNELL, JOHN LOCASCIO – GRAPHIC DESIGNERS

CLIENT: ANCHORAGE MUSEUM BUILDING COMMITTEE

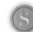

CREATIVE FIRM: Y&R SOUTH AFRICA – WOODMEAD, SOUTH AFRICA

CREATIVE TEAM: MICHAEL BLORE – CHIEF CREATIVE OFFICER; LIAM WIELOPOLSKI, CLINTON BRIDGEFORD – EXECUTIVE CREATIVE DIRECTORS; ERIC WITTSTOCK – COPYWRITER; BRUCE MURPHY – ART DIRECTOR

CLIENT: NINTENDO

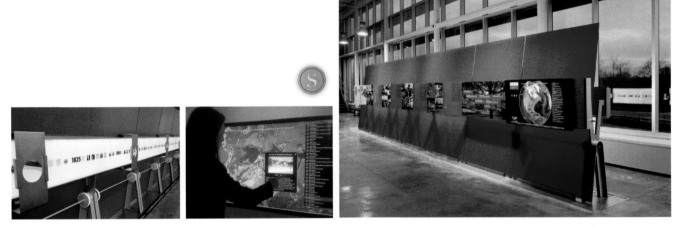

CREATIVE FIRM: RALPH APPELBAUM ASSOCIATES – NEW YORK, NY, USA

CREATIVE TEAM: AMANDA VOSS – GRAPHIC DESIGNER; MURPHY BURHAM BUTTRICK – DESIGN ARCHITECTS; BIBER PARTNERSHIP – ARCHITECT OF RECORD; KUBIC – FABRICATOR; AUDIO VIDEO & CONTROLS, DAVID BIANCIARDI – AUDIO-VISUAL INTEGRATION; ONOMY LABS – INTERACTIVE MEDIA; TECHNICAL ARTISTRY, KYLE CHEPULIS – LIGHTING; PETER MAUSS – ESTO – PHOTOGRAPHER; RALPH APPELBAUM – PRINCIPAL IN CHARGE; RICK SOBEL – PROJECT DIRECTOR; MICHAEL MAGGIO – PROJECT MANAGER/SENIOR EXHIBIT DESIGNER; JOSH HARTLEY – SENIOR GRAPHIC DESIGNER; KATE CURY – CONTENT DEVELOPER; GRAHAM PLUMB – INTERACTIVE DEVELOPER

CLIENT: RUTGERS UNIVERSITY

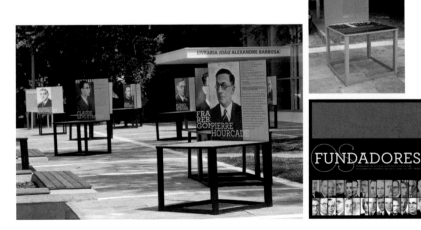

CREATIVE FIRM: CASA REX – SAO PAULO, BRAZIL

CREATIVE TEAM: GUSTAVO PIQUEIRA – CREATIVE DIRECTOR/DESIGN; SAMIA JACINTHO – DESIGN; CAMILE LEÃO, THAIS GUERRA – ASSISTANT DESIGNERS

CLIENT: UNIVERSITY OF SÃO PAULO (USP)

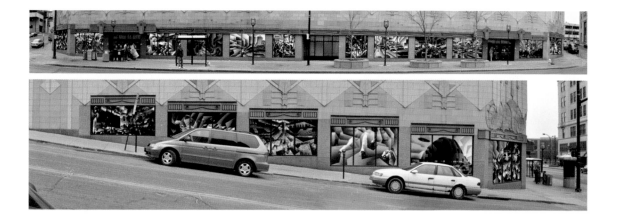

CREATIVE FIRM: UNIVERSITY OF AKRON/DESIGN X NINE – AKRON, OH, USA
CREATIVE TEAM: JANICE TR`OUTMAN, JOHN MORRISON – CREATIVE DIRECTORS; DESIGN X NINE TEAM; JEFF DUMIRE – STUDENT DESIGNER
CLIENT: THE UNIVESITY OF AKRON

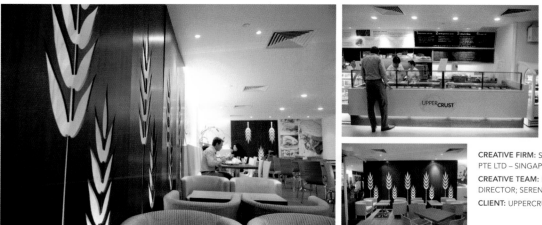

CREATIVE FIRM: SPLASH PRODUCTIONS PTE LTD – SINGAPORE
CREATIVE TEAM: NORMAN LAI – ART DIRECTOR; SERENE SEE – COPYWRITER
CLIENT: UPPERCRUST

CREATIVE FIRM: BETH SINGER DESIGN – ARLINGTON, VA, USA
CREATIVE TEAM: BETH SINGER – ART DIRECTOR; HOWARD SMITH, DENNIS TURBEVILLE – DESIGNERS; MARGARET CARSELLO – ILLUSTRATOR
CLIENT: AMERICAN ISRAEL PUBLIC AFFAIRS COMMITTEE

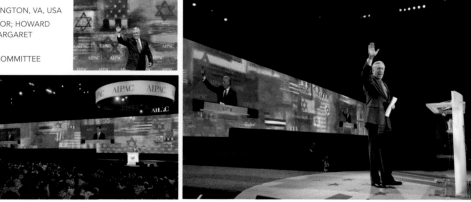

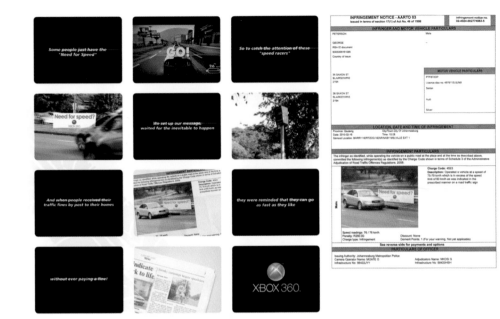

CREATIVE FIRM: Y&R SOUTH AFRICA – WOOD-MEAD, SOUTH AFRICA

CREATIVE TEAM: MICHAEL BLORE – CHIEF CREATIVE OFFICER; LIAM WIELOPOLSKI, CLINTON BRIDGEFORD – EXECUTIVE CREATIVE DIRECTORS; LEON KOTZE – COPYWRITER; RORY WELGEMOED, MBUSO NDLOVU – ART DIRECTORS

CLIENT: XBOX 360

CREATIVE FIRM: RALPH APPELBAUM ASSOCIATES – NEW YORK, NY, USA

CREATIVE TEAM: HOLLES HOUGHTON – CONTENT COORDINATOR; DANIEL MEREDITH, ANTHONY LUALDI, SARAH COFFIN – 3D DESIGN; MATTHEW MCNERNEY, ROBERT HOMACK, NANCY HOERNER, GABRIELE SCHIES, ROB BOLESTA – GRAPHIC DESIGN; TOBIN STARR + PARTNERS, PLLC – ARCHITECT OF RECORD; PEI COBB FREED & PARTNERS ARCHITECTS LLP – ARCHITECT; MALTBIE – FABRICATOR; ELECTROSONIC, INC – AUDIO–VISUAL INTEGRATION; UNIFIED FIELD – INTERACTIVE MEDIA; TECHNICAL ARTISTRY, KYLE CHEPULIS – LIGHTING; JAFFE HOLDEN – SYSTEMS; MARY SEELHORST – SCRIPTWRITING; LESLIE E. ROBERTSON ASSOCIATES, R.L.L.P. – STRUCTURAL ENGINEERING; SEAN BUSHER – PHOTOGRAPHER; RALPH APPELBAUM – PRINCIPAL IN CHARGE; DENNIS COHEN – PROJECT DIRECTOR; MARIANNE SCHUIT, JOHN BOYER – PROJECT MANAGERS; SARAH VAN HAASTERT – CONTENT DEVELOPER; JACKIE PETERSON – CONTENT COORDINATOR

CLIENT: THE CITY OF CHARLOTTE

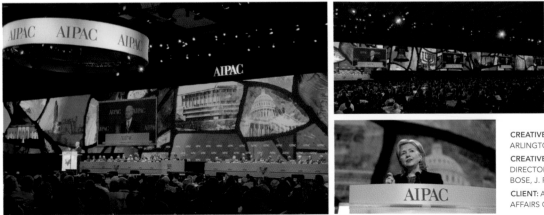

CREATIVE FIRM: BETH SINGER DESIGN – ARLINGTON, VA, USA

CREATIVE TEAM: BETH SINGER – ART DIRECTOR; HOWARD SMITH, BARBARA BOSE, J. R. MELVIN – DESIGNERS

CLIENT: AMERICAN ISRAEL PUBLIC AFFAIRS COMMITTEE

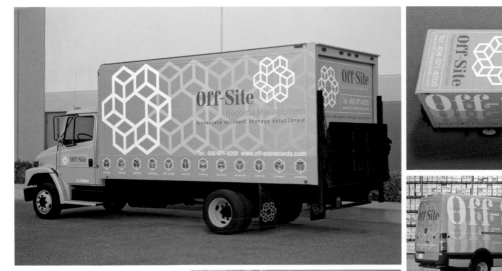

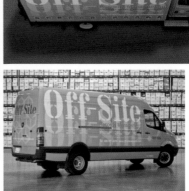

CREATIVE FIRM: GEE + CHUNG DESIGN – SAN FRANCISCO, CA, USA

CREATIVE TEAM: EARL GEE – CREATIVE DIRECTOR/DESIGNER/ILLUSTRATOR; RG CREATIONS, INC. – FABRICATOR

CLIENT: OFF–SITE RECORDS MANAGEMENT

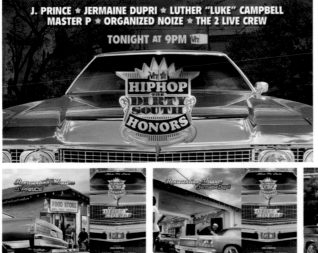

CREATIVE FIRM: MTV NETWORKS – NEW YORK, NY, USA

CREATIVE TEAM: NIGEL COX–HAGAN – EVP CREATIVE & MARKETING; PHIL DELBOURGO – SVP BRAND & DESIGN; TRACI TERRILL – VP EDITORIAL; JIMMY WENTZ – VP OFF–AIR CREATIVE; ALLISON SIERRA – DIRECTOR PROJECT MANAGEMENT; JULIE RUIZ – ART DIRECTOR; JESSE RAKER – DESIGNER; DAN TUCKER – WRITER

CLIENT: VH1

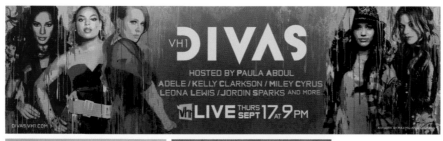

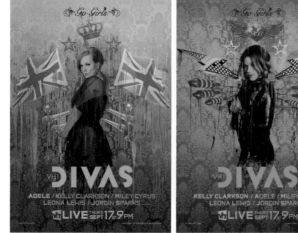

CREATIVE FIRM: MTV NETWORKS – NEW YORK, NY, USA

CREATIVE TEAM: NIGEL COX–HAGAN – EVP CREATIVE & MARKETING; PHIL DELBOURGO – SVP BRAND & DESIGN; JIMMY WENTZ – VP OFF–AIR CREATIVE; ALLISON SIERRA – DIRECTOR PROJECT MANAGEMENT; JULIE RUIZ – ART DIRECTOR; NICOLE MORGESE – WRITER; MAXIMILIAN WIEDEMANN – ILLUSTRATOR

CLIENT: VH1

CREATIVE FIRM: FOUNDRY CREATIVE – CALGARY, AB, CANADA

CREATIVE TEAM: ZAHRA ALHARAZI – CREATIVE DIRECTOR; KYLIE HENRY, LOUISE UHRENHOLT – DESIGNERS

CLIENT: TRAVEL ALBERTA

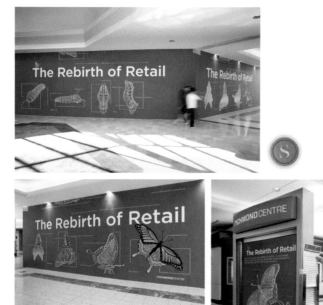

CREATIVE FIRM: HANGAR 18 – VANCOUVER, BC, CANADA

CREATIVE TEAM: VIDA JURCIC – CREATIVE DIRECTOR; RYAN ROMERO – DESIGNER; CASSIE PLOTNIKOFF – PROJECT MANAGER; JOANNE HENDERSON – PRODUCTION MANAGER; JOAN HUNTER – PRODUCTION ARTIST

CLIENT: RICHMOND CENTRE

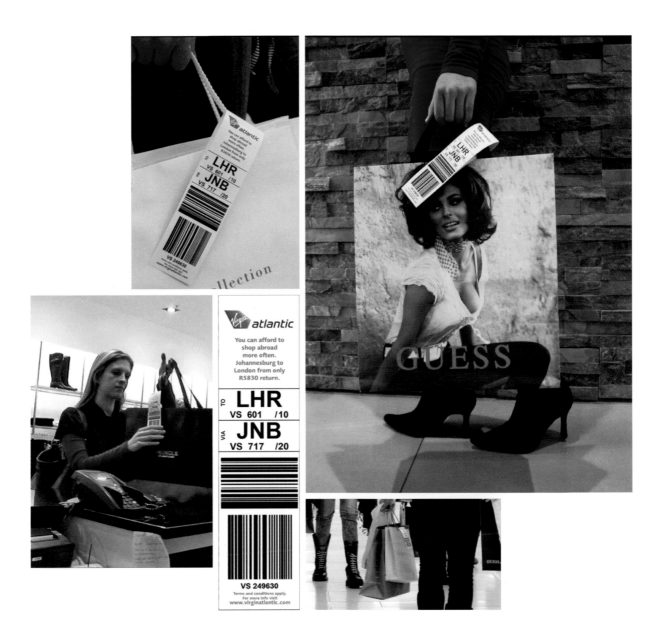

PLATINUM

LUGGAGE TAGS

CREATIVE FIRM: Y&R SOUTH AFRICA – WOODMEAD, SOUTH AFRICA

CREATIVE TEAM: MICHAEL BLORE – CHIEF CREATIVE OFFICER; LIAM WIELOPOLSKI, CLINTON BRIDGEFORD – EXECUTIVE CREATIVE DIRECTORS; KATHERINE GLOVER – COPYWRITER; STEVE DIRNBERGER, JACQUE MOODLEY – ART DIRECTORS

CLIENT: VIRGIN ATLANTIC AIRLINES

Nothing is more flattering to a creative director than a simple, exciting concept and free rein—and it shows in the retelling. "The client came to us with a simple request," says Liam Wielopolski at Y&R South Africa in Woodmead. "'We've got a really great deal, fill our planes.'"

Virgin Atlantic already was offering a great price on return airfares from Johannesburg to London, and so Y&R's job was simply to come up with a fun, impactful (and affordable) way to communicate this to the masses. Says Wielopolski: "We decided to hit people when they were already

spending money, and in doing so, they so would realize exactly how affordable Virgin Atlantic Economy is." To get the desired impact and leave no question as to the nature of the client, Y&R created realistic–looking airline baggage tags with the desired message, then had the tags attached to shopping bags at fashion stores in shopping malls. "Everybody who shops gets a bag," Wielopolski explains. "If you add something interesting to it, people will interact with it and read your message." The low price sold itself, and Virgin Atlantic Economy's seats became a hot ticket themselves, selling out completely.

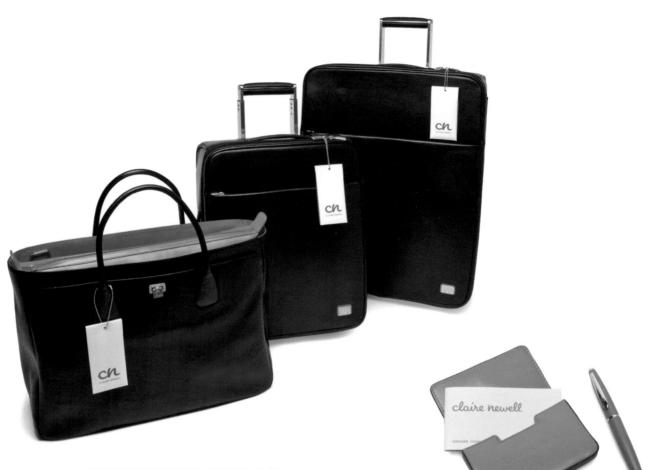

CREATIVE FIRM: BRAND ENGINE – SAUSALITO, CA, USA

CREATIVE TEAM: TOM DAVIDSON, WILL BURKE – ART DIRECTORS; TOM DAVIDSON, MIKE JOHNSON, MEEGAN PEERY, BILL KERR, CORALIE RUSSO – DESIGNERS

CLIENT: CLAIRE NEWELL

CREATIVE FIRM:
ZUAN CLUB – TOKYO,
JAPAN
CREATIVE TEAM:
AKIHIKO TSUKA-
MOTO – DESIGN/ART
DIRECTION
CLIENT: JEWERY
FOUR C, INC.

CREATIVE FIRM: BLUEZOOM –
GREENSBORO, NC, USA
CLIENT: BLUEZOOM

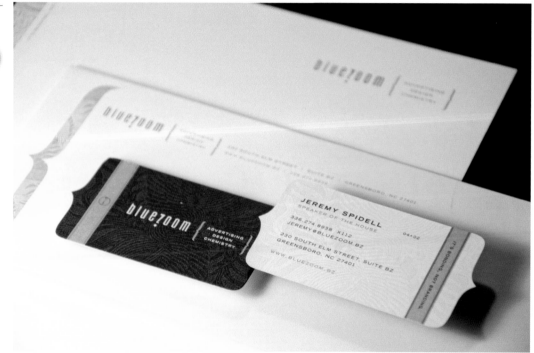

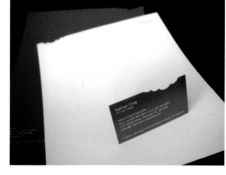

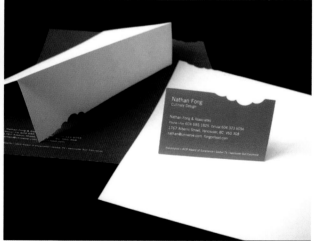

CREATIVE FIRM: HANGAR 18 – VANCOUVER, BC, CANADA
CREATIVE TEAM: VIDA JURCIC – CONCEPT AND DESIGN;
JOANNE HENDERSON – PRODUCTION MANAGER; JOAN
HUNTER – PRODUCTION ARTIST
CLIENT: NATHAN FONG

armtec
VISION | BUILT

CREATIVE FIRM: ZYNC – TORONTO, ON, CANADA
CREATIVE TEAM: MARKO ZONTA – CREATIVE DIRECTOR; LEE BOULDEN – DESIGNER
CLIENT: ARMTEC

BRAINSTORM
Teaching Software. Teaching People.

CREATIVE FIRM: MODERN8 – SALT LAKE CITY, UT, USA
CREATIVE TEAM: RANDALL SMITH – CREATIVE DIRECTOR;
BRANDON FRATTO – DESIGNER
CLIENT: BRAINSTORM INC.

ChirpE

CREATIVE FIRM: FIXATION MARKETING – BETHSEDA, MD, USA
CREATIVE TEAM: BRENT ALMOND – DESIGNER
CLIENT: A2Z INC.

NIGERIAN

CREATIVE FIRM: INTERBRAND SAMPSON – SANDTON, SOUTH AFRICA
CREATIVE TEAM: ANTON KRUGEL – DESIGN DIRECTOR
CLIENT: NIGERIAN EAGLE AIRLINES

MATHEMATICS & COMPUTER CLUB

CREATIVE FIRM: GRAIN CREATIVE CONSULTANTS – SURRY HILLS, NSW, AUSTRALIA
CREATIVE TEAM: JURE LEKO – CREATIVE DIRECTOR
CLIENT: MATHEMATICS & COMPUTER CLUB

Cirque de la Mer
A Sound Education

CREATIVE FIRM: TFI ENVISION, INC. – NORWALK, CT, USA
CREATIVE TEAM: ELIZABETH P. BALL – CREATIVE DIRECTOR; BRIEN O'REILLY – ART DIRECTOR/DESIGNER
CLIENT: THE MARITIME AQUARIUM AT NORWALK

CREATIVE FIRM: OCULUS DESIGN PTE LTD – SINGAPORE
CREATIVE TEAM: JONATHAN ENG – DESIGN DIRECTOR
CLIENT: WORKPLACE SAFETY & HEALTH COUNCIL

CREATIVE FIRM: INTERBRAND SAMPSON – SANDTON, SOUTH AFRICA
CREATIVE TEAM: ANTON KRUGEL – DESIGN DIRECTOR; BLAKE ANDERSON, SEAN OBERHOLSTER – DESIGNERS
CLIENT: COMMERCIAL BANK OF AFRICA

CREATIVE FIRM: INTERBRAND SAMPSON – SANDTON, SOUTH AFRICA
CREATIVE TEAM: ANTON KRUGEL – DESIGN DIRECTOR; @126 ARCHITECTS – EXTERIOR DESIGNERS; PHILLIP SOLOMON – FORM DESIGNER
CLIENT: GULF ENERGY

CREATIVE FIRM: ZYNC – TORONTO,' ON, CANADA
CREATIVE TEAM: MARKO ZONTA – CREATIVE DIRECTOR; LEE BOULDEN – DESIGNER
CLIENT: FROST PHOTO

LEA & SANDEMAN

'MOST ORIGINAL WINE MERCHANTS'

CREATIVE FIRM: LEWIS MOBERLY – LONDON, UK
CREATIVE TEAM: MARY LEWIS – CREATIVE DIRECTOR; PAUL CILIA LA CORTE, MARK STUBBINGTON – DESIGNERS
CLIENT: LEA & SANDEMAN

CREATIVE FIRM: MERCHAN–DESIGN – SAO PAULO, BRAZIL
CREATIVE TEAM: MARCELO LOPES – DESIGNER/DESIGNER DIRECTOR
CLIENT: POSADAS DO BRASIL

CREATIVE FIRM: DESIGN NUT – KENSINGTON, MD, USA
CREATIVE TEAM: BRENT ALMOND – DESIGNER/ILLUSTRATOR
CLIENT: PIPER WATSON PHOTOGRAPHY

CREATIVE FIRM: EURO RSCG C&O – PARIS, FRANCE
CREATIVE TEAM: KARIM OURABAH – PRODUCER; THIERRY GROULEAUD – PRODUCTION DIRECTOR; LUCIE LEBAZ – ART DIRECTOR; REZA BASSIRI – CREATIVE DIRECTOR
CLIENT: MUSÉES DE CORSE

CREATIVE FIRM: PENSARÉ DESIGN GROUP – WASHINGTON, D.C., USA
CREATIVE TEAM: MARY ELLEN VEHLOW – CREATIVE DIRECTOR; AMY E. BILLINGHAM – DESIGNER
CLIENT: WALDO, SLUGGO & ME

projeto cidadania

CREATIVE FIRM: MENDES PUBLICIDADE – BELEM, BRAZIL

CREATIVE TEAM: OSWALDO MENDES – CREATIVITY DIRECTOR; MARIA ALICE PENNA – ART DIRECTOR

CLIENT: GOVERNO DO ESTADO DO PARÁ.

REEL AFFIRMATIONS
Washington DC's International LGBT Film Festival

CREATIVE FIRM: DESIGN NUT – KENSINGTON, MD, USA

CREATIVE TEAM: BRENT ALMOND – DESIGNER

CLIENT: ONE IN TEN`

luna·soma·jiva

CREATIVE FIRM: KALICO DESIGN – FREDERICK, MD, USA

CREATIVE TEAM: KIMBERLY DOW – DESIGNER/ILLUSTRATOR

CLIENT: LUNA SOMA JIVA

FXRAGILE

CREATIVE FIRM: ZYNC – TORONTO, ON, CANADA

CREATIVE TEAM: MARKO ZONTA – CREATIVE DIRECTOR

CLIENT: FRAGILE X RESEARCH FOUNDATION OF CANADA

Parker Poe

CREATIVE FIRM: GREENFIELD/BELSER LTD. – WASHINGTON, D.C., USA

CREATIVE TEAM: TIM FROST – DESIGNER

CLIENT: PARKER POE

CREATIVE FIRM: FUTUREBRAND GMBH – HAMBURG, GERMANY

CREATIVE TEAM: GÜNTER SENDLMEIER – CEO/CCO; JONATHAN SVEN AMELUNG – CREATIVE DIRECTOR; JESSICA WATERMANN – ACCOUNT DIRECTOR; HOLGER LENDNER – MANAGING DIRECTOR (YALOOK.COM)

CLIENT: FASHIONWORLD GMBH (A MEMBER OF THE OTTO GROUP)

origio

CREATIVE FIRM: REPUTATION – COPENHAGEN, DENMARK

CREATIVE TEAM: CARSTEN LOLAND – CREATIV DIRECTOR

CLIENT: ORIGIO

FLYING PENGUIN
PICTURES

CREATIVE FIRM: STEPHEN LONGO DESIGN ASSOCIATES – WEST ORANGE, NJ, USA

CREATIVE TEAM: STEPHEN LONGO – ART DIRECTOR

CLIENT: FLYING PENGUIN PICTURES

CREATIVE FIRM: DESIGN NUT – KENSINGTON, MD, USA
CREATIVE TEAM: BRENT ALMOND – DESIGNER/ILLUSTRATOR
CLIENT: GAY MEN'S CHORUS OF WASHINGTON DC

CREATIVE FIRM: ZULU ALPHA KILO – TORONTO, ON, CANADA
CREATIVE TEAM: ZAK MROUEH, JOSEPH BONNICI – CREATIVE DIRECTORS; MARK FRANCOLINI – ART DIRECTOR; ERICK NIELSEN – DESIGNER; EILEEN SMITH – PRODUCTION MANAGER; BARRETT HOLMAN – ACCOUNT SUPERVISOR
CLIENT: HONOUR COMBAT CHAMPIONSHIPS

CREATIVE FIRM: INTERBRAND SAMPSON – SANDTON, SOUTH AFRICA
CREATIVE TEAM: SEAN OBERHOLSTER – DESIGNER; ANTON KRUGEL – DESIGN DIRECTOR
CLIENT: HALO ADVERTISING

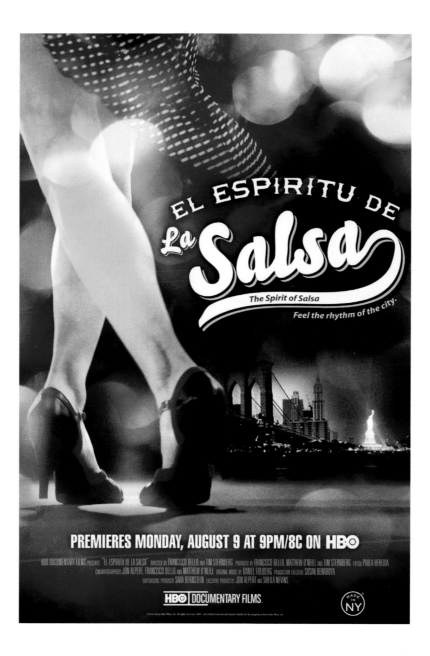

FEEL THE RHYTHM OF THE CITY

 PLATINUM

CREATIVE FIRM: HBO – NEW YORK, NY, USA

CREATIVE TEAM: VENUS DENNISON – CREATIVE DIRECTOR; ANA RACELIS – DESIGN MANAGER; JENNIFER MCDEARMAN – COPYWRITER; ARDELLA WILSON – ASSOCIATE PROJECT MANAGER

CLIENT: HBO DOCUMENTARY FILMS

There's something extraordinary about salsa. Unlike other dances that demand years of training, salsa invites anyone, at anytime, to step in and share the experience. The acclaimed documentary Espiritu De La Salsa follows ten such participants, everyday New Yorkers from all over the city who connect at a Spanish Harlem studio for six weeks of intense rehearsals, leading up to an electric public performance.

A highlight of the 2010 HBO Documentary Films® Summer Series, the film needed a compelling poster to promote tune–in. In addition, the art would be used for screening invitations, DVD packaging and online executions. So how do you capture the film's incredible spirit in one poster? HBO® Off–Air Creative Services met this challenge with a range of creative explorations. Initially, using individual dancer's photos seemed like a natural solution, but solo shots proved too limiting.

For the final creative, iconic images–a pair of legs crossed mid–move and New York City landmarks–plus a warm and welcoming color palette best serve the story. The result is a subtle and sexy tribute to the dance.

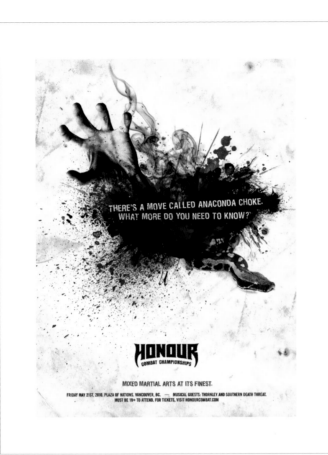

CREATIVE FIRM: ZULU ALPHA KILO – TORONTO, ON, CANADA

CREATIVE TEAM: ZAK MROUEH, JOSEPH BONNICI – CREATIVE DIRECTORS; MARK FRANCOLINI – ART DIRECTOR; ERICK NIELSEN – DESIGNER; EILEEN SMITH – PRODUCTION MANAGER; BARRETT HOLMAN – ACCOUNT SUPERVISOR

CLIENT: HONOUR COMBAT CHAMPIONSHIPS

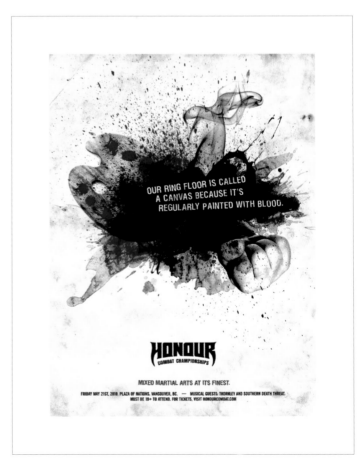

CREATIVE FIRM: ZULU ALPHA KILO – TORONTO, ON, CANADA

CREATIVE TEAM: ZAK MROUEH, JOSEPH BONNICI – CREATIVE DIRECTORS; MARK FRANCOLINI – ART DIRECTOR; ERICK NIELSEN – DESIGNER; EILEEN SMITH – PRODUCTION MANAGER; BARRETT HOLMAN – ACCOUNT SUPERVISOR

CLIENT: HONOUR COMBAT CHAMPIONSHIPS

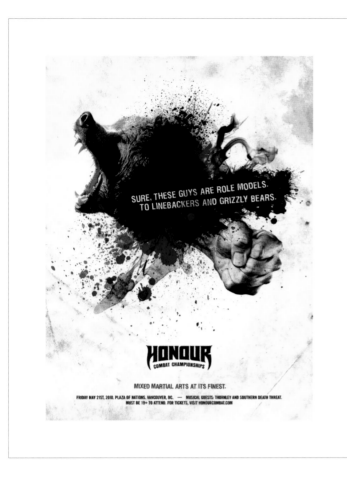

CREATIVE FIRM: ZULU ALPHA KILO – TORONTO, ON, CANADA

CREATIVE TEAM: ZAK MROUEH, JOSEPH BONNICI – CREATIVE DIRECTORS; MARK FRANCOLINI – ART DIRECTOR; ERICK NIELSEN – DESIGNER; EILEEN SMITH – PRODUCTION MANAGER; BARRETT HOLMAN – ACCOUNT SUPERVISOR

CLIENT: HONOUR COMBAT CHAMPIONSHIPS

CREATIVE FIRM: NEW MOMENT NEW IDEAS COMPANY – SKOPJE, MACEDONIA

CREATIVE TEAM: NIKOLA VOJNOV, DUSAN DRAKALSKI – CREATIVE DIRECTORS; NIKOLA VOJNOV – COPYWRITER

CLIENT: SONIX

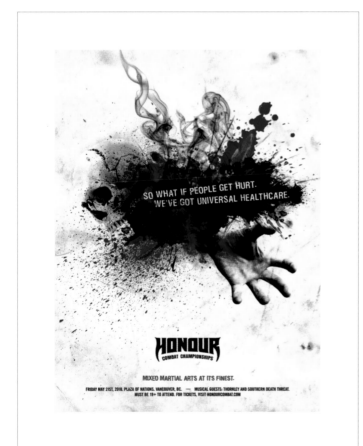

CREATIVE FIRM: ZULU ALPHA KILO – TORONTO, ON, CANADA

CREATIVE TEAM: ZAK MROUEH, JOSEPH BONNICI – CREATIVE DIRECTORS; MARK FRANCOLINI – ART DIRECTOR; ERICK NIELSEN – DESIGNER; EILEEN SMITH – PRODUCTION MANAGER; BARRETT HOLMAN – ACCOUNT SUPERVISOR

CLIENT: HONOUR COMBAT CHAMPIONSHIPS

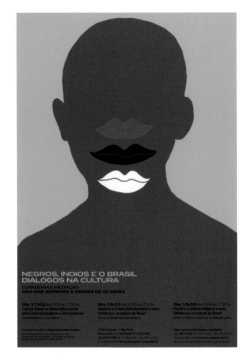

CREATIVE FIRM: CASA REX – SAO PAULO, BRAZIL

CREATIVE TEAM: GUSTAVO PIQUEIRA – CREATIVE DIRECTOR/DESIGN; SAMIA JACINTHO – DESIGN; CAMILE LEÃO – ASSISTANT DESIGNER

CLIENT: AEP I ARTEDUCAÇÃO PRODUÇÕES

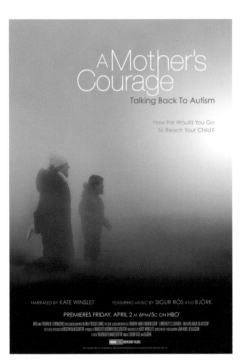

CREATIVE FIRM: HBO – NEW YORK, NY, USA

CREATIVE TEAM: VENUS DENNISON – CREATIVE DIRECTOR; ALLAN WAI – DESIGN MANAGER; ANTHONY VIOLA – ART DIRECTOR; ANDREW KANZER – COPYWRITER; ARDELLA WILSON – ASSOCIATE PROJECT MANAGER

CLIENT: HBO DOCUMENTARY FILMS

CREATIVE FIRM: ZULU ALPHA KILO – TORONTO, ON, CANADA

CREATIVE TEAM: ZAK MROUEH, JOSEPH BONNICI – CREATIVE DIRECTORS; MARK FRANCOLINI – ART DIRECTOR; ERICK NIELSEN – DESIGNER; EILEEN SMITH – PRODUCTION MANAGER; BARRETT HOLMAN – ACCOUNT SUPERVISOR

CLIENT: HONOUR COMBAT CHAMPIONSHIPS

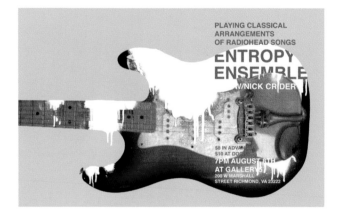

CREATIVE FIRM: MENDED ARROW DESIGN – RICHMOND, VA, USA

CREATIVE TEAM: BIZHAN KHODABANDEH – DESIGNER/PHOTOGRAPHER

CLIENT: GALLERY 5

CREATIVE FIRM: COOPER SMITH & COMPANY – DES MOINES, IA, USA
CREATIVE TEAM: SALLY COOPER SMITH – DESIGNER
CLIENT: ARTCRANK

CREATIVE FIRM: MARK OLIVER, INC. – SOLVANG, CA, USA
CREATIVE TEAM: MARK OLIVER – CREATIVE DIRECTOR/DESIGNER
CLIENT: CARHARTT WINERY
URL: WWW.MARKOLIVERINC.COM

CREATIVE FIRM: KANTORWASSINK – GRAND RAPIDS, MI, USA
CREATIVE TEAM: DAVE KANTOR, WENDY WASSINK, TIM CALKINS – CREATIVE
CLIENT: JUICE BALL

CREATIVE FIRM: KELLY BRYANT DESIGN – AUBURN, AL, USA
CREATIVE TEAM: KELLY BRYANT – ART DIRECTOR/DESIGNER/
ILLUSTRATOR; RANDY BARTLETT – EDITOR; CLARK LUNDELL
– EDITOR/WRITER
CLIENT: AUBURN UNIV DEPT OF INDUSTRIAL + GRAPHIC
DESIGN

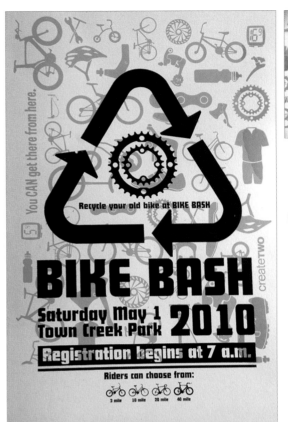

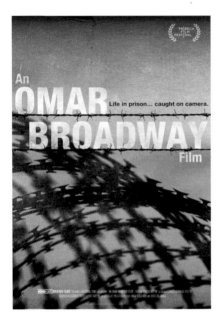

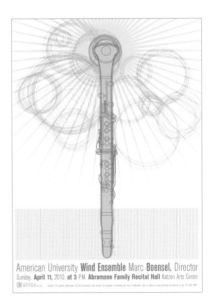

CREATIVE FIRM: SCHELLHAS DESIGN – CINCINNATI, OH, USA
CREATIVE TEAM: HANS SCHELLHAS – DESIGNER
CLIENT: CATERPILLAR TRACKS

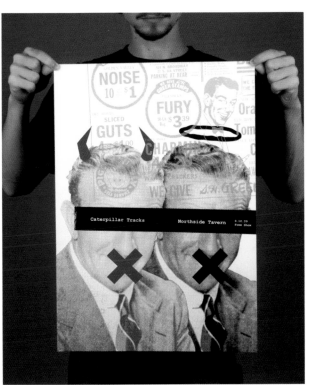

CREATIVE FIRM: KATE RESNICK DESIGN – FAIRFAX, VA, USA
CREATIVE TEAM: KATE RESNICK – DESIGNER
CLIENT: KATZEN ARTS CENTER

CREATIVE FIRM: HBO – NEW YORK, NY, USA
CREATIVE TEAM: VENUS DENNISON – CREATIVE DIRECTOR; ANA RACELIS – DESIGN MANAGER; CARLOS TEJEDA – ART DIRECTOR; JENNIFER MCDEARMAN – COPYWRITER; ELIZABETH LANESE – ASSOCIATE PROJECT MANAGER
CLIENT: HBO DOCUMENTARY FILMS

CREATIVE FIRM: CREATETWO – AUBURN, AL, USA
CREATIVE TEAM: KEVIN SMITH, CREATETWO – DESIGNERS
CLIENT: CREATETWO
URL: HTTP://LETTERPRESSPOSTER.COM/

KEVORKIAN

THERE'S MORE TO HIS LIFE THAN DEATH.

PREMIERES MONDAY, JUNE 28 AT 9PM/8C ON HBO

HBO DOCUMENTARY FILMS. AND FOUNDATION FILMS PRESENT A BEE HOLDER PRODUCTION IN ASSOCIATION WITH FAIRHAVEN FILMS "KEVORKIAN" DIRECTED BY MATTHEW GALKIN PRODUCED BY STEVE LEE JONES MICHAEL LaFETRA CO-EDITORS PRODUCED BY MATTHEW GALKIN SCOTT ALTOMARE TROY POWERS STEPHEN A. MARKEY III DIRECTOR OF PHOTOGRAPHY PAUL DOKUCHITZ MUSIC BY JAMES S LAVINO CO-PRODUCED BY TIM K. SMITH ASSOCIATE PRODUCER BRYAN QUINN

CREATIVE FIRM: HBO – NEW YORK, NY, USA
CREATIVE TEAM: VENUS DENNISON – CREATIVE DIREC-TOR; ANA RACELIS – DESIGN MANAGER; SETH LUTSKY – DESIGNER; JENNIFER MCDEARMAN – COPYWRITER; ARDELLA WILSON – ASSOCIATE PROJECT MANAGER
CLIENT: HBO DOCUMENTARY FILMS

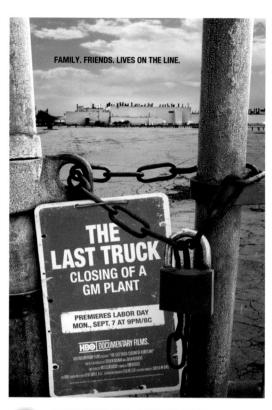

FAMILY. FRIENDS. LIVES ON THE LINE.

THE LAST TRUCK
CLOSING OF A GM PLANT

PREMIERES LABOR DAY MON., SEPT. 7 AT 9PM/8C

HBO DOCUMENTARY FILMS.

CREATIVE FIRM: HBO – NEW YORK, NY, USA
CREATIVE TEAM: VENUS DENNISON – CREATIVE DIREC-TOR; ANA RACELIS – DESIGN MANAGER; CARLOS TEJEDA – ART DIRECTOR; JENNIFER MCDEARMAN – COPYWRITER; HEATHER THOMAS – PROJECT MANAGER
CLIENT: HBO DOCUMENTARY FILMS

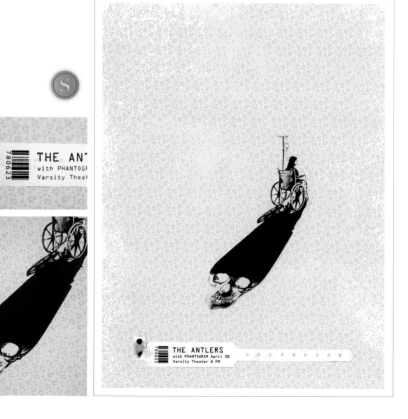

CREATIVE FIRM: INTELLIGENT FISH STUDIO – WOODBUY, MN, USA
CREATIVE TEAM: BRIAN DANAHER – ART DIRECTOR/DESIGNER/ILLUSTRATOR
CLIENT: THE ANTLERS

Imagine what a buck could do.

CREATIVE FIRM: ALCONE MARKETING – IRVINE, CA, USA
CREATIVE TEAM: JUSTIN WRIGHT – ART DIRECTOR;
JASON PENNING – SR. ART DIRECTOR; CARLOS MUSQUEZ,
CAMERON YOUNG – CREATIVE DIRECTORS; LUIS CAMANO
– CHIEF CREATIVE OFFICER
CLIENT: CALIFORNIA LOTTERY

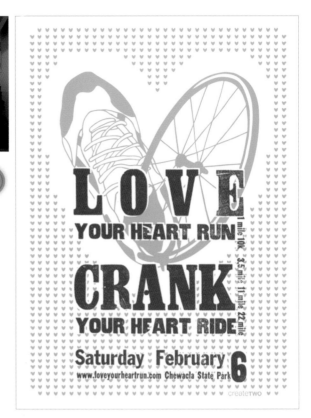

CREATIVE FIRM: CREATETWO – AUBURN, AL, USA
CREATIVE TEAM: KEVIN SMITH, CREATETWO, BETHANY HECK – DESIGNERS
CLIENT: EXCEPTIONAL OUTREACH ORGANIZATION
URL: HTTP://LETTERPRESSPOSTER.COM/

CREATIVE FIRM: CHEMI MONTES DESIGN – FALLS CHURCH, VA, USA
CREATIVE TEAM: CHEMI MONTES – ART DIRECTOR/ILLUSTRATOR
CLIENT: AU COLLEGE OF ARTS AND SCIENCES

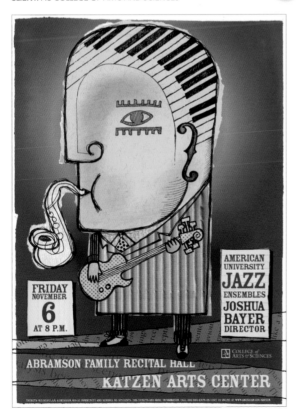

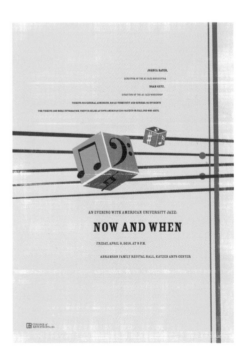

CREATIVE FIRM: KATE RESNICK DESIGN – FAIRFAX, VA, USA
CREATIVE TEAM: KATE RESNICK – DESIGNER
CLIENT: KATZEN ARTS CENTER

CREATIVE FIRM: HBO – NEW YORK, NY, USA
CREATIVE TEAM: VENUS DENNISON – CREATIVE DIRECTOR; ALLAN WAI – DESIGN MANAGER; MICHELLE ZULAUF – DESIGNER; ANDREW KANZER – COPYWRITER; ELIZABETH LANESE – ASSOCIATE PROJECT MANAGER
CLIENT: HBO DOCUMENTARY FILMS

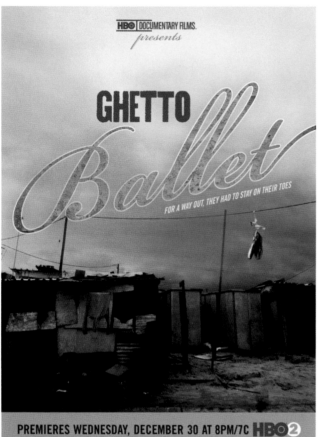

CREATIVE FIRM: INTELLIGENT FISH STUDIO – WOODBUY, MN, USA
CREATIVE TEAM: BRIAN DANAHER – ART DIRECTOR/DESIGNER/ILLUSTRATOR; VGKIDS – SCREEN PRINTER
CLIENT: CEDAR CULTURAL CENTER

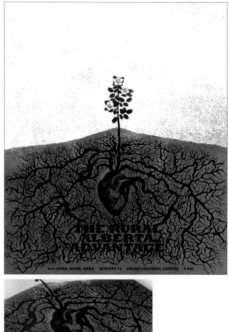

CREATIVE FIRM: CHEMI MONTES DESIGN – FALLS CHURCH, VA, USA
CREATIVE TEAM: CHEMI MONTES – ART DIRECTION/DESIGN/PHOTOGRAPHY
CLIENT: AU COLLEGE OF ARTS AND SCIENCES

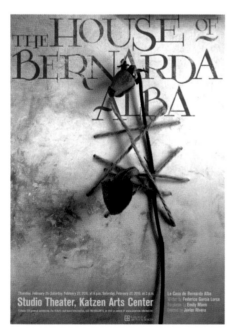

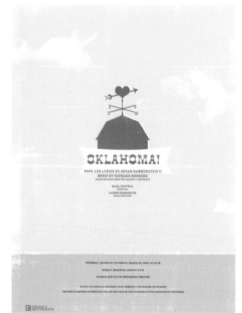

CREATIVE FIRM: KATE RESNICK DESIGN – FAIRFAX, VA, USA
CREATIVE TEAM: KATE RESNICK – DESIGNER
CLIENT: HAROLD AND SYLVIA GREENBERG THEATRE

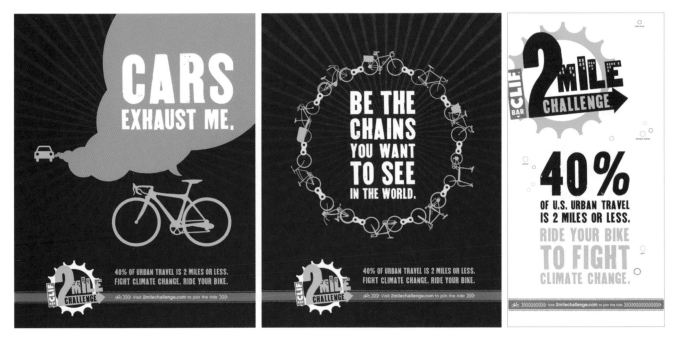

CREATIVE FIRM: CLIF BAR & COMPANY – EMERYVILLE, CA, USA
CREATIVE TEAM: MARK BOEDIMAN – SENIOR DESIGNER; JOHN MARIN – CREATIVE DIRECTOR; CHRISTOPHER SWANNER – COPYWRITER; ELLY CHO – PRODUCTION
CLIENT: CLIF BAR & COMPANY

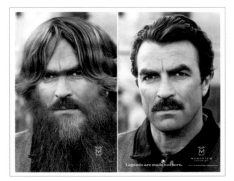

CREATIVE FIRM: HANGAR 18 – VANCOUVER, BC, CANADA
CREATIVE TEAM: BEN HUDSON – CREATIVE DIRECTOR/DE-SIGNER; TODD CHAPMAN, ANDREW SCHICK – PRODUCTION
CLIENT: MOMENTUM GROOMING

CREATIVE FIRM: CLIF BAR & COMPANY – EMERYVILLE, CA, USA
CREATIVE TEAM: MARK BOEDIMAN – SENIOR DESIGNER; CHRISTOPHER SWANNER – COPYWRITER; MICHAEL VARISTOM – PRODUCTION; MATTHEW LOYD – CREATIVE DIRECTOR
CLIENT: CLIF BAR & COMPANY

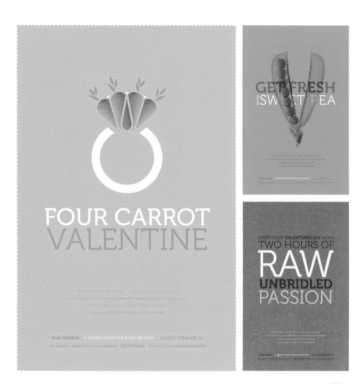

CREATIVE FIRM: HBO – NEW YORK, NY, USA

CREATIVE TEAM: VENUS DENNISON – CREATIVE DIRECTOR; ALLAN WAI – DESIGN MANAGER; GARY ST. CLARE – DESIGNER; STEPHEN KAMSLER – COPYWRITER; ARDELLA WILSON – ASSOCIATE PROJECT MANAGER

CLIENT: HBO DOCUMENTARY FILMS

CREATIVE FIRM: COOPER SMITH & COMPANY – DES MOINES, IA, USA

CREATIVE TEAM: ROBIN WASTENEY – ART DIRECTOR; MATT DIRKX – GRAPHIC DESIGNER; SALLY COOPER SMITH – CREATIVE DIRECTOR; SHEREE CLARK – WRITER

CLIENT: FORK IN THE ROAD

CREATIVE FIRM: MTV NETWORKS – NEW YORK, NY, USA

CREATIVE TEAM: DEVON CLARK – CREATOR; ROLYN BARTHLEMAN – ART DIRECTOR

CLIENT: COMEDY CENTRAL

CREATIVE FIRM: PLUMBLINE STUDIOS, INC – NAPA, CA, USA
CREATIVE TEAM: DOM MORECI – CREATIVE DIRECTOR; ROBERT BURNS – DESIGN DIRECTOR; MIKE ELI, SAVANNA SNOW – ILLUSTRATORS
CLIENT: MASHERY

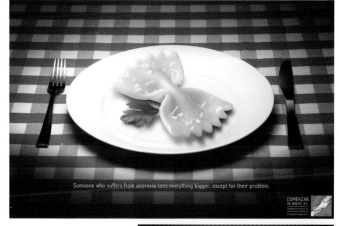

 CREATIVE FIRM: DIESTE – DALLAS, TX, USA
CREATIVE TEAM: CARLOS TOURNE – CHIEF CREATIVE OFFICER; PATY MARTINEZ, FLORENCIA LEIBASCHOFF – CREATIVE DIRECTORS; FLORENCIA LEIBASCHOFF, EDUARDO DURAN – COPYWRITERS; JOSE SUASTE – ART DIRECTOR
CLIENT: NUEVO COMENZAR

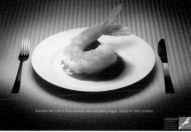

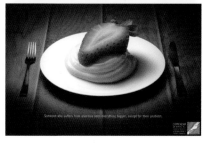

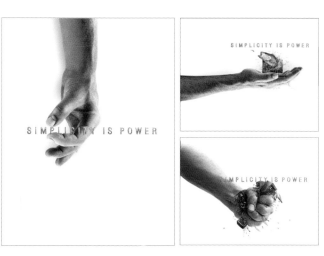

CREATIVE FIRM: TAYLOR JAMES – LONDON, UK
CREATIVE TEAM: AGENCY – Y&R, SAN FRANCISCO; CREATIVE PRODUCTION – TAYLOR JAMES
CLIENT: CITRIX SYSTEMS INC.
URL: HTTP://WWW.TAYLORJAMES.COM/CITRIX–HANDS/

CREATIVE FIRM: AD PLANET GROUP – SINGAPORE

CREATIVE TEAM: JAMES TAN – PRODUCTION MANAGER; MARY LIM, CHERIE TAN – ACCOUNT DIRECTORS; LEO TECK CHONG – EXECUTIVE CREATIVE DIRECTOR; ALFRED TEO – ASSOCIATE CREATIVE DIRECTOR; TAN LEONG LEE – SENIOR ART DIRECTOR; WU YU – ART DIRECTOR

CLIENT: BEAUTY EXPRESS INTERNATIONAL

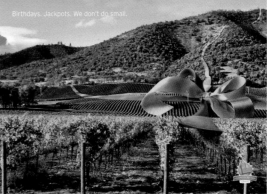

CREATIVE FIRM: ALCONE MARKETING – IRVINE, CA, USA

CREATIVE TEAM: JASON PENNING – SR. ART DIRECTOR; JUSTIN WRIGHT – ART DIRECTOR; CARLOS MUSQUEZ, CAMERON YOUNG – CREATIVE DIRECTORS; LUIS CAMANO – CHIEF CREATIVE OFFICER

CLIENT: CALIFORNIA LOTTERY

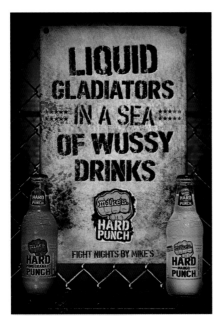

CREATIVE FIRM: ALCONE MARKETING – IRVINE, CA, USA

CREATIVE TEAM: PAUL ULLOA – ART DIRECTOR; NICK ROOTH, KEVIN KLEBER – CREATIVE DIRECTORS; LUIS CAMANO – CHIEF CREATIVE OFFICER

CLIENT: MIKE'S HARD LEMONADE

CREATIVE FIRM: CLINE DAVIS AND MANN LLC – NEW YORK, NY, USA

CREATIVE TEAM: MARK FRIEDMAN, CHRIS PALMER – CREATIVE DIRECTORS; SAMANTHA WILEY – ART SUPERVISOR; ARIELLA STOK – COPY SUPERVISOR

CLIENT: CHILDREN'S HOSPITAL AT MONTEFIORE

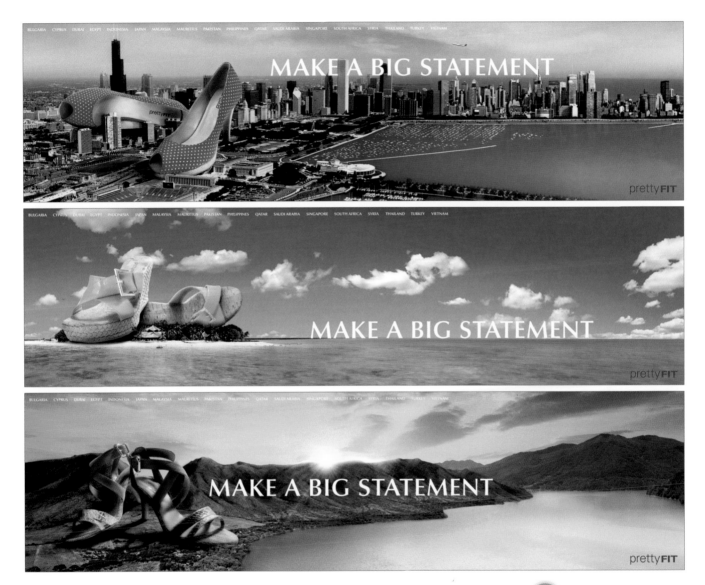

CREATIVE FIRM: PLANET ADS AND DESIGN P/L – SINGAPORE
CREATIVE TEAM: HAL SUZUKI – CREATIVE DIRECTOR; SUZANNE LAURIDSEN – SENIOR COPYWRITER; EDWIN ENERO – ART DIRECTOR
CLIENT: FREEMEN PTE LTD

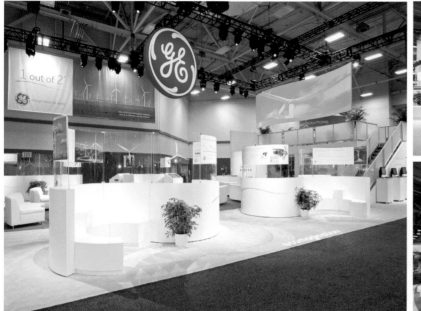

CREATIVE FIRM: EP&M INTERNATIONAL – ALBANY, NY, USA

CREATIVE TEAM: TIFFENY CANTU – PROJECT MANAGER; LILY WEI – DESIGNER

CLIENT: GE ENERGY

URL: WWW.EPMEXHIBITS.COM

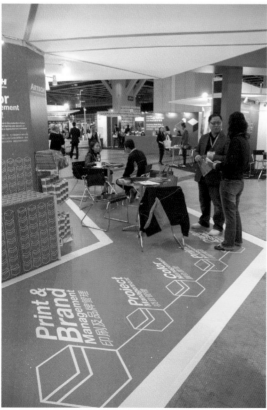

CREATIVE FIRM: TORRE LAZUR MCCANN – PARSIPPANY, NJ, USA

CREATIVE TEAM: DEBRA FEATH – VP, ACD, ART; MARCIA GOD-
DARD – EVP, CD; NANCY SCHROETER – VP, ASSOCIATE CREATIVE
DIRECTOR, ART; LIN BETANCOURT – VP, GROUP CREATIVE DIREC-
TOR, COPY; JENNIFER DEE – VP, EXECUTIVE PRODUCER; JENNA
BADGLEY – SR. ACCOUNT EXEC.; SCOTT SISTI – DIRECTOR OF
INTERACTIVE MEDIA; KATHARINE IMBRO – VP, ACD, COPY

CLIENT: BOEHRINGER INGELHEIM

URL: HTTP://AGENCYSUBMISSION.COM/BI_AWARDS_SUBMISSION/

CREATIVE FIRM: TWICE GRAPHICS – KWUN TONG, KOWLOON, HONG KONG

CREATIVE TEAM: STEVE LAU – DESIGN DIRECTOR; CLEMENT SO – SENIOR
DESIGNER; JACKSON TSE – DESIGNER

CLIENT: ARTECH

URL: WWW.TWICEGRAPHICS.COM

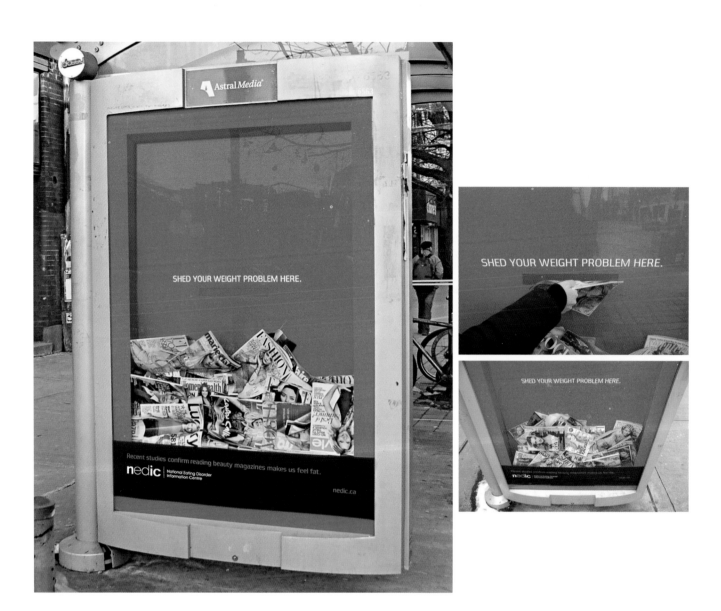

SHED YOUR WEIGHT PROBLEM *HERE.*

SHED YOUR WEIGHT PROBLEM *HERE.*

 PLATINUM

SHED

CREATIVE FIRM: ZULU ALPHA KILO – TORONTO, ON, CANADA

CREATIVE TEAM: ZAK MROUEH – CREATIVE DIRECTOR; MARKETA KRIVY – ART DIRECTOR; TROY MCCLURE – COPYWRITER; GRANT CLELAND – DESIGNER; MIKE THOANG – PRODUCTION ARTIST; EILEEN SMITH PRODUCTION – MANAGER

CLIENT: NATIONAL EATING DISORDER INFORMATION CENTRE

When most fashions look best on a hanger, what more accurate way to show them but on a model who has the dimensions of a human clothes hanger? To break women of this "ideal," the National Eating Disorder Information Centre (NEDIC), a nonprofit organization that provides information to Canadians on eating disorders,

came to Toronto agency Zulu Alpha Kilo to create a campaign that would stand apart from, well, the standard approach to beauty. "Eating disorders are at all all–time high," explains NEDIC. Adds Zulu: "Looking at many other ads for this cause, we realized that all of them target the public to create awareness. The problem was that the public wasn't responsible for the images of emaciated, over–retouched models." Zulu took a new approach, targeting the fashion industry with a campaign that would hit the fashion press where they live: in their offices and on the streets.

The campaign featured a tiny T–shirt that was sent to fashion editors and press

with the instructions, "Please try this on to experience how your ads make us feel," a greeting card with a message thanking the recipients "for making me such a successful anorexic" and, as the coup de grace, interactive transit posters located in the fashion district. "It asked women to shed their weight problems by depositing fashion magazines into the shelter," Zulu says. In spite of a small budget, the campaign generated a groundswell of media coverage around the world. Traffic to NEDIC's website rose 250 percent and fashion editor Bernadette Morra said about the campaign, "It's brilliant. I think it very much taps into how a lot of women feel."

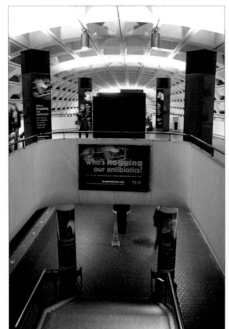

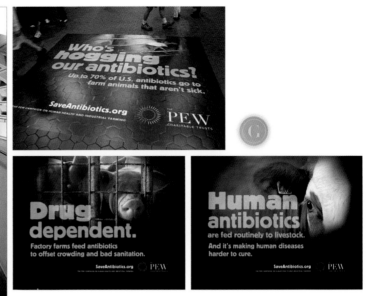

CREATIVE FIRM: PENSARÉ DESIGN GROUP – WASHINGTON, D.C., USA
CREATIVE TEAM: MARY ELLEN VEHLOW – CREATIVE DIRECTOR; LAUREN EMERITZ – DESIGNER
CLIENT: JOHN FRANZÉN / THE PEW CHARITABLE TRUSTS

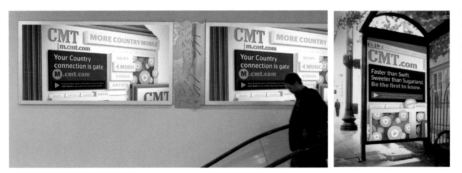

CREATIVE FIRM: MTV NETWORKS – NEW YORK, NY, USA
CREATIVE TEAM: JEFF NICHOLS – CREATIVE DIRECTOR; JASON SKINNER – ART DIRECTOR; BRAD DAVIS – DESIGNER; ERICA MYERS, JUDSON AIKENS – PROJECT MANAGERS
CLIENT: CMT

CREATIVE FIRM: DIESTE – DALLAS, TX, USA
CREATIVE TEAM: ALDO QUEVEDO – CHIEF CREATIVE OFFICER; CARLOS TOURNE – EXECUTIVE CREATIVE DIRECTOR; FLORENCIA LEIBASCHOFF – CREATIVE DIRECTOR; IGNACIO ROMERO, FLORENCIA LEIBASCHOFF – COPYWRITERS; JOSE SUASTE – ART DIRECTOR
CLIENT: LATINO CULTURAL CENTER

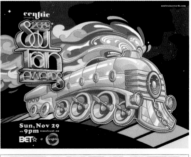

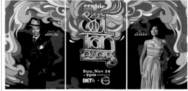

CREATIVE FIRM: MTV NETWORKS – NEW YORK, NY, USA
CREATIVE TEAM: NIGEL COX–HAGAN – EVP CREATIVE & MARKETING; PHIL DELBOURGO – SVP BRAND & DE-SIGN; TRACI TERRILL – VP EDITORIAL; JIMMY WENTZ – VP OFF–AIR CREATIVE; KESIME BERNARD – CREATIVE DIRECTOR; ALLISON SIERRA – DIRECTOR PROJECT MANAGEMENT; JULIE RUIZ – ART DIRECTOR; JESSE RAKER – DESIGNER; KIM NGUYEN – WRITER; TRISTAN EATON – ILLUSTRATOR
CLIENT: CENTRIC

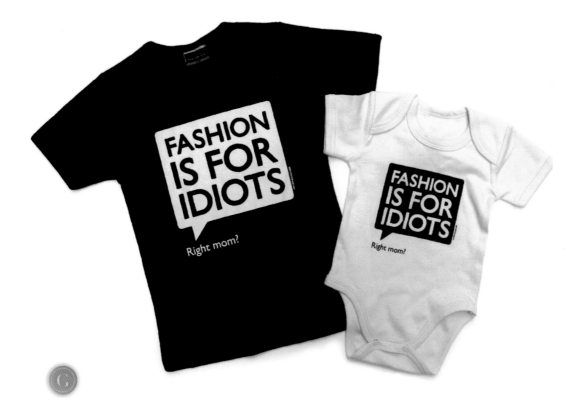

CREATIVE FIRM: REPUTATION – COPENHAGEN, DENMARK
CREATIVE TEAM: CARSTEN LOLAND – CREATIV DIRECTOR; PAUL BAREFOOT – COPYWRITER
CLIENT: CHARITY PROJECT

CREATIVE FIRM: MARC ATLAN DESIGN, INC. –
VENICE, CA, USA

CREATIVE TEAM: MARC ATLAN – CREATIVE
DIRECTOR

CLIENT: SESAME STREET©

 CREATIVE FIRM: MARC ATLAN DESIGN, INC. – VENICE, CA, USA

CREATIVE TEAM: MARC ATLAN – CREATIVE DIRECTOR

CLIENT: JAMES PERSE LOS ANGELES

 CREATIVE FIRM: REPUTATION – COPENHAGEN, DENMARK

CREATIVE TEAM: CARSTEN LOLAND – CREATIVE DIRECTOR; ULF WESTMARK – COPYWRITER

CLIENT: SELF PROMOTION

 CREATIVE FIRM: PLUMBLINE STUDIOS, INC – NAPA, CA, USA

CREATIVE TEAM: DOM MORECI – CREATIVE DIRECTOR; ERIC BALL – DESIGNER

CLIENT: RANCH WINERY

CREATIVE FIRM: UNIVERSITY OF AKRON/DESIGN X NINE – AKRON, OH, USA

CREATIVE TEAM: JANICE TROUTMAN, JOHN MORRISON – CREATIVE DIRECTORS; DESIGN X NINE TEAM – STUDENT DESIGNERS

CLIENT: GRAPHIC DESIGN PROGRAM AT THE MYERS SCHOOL OF ART

CREATIVE FIRM: MODO MODO AGENCY – ATLANTA, GA, USA

CREATIVE TEAM: JENNIFER WATSON – CREATIVE DIRECTOR; KIRK WELLS – ART DIRECTOR

CLIENT: MODO MODO AGENCY

CREATIVE FIRM: HANGAR 18 – VANCOUVER, BC, CANADA

CREATIVE TEAM: VIDA JURCIC – CREATIVE DIRECTOR/DESIGNER; JOANNE HENDERSON – PRODUCTION MANAGER; JOAN HUNTER – PRODUCTION ARTIST

CLIENT: BC SPCA

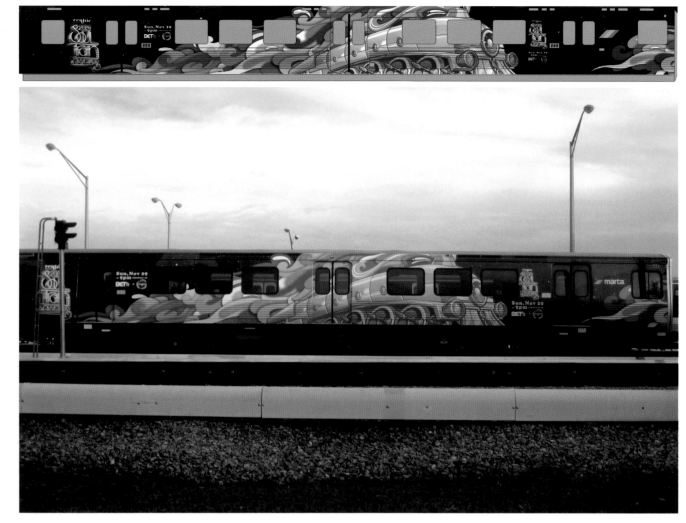

CREATIVE FIRM: MTV NETWORKS – NEW YORK, NY, USA
CREATIVE TEAM: NIGEL COX–HAGAN – EVP CREATIVE & MARKETING; PHIL DELBOURGO – SVP BRAND & DESIGN; JIMMY WENTZ – VP OFF–AIR CREATIVE; ALLISON SIERRA – DIRECTOR PROJECT MANAGEMENT; JULIE RUIZ – ART DIRECTOR; JESSE RAKER – DESIGNER; KIM NGUYEN – WRITER
CLIENT: CENTRIC

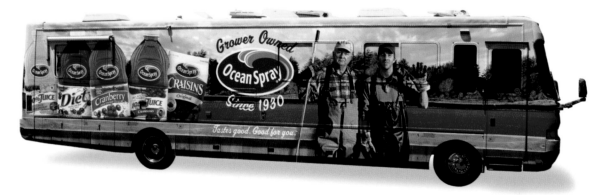

CREATIVE FIRM: MEDIACONCEPTS CORPORATION – ASSONET, MA, USA
CREATIVE TEAM: GREG DOBOS – CREATIVE DIRECTOR/ART DIRECTOR
CLIENT: OCEAN SPRAY

PACKAGING

CREATIVITY AWARDS ANNUAL

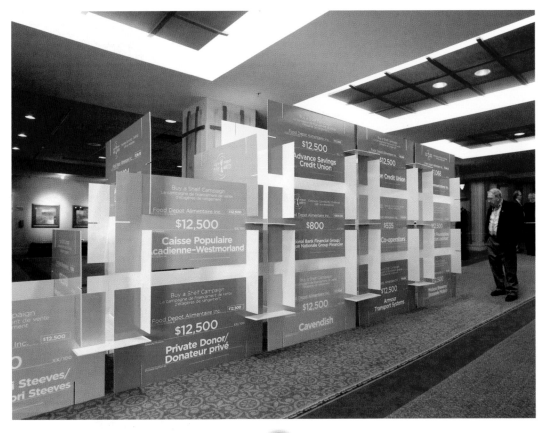

CREATIVE FIRM: ATLANTIC LOTTERY – MONCTON, NB, CANADA
CREATIVE TEAM: CHRISTINE BERNARD – GRAPHIC DESIGNER
CLIENT: ATLANTIC LOTTERY

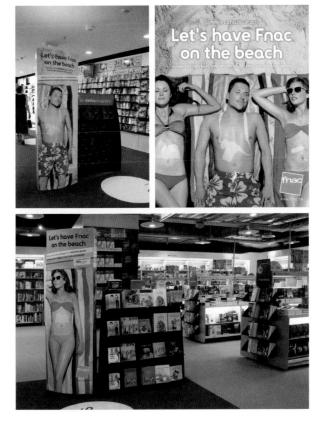

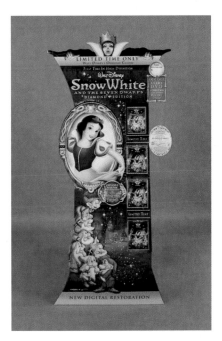

CREATIVE FIRM: SMURFIT–STONE IMAGE PAC
– CAMEO DIVISION – CHICAGO, IL, USA
CLIENT: WALT DISNEY STUDIOS HOME
ENTERTAINMENT

CREATIVE FIRM: LUON – OVERIJSE, BELGIUM
CLIENT: FNAC

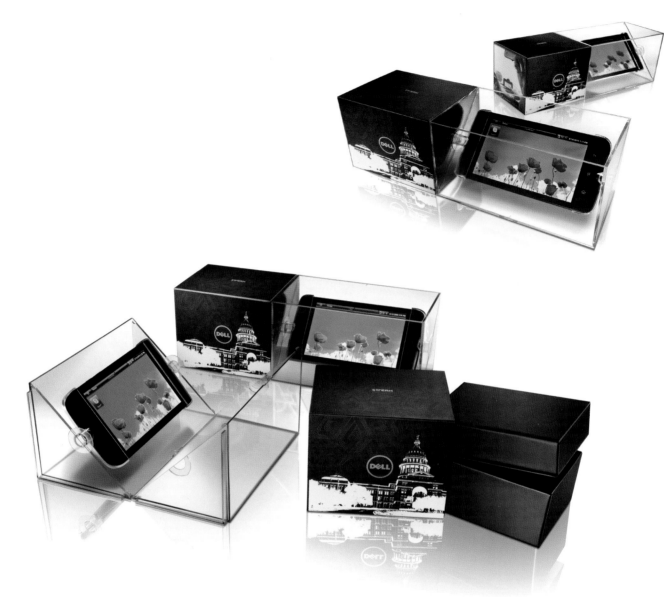

Ⓟ PLATINUM

STREAK

CREATIVE FIRM: DELL INC. – ROUND ROCK, TX, USA
CREATIVE TEAM: DELL VIBE DELL INHOUSE
CLIENT: DELL INC.

With fierce competition among makers of touchscreen mobile computing devices, any possible player hoping for a chance has to make its product appear to be something truly extraordinary. For the Streak, Dell's first foray into the five–inch screen size category of such devices, it wanted to show that it was more than just a mobile device but a true five–inch Dell computer, complete with still and video cameras and Stage, a unified platform for apps.

"The primary goal of the VIBE team for designing the packaging was to skip the sales talk and get the product literally in the customer's hands," says the agency that created the simple clear acetate packaging for the Streak. "The solution shows a 360° perspective of Streak and allows the customer to pick up the package and understand exactly how well the product will fit in their hands."

To bring this elegant package to its customers with a slim price tag, VIBE's specific cost–saving innovations include singular tooling (that is, the two parts of the product case have identical mounts, making the two halves interchangeable) and singular printing and translation that allows Dell to develop the instructions and ship them anywhere in the world without the need for language–specific sorting. Both Dell and VIBE are proud of their handiwork: "An understated image of the Texas State Capital Building in Austin gives a nod to Dell headquarters and the local pride of those who worked to create a product and packaging solution that are perfectly paired," they report.

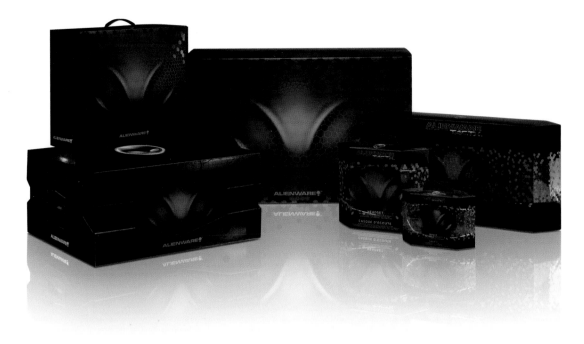

CREATIVE FIRM: DELL INC. – ROUND ROCK, TX, USA
CREATIVE TEAM: DELL VIBE INHOUSE DESIGN TEAM
CLIENT: DELL INC.

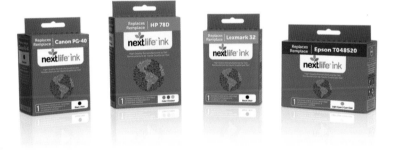

CREATIVE FIRM: DELL INC. – ROUND ROCK, TX, USA
CREATIVE TEAM: DELL VIBE DELL INHOUSE
CLIENT: DELL INC.

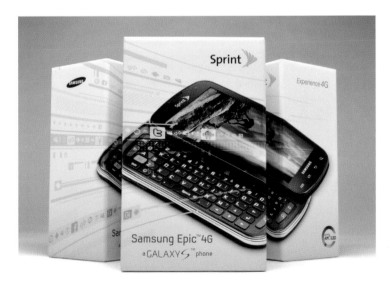

CREATIVE FIRM: DEUTSCH DESIGN WORKS – SAN FRANCISCO, CA, USA
CREATIVE TEAM: ERIKA KRIEGER – DESIGN DIRECTOR; PAULINE AU – DESIGNER; LLOYD HRYCIW – PHOTOGRAPHER
CLIENT: SPRINT

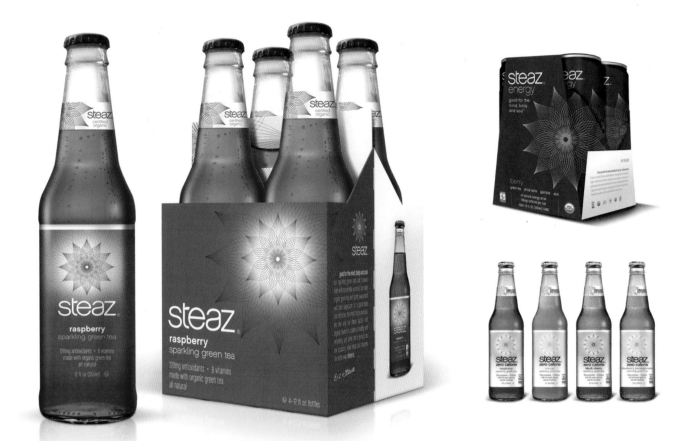

 PLATINUM

STEAZ SPARKLING GREEN TEAS

CREATIVE FIRM: WALLACE CHURCH, INC. – NEW YORK, NY, USA

CREATIVE TEAM: STAN CHURCH – CREATIVE DIRECTOR; MARCO ESCALANTE – DESIGN DIRECTOR/DESIGNER

CLIENT: THE HEALTHY BEVERAGE COMPANY

URL: WWW.STEAZ.COM

From a marketability standpoint, tea has come a long way–and with it, there's more competition than ever among producers. Steaz, "The Healthy Beverage Company," teamed with New York creative Wallace Church to create a fresh new look for its organic Steaz Sparkling Green Tea line. From the start, Steaz' mission has been "to build a healthier world with great–tasting beverages that benefit Mind, Body, Soul…and Planet," the agency says. To create a design that expressed the very essence of this brand–"vitality, energy and passion with a Zen–cool sensibility," it says–the firm positioned a delicate, geometrically symmetrical lotus flower line drawing as the central design package element, with each tea flavor distinguished by its own color scheme. "This icon seems to radiate energy and vitality, embodying the holistic sensibility of the brand," Wallace Church explains. "The refreshed look and feel of the new Steaz Teas identity reinforces the lighthearted, healthy positioning of the brand, making it appealing to both young and old."

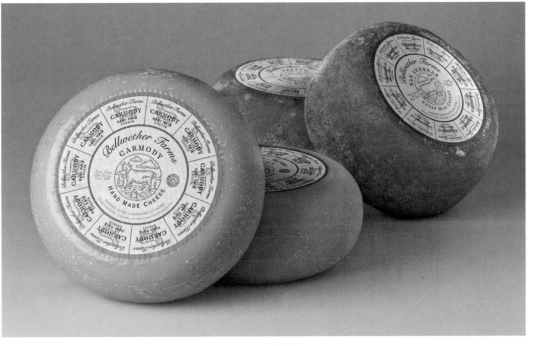

CREATIVE FIRM: MARK OLIVER, INC. – SOLVANG, CA, USA
CREATIVE TEAM: MARK OLIVER – CREATIVE DIRECTOR; PATTY DRISKEL – ART DIRECTOR; SUDI MCCOLLUM – ILLUSTRATOR
CLIENT: BELLWETHER FARM
URL: WWW.MARKOLIVERINC.COM

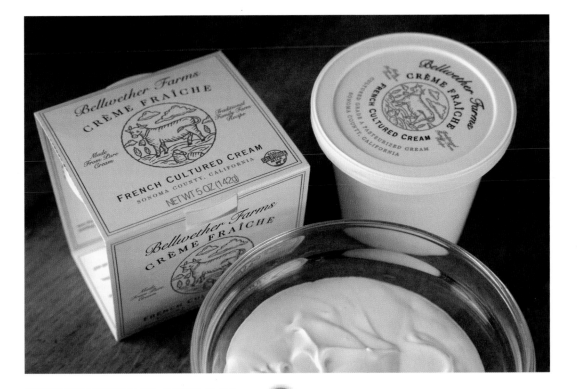

CREATIVE FIRM: MARK OLIVER, INC. – SOLVANG, CA, USA
CREATIVE TEAM: MARK OLIVER – CREATIVE DIRECTOR; PATTY DRISKEL – DESIGNER; SUDI MCCOLLUM – ILLUSTRATOR
CLIENT: BELLWETHER FARM
URL: WWW.MARKOLIVERINC.COM

CREATIVE FIRM: BELIEVE IN LIMITED – EXETER, UK

CREATIVE TEAM: BLAIR THOMSON – CREATIVE DIRECTOR/DESIGNER; PAUL WARREN, TISH ENGLAND – COPYWRITERS

CLIENT: BUCKFAST ORGANIC BAKERY / CLIVES'

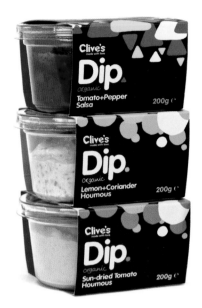

CREATIVE FIRM: BRAND ENGINE – SAUSALITO, CA, USA

CREATIVE TEAM: PAUL VAN DEN BERG – CREATIVE DIRECTOR; CORALIE RUSSO, PAUL VAN DEN BERG – DESIGNERS; MIKE WEPPLO – PHOTOGRAPHIC EDITOR

CLIENT: CHIQUITA

CREATIVE FIRM: STUDIO TWO – LENOX, MA, USA

CREATIVE TEAM: HEATHER ROSE – SENIOR DESIGNER; KEVIN SPRAGUE – CREATIVE DIRECTOR

CLIENT: BARRINGTON COFFEE ROASTING COMPANY

URL: HTTP://WWW.BARRINGTONCOFFEE.COM/

CREATIVE FIRM: SPRING DESIGN PARTNERS, INC. – NEW YORK, NY, USA

CREATIVE TEAM: RON WONG – EXECUTIVE CREATIVE DIRECTOR

CLIENT: BACARDI USA

CREATIVE FIRM: KLIM DESIGN, INC. – AVON, CT, USA

CREATIVE TEAM: MATT KLIM, MARCUS KLIM – ART DIRECTORS; PETER KLIMKIEWICZ – GRAPHIC DESIGNER; GREG KLIM – PHOTOGRAPHER

CLIENT: CASA CUERVO SA DE CV

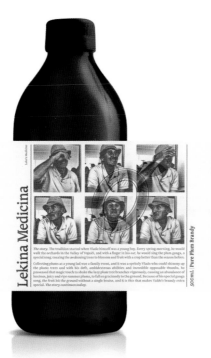

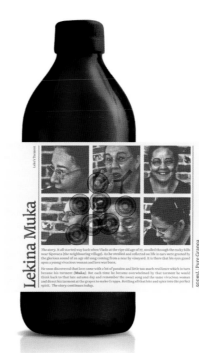

CREATIVE FIRM: GRAIN CREATIVE CONSULTANTS – SURRY HILLS, NSW, AUSTRALIA

CREATIVE TEAM: JURE LEKO – CREATIVE DIRECTOR/DESIGNER/PHOTOGRAPHER

CLIENT: LEKO'S SPIRITS

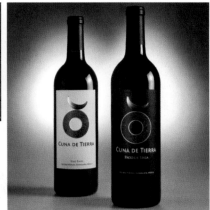

CREATIVE FIRM: SIGNI – MEXICO
CREATIVE TEAM: DANIEL CASTELAO – ART DIRECTOR; PABLO GARCIA – DESIGNER
CLIENT: CUNA DE TIERRA

CREATIVE FIRM: MARK OLIVER, INC. – SOLVANG, CA, USA
CREATIVE TEAM: MARK OLIVER – CREATIVE DIRECTOR; PATTY DRISKEL – ART DIRECTOR; DEBORAH DENKER – PHOTOGRAPHER; CLAIRE STANCER – FOOD STYLIST
CLIENT: ORC FOODS
URL: WWW.MARKOLIVERINC.COM

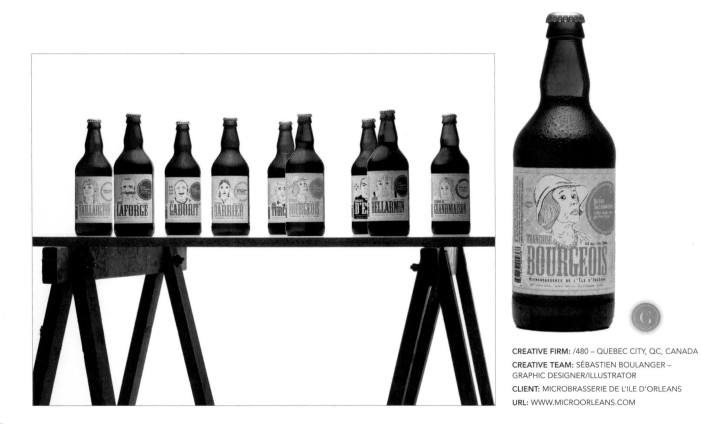

CREATIVE FIRM: /480 – QUEBEC CITY, QC, CANADA
CREATIVE TEAM: SÉBASTIEN BOULANGER – GRAPHIC DESIGNER/ILLUSTRATOR
CLIENT: MICROBRASSERIE DE L'ILE D'ORLEANS
URL: WWW.MICROORLEANS.COM

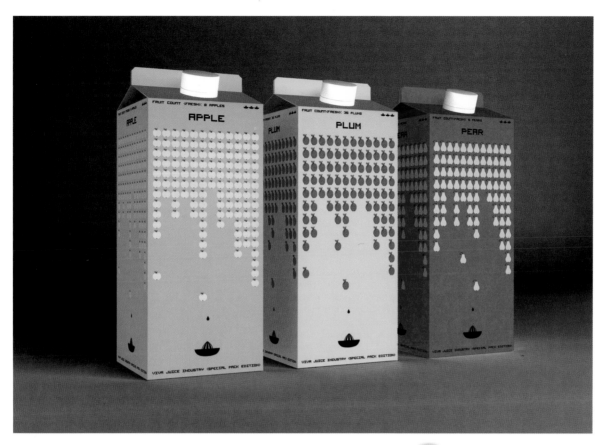

CREATIVE FIRM: NEW MOMENT NEW IDEAS COMPANY – SKOPJE, MACEDONIA
CREATIVE TEAM: DUSAN DRAKALSKI – CREATIVE DIRECTOR; NIKOLA VOJNOV – ART DIRECTOR/DESIGNER
CLIENT: VIVAKS

CREATIVE FIRM: SPRING DESIGN PARTNERS, INC. – NEW YORK, NY, USA
CREATIVE TEAM: RON WONG – EXECUTIVE CREATIVE DIRECTOR
CLIENT: MOLSON COORS CANADA

CREATIVE FIRM: CBX – NEW YORK, NY, USA
CLIENT: DUANE READE

CREATIVE FIRM: MARK OLIVER, INC. – SOLVANG, CA, USA

CREATIVE TEAM: MARK OLIVER – CREATIVE DIRECTOR; PATTY DRISKEL – DESIGNER; JOHN BURNS – LETTERING

CLIENT: GAYTAN FOOD

URL: WWW.MARKOLIVERINC.COM

CREATIVE FIRM: SPRING DESIGN PARTNERS, INC. – NEW YORK, NY, USA

CREATIVE TEAM: RON WONG – EXECUTIVE CREATIVE DIRECTOR

CLIENT: BARSOL PISCO

CREATIVE FIRM: FACTOR TRES BRANDING & STRATEGIC DESIGN – MEXICO

CREATIVE TEAM: RODRIGO CORDOVA – CREATIVE DIRECTOR; SERGIO ENRIQUEZ – ILLUSTRATOR; ANGEL GONZALEZ – DESIGN DIRECTOR; MALENA GUTIERREZ – ACCOUNT DIRECTOR

CLIENT: BIOSFUERZO

CREATIVE FIRM: CBX – NEW YORK, NY, USA

CLIENT: DUANE READE

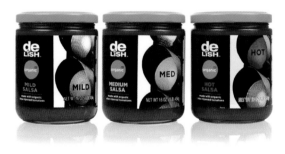

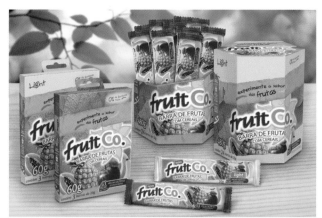

CREATIVE FIRM: SPICE DESIGN – SAO PAULO, BRAZIL

CREATIVE TEAM: GABRIELA TISCHER – DESIGN DIRECTOR; DANIELLA LIMA – ACCOUNT DIRECTOR; JOEL BENTO – DESIGNER

CLIENT: VALE DO RIO PARDO

CREATIVE FIRM: CBX – NEW YORK, NY, USA

CLIENT: DUANE READE

CREATIVE FIRM: DESIGN RESOURCE CENTER (DRC) – NAPERVILLE, IL, USA

CREATIVE TEAM: DON DZIELINSKI – CREATIVE DIRECTOR; TRACI MILNER – SENIOR DESIGNER

CLIENT: ALDI, INC.

CREATIVE FIRM: MIYA GRAPHIX – TOKYO, JAPAN

CREATIVE TEAM: MANABU MIYA – ART DIRECTION & DESIGN

CLIENT: LOTTE CO., LTD

CREATIVE FIRM: CBX – NEW YORK, NY, USA

CLIENT: DUANE READE

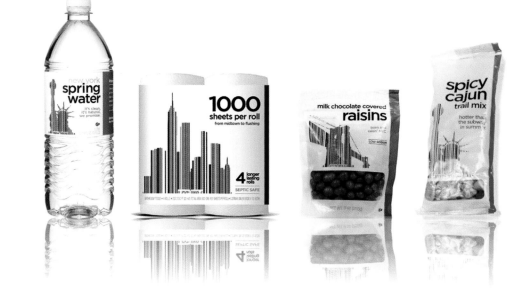

CREATIVE FIRM: DESIGN RESOURCE CENTER (DRC) – NAPERVILLE, IL, USA

CREATIVE TEAM: DON DZIELINSKI – CREATIVE DIRECTOR; GARY ROSE – SENIOR DESIGNER

CLIENT: ALDI, INC.

CREATIVE FIRM: LEWIS MOBERLY – LONDON, UK

CREATIVE TEAM: MARY LEWIS – CREATIVE DIRECTOR; JOANNE SMITH, MARK STUBBINGTON – DESIGNERS

CLIENT: KONIKS TAIL

URL: HTTP://WWW.KONIKSTAIL.COM

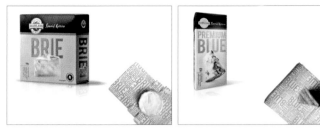

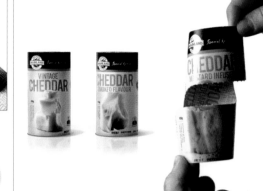

CREATIVE FIRM: GRAIN CREATIVE CONSULTANTS – SURRY HILLS, NSW, AUSTRALIA

CREATIVE TEAM: JURE LEKO – CREATIVE DIRECTOR; JEREMY TOMBS – SENIOR DESIGNER; STEVEN POPOVICH – PHOTOGRAPHER/RETOUCHING

CLIENT: FONTERRA

CREATIVE FIRM: SPRING DESIGN PARTNERS, INC. – NEW YORK, NY, USA

CREATIVE TEAM: RON WONG – EXECUTIVE CREATIVE DIRECTOR

CLIENT: MOLSON COORS CANADA

CREATIVE FIRM: CBX – NEW YORK, NY, USA

CLIENT: DUANE READE

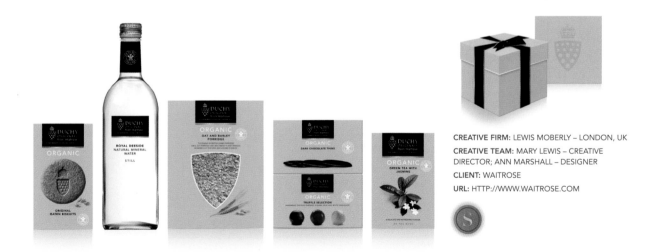

CREATIVE FIRM: LEWIS MOBERLY – LONDON, UK

CREATIVE TEAM: MARY LEWIS – CREATIVE DIRECTOR; ANN MARSHALL – DESIGNER

CLIENT: WAITROSE

URL: HTTP://WWW.WAITROSE.COM

CREATIVE FIRM: ZUNDA GROUP, LLC – SOUTH NORWALK, CT, USA

CREATIVE TEAM: CHARLES ZUNDA – CREATIVE DIRECTOR/PRINCIPAL; TODD NICKEL – ART DIRECTOR/SENIOR DESIGNER; CAROLYN TAYLOR – PHOTOGRAPHER

CLIENT: BIMBO BAKERIES USA

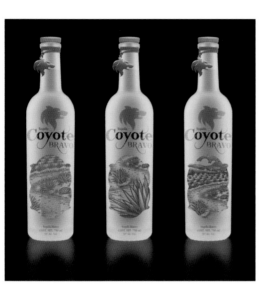

CREATIVE FIRM: FACTOR TRES BRANDING & STRATEGIC DESIGN – MEXICO

CREATIVE TEAM: RODRIGO CORDOVA – CREATIVE DIRECTOR; ANGEL GONZALEZ – DESIGN DIRECTOR; SERGIO ENRIQUEZ – ILLUSTRATOR; MALENA GUTIERREZ – ACCOUNT DIRECTOR

CLIENT: TEQUILA COYOTE

CREATIVE FIRM: DEUTSCH DESIGN WORKS – SAN FRANCISCO, CA, USA

CREATIVE TEAM: JESS GIAMBRONI – DESIGNER

CLIENT: INFINIUM SPIRITS

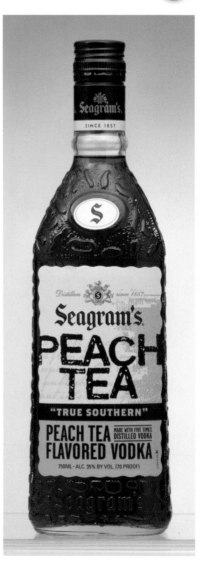

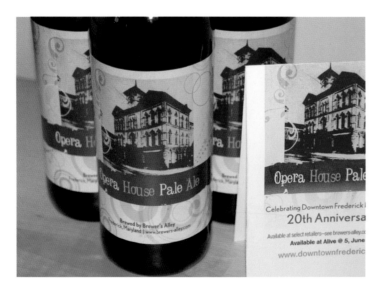

CREATIVE FIRM: KALICO DESIGN – FREDERICK, MD, USA

CREATIVE TEAM: KIMBERLY DOW – ART DIRECTOR/DESIGNER; KARA NORMAN – PROJECT MANAGER

CLIENT: DOWNTOWN FREDERICK PARTNERSHIP

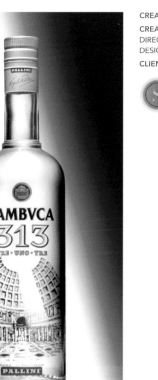

CREATIVE FIRM: KLIM DESIGN, INC. – AVON, CT, USA
CREATIVE TEAM: MATT KLIM, MARCUS KLIM – ART DIRECTORS; PETER KLIMKIEWICZ – GRAPHIC DESIGNER; GREG KLIM – PHOTOGRAPHER
CLIENT: PALLINI

CREATIVE FIRM: PUIGFALCO – BARCELONA, SPAIN
CLIENT: COMERCIAL MASOLIVER

CREATIVE FIRM: BELIEVE IN LIMITED – EXETER, UK
CREATIVE TEAM: BLAIR THOMSON – CREATIVE DIRECTOR/DESIGNER; TISH ENGLAND – COPYWRITER
CLIENT: SCHMOO

CREATIVE FIRM: LITTLE BIG BRANDS – NYACK, NY, USA

CREATIVE TEAM: JOHN NUNZIATO – CREATIVE DIRECTOR, LITTLE BIG BRANDS; LAURA GOLBEN – DESIGNER, LITTLE BIG BRANDS; BEN LEWIS – CEO, PURBLU BEVERAGES, INC.

CLIENT: PURBLU BEVERAGES, INC.

CREATIVE FIRM: DEUTSCH DESIGN WORKS – SAN FRANCISCO, CA, USA

CREATIVE TEAM: BARRY DEUTSCH – ART DIRECTOR; HARUMI KUBO, DIDEM CARIS-SIMO – DESIGNERS; HARUMI KUBO – ILLUSTRATOR

CLIENT: HANSEN'S BEVERAGE COMPANY

CREATIVE FIRM: DESIGN RESOURCE CENTER (DRC) – NAPERVILLE, IL, USA

CREATIVE TEAM: DON DZIELINSKI – CREATIVE DIRECTOR; TRACI MILNER – SENIOR DESIGNER

CLIENT: ALDI, INC.

CREATIVE FIRM: STERLING BRANDS – NEW YORK, NY, USA

CREATIVE TEAM: SIMON LINCE – ART DIRECTOR; DAVE CARLINO – DESIGNER; NOEL BARNHURST – PHOTOGRAPHER

CLIENT: NESTLÉ

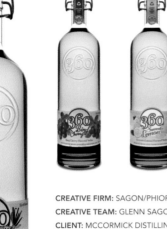

CREATIVE FIRM: SAGON/PHIOR – LOS ANGELES, CA, USA

CREATIVE TEAM: GLENN SAGON – CREATIVE DIRECTOR; PATRICK FEE – CO–CREATIVE DIRECTOR

CLIENT: MCCORMICK DISTILLING

CREATIVE FIRM: KLIM DESIGN, INC. – AVON, CT, USA

CREATIVE TEAM: MATT KLIM, MARCUS KLIM – ART DIRECTORS; PETER KLIMKIEWICZ – GRAPHIC DESIGNER; GREG KLIM – PHOTOGRAPHER

CLIENT: PALLINI

CREATIVE FIRM: STERLING BRANDS – NEW YORK, NY, USA

CREATIVE TEAM: SIMON LINCE – ART DIRECTOR; STEPHANIE KROMPIER – DESIGNER; CHRIS VINCENT, BRENT TAYLOR – PHOTOGRAPHERS

CLIENT: GREGORY'S BOX'D BEVERAGES

CREATIVE FIRM: ZUNDA GROUP, LLC – SOUTH NORWALK, CT, USA

CREATIVE TEAM: CHARLES ZUNDA – CREATIVE DIRECTOR/PRINCI-PAL; MAIJA RIEKSTINS–RUTENS – SENIOR DESIGNER

CLIENT: NEWMAN'S OWN, INC.

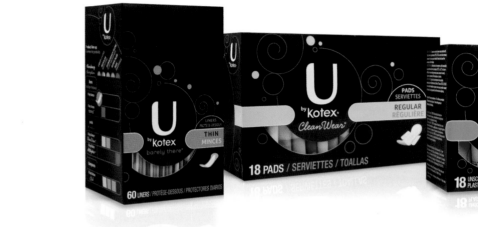

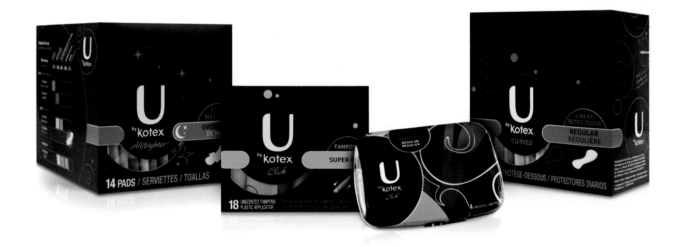

PLATINUM

U BY KOTEX

CREATIVE FIRM: CBX – NEW YORK, NY, USA
CLIENT: KIMBERLY CLARK

Personal feminine hygiene products have come a long way since the days of the belt and pad–or, before then, the reusable cloth of our grandmothers' generation. According to New York branding agency CBX, Kotex, the pioneer of disposable pads, wanted to "reinvent the feminine hygiene category" and create a brand that would appeal to millennial women. "Speak to them with honesty, in a voice like their own: irreverent, optimistic, and self–assured," the firm says.

CBX knew that packaging was just one, yet key, way to convey the "brand promise" of U by Kotex–truth and transparency (an honest and open approach to vaginal care), self–expression (choice in color and design), and confidence and feminine strength (packaging to reflect the consumers' values). "The biggest challenge was narrowing down the amazing creative options," the agency says. "Seriously!" Kotex' owner, Kimberly–Clark, played an active role in directing the process, but one thing was for certain: regardless of the particular product variety, everyone loved the black packaging.

"There are so many levels of choices to be made in the feminine hygiene category,"

CBX says. In the end, the packaging came back to the original brand promise, with multicolored wrappers discreetly concealing the product ("They look like candy wrappers in your purse or backpack, not tampons"), a bold and confident black box ("Your boyfriend wouldn't know what's inside the pack if it's sitting on your bathroom counter"), a contrast of matte and high–gloss varnish to suggest a high–end commodity, and a stylized new brandmark that's bold, lightweight, and contemporary all at the same time–"all needed to feel fashion forward and youthful," says the agency.

CREATIVE FIRM: MARC ATLAN DESIGN, INC. – VENICE, CA, USA

CREATIVE TEAM: MARC ATLAN – CREATIVE DIRECTOR

CLIENT: KJAER WEIS

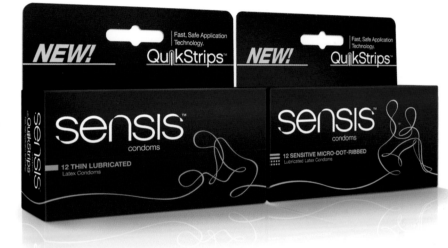

CREATIVE FIRM: SPRING DESIGN PARTNERS, INC. – NEW YORK, NY, USA

CREATIVE TEAM: RON WONG – EXECUTIVE CREATIVE DIRECTOR

CLIENT: GROVE MEDICAL

CREATIVE FIRM: CASA REX – SAO PAULO, BRAZIL

CREATIVE TEAM: GUSTAVO PIQUEIRA – CREATIVE DIRECTOR/DESIGN; LUIZ SANCHES, SAMIA JACINTHO – DESIGN; LILIAN MEIRELES – ASSISTANT DESIGNER

CLIENT: UNILEVER

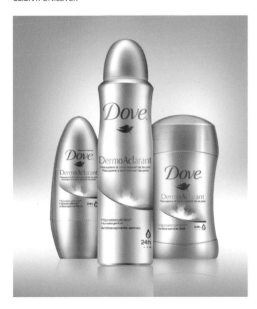

CREATIVE FIRM: CASA REX – SAO PAULO, BRAZIL

CREATIVE TEAM: GUSTAVO PIQUEIRA – CREATIVE DIRECTOR/DESIGN; INGRID LAFALCE – DESIGN; DANILO HELVADJIAN, LEONARDO RODRIGUES, LILIAN MEIRELES – ASSISTANT DESIGNERS

CLIENT: UNILEVER ARGENTINA

 PLATINUM

TULIPS

CREATIVE FIRM: SALTPEPPER BRAND DESIGN S.C. –
WARSZAWA, POLAND
CREATIVE TEAM: ALEKSANDER KOCZY – CREATIVE
DIRECTOR
CLIENT: TIKKURILA POLSKA S.A

Paint is all about reinvention. Naturally, even a paint line—especially a paint line—would want to rethink its image from time to time, and to do so, Tikkurila looked to SaltPepper Brand Design to redesign its entire product line package, including streamlining its look and integrating a new logo of the Optiva subbrand.

"We were asked not to use photos," says creative director Aleksander Koczy. Instead, the agency created a new, upscale premium identity to the line by creating the illusion of photographs of flowers that actually were images of brushes dipped in paint. Each paint variety—matte, satin, etc.—sports a different color of "flower" against a black satin background. The stunning labels convey a sense of exclusivity, while inspiring the consumer, perhaps, to be a bit more creative than he or she may have expected.

CREATIVE FIRM: LEWIS MOBERLY – LONDON, UK
CREATIVE TEAM: MARY LEWIS – CREATIVE DIRECTOR
CLIENT: THE KIDS COOKING COMPANY

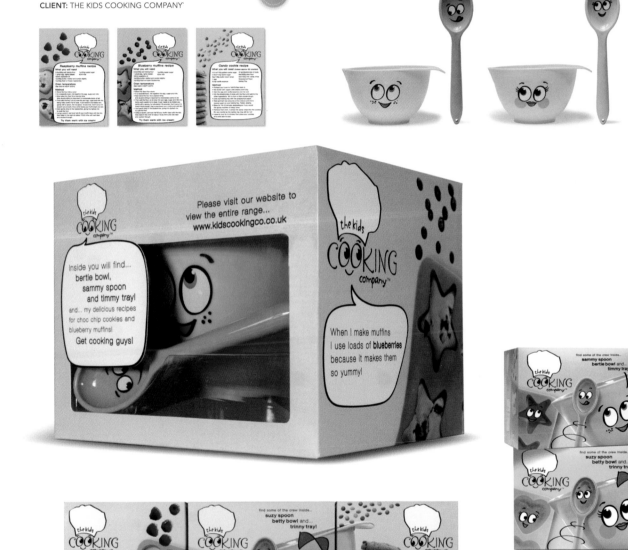

CREATIVE FIRM: ZUAN CLUB – TOKYO, JAPAN

CREATIVE TEAM: AKIHIKO TSUKAMOTO – DESIGN/ART DIRECTION; RADICAL SUZUKI – ILLUSTRATION

CLIENT: SEA ROAD INTERNATIONAL CORPORATION

CREATIVE FIRM: REPUTATION – COPENHAGEN, DENMARK

CREATIVE TEAM: CARSTEN LOLAND – CREATIVE DIRECTOR; LOTTE HEIRING – ART DIRECTOR

CLIENT: PHARMACOSMOS

PLATINUM

CREATIVE FIRM: SHERIFF DESIGN – ELKINS PARK, PA, USA
CREATIVE TEAM: PAUL SHERIFF – ART DIRECTOR; GREG PUGLESE – DESIGNER
CLIENT: MARSHA BROWN

MARSHA BROWN MENU

There's a taste of the Big Easy right in New Hope, Pennsylvania, halfway between Philadelphia and New York City: Marsha Brown New Orleans Restaurant—and designer Paul Sheriff had to present the flavor of the experience before diners even took their first bite. "I knew after meeting the owner, Marsha Brown, that the design challenge to establish a unique identity for this incredibly eclectic, tastefully designed upscale restaurant was a perfect fit for my boutique design studio," the owner of Sheriff Design says. Partnering with fabric designers in New York City, a Bay Area wallpaper company, and an online supplier of unique book corners, Sheriff created a menu that reflected his client's sense of whimsical style. Even the menu involved specialty finishing, as Sheriff and Brown employed an artisanal bookbinding shop in Philadelphia to put it all together. While trying to fit the entire menu onto one page initially appeared to be a challenge, says Sheriff, it "actually worked in favor of our design aesthetics, allowing us to be more sensitive with the use of typography....The multitude of fonts mimics the mood of this nontraditional Creole restaurant and reflects the restrained chaos and excitement of the restaurant."

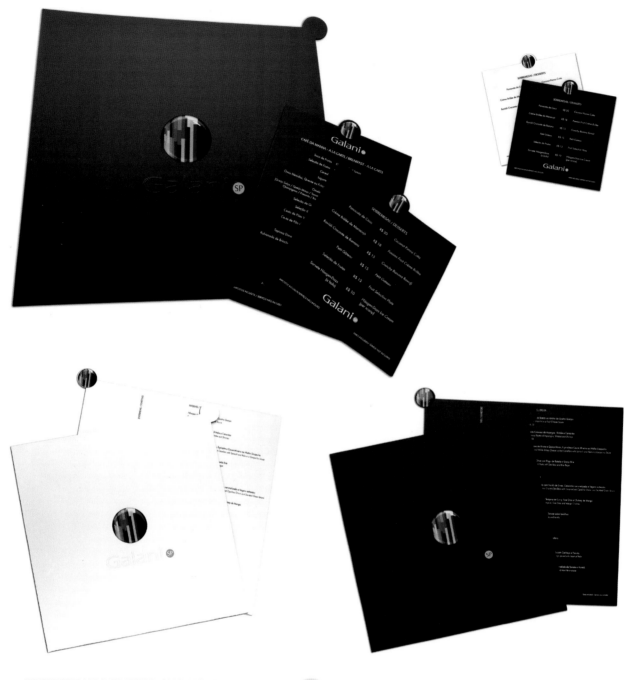

CREATIVE FIRM: MERCHAN–DESIGN – SAO PAULO, BRAZIL
CREATIVE TEAM: MARCELO LOPES – DESIGNER/DESIGNER DIRECTOR
CLIENT: POSADAS DO BRASIL
URL: CAESAR–PARK.COM

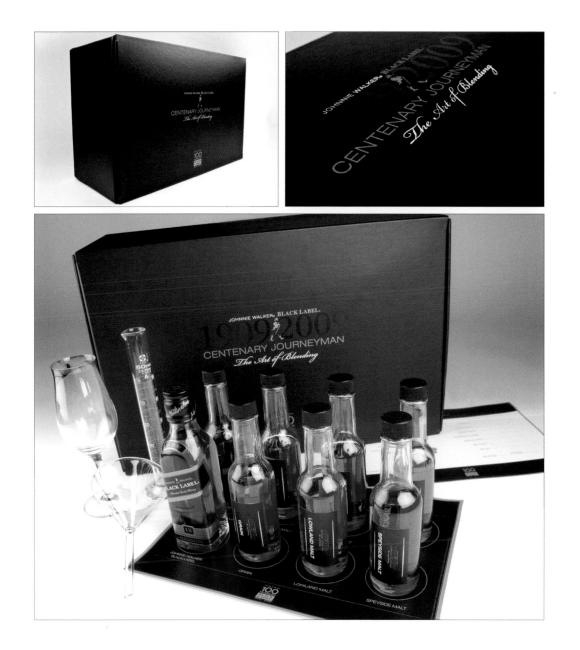

PLATINUM

CREATIVE FIRM: HUNTER PUBLIC RELATIONS – NEW YORK, NY, USA

CREATIVE TEAM: LOUISA CARAGAN – CREATIVE DIRECTOR/DESIGNER

CLIENT: DIAGEO NORTH AMERICA

Johnnie Walker Black Label is the most popular super–premium blended Scotch whisky in the world, and for its 100th anniversary, not just a toast would be enough. New York's Hunter Public Relations sought to illustrate the brand's century–long journey from a grocer's blend to a symbol of excellence, using the brand's hallmark, "The Art of Blending."

JOHNNIE WALKER BLACK LABEL BLENDING KIT

To celebrate this art–and encourage creative mixology in Johnnie Walker drinkers–creative designer Louisa Caragan conceived at–home blending kits for influential spirits writers and bloggers across the country. To go with the kits, Hunter presented a live webcast created to bring the Blending Room to viewers' desktops with nosing, tasting, and blending exercises and a live Q&A with the Master Blender. The kits–which included one bottle of Johnnie Walker Black, seven bottles containing whiskies representing each source region, one

snifter, one measuring device, one funnel, one empty sample bottle for storing the recipient's own blend, a tasting map, a map of the whisky regions of Scotland, and a USB drive with anniversary press materials–presented its own challenges. According to Caragan, the box had to be "compact while sturdy enough to include all of the items needed for the blending exercises." As a finishing touch, she created a new logo derived from three existing brand logos especially for the blending kit to extend the theme of blending while maintaining brand equity.

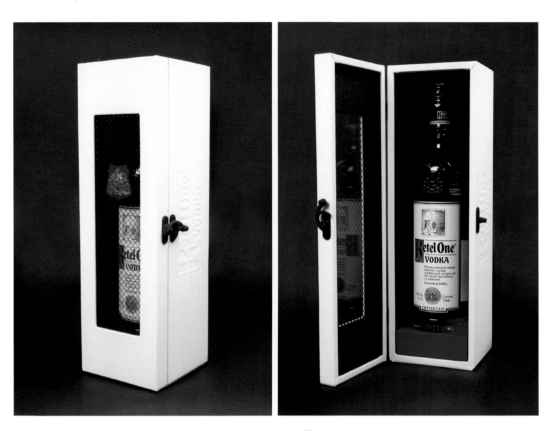

CREATIVE FIRM: HUNTER PUBLIC RELATIONS – NEW YORK, NY, USA
CREATIVE TEAM: LOUISA CARAGAN – CREATIVE DIRECTOR/DESIGNER
CLIENT: DIAGEO NORTH AMERICA

CREATIVE FIRM: HBO – NEW YORK, NY, USA
CREATIVE TEAM: ARDELLA WILSON – ASSOCIATE PROJECT MANAGER; VENUS DEN-NISON – CREATIVE DIRECTOR; ANA RACELIS – DESIGN MANAGER; CARLOS TEJEDA, MARY TCHORBAJIAN – ART DIRECTORS; JENNIFER MCDEARMAN – COPYWRITER; RUSSELL SANDIFORD – COPY EDITOR
CLIENT: AFFILIATE MARKETING SALES & PLANNING

CREATIVE FIRM: WALLACE CHURCH, INC. – NEW YORK, NY, USA
CREATIVE TEAM: STAN CHURCH – CREATIVE DIRECTOR; LOU ANTONUCCI – DESIGNER
CLIENT: WALLACE CHURCH, INC
URL: WWW.WALLACECHURCH.COM

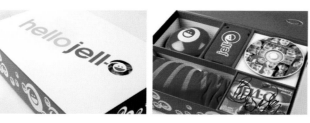

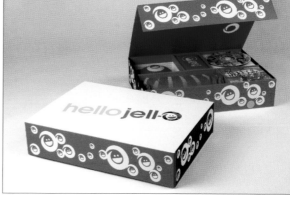

CREATIVE FIRM: HUNTER PUBLIC RELATIONS – NEW YORK, NY, USA
CREATIVE TEAM: LOUISA CARAGAN – CREATIVE DIRECTOR/DESIGNER
CLIENT: KRAFT

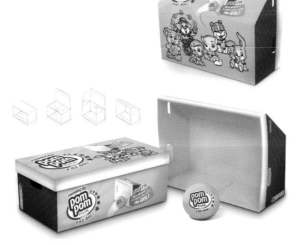

CREATIVE FIRM: WALLACE CHURCH,
INC. – NEW YORK, NY, USA
CREATIVE TEAM: STAN CHURCH –
CREATIVE DIRECTOR; AKIRA YASUDA
– DESIGNER
CLIENT: WALLACE CHURCH, INC
URL: WWW.WALLACECHURCH.COM

CREATIVE FIRM: SPICE DESIGN – SAO PAULO, BRAZIL
CREATIVE TEAM: GABRIELA TISCHER – DESIGN DIRECTOR; DANIELLA LIMA – ACCOUNT
DIRECTOR; BERNARDO BELONI BIZELLI, DENISE FUJITA – DESIGNERS
CLIENT: HYPERMARCAS

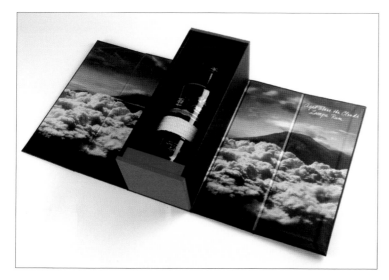

CREATIVE FIRM: HUNTER PUBLIC RELATIONS – NEW YORK, NY, USA
CREATIVE TEAM: LOUISA CARAGAN – CREATIVE DIRECTOR/DESIGNER; LAURA DESILVIO – DESIGNER
CLIENT: DIAGEO NORTH AMERICA

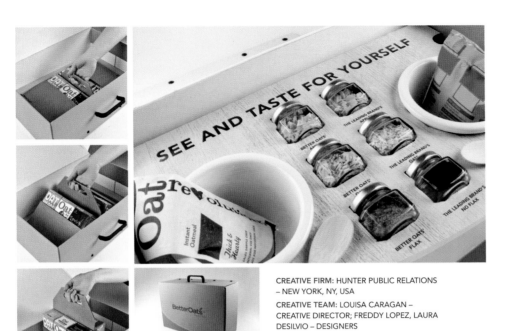

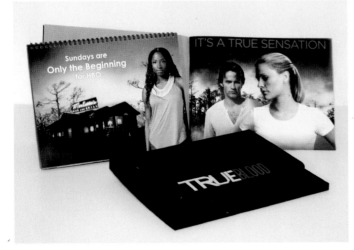

CREATIVE FIRM: HUNTER PUBLIC RELATIONS
– NEW YORK, NY, USA
CREATIVE TEAM: LOUISA CARAGAN –
CREATIVE DIRECTOR; FREDDY LOPEZ, LAURA
DESILVIO – DESIGNERS
CLIENT: RED ENGINE FOODS

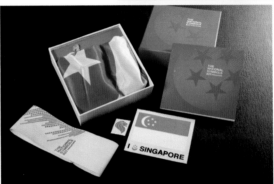

CREATIVE FIRM: SPLASH PRODUCTIONS PTE LTD – SINGAPORE
CREATIVE TEAM: BRICE LI – ART DIRECTOR; SHIJIN LI – DESIGNER; ENTRACO PRINTING PTE LTD – PRINTER
CLIENT: NATIONAL HERITAGE BOARD

CREATIVE FIRM: HBO – NEW YORK, NY, USA
CREATIVE TEAM: HEATHER THOMAS –
PROJECT MANAGER; VENUS DENNISON
– CREATIVE DIRECTOR; ANA RACELIS –
DESIGN MANAGER; CARLOS TEJEDA, MARY
TCHORBAJIAN – ART DIRECTORS; JENNIFER
MCDEARMAN – COPYWRITER; RUSSELL
SANDIFORD – COPY EDITOR
CLIENT: ENTERPRISES

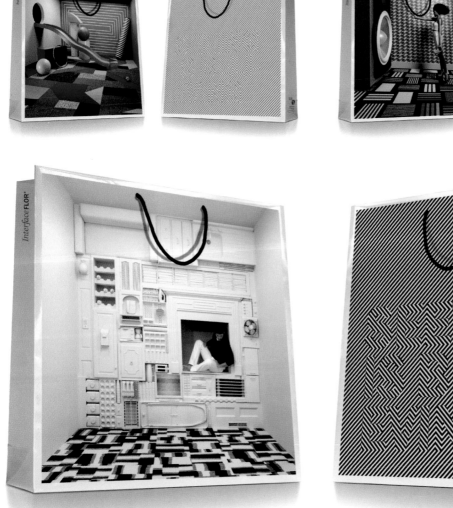

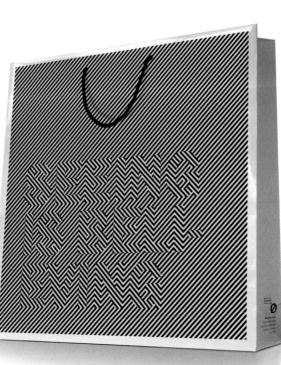

PLATINUM

CREATIVE FIRM: TOTH – CAMBRIDGE, MA, USA

CREATIVE TEAM: ROBERT VALENTINE – CREATIVE DIREC-
TOR; JACK WHITMAN – DESIGNER; MIKE TOTH – CHIEF
CREATIVE OFFICER; GEOF KEARN – PHOTOGRAPHER;
YVONNE BARRIGA – SHOOT PRODUCER

CLIENT: INTERFACEFLOR

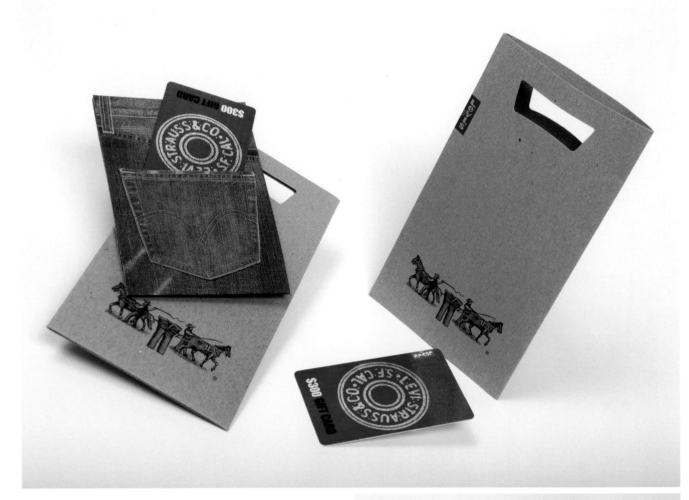

CREATIVE FIRM: SIGNATURE LTD – HONG KONG

CREATIVE TEAM: JOSEPH LUI – CREATIVE DIRECTOR/ART DIRECTOR;
BANANA CHAN – GRAPHIC DESIGNER

CLIENT: LEVI'S

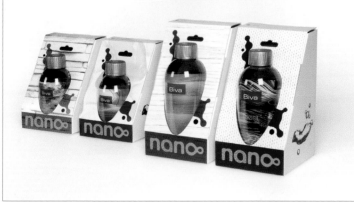

CREATIVE FIRM: MERKUR – NAKLO, SLOVENIA

CREATIVE TEAM: BLAZ BEZEK – BRAND MANAGER; ALJOSA SENK
– CREATIVE/ART DIRECTOR

CLIENT: BIVA

URL: WWW.MERKUR.EU

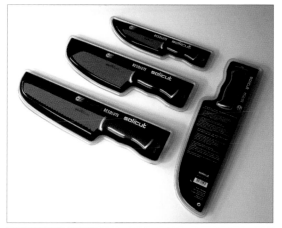

CREATIVE FIRM: COASTLINES CREATIVE GROUP –
VANCOUVER, BC, CANADA

CREATIVE TEAM: BYRON DOWLER – CREATIVE
DIRECTOR; ANGIE LAU – DESIGNER

CLIENT: SUPERFEET WORLDWIDE, INC.

URL: WWW.SUPERFEET.COM

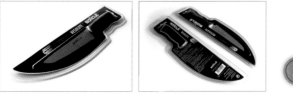

CREATIVE FIRM: IFP DESIGN – HAMBURG, GERMANY

CREATIVE TEAM: JONATHAN SVEN AMELUNG – CREATIVE DIRECTOR;
MATTHIAS RIBBE – MANAGING DIRECTOR

CLIENT: FELIX SOLICUT GMBH

CREATIVE FIRM: ZUNDA GROUP, LLC – SOUTH NORWALK, CT, USA
CREATIVE TEAM: CHARLES ZUNDA – CREATIVE DIRECTOR/PRINCIPAL
CLIENT: GRACO CHILDREN'S PRODUCTS

CREATIVE FIRM: PRIMARY DESIGN, INC. – HAVERHILL, MA, USA
CREATIVE TEAM: ALLISON DAVIS – VP, CREATIVE SERVICES;
JULES EPSTEIN – CREATIVE DIRECTOR; SHARYN ROGERS – CO
CREATIVE DIRECTOR
CLIENT: ARALIA OLIVE OILS

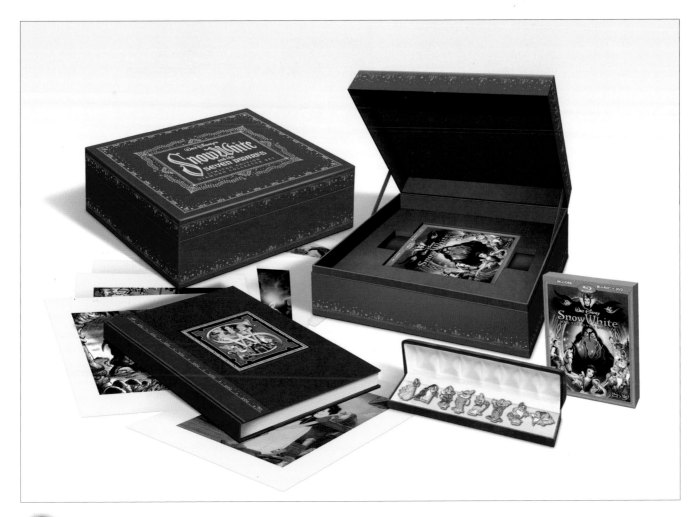

 PLATINUM

CREATIVE FIRM: WALT DISNEY STUDIOS HOME ENTER-
TAINMENT – BURBANK, CA, USA

CREATIVE TEAM: ANDY SIDITSKY – SVP, WW CREATIVE
SERVICES; ANDY ENGEL – ART DIRECTOR; MARK HASSEN –
VP, CREATIVE PRINT PRODUCTION

CLIENT: ANDY SIDITSKY/WALTDISNEYSTUDIOS HOME
ENTERTAINMENT

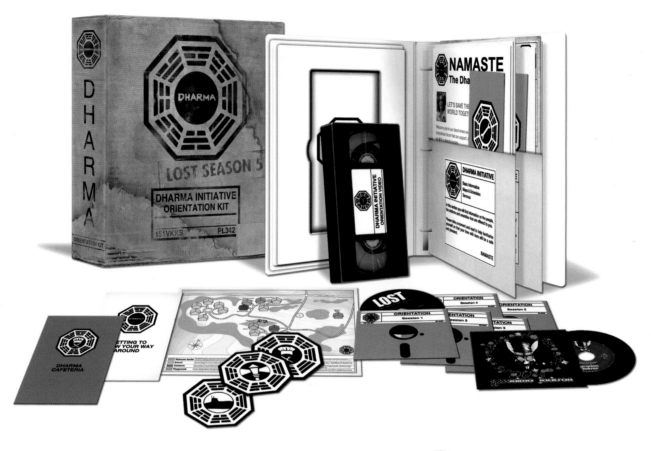

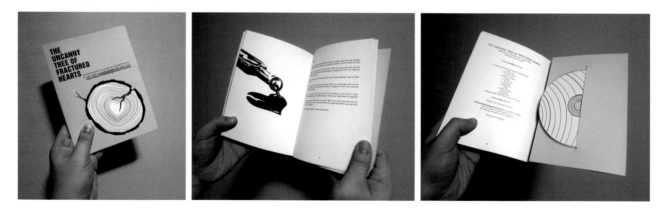

CREATIVE FIRM: WALT DISNEY STUDIOS HOME ENTERTAINMENT – BURBANK, CA, USA
CREATIVE TEAM: ANDY SIDITSKY – SVP, WW CREATIVE SERVICES; MARK HASSEN – VP, PRINT PRODUCTION AGI
CLIENT: ANDY SIDITSKY/WALTDISNEYSTUDIOS HOME ENTERTAINMENT

CREATIVE FIRM: SINGAPORE
CREATIVE TEAM: ZHIWEI XU – COPYWRITER; WEE LING LIM – ART DIRECTOR
CLIENT: ANOTHER SUNDAY AFTERNOON

PUBLICATIONS

PLATINUM

IDENTITY BY STEWART COHEN

CREATIVE FIRM: STEWART COHEN PICTURES – DALLAS, TX, USA
CREATIVE TEAM: STEWART COHEN – PHOTOGRAPHER; TODD HART – DESIGNER
CLIENT: STEWART COHEN

Dallas photographer Stewart Cohen has photographed some of the world's most fascinating personalities, and his book Identity is a large–scale celebration of the resulting images and handwritten notes from his subjects. To create a timeless, contemporary–feeling monograph and encapsulate the work into a printed book, designer Todd Hart strived to keep the design clean and let the photographs and letters from the subjects be the focus. Even when trying to find the right printing partner, he says, "We would often have to refocus to stay true to the original cause." This commitment to unity extended to the typography. "The way we handled the typography of the inside cover was to use the actual letters of the subjects and layered them to set the feel of the book," Hart says. "Conceptually that communicated the book itself, which is a collection of human spirit."

CREATIVE FIRM: GRAND CENTRAL PUBLISHING/HACHETTE BOOK GROUP – NEW YORK, NY, USA
CLIENT: GRAND CENTRAL PUBLISHING

CREATIVE FIRM: CASA REX – SAO PAULO, BRAZIL
CREATIVE TEAM: GUSTAVO PIQUEIRA – CREATIVE DIRECTOR/DESIGN/ILLUSTRATION; SAMIA JACINTHO – DESIGN/ILLUSTRATION
CLIENT: EDIÇÕES JOGO DE AMARELINHA

FRASE & EFEITO

CREATIVE FIRM: CASA REX – SAO PAULO, BRAZIL
CREATIVE TEAM: GUSTAVO PIQUEIRA – CREATIVE DIRECTOR/DESIGN; SAMIA JACINTHO – DESIGN
CLIENT: ATELIÊ EDITORIAL

CREATIVE FIRM: GRAND CENTRAL PUBLISHING/
HACHETTE BOOK GROUP – NEW YORK, NY, USA
CLIENT: GRAND CENTRAL PUBLISHING

CREATIVE FIRM: GRAND CENTRAL PUBLISHING/
HACHETTE BOOK GROUP – NEW YORK, NY, USA
CLIENT: GRAND CENTRAL PUBLISHING

CREATIVE FIRM: MARC ATLAN
DESIGN, INC. – VENICE, CA, USA
CREATIVE TEAM: MARC ATLAN –
CREATIVE DIRECTOR
CLIENT: BARRICADE BOOKS

CREATIVE FIRM: SCOTT ADAMS DESIGN ASSOCIATES – MINNEAPOLIS, MN, USA
CREATIVE TEAM: SCOTT ADAMS – DESIGNER/ILLUSTRATOR; SHAWN PRESLEY –
PROJECT MANAGER
CLIENT: KENYON COLLEGE

CREATIVE FIRM: GRAND CENTRAL PUBLISHING/
HACHETTE BOOK GROUP – NEW YORK, NY, USA
CLIENT: GRAND CENTRAL PUBLISHING

CREATIVE FIRM: GRAND CENTRAL PUBLISHING/
HACHETTE BOOK GROUP – NEW YORK, NY, USA
CLIENT: TWELVE

CREATIVE FIRM: GRAND CENTRAL PUBLISHING/
HACHETTE BOOK GROUP – NEW YORK, NY, USA
CLIENT: TWELVE

CREATIVE FIRM: SPLASH PRODUCTIONS PTE LTD – SINGAPORE

CREATIVE TEAM: STANLEY YAP – ART DIRECTOR; JAT LENG LOW – SENIOR COPYWRITER; ENTRACO PRINTING PTE LTD – PRINTER

CLIENT: TAY BAK CHIANG

CREATIVE FIRM: GRAND CENTRAL PUBLISHING/ HACHETTE BOOK GROUP – NEW YORK, NY, USA

CLIENT: GRAND CENTRAL PUBLISHING

CREATIVE FIRM: GRAND CENTRAL PUBLISHING/ HACHETTE BOOK GROUP – NEW YORK, NY, USA

CLIENT: GRAND CENTRAL PUBLISHING

GRAHAM MOORE

A NOVEL

the *Sherlockian*

CREATIVE FIRM: GRAND CENTRAL PUBLISHING/HACHETTE BOOK GROUP – NEW YORK, NY, USA
CLIENT: TWELVE

Late for School

Steve Martin

Illustrated by **C. F. Payne**

Includes CD with the song "Late for School" performed by Steve Martin

CREATIVE FIRM: GRAND CENTRAL PUBLISHING/HACHETTE BOOK GROUP – NEW YORK, NY, USA
CLIENT: GRAND CENTRAL PUBLISHING

THE DAILY SHOW WITH JON STEWART PRESENTS

EARTH

(THE BOOK)

A Visitor's Guide to the Human Race

CREATIVE FIRM: GRAND CENTRAL PUBLISHING/HACHETTE BOOK GROUP – NEW YORK, NY, USA
CLIENT: GRAND CENTRAL PUBLISHING

THE FUTURE IS

EXXON

PAUL ROBERTS
AUTHOR OF *THE END OF OIL*

CREATIVE FIRM: GRAND CENTRAL PUBLISHING/ HACHETTE BOOK GROUP – NEW YORK, NY, USA
CLIENT: TWELVE

CREATIVE FIRM: GRAND CENTRAL PUBLISHING/
HACHETTE BOOK GROUP – NEW YORK, NY, USA
CLIENT: TWELVE

CREATIVE FIRM: GRAND CENTRAL PUBLISHING/
HACHETTE BOOK GROUP – NEW YORK, NY, USA
CLIENT: TWELVE

CREATIVE FIRM: CASA REX – SAO PAULO, BRAZIL
CREATIVE TEAM: GUSTAVO PIQUEIRA – CREATIVE
DIRECTOR/DESIGN; SAMIA JACINTHO – DESIGN;
CAMILE LEÃO – ASSISTANT DESIGNER
CLIENT: EDITORA EDUSP

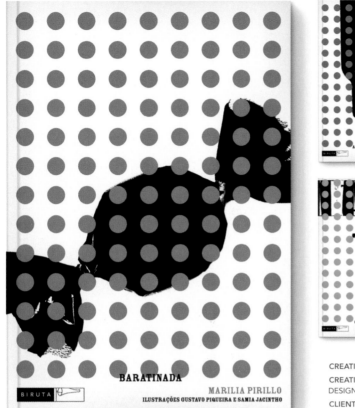

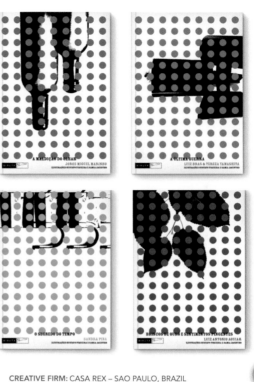

CREATIVE FIRM: CASA REX – SAO PAULO, BRAZIL

CREATIVE TEAM: GUSTAVO PIQUEIRA – CREATIVE DIRECTOR/
DESIGN/ILLUSTRATION; SAMIA JACINTHO – DESIGN/ILLUSTRATION

CLIENT: EDITORA BIRUTA

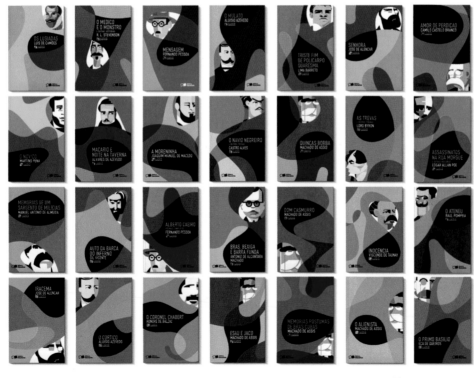

CREATIVE FIRM: CASA REX – SAO PAULO, BRAZIL

CREATIVE TEAM: GUSTAVO PIQUEIRA – CREATIVE DIRECTOR/DESIGN; SAMIA JACINTHO – DESIGN;
CAMILE LEÃO, THAIS GUERRA – ASSISTANT DESIGNERS; CARVALL – ILLUSTRATOR

CLIENT: EDIÇÕES JOGO DE AMARELINHA

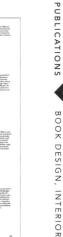

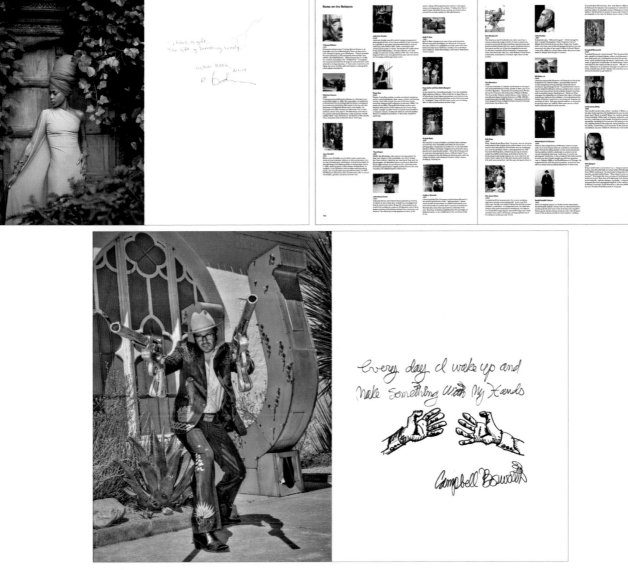

PLATINUM

CREATIVE FIRM: STEWART COHEN PICTURES – DALLAS, TX, USA

CREATIVE TEAM: STEWART COHEN – PHOTOGRAPHER; TODD HART – DESIGNER

CLIENT: STEWART COHEN

IDENTITY BY STEWART COHEN

Dallas photographer Stewart Cohen has photographed some of the world's most fascinating personalities, and his book Identity is a large–scale celebration of the resulting images and handwritten notes from his subjects. To create a timeless, contemporary–feeling monograph and encapsulate the work into a printed book, designer Todd Hart strived to keep the design clean and let the photographs and letters from the subjects be the focus. Even when trying to find the right printing partner, he says, "We would often have to refocus to stay true to the original cause." This commitment to unity extended to the typography. "The way we handled the typography of the inside cover was to use the actual letters of the subjects and layered them to set the feel of the book," Hart says. "Conceptually that communicated the book itself, which is a collection of human spirit."

a story for all ages

change

judith barnes and erick james

illustrated by jeff grader

CREATIVE FIRM: DESIGN FOR A SMALL PLANET – MOUNT HOLLY, NC, USA
CREATIVE TEAM: JUDITH BARNES, ERICK JAMES – AUTHORS; JEFF GRADER – ILLUSTRATOR; MICHAEL CHRISNER – CREATIVE DIRECTOR
CLIENT: JUDITH BARNES AND ERICK JAMES

CREATIVE FIRM: JOAQUIM CHEONG DESIGN – MACAU, CHINA
CREATIVE TEAM: KUOKWAI CHEONG – CREATIVE DIRECTOR/DESIGNER
CLIENT: CULTURAL AFFAIRS BUREAU OF THE MACAO S.A.R. GOVERN

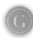

CREATIVE FIRM: JOAQUIM CHEONG DESIGN – MACAU, CHINA
CREATIVE TEAM: KUOKWAI CHEONG – CREATIVE DIRECTOR/DESIGNER
CLIENT: MACAO DESIGNERS ASSOCIATION

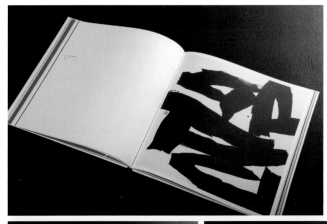

CREATIVE FIRM: SPLASH PRODUCTIONS PTE LTD – SINGAPORE

CREATIVE TEAM: STANLEY YAP – ART DIRECTOR; JAT LENG LOW – SENIOR COPYWRITER; ENTRACO PRINTING PTE LTD – PRINTER

CLIENT: TAY BAK CHIANG

CREATIVE FIRM: FOUNDRY CREATIVE – CALGARY, AB, CANADA

CREATIVE TEAM: ZAHRA ALHARAZI – CREATIVE DIRECTOR; KYLIE HENRY – DESIGNER; RIC KOKOTOVICH – PHOTOGRAPHER

CLIENT: NEWALTA AND RIC KOKOTOVICH

CREATIVE FIRM: MUSEO DE ARTE MODERNO DE MEDELLÍN – MEDELLIN, COLOMBIA

CREATIVE TEAM: JUAN DIEGO RESTREPO – GRAPHIC DESIGNER; OSCAR ROLDÁN–ALZATE – CURATOR

CLIENT: MUSEO DE ARTE MODERNO DE MEDELLÍN

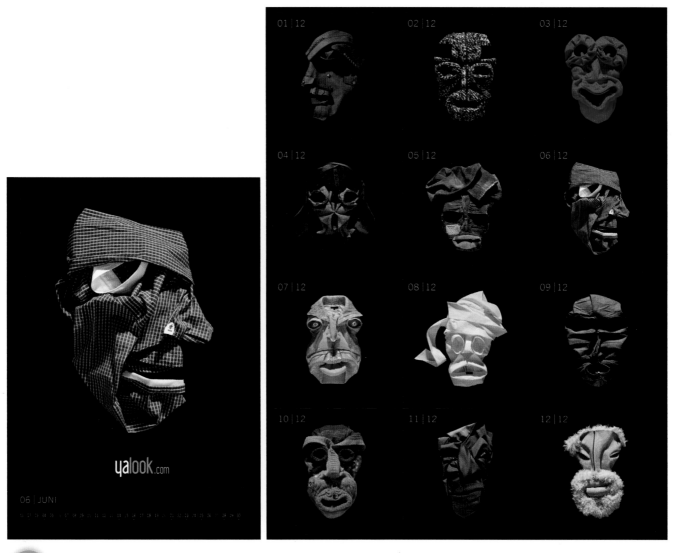

06 | JUNI

FASHION FACES CALENDAR 2010

CREATIVE FIRM: FUTUREBRAND GMBH – HAMBURG, GERMANY

CREATIVE TEAM: GÜNTER SENDLMEIER – CEO/CCO; JONATHAN SVEN AMELUNG – CREATIVE DIRECTOR; JESSICA WATERMANN – ACCOUNT DIRECTOR; BELA BORSODI – PHOTOGRAPHER; HOLGER LENDNER – MANAGING DIRECTOR (YALOOK.COM); JÖRN MIKOWKSY – CHIEF BUYER (YALOOK.COM)

CLIENT: FASHIONWORLD GMBH (A MEMBER OF THE OTTO GROUP)

Whoever coined the phrase "Clothes make the man" never dreamed of such a literal interpretation.

For online fashion retailer Yalook.com's Fashion Faces Calendar 2010, agency FutureBrand GmbH devised a striking look as part of the brand launch. Creative director Jonathan Sven Amelung wanted to show a trendy and fashionable target group that buying fashion online could be an experience on par with an offline advisory service. "The challenge and key objective were to raise awareness and establish Yalook.com as a must–have online fashion shop for people who are looking for personality and character," the Hamburg–based Amelung says. "Fine feathers make fine birds, and clothing emphasizes personality and shows people's character and lifestyle."

Amelung "awakened" the clothing of the collection and made the clothes–not the models–the stars of the campaign, enlisting New York photographer Bela Borsodi to artfully fold pieces from the collection into twelve individual "fashion faces." "The garments were not cut or glued, just folded," says Amelung. The resulting anthropomorphic visages certainly do illustrate character–from a Karl Lagerfeld sport coat twisted into a dapper, jewel–eyed male face to a women's blouse reinterpreted as a cross between Darth Vader and Munch's *The Scream*. As the focus of the company's print ads and calendar, the dozen faces became Yalook.com's signature visual and generated buzz for the fledgling brand. The calendar, in fact, proved so popular that demand exceeded supply–but a lucky thousand customers got their copies in time for the New Year.

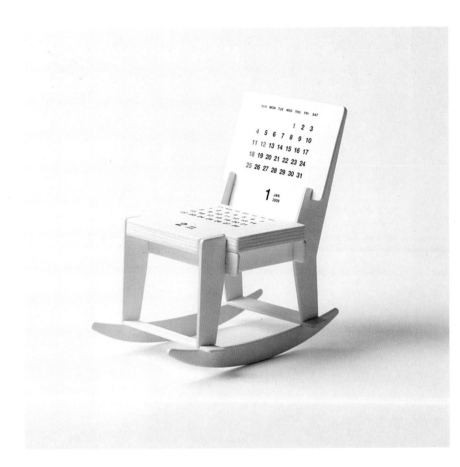

CREATIVE FIRM: GOOD MORNING INC. – TOKYO, JAPAN
CREATIVE TEAM: KATSUMI TAMURA – ART DIRECTOR;
GOOD MORNING INC.
CLIENT: GOOD MORNING INC.
URL: WWW.GOODMORNING.CO.JP

CREATIVE FIRM: SIGNATURE LTD – HONG KONG
CREATIVE TEAM: JOSEPH LUI – CREATIVE
DIRECTOR/ART DIRECTOR; MANDY CHEAH –
GRAPHIC DESIGNER
CLIENT: LEVI'S

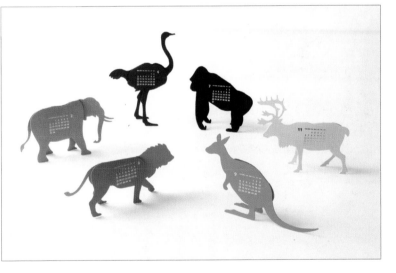

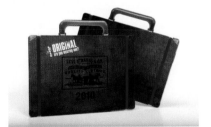

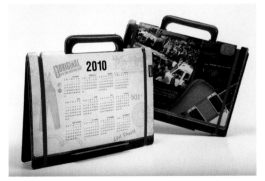

CREATIVE FIRM: GOOD MORNING INC. – TOKYO, JAPAN
CREATIVE TEAM: KATSUMI TAMURA – ART DIRECTOR;
GOOD MORNING INC.
CLIENT: GOOD MORNING INC.
URL: WWW.GOODMORNING.CO.JP

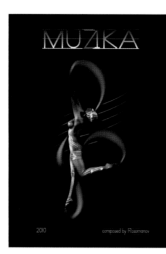

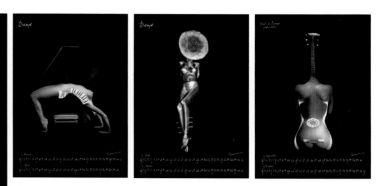

CREATIVE FIRM: BATO & DIVAJN – SKOPJE, MACEDONIA
CREATIVE TEAM: ZORAN ROSOMANOV – COMPLETE AUTHOR
CLIENT: BATO & DIVAJN

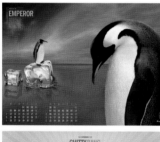

CREATIVE FIRM: GOOD MORNING INC. – TOKYO, JAPAN
CREATIVE TEAM: KATSUMI TAMURA – ART DIRECTOR; GOOD MORNING INC.
CLIENT: GOOD MORNING INC.
URL: WWW.GOODMORNING.CO.JP

CREATIVE FIRM: SPIRIT DESIGNS (P) LTD. –
GURGAON, INDIA
CREATIVE TEAM: RAJEEV GUPTA
– CREATIVE DIRECTOR; RANJANA NARAIN –
COPY DIRECTOR
CLIENT: PRAGATI OFFSET

CREATIVE FIRM: OXYGEN –
MUSCAT, OMAN
CREATIVE TEAM: TEAM OXYGEN
CLIENT: OXYGEN

CREATIVE FIRM: ZUAN CLUB – TOKYO, JAPAN

CREATIVE TEAM: AKIHIKO TSUKAMOTO – DESIGN/ART DIRECTION; MASAMI OUCHI – CREATIVE DIRECTION; HARUMI KIMURA, YUKARI MIYAG – ILLUSTRATION; MASAYUKI MINODA – COPYWRITER

CLIENT: ARJOWIGGINS K.K.

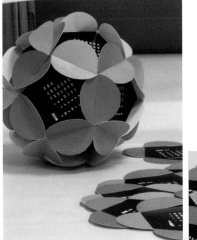

CREATIVE FIRM: DRAFTFCB+ULKA – GURGAON, INDIA

CREATIVE TEAM: SUMIT VASHISTH – SR. VISUALISER; MALVIKA JAIN – COPYWRITER

CLIENT: TATA DOCOMO, GSM MOBILE SERVICE

CREATIVE FIRM: JURCZYK DESIGN – LODZ, POLAND

CREATIVE TEAM: IZABELA JURCZYK – GRAPHIC DESIGNER

CLIENT: ANTALIS POLAND

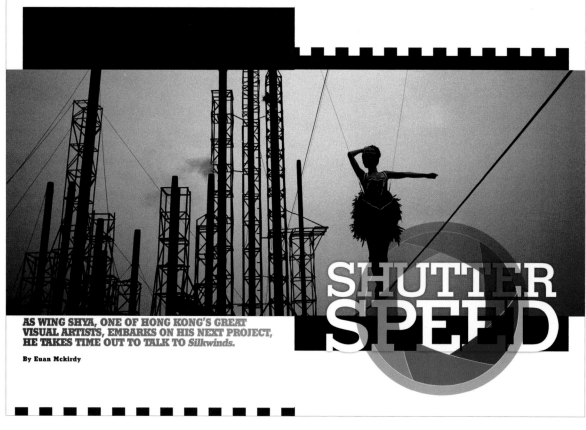

SHUTTER SPEED

AS WING SHYA, ONE OF HONG KONG'S GREAT VISUAL ARTISTS, EMBARKS ON HIS NEXT PROJECT, HE TAKES TIME OUT TO TALK TO *Silkwinds.*

By Euan Mckirdy

CREATIVE FIRM: EMPHASIS MEDIA LIMITED – NORTH POINT, HONG KONG

CREATIVE TEAM: INNES DOIG – EDITORIAL DIRECTOR; PERCY CHUNG – ASSOCIATE CREATIVE DIRECTOR; TERESITA KHAW – ART DIRECTOR; EVA CHAN – PHOTO EDITOR

CLIENT: SILKAIR

CREATIVE FIRM: INCORPORATION LIMITED – HONG KONG

CREATIVE TEAM: LOCKY LAI, MAY LUI – CREATIVE DIRECTORS; WISTER CHEUK – MULTI–MEDIA DESIGNER; CAROL SHIH – SENIOR PROJECT EDITOR; JESSICA YAM – SENIOR EDITOR

CLIENT: INMAGAZINE

CREATIVE FIRM: CINMEDIA CO. LTD. – HONG KONG

CREATIVE TEAM: ANDY TAN – CREATIVE DIRECTOR

CLIENT: CHINA SOUTHERN AIRLINES

CREATIVE FIRM: EMPHASIS MEDIA LIMITED – NORTH POINT, HONG KONG

CREATIVE TEAM: INNES DOIG – EDITORIAL DIRECTOR; PERCY CHUNG – ASSOCIATE CREATIVE DIRECTOR; TERESITA KHAW – ART DIRECTOR; EVA CHAN – PHOTO EDITOR

CLIENT: SILKAIR

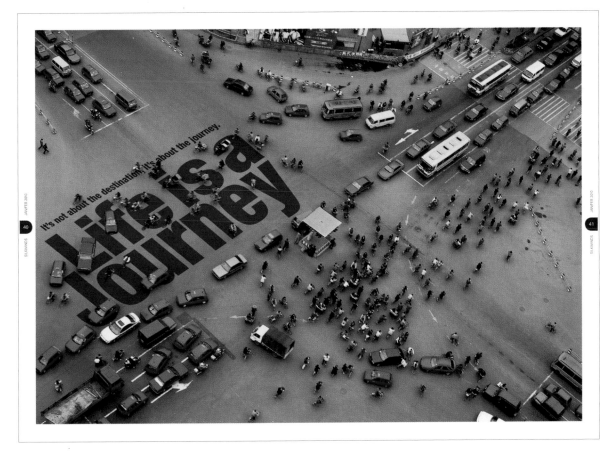

CREATIVE FIRM: EMPHASIS MEDIA LIMITED – NORTH POINT, HONG KONG

CREATIVE TEAM: INNES DOIG – EDITORIAL DIRECTOR; PERCY CHUNG – ASSOCIATE CREATIVE DIRECTOR; TERESITA KHAW – ART DIRECTOR; EVA CHAN – PHOTO EDITOR

CLIENT: SILKAIR

CREATIVE FIRM: INK PUBLISHING – BROOKLYN, NY, USA
CREATIVE TEAM: SHANE LUITJENS – ART DIRECTOR; TIM VIENCKOWSKI, ELSIE ALDAHONDO – GRAPHIC DESIGNERS
CLIENT: AIRTRAN AIRWAYS

CREATIVE FIRM: EMPHASIS MEDIA LIMITED – NORTH POINT, HONG KONG
CREATIVE TEAM: INNES DOIG – EDITORIAL DIRECTOR; PERCY CHUNG – ASSOCIATE CREATIVE DIRECTOR; TERESITA KHAW – ART DIRECTOR; EVA CHAN – PHOTO EDITOR
CLIENT: SILKAIR

CREATIVE FIRM: INK PUBLISHING – BROOKLYN, NY, USA
CREATIVE TEAM: SHANE LUITJENS – ART DIRECTOR; TIM VIENCKOWSKI, ELSIE ALDA-HONDO – GRAPHIC DESIGNERS
CLIENT: AIRTRAN AIRWAYS

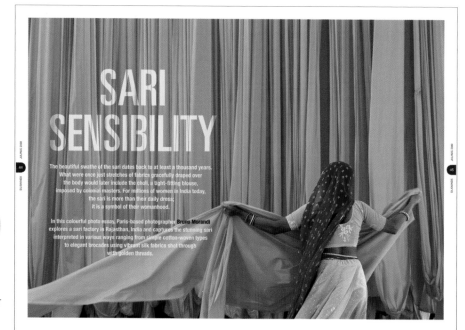

CREATIVE FIRM: EMPHASIS MEDIA LIMITED – NORTH POINT, HONG KONG
CREATIVE TEAM: INNES DOIG – EDITORIAL DIRECTOR; PERCY CHUNG – ASSOCIATE CREATIVE DIRECTOR; TERESITA KHAW – ART DIRECTOR; EVA CHAN – PHOTO EDITOR
CLIENT: SILKAIR

1. Cut out.
2. Place in cap.

Congratulations, Novartis...most admired pharmaceutical company of the year.

TORRE LAZUR McCANN | echo | TORRE LAZUR MANAGED MARKETS

CREATIVE FIRM: TORRE LAZUR MCCANN – PARSIPPANY, NJ, USA

CREATIVE TEAM: CHRISTIAN GORRIE – VP, ASSOCIATE CREATIVE DIRECTOR, ART; LIN BETAN-COURT – VP, GROUP CREATIVE DIRECTOR, COPY; MARCIA GODDARD – EVP, CREATIVE DIRECTOR

CLIENT: NOVARTIS

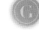

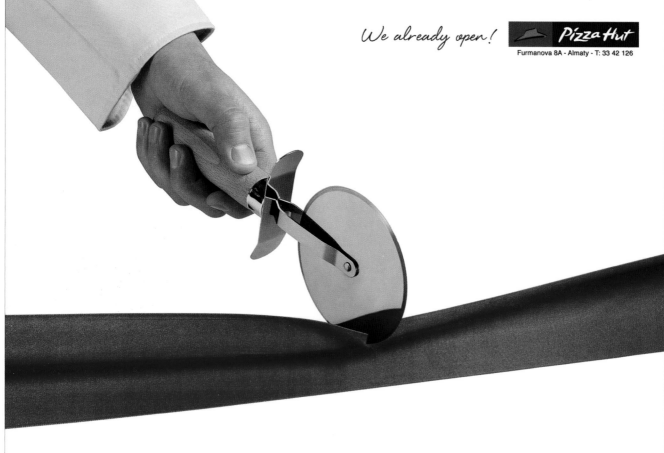

We already open!

PizzaHut

Furmanova 8A - Almaty - T: 33 42 126

CREATIVE FIRM: TBWA\CENTRAL ASIA – ALMATY, KAZAKHSTAN
CREATIVE TEAM: JUAN PABLO VALENCIA – CREATIVE DIRECTOR/COPYWRITER/ART DIRECTOR; JANUSZ MOROZ – NEW BUSINESS DIRECTOR
CLIENT: PIZZA HUT

CREATIVE FIRM: MIRESBALL – SAN DIEGO, CA, USA
CREATIVE TEAM: JOHN BALL – CREATIVE DIRECTOR; BETH FOLKERTH – SENIOR DESIGNER
CLIENT: LUX

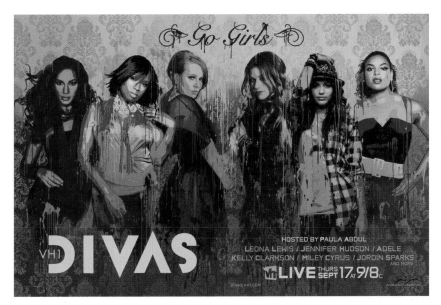

CREATIVE FIRM: MTV NETWORKS – NEW YORK, NY, USA
CREATIVE TEAM: NIGEL COX–HAGAN – EVP CREATIVE & MARKETING; PHIL DELBOURGO – SVP BRAND & DESIGN; JIMMY WENTZ – VP OFF–AIR CREATIVE; ALLISON SIERRA – DIRECTOR PROJECT MANAGEMENT; JULIE RUIZ – ART DIRECTOR; NICOLE MORGESE – WRITER; MAXIMILIAN WIEDEMANN – ILLUSTRATOR
CLIENT: VH1

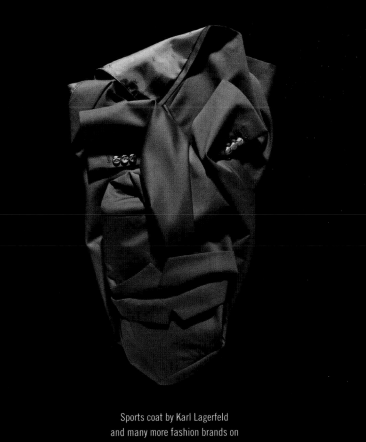

Sports coat by Karl Lagerfeld
and many more fashion brands on

CREATIVE FIRM: FUTUREBRAND GMBH – HAMBURG, GERMANY
CREATIVE TEAM: GÜNTER SENDLMEIER – CEO/CCO; JONATHAN SVEN AMELUNG – CREATIVE DIRECTOR; JESSICA WATERMANN – ACCOUNT DIRECTOR; BELA BORSODI – PHOTOGRAPHER; TRI VU – DESIGNER; HOLGER LENDNER – MANAGING DIRECTOR (YALOOK.COM)
CLIENT: FASHIONWORLD GMBH (A MEMBER OF THE OTTO GROUP)

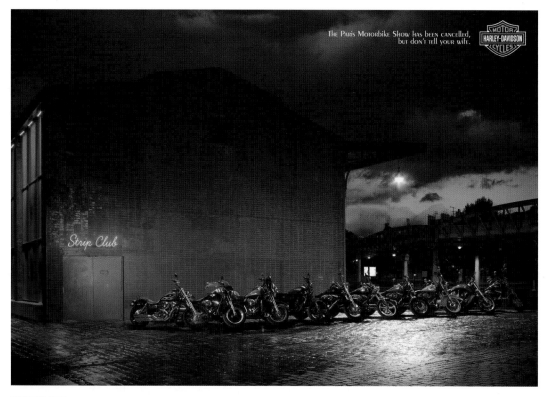

The Paris Motorbike Show has been cancelled, but don't tell your wife.

Strip Club

CREATIVE FIRM: EURO RSCG C&O – PARIS, FRANCE

CREATIVE TEAM: VIRGINIE BERGOUGNOUX – ART BUYING; DENYS VINSON – PHOTOGRAPHER; OLIVIER MOULIERAC, JÉRÔME GALINHA – CREATIVE DIRECTORS; JULIEN SAURIN – ART DIRECTOR; NICOLAS GADESAUDE – COPYWRITER; JEAN–MARC HULEUX – AGENCY ACCOUNT MANAGER; EMANUELLE RONSLIN – AGENCY PRODUCER

CLIENT: HARLEY DAVIDSON

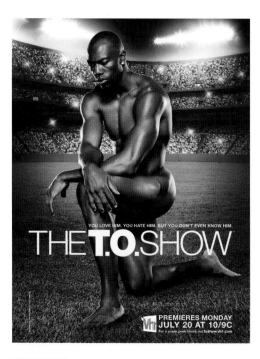

YOU LOVE HIM. YOU HATE HIM. BUT YOU DON'T EVEN KNOW HIM.

THE T.O. SHOW

PREMIERES MONDAY JULY 20 AT 10/9C
For a sneak peek check out toshow.vh1.com

CREATIVE FIRM: MTV NETWORKS – NEW YORK, NY, USA

CREATIVE TEAM: NIGEL COX–HAGAN – EVP CREATIVE & MARKETING; PHIL DELBOURGO – SVP BRAND & DESIGN; TRACI TERRILL – VP EDITORIAL; JIMMY WENTZ – VP OFF–AIR CREATIVE; ALLISON SIERRA – DIRECTOR PROJECT MANAGEMENT; PIOTR SIKORA – PHOTOGRAPHER/DIRECTOR OF PHOTOGRAPHY; JESSE RAKER – DESIGNER; DAN TUCKER – WRITER

CLIENT: VH1

CREATIVE FIRM: MTV NETWORKS – NEW YORK, NY, USA

CREATIVE TEAM: NIGEL COX–HAGAN – EVP CREATIVE & MARKETING; PHIL DELBOURGO – SVP BRAND & DESIGN; TRACI TERRILL – VP EDITORIAL; JIMMY WENTZ – VP OFF–AIR CREATIVE; ALLISON SIERRA – DIRECTOR PROJECT MANAGEMENT; JULIE RUIZ – ART DIRECTOR; JESSE RAKER – DESIGNER; DAN TUCKER – WRITER

CLIENT: VH1

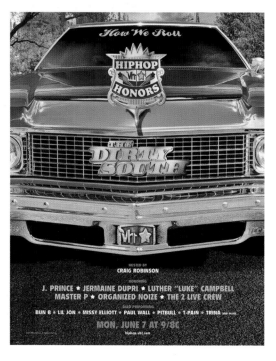

How We Roll

HIPHOP HONORS

THE DIRTY SOUTH

HOSTED BY
CRAIG ROBINSON

HONORING

J. PRINCE ★ JERMAINE DUPRI ★ LUTHER "LUKE" CAMPBELL
MASTER P ★ ORGANIZED NOIZE ★ THE 2 LIVE CREW

ALSO PERFORMING

BUN B ★ LIL JON ★ MISSY ELLIOTT ★ PAUL WALL ★ PITBULL ★ T-PAIN ★ TRINA AND MORE

MON. JUNE 7 AT 9/8C
hiphop.vh1.com

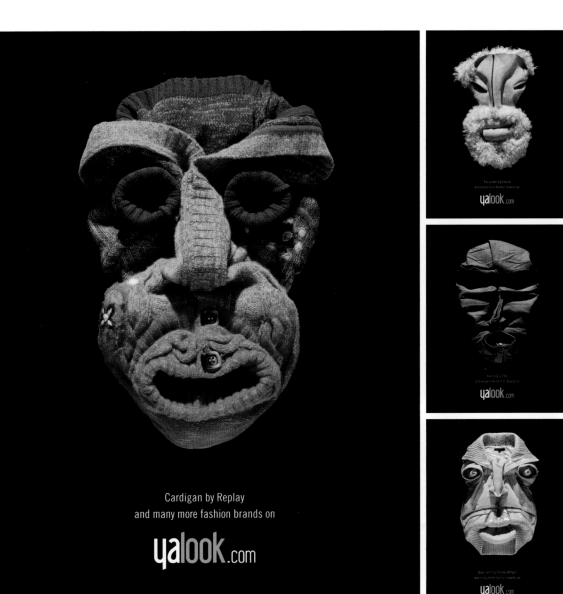

Cardigan by Replay
and many more fashion brands on

yalook.com

(P) PLATINUM

YALOOK.COM – FASHION FACES

CREATIVE FIRM: FUTUREBRAND GMBH – HAMBURG, GERMANY

CREATIVE TEAM: GÜNTER SENDLMEIER – CEO/CCO; JONATHAN SVEN AMELUNG – CREATIVE DIRECTOR; JESSICA WATERMANN – ACCOUNT DIRECTOR; BELA BORSODI – PHOTOGRAPHER; TRI VU – DESIGNER; HOLGER LENDNER – MANAGING DIRECTOR (YALOOK.COM)

CLIENT: FASHIONWORLD GMBH (A MEMBER OF THE OTTO GROUP)

Whoever coined the phrase "Clothes make the man" never dreamed of such a literal interpretation.

For online fashion retailer Yalook.com's Fashion Faces Calendar 2010, agency FutureBrand GmbH devised a striking look as part of the brand launch. Creative director

Jonathan Sven Amelung wanted to show a trendy and fashionable target group that buying fashion online could be an experience on par with an offline advisory service. "The challenge and key objective were to raise awareness and establish Yalook.com as a must–have online fashion shop for people who are looking for personality and character," the Hamburg–based Amelung says. "Fine feathers make fine birds, and clothing emphasizes personality and shows people's character and lifestyle."

Amelung "awakened" the clothing of the collection and made the clothes–not the models–the stars of the campaign, enlisting New York photographer Bela Borsodi

to artfully fold pieces from the collection into twelve individual "fashion faces." "The garments were not cut or glued, just folded," says Amelung. The resulting anthropomorphic visages certainly do illustrate character–from a Karl Lagerfeld sport coat twisted into a dapper, jewel–eyed male face to a women's blouse reinterpreted as a cross between Darth Vader and Munch's *The Scream*. As the focus of the company's print ads and calendar, the dozen faces became Yalook.com's signature visual and generated buzz for the fledgling brand. The calendar, in fact, proved so popular that demand exceeded supply–but a lucky thousand customers got their copies in time for the New Year.

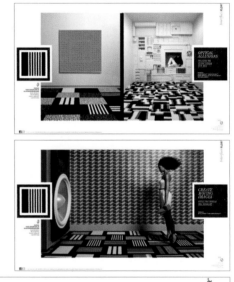

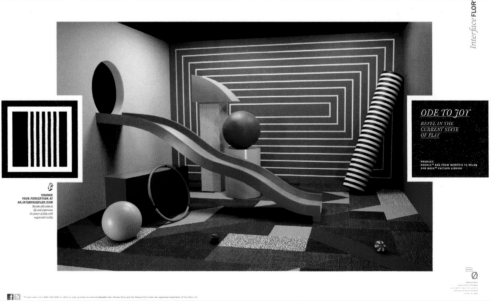

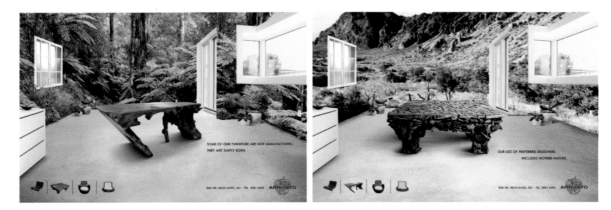

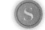

CREATIVE FIRM: CONTEXTO PROPAGANDA LTDA – SAO PAULO, BRAZIL

CREATIVE TEAM: OLAVO ROCHA, RODRIGO MARAGLIANO – CREATIVE DIRECTORS; RAFAEL FERNANDES – COPYWRITER; MARCUS MALTA – ART DIRECTOR

CLIENT: ARRIVATO

CREATIVE FIRM: PLANET ADS AND DESIGN P/L – SINGAPORE

CREATIVE TEAM: HAL SUZUKI – CREATIVE DIRECTOR; SUZANNE LAURIDSEN – SENIOR COPYWRITER; EDWIN ENERO – ART DIRECTOR

CLIENT: FREEMEN PTE LTD

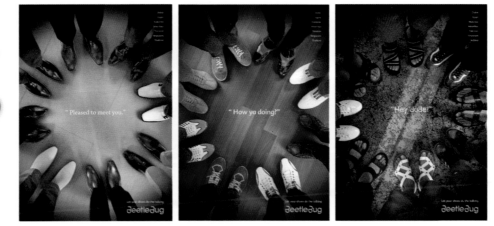

CREATIVE FIRM: Y&R – TORONTO, ON, CANADA

CREATIVE TEAM: CHRIS MCGROARTY – SR. V.P. CREATIVE DIRECTOR; JESSE SENKO, BRYAN KERR – ART DIRECTORS; MICHAEL TUNG – WRITER; CLAY STANG – PHOTOGRAPHER; PAOLO RIZZO – ILLUSTRATOR; STEVEN COOMBER – DESIGNER

CLIENT: FORD OF CANADA

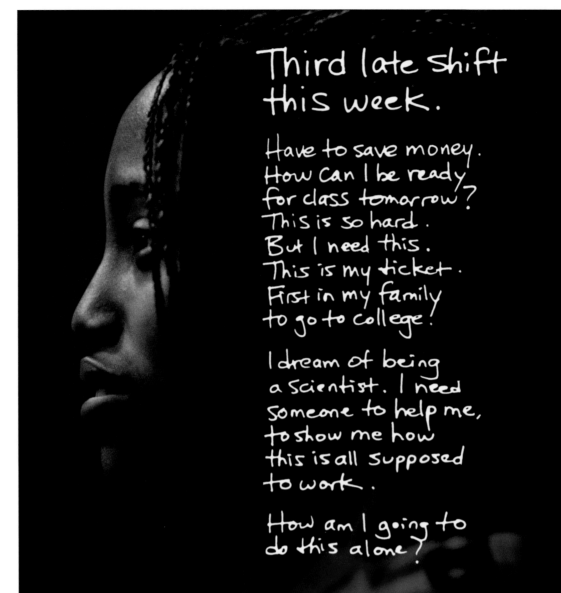

Third late shift
this week.

Have to save money.
How can I be ready
for class tomorrow?
This is so hard.
But I need this.
This is my ticket.
First in my family
to go to college!

I dream of being
a scientist. I need
someone to help me,
to show me how
this is all supposed
to work.

How am I going to
do this alone?

ACS
Chemistry for Life®

AMERICAN CHEMICAL SOCIETY

The ACS Scholars Program provides financial assistance, mentoring, and networking to talented students from groups that are underrepresented in the chemical sciences. Please donate now. You'll be unlocking the doors of opportunity for future chemists. **www.acs.org/dreams**

CREATIVE FIRM: LEVINE & ASSOCIATES – WASHINGTON, D.C., USA
CREATIVE TEAM: JOHN VANCE – PRESIDENT; LAUREN HASSANI – DESIGNER
CLIENT: AMERICAN CHEMICAL SOCIETY

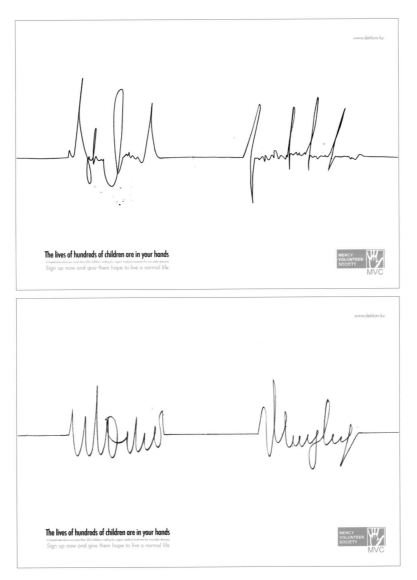

CREATIVE FIRM: TBWA\CENTRAL ASIA – ALMATY, KAZAKHSTAN

CREATIVE TEAM: JUAN PABLO VALENCIA – CREATIVE DIRECTOR/COPYWRITER/ART DIRECTOR; DENIS SMIRNOV – ILLUSTRATOR; JANUSZ MOROZ – NEW BUSINESS DIRECTOR

CLIENT: MERCY VOLUNTEER SOCIETY

celebrate the *harvest*

corn and corning:
a local tradition

wines for every
day of the week

apple pie contests
still rule

an award-winning
itty bitty kitchen

local chef's club
chews the fat

food choices:
for better or for worse

+ *recipes, tips and more*

FALL 2010

CREATIVE FIRM: MCM COMMUNICATIONS – PITTSBURGH, PA, USA
CREATIVE TEAM: JOHN CARPENTER – PRESIDENT; ADRIANA JACOUD – ART DIRECTOR; HEATHER MULL – PHOTOGRAPHER; CHRISTINA FRENCH – PUBLISHER
CLIENT: TABLE MAGAZINE

CREATIVE FIRM: INK PUBLISHING – BROOKLYN, NY, USA
CREATIVE TEAM: RICKARD WESTIN – ART DIRECTOR
CLIENT: VIRGIN TRAINS

CREATIVE FIRM: PENSARÉ DESIGN GROUP – WASHINGTON, D.C., USA
CREATIVE TEAM: MARY ELLEN VEHLOW – CREATIVE DIRECTOR; AMY E. BILLINGHAM – DESIGNER; CINDY VIZZA – EDITOR; GOOD PRINTERS – PRINTER
CLIENT: NATIONAL CLUB ASSOCIATION

CREATIVE FIRM: AGENCY FISH – LONDON, UK
CLIENT: QATAR AIRWAYS

(P) PLATINUM

FLUORO7

CREATIVE FIRM: HOUSEMOUSE – MELBOURNE, VIC, AUSTRALIA

CREATIVE TEAM: MIGUEL VALENZUELA – CREATIVE DIRECTOR; ARRON CURRAN – SENIOR DESIGNER

CLIENT: HOUSEMOUSE

URL: FLUOROMAG.COM

To create a magazine all about design, who's better qualified better than an actual design agency? For *fluoro*, publisher Fluoro Publications Pty. Ltd. enlisted Melbourne, Australia firm housemouse to provide an omniscient perspective of design, arts, fashion, and culture while demonstrating a balance between pop and avant–garde design and print. According to the creatives–director Miguel Valenzuela and senior designer Arron Curran–*fluoro* "aims to return a print consciousness to its readership, engaging with emerging local and world–class innovation, art, fashion, and design. *Fluoro* merges the best in the talent of local writers and designers alongside a diverse range of topics, products, brands, and artists"–all with Melbourne as home base to a local and international audience.

The winning issue, *fluoro7*, is based around the theme of senses, from three different environmentally sustainable paper stocks to cold foil printing and sewn binding to a Braille–embossed cover. It was just what the publisher wanted. "The client wanted *fluoro* to provide more than just a visual experience to its readers," say Valenzuela and Curran. "It had to provide a tactical one, allowing the readers to touch and feel their way. The end result should inspire readers."

CREATIVE FIRM: TAYLOR DESIGN – STAMFORD, CT, USA

CREATIVE TEAM: DANIEL TAYLOR – CREATIVE DIRECTOR; HANNAH FICHANDLER – ART DIRECTOR/DESIGN-ER; SUZANNE GRAY – EDITOR/WRITER; ANDREW LICHTENSTEIN, DON HAMERMAN – PHOTOGRAPHERS

CLIENT: SARAH LAWRENCE COLLEGE

CREATIVE FIRM: LEVINE & ASSOCIATES – WASHINGTON, D.C., USA

CREATIVE TEAM: JENNIE JARIEL – ART DIRECTOR; JANICE KWA, JESSICA BLANCHARD – DESIGNERS

CLIENT: AARP INTERNATIONAL

CREATIVE FIRM: AGENCY FISH – LONDON, UK

CLIENT: QATAR AIRWAYS

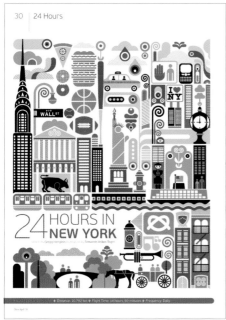

CREATIVE FIRM: AGENCY FISH –
LONDON, UK

CLIENT: QATAR AIRWAYS

CREATIVE FIRM: AGENCY FISH – LONDON, UK

CLIENT: QATAR AIRWAYS

CREATIVE FIRM: MCM COMMUNICATIONS –
PITTSBURGH, PA, USA

CREATIVE TEAM: ADRIANA JACOUD – ART
DIRECTOR; HEATHER MULL – PHOTOGRA-
PHER; CHRISTINA FRENCH – PUBLISHER

CLIENT: TABLE MAGAZINE

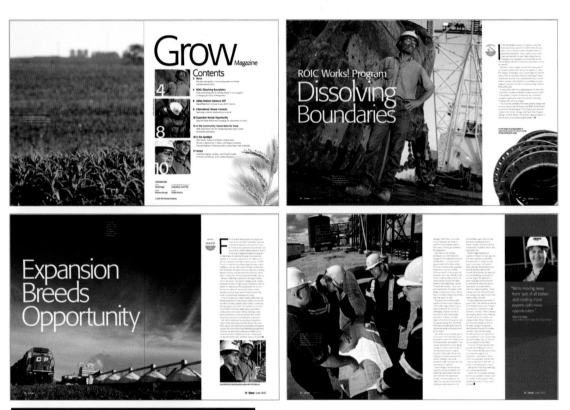

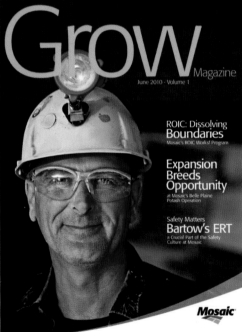

CREATIVE FIRM: FRANKE+FIORELLA – MINNEAPOLIS, MN, USA

CREATIVE TEAM: CRAIG FRANKE – PRINCIPAL/CREATIVE DIRECTOR; TODD MONGE – SENIOR DESIGNER; SHANNON KEOUGH – COPYWRITER; SHERYL NAGEL – COPYWRITER/EDITOR

CLIENT: THE MOSAIC COMPANY

PLATINUM

CREATIVE FIRM: PLUMBLINE STUDIOS, INC – NAPA, CA, USA
CREATIVE TEAM: ROBERT BURNS – DESIGN DIRECTOR; ERIC
BALL – DESIGNER
CLIENT: CRESTWOOD BEHAVIORAL HEALTH

CREATIVE FIRM: REDPOINT DESIGN DIRECTION – MIDLAND, MI, USA
CREATIVE TEAM: CLARK MOST – DESIGNER/ILLUSTRATOR; TY SMITH – ILLUSTRATOR
CLIENT: CENTRAL MICHIGAN UNIVERSITY

CREATIVE FIRM: MIRESBALL – SAN DIEGO, CA, USA
CREATIVE TEAM: JOHN BALL – CREATIVE DIRECTOR; BETH FOLKERTH, GALE
SPITZLEY – SENIOR DESIGNERS; JASON MOLL – DESIGNER
CLIENT: LUX

CREATIVE FIRM: MISSOURI BOTANICAL
GARDEN – BRENTWOOD, MO, USA
CREATIVE TEAM: ELLEN FLESCH SENIOR
– GRAPHIC DESIGNER
CLIENT: MISSOURI BOTANICAL GARDEN

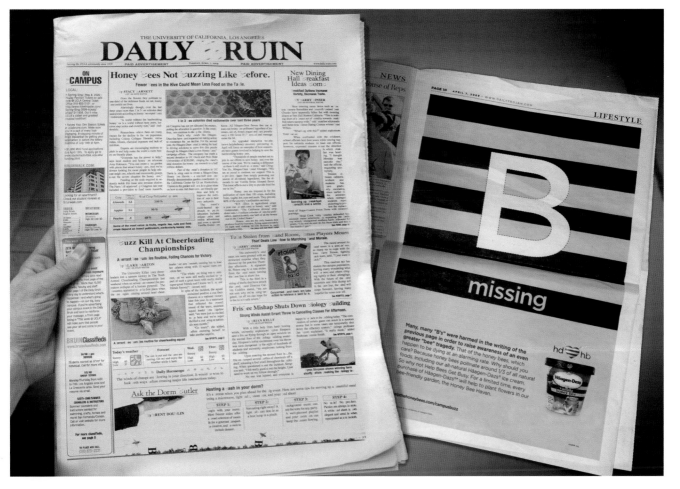

CREATIVE FIRM: ALCONE MARKETING – IRVINE, CA, USA

CREATIVE TEAM: CHAD LASOTA, RENATA CARROLL – ART DIRECTORS; CARLOS MUSQUEZ , KEVIN KLEBER – CREATIVE DIRECTORS; LUIS CAMANO – CHIEF CREATIVE OFFICER

CLIENT: HAAGEN DAZS

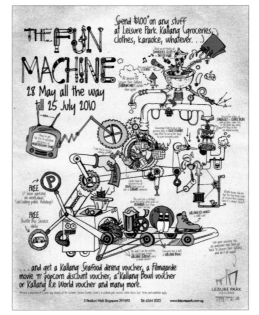

CREATIVE FIRM: PLANET ADS AND DESIGN P/L – SINGAPORE

CREATIVE TEAM: HAL SUZUKI – CREATIVE DIRECTOR; SUZANNE LAURIDSEN – SENIOR COPYWRITER; EDWIN ENERO – ART DIRECTOR; ADMIRA PUSTIKA – GRAPHIC DESIGNER/ ILLUSTRATOR

CLIENT: LEISURE PARK KALLANG

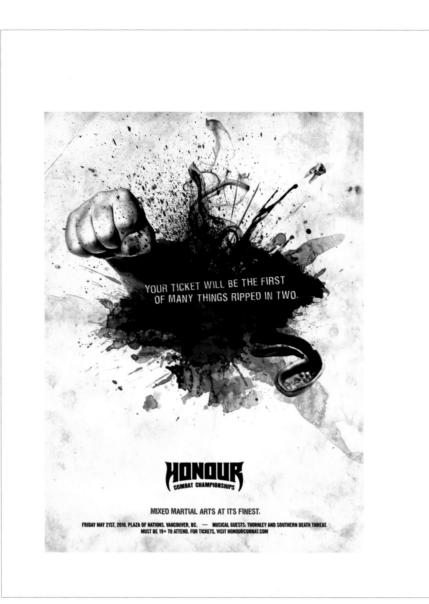

CREATIVE FIRM: ZULU ALPHA KILO – TORONTO, ON, CANADA

CREATIVE TEAM: ZAK MROUEH, JOSEPH BONNICI – CREATIVE DIRECTORS; MARK FRANCOLINI – ART DIRECTOR; ERICK NIELSEN – DESIGNER; EILEEN SMITH – PRODUCTION MANAGER; BARRETT HOLMAN – ACCOUNT SUPERVISOR

CLIENT: HONOUR COMBAT CHAMPIONSHIPS

CREATIVE FIRM: Y&R SOUTH AFRICA – WOODMEAD, SOUTH AFRICA

CREATIVE TEAM: MICHAEL BLORE – CHIEF CREATIVE OFFICER; CLINTON BRIDGEFORD, LIAM WIELOPOLSKI – EXECUTIVE CREATIVE DIRECTORS; WERNER MARAIS – COPYWRITER; KEVIN PORTELLAS – ART DIRECTOR

CLIENT: LAND ROVER

CREATIVE FIRM: JWT SPECIALIZED COMMUNICATIONS – NEW YORK, NY, USA

CREATIVE TEAM: JEFF BOCKMAN – COPYWRITER/CD; ANANT PANCHAL – ART DIRECTOR/CD

CLIENT: SUNLIFE FINANCIAL

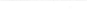 PLATINUM

TOY SOLDIERS

CREATIVE FIRM: Y&R SOUTH AFRICA – WOODMEAD, SOUTH AFRICA

CREATIVE TEAM: MICHAEL BLORE – CHIEF CREATIVE OFFICER; LIAM WIELOPOLSKI – EXECUTIVE CREATIVE DIRECTOR; ALISON STANSFIELD, MBUSO NDLOVU – ART DIRECTORS; IAN FRANKS, SEBASTIAN SCHNEIDER – COPYWRITERS

CLIENT: UNICEF

To a small child, nothing is more comforting than a beloved toy. In their dreams, a stuffed puppy can scare off the monster under the bed, or a platoon of toy soldiers can defend against o ther things that go bump in the night. However, the reality is not so simple.

For a public service campaign, Liam Wielopolski, the executive creative director at Y&R South Africa in Woodmead wanted to show the major problem that is child abuse and how it cuts across social and racial boundaries around the world. Specifically, he says, UNICEF charged the agency to develop a newspaper campaign that would be both powerful and dramatic. "Our biggest challenge was creating a campaign that could use the visual metaphor of children being protected from unseen, but serious, danger by everyday childhood objects," says Wielopolski. Visually, "it is the children themselves who are actually terrified in their own home environment and they set up their own protection as best as they can"—with toy soldiers, building blocks, and a plush dog. Photographer Steve Tanchel perfectly recreated the spooky darkness of children's bedrooms, and the headline plaintively challenges parents everywhere: "If you don't fight child abuse, who will?"

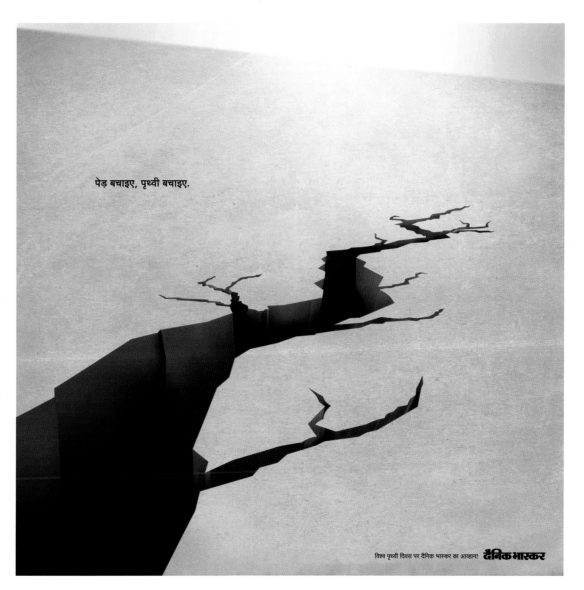

CREATIVE FIRM: PURPLE FOCUS PVT. LTD. – INDORE, INDIA

CREATIVE TEAM: MAHENDRA NAGWANSHI – SENIOR VISUALIZER

CLIENT: SOCIAL INITIATIVE BY PURPLE FOCUS

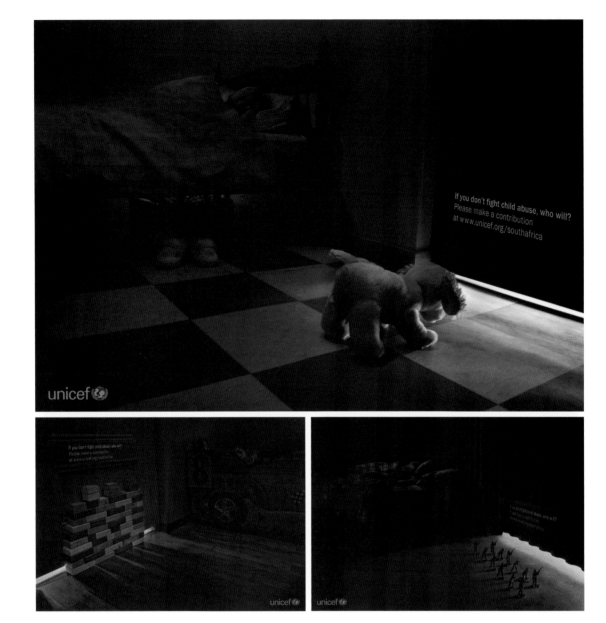

If you don't fight child abuse, who will?
Please make a contribution
at www.unicef.org/southafrica

CREATIVE FIRM: Y&R SOUTH AFRICA – WOODMEAD, SOUTH AFRICA

CREATIVE TEAM: MICHAEL BLORE – CHIEF CREATIVE OFFICER; LIAM WIELOPOLSKI – EXECUTIVE CREATIVE DIRECTOR; ALISON STANSFIELD, MBUSO NDLOVU – ART DIRECTORS; IAN FRANKS, SEBASTIAN SCHNEIDER – COPYWRITERS

CLIENT: UNICEF

(P) PLATINUM

TOY SOLDIERS

To a small child, nothing is more comforting than a beloved toy. In their dreams, a stuffed puppy can scare off the monster under the bed, or a platoon of toy soldiers can defend against o ther things that go bump in the night. However, the reality is not so simple.

For a public service campaign, Liam Wielopolski, the executive creative director at Y&R South Africa in Woodmead wanted to show the major problem that is child abuse and how it cuts across social and racial boundaries around the world. Specifically, he says, UNICEF charged the agency to develop a newspaper campaign

that would be both powerful and dramatic. "Our biggest challenge was creating a campaign that could use the visual metaphor of children being protected from unseen, but serious, danger by everyday childhood objects," says Wielopolski. Visually, "it is the children themselves who are actually terrified in their own home environment and they set up their own protection as best as they can"—with toy soldiers, building blocks, and a plush dog. Photographer Steve Tanchel perfectly recreated the spooky darkness of children's bedrooms, and the headline plaintively challenges parents everywhere: "If you don't fight child abuse, who will?"

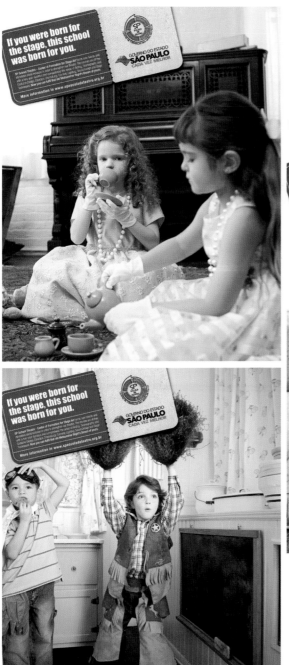

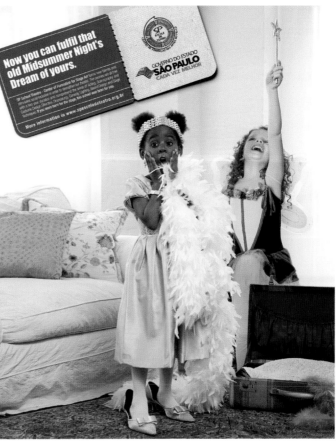

CREATIVE FIRM: CONTEXTO PROPAGANDA LTDA – SAO PAULO, BRAZIL

CREATIVE TEAM: OLAVO ROCHA – CREATIVE DIRECTOR; FABRICIO KASSICK – ART DIRECTOR; OSCAR NESTAREZ – COPYWRITER

CLIENT: GOVERNO DO ESTADO DE SÃO PAULO

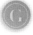

CREATIVE FIRM: DB CORP LTD (DAINIK BHASKAR GROUP) – MUMBAI, INDIA
CREATIVE TEAM: YATISH RAJAWAT – MANAGING EDITOR
CLIENT: DAINIK BHASKAR GROUP

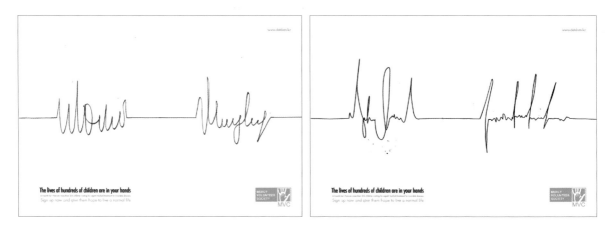

CREATIVE FIRM: TBWA\CENTRAL ASIA – ALMATY, KAZAKHSTAN
CREATIVE TEAM: JUAN PABLO VALENCIA – CREATIVE DIRECTOR/COPYWRITER/ART DIRECTOR; DENIS SMIRNOV – ILLUSTRATOR; JANUSZ MOROZ
– NEW BUSINESS DIRECTOR
CLIENT: MERCY VOLUNTEER SOCIETY

ILLUSTRATION

CREATIVITY AWARDS ANNUAL

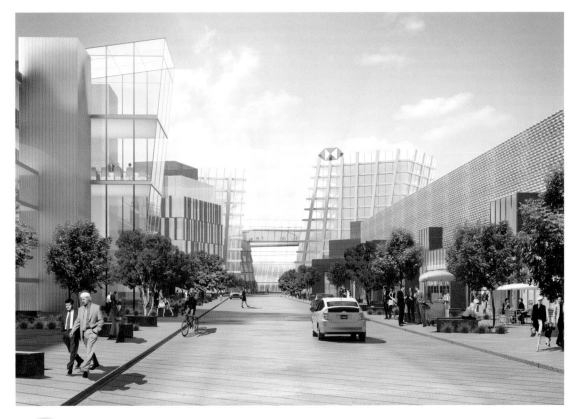

CREATIVE FIRM: STUDIO RENDERING, INC. – CHICAGO, IL, USA
CLIENT: CSAO

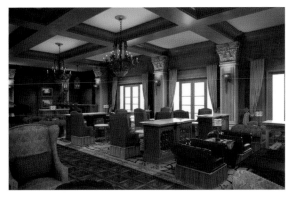

CREATIVE FIRM: STUDIO RENDERING, INC. – CHICAGO, IL, USA
CLIENT: DAVID MICHAELS

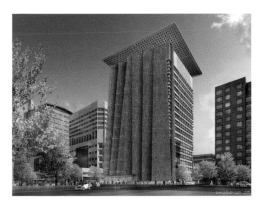

CREATIVE FIRM: BAUMBERGER STUDIO – PORTLAND, OR, USA
CREATIVE TEAM: SCOTT BAUMBERGER – OWNER/ILLUSTRATOR
CLIENT: SERA ARCHITECTS

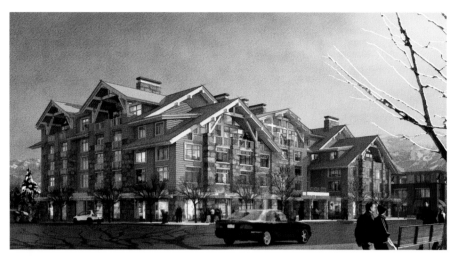

 CREATIVE FIRM: BAUMBERGER STUDIO – PORTLAND, OR, USA
CREATIVE TEAM: SCOTT BAUMBERGER – OWNER/ILLUSTRATOR
CLIENT: CALLISON

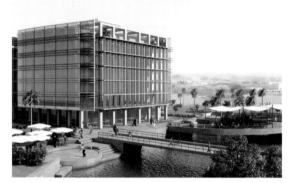

CREATIVE FIRM: STUDIO RENDERING, INC. – CHICAGO, IL, USA
CLIENT: HGA

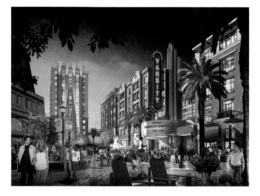

CREATIVE FIRM: BAUMBERGER STUDIO – PORTLAND, OR, USA
CREATIVE TEAM: SC'OTT BAUMBERGER – OWNER/ILLUSTRATOR
CLIENT: SB ARCHITECTS

 CREATIVE FIRM: STUDIO RENDERING, INC. –
CHICAGO, IL, USA
CLIENT: SOTHEBY'S

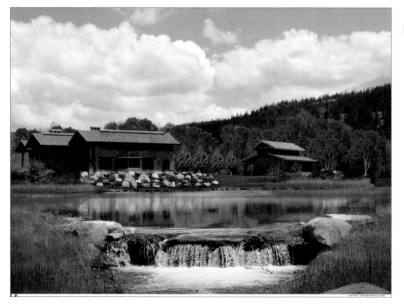

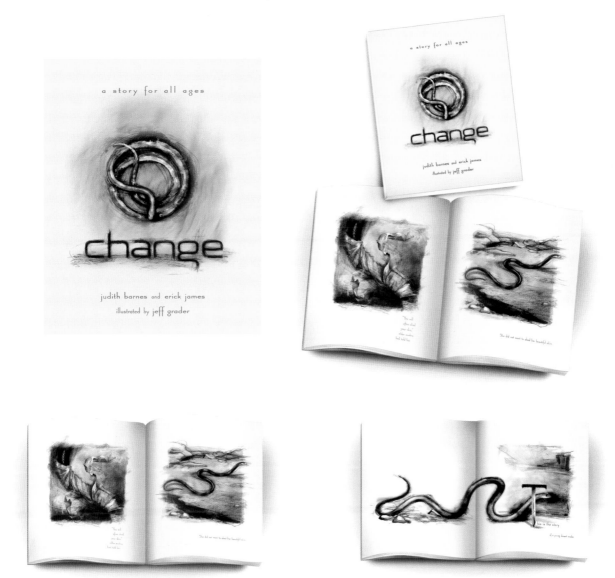

PLATINUM

CREATIVE FIRM: DESIGN FOR A SMALL PLANET – MOUNT HOLLY, NC, USA

CREATIVE TEAM: JUDITH BARNES, ERICK JAMES – AUTHORS; JEFF GRADER – ILLUSTRATOR; MICHAEL CHRISNER – CREATIVE DIRECTOR

CLIENT: JUDITH BARNES AND ERICK JAMES

CHANGE: A STORY FOR ALL AGES

Humans have told stories about animals since time immemorial. (Remember Aesop?) The book *Change: A Story For All Ages*, is a fable about a winsome snake, a wise coyote, a big lesson, and the impact of a word. To convey the simple but powerful message, Mount Holly, North Carolina creative firm design for a small planet came up with sweeping, monochrome pictures that look effortless but have a rich depth of tone. According to creative director Michael Chrisner, "This special story required extraordinary illustrations, while the unique and nuanced design required extraordinary paper by Mohawk. The

hand–tinted drawings and the subtlety of soft pastels alongside intense full–bleed night scenes all offered design and printing challenges. But readers and booksellers have consistently praised the book as an inspiration as well as a visual and tactile success."

And *Change* is a keeper. Touted as a teaching tool, counseling aid, and comforting gift for children or adults dealing with change, it is the first book in the "The Story of Communication" series on the art, science, and magic of how people interact–and, in an unexpected way, becomes an object of interaction itself.

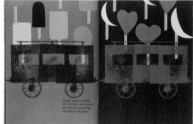

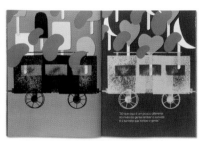

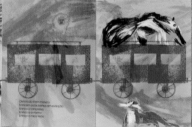

CREATIVE FIRM: CASA REX – SAO PAULO, BRAZIL

CREATIVE TEAM: GUSTAVO PIQUEIRA – CREATIVE DIRECTOR/DESIGN/ILLUSTRATOR; SAMIA JACINTHO – DESIGN

CLIENT: EDITORA BIRUTA

CREATIVE FIRM: WENDELL MINOR DESIGN – WASHINGTON, CT, USA

CREATIVE TEAM: WENDELL MINOR – ILLUSTRATOR; JEAN CRAIGHEAD GEORGE – AUTHOR; LAURA GERINGER – EDITOR; MARTHA RAGO – ART DIRECTOR

CLIENT: HARPERCOLLINS

URL: WWW.MINORART.COM

CREATIVE FIRM: WENDELL MINOR DESIGN – WASHINGTON, CT, USA

CREATIVE TEAM: WENDELL MINOR – ILLUSTRATOR; JEAN CRAIGHEAD GEORGE – AUTHOR; LUCIA MONFRIED – EDITOR; SARA REYNOLDS – ART DIRECTOR

CLIENT: DUTTON CHILDREN'S BOOKS, A DIVISION OF PENGUIN YOUNG READERS

URL: WWW.MINORART.COM

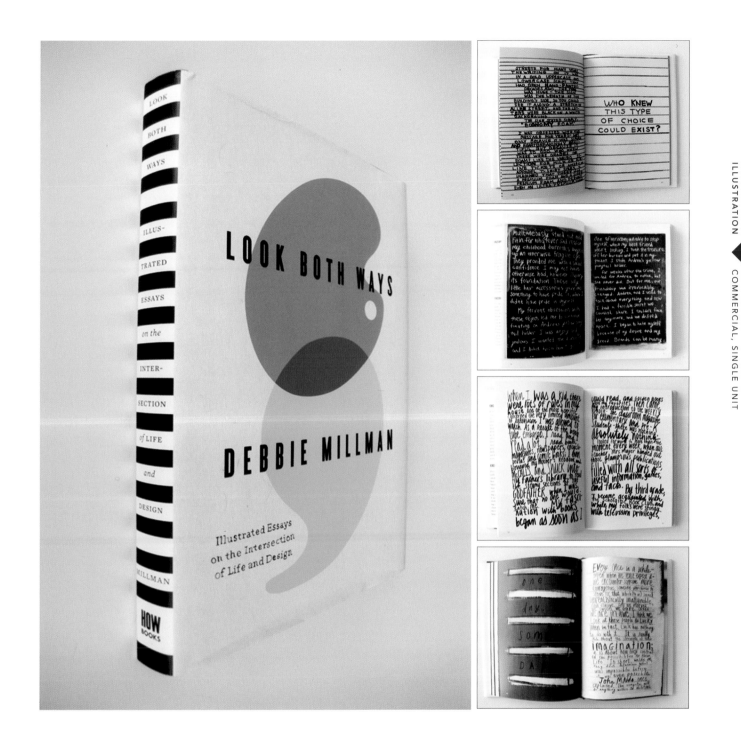

 PLATINUM

CREATIVE FIRM: STERLING BRANDS – NEW YORK, NY, USA
CREATIVE TEAM: DEBBIE MILLMAN – AUTHOR/ILLUSTRA-
TOR/DESIGNER; RODRIGO CORRAL – COVER DESIGN AND
CO–DESIGN ON TYPOGRAPHY
CLIENT: SELF–PROMOTION

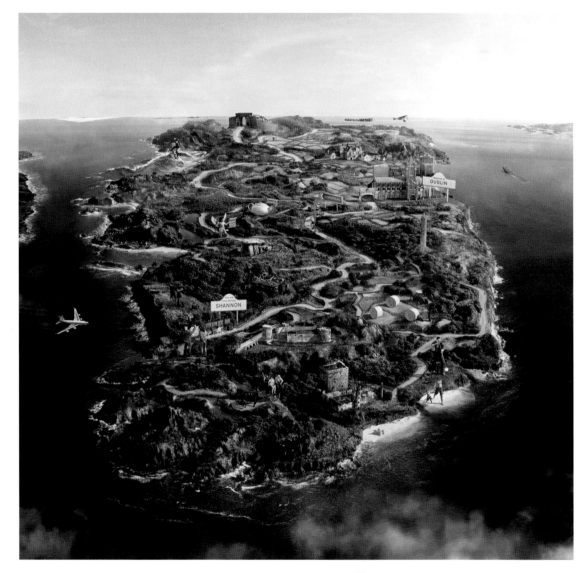

CREATIVE FIRM: TAYLOR JAMES – LONDON, UK
CREATIVE TEAM: AGENCY – JWT, LONDON; CREATIVE PRODUCTION – TAYLOR JAMES
CLIENT: TOURISM IRELAND
URL: HTTP://WWW.TAYLORJAMES.COM/

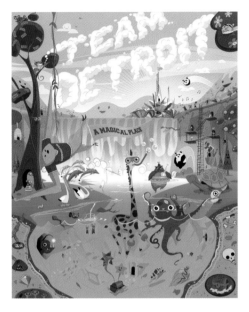

CREATIVE FIRM: SKIDMORE – ROYAL OAK, MI, USA
CREATIVE TEAM: GUY ALLEN – ILLUSTRATOR
CLIENT: TEAM DETROIT

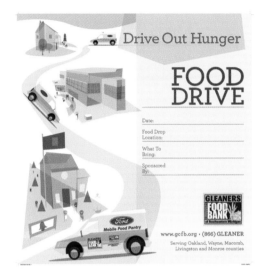

CREATIVE FIRM: SKIDMORE – ROYAL OAK, MI, USA
CREATIVE TEAM: GUY ALLEN – ILLUSTRATOR;
LAURA LYBEER–HILPERT – DESIGNER
CLIENT: GLEANERS COMMUNITY FOOD BANK

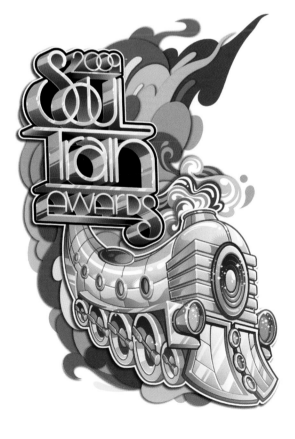

CREATIVE FIRM: MTV NETWORKS – NEW YORK, NY, USA
CREATIVE TEAM: NIGEL COX–HAGAN – EVP CREATIVE &
MARKETING; PHIL DELBOURGO – SVP BRAND & DESIGN;
TRACI TERRILL – VP EDITORIAL; JIMMY WENTZ – VP OFF–
AIR CREATIVE; KESIME BERNARD – CREATIVE DIRECTOR;
ALLISON SIERRA – DIRECTOR PROJECT MANAGEMENT;
JULIE RUIZ – ART DIRECTOR; JESSE RAKER – DESIGNER;
KIM NGUYEN – WRITER; TRISTAN EATON – ILLUSTRATOR
CLIENT: CENTRIC

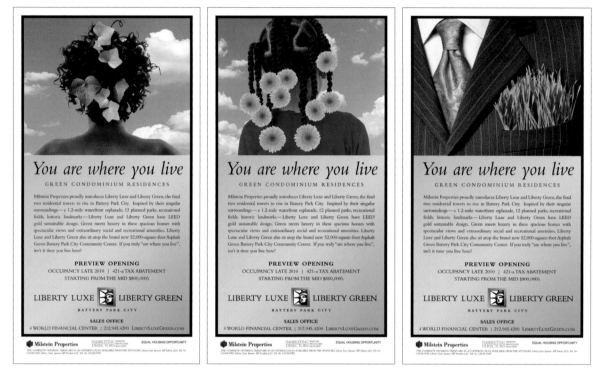

CREATIVE FIRM: SHERMAN ADVERTISING/MERMAID, INC. – NEW YORK, NY, USA

CREATIVE TEAM: SHARON MCLAUGHLIN – CREATIVE DIRECTOR; STEPHEN MORSE – RETOUCHER

CLIENT: LIBERTY LUXE / LIBERTY GREEN

 PLATINUM

WHEN THE BODY ATTACKS ITSELF

CREATIVE FIRM: TAYLOR JAMES – LONDON, UK
CREATIVE TEAM: AGENCY – GSW WORLDWIDE; CREATIVE
PRODUCTION – TAYLOR JAMES
CLIENT: KALBITOR, DYAX CORP
URL: HTTP://WWW.TAYLORJAMES.COM/

Hereditary angiodema, known as HAE, is a hereditary immune system condition that can cause airway blockage, swelling, and abdominal cramping–and even death. Fortunately for HAE sufferers, there is a treatment in the form of a drug called Kalbitor, manufactured by the Dyax Corporation. London– based creative production studio, Taylor James Ltd. created three visually striking shots for the drug's most recent print campaign–combining original photography and CGI–illustrating the various attacks associated with the disease. Speaking of the work, the studio says, "the forms of hands creeping underneath the skin visually represented the edema that is produced during these attacks."

Taylor James relished the challenge, "not only was it very complex to create realistic CGI skin that matched that of the photographed talent, it was also a complicated process to convey the appropriate visual depiction of each attack while maintaining readability," the studio reports. "The 'Neck' shot is a perfect example of this balancing act, as the 'attacking hands' are coming from under the skin but are simultaneously conveying a squeezing or choking action as if on top of the skin. Getting this dynamic just right required the team to work very closely with our clients, which is where our streamlined production pipeline really shines." By breaking down the project into easy–to–understand production stages, this facilitated collaboration between all parties involved, bringing simple clarity to the otherwise difficult discipline of CGI. "Allowing our clients to play such an active role throughout, meant we minimized creative setbacks and gained the benefit of their insights at the correct times. It is this type of creative management from concept to completion that ensures the success of a complex project such as this."

CREATIVE FIRM: STUDIO RENDERING, INC. – CHICAGO, IL, USA

Despite the exponential growth of online retailers and a public ever more entranced by digital media, indie booksellers continue to seduce literature lovers.

The Life and Times of Independent Bookstores

BY SARAH L. STEWART
ILLUSTRATIONS BY THOMAS ALLEN

FEBRUARY 2009 **GO MAGAZINE**

 PLATINUM

THE LIFE AND TIMES OF INDEPENDENT BOOKSTORES

CREATIVE FIRM: INK PUBLISHING – BROOKLYN, NY, USA
CREATIVE TEAM: SHANE LUITJENS – ART DIRECTOR; TIM VIENCKOWSKI, ELSIE ALDAHONDO – GRAPHIC DESIGNERS; THOMAS ALLEN – ILLUSTRATOR
CLIENT: AIRTRAN AIRWAYS

Is the independent bookstore dying? Not if Shane Luitjens has anything to say about that. During the assignment meeting, INK Publishing's art director was very excited about all the different ways he could present a story on this beloved institution. "We wanted to present these increasingly rare shops as interesting environments in which to have fulfilling experiences," he says. Avoiding cliché– or, at the very least, the obvious–was a primary goal: "The visual challenge was communicating the love of the written page without getting stuck in picture of book stacks. I wanted to communicate the playful feeling and reverence for literature that all avid readers feel when approaching bookstores."

To convey that these special environments built to support readers are full of adventure, Luitjens immediately thought of the equally adventurous photo illustrator Thomas Allen. "I knew he could bring the design not only the wit," says Luitjens, "and by using texts in unique ways, his work echoes what these bookstores are doing in response to the changing nature of the business." Allen's prints evoke a retro, dime–store novel feeling–the perfect match for an old idea reinvented as the latest in cool. "The job of the art director is to affirm and even support that story, so that within a fraction of a second, the reader understands," says Luitjens. "The big challenge is to have it all work in harmony."

Even the elements within the image have a certain harmony to them, too. "The fonts are brand fonts," Luitjens explains. "Colors are dusty tones to reflect the used tomes. The book opposing the illustration just drives the message of the photoillo by saying that yes, this is about the books…but it's also about the interre-lationships of the books and sellers." And besides, who doesn't love going to bed with a good book?

CreativeReview

The CGI issue | Advertising, design and visual culture | June 2010 | £5.90

CREATIVE FIRM: TAYLOR JAMES – LONDON, UK
CREATIVE TEAM: TAYLOR JAMES – CGI PRODUCTION; ILLUSTRATION – VON
CLIENT: CREATIVE REVIEW
URL: HTTP://WWW.TAYLORJAMES.COM/CREATIVE–REVIEW–OWL/

CREATIVE FIRM: SKIDMORE – ROYAL OAK, MI, USA
CREATIVE TEAM: GARY SPONDIKE – SENIOR ACCOUNT DIRECTOR; GUY ALLEN – ILLUSTRATOR
CLIENT: COMMUNICATION WORLD MAGAZINE

CREATIVE FIRM: INK PUBLISHING – BROOKLYN, NY, USA
CREATIVE TEAM: GARY COOK – ART DIRECTOR; OLIVIER KUGLER – ILLUSTRATOR
CLIENT: JAZEERA

PHOTOGRAPHY

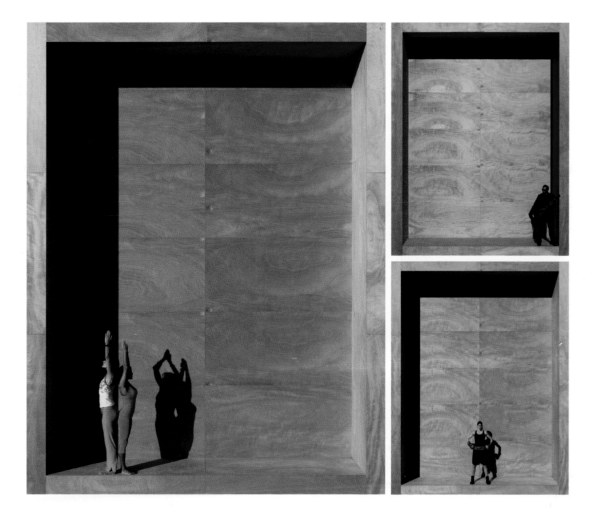

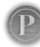 **PLATINUM**

CREATIVE FIRM: NESNADNY + SCHWARTZ – CLEVELAND, OH, USA

CREATIVE TEAM: MARK SCHWARTZ – CREATIVE DIRECTOR; MICHELLE MOEHLER, CINDY LOWREY, KEITH PISHNERY – DESIGNERS; COKE O'NEAL – PHOTOGRAPHER; GLENN RENWICK – WRITER

CLIENT: THE PROGRESSIVE CORPORATION

For the past 28 years, The Progressive Corporation has commissioned Nesnadny + Schwartz (N+S), a Cleveland visual communications firm, to create its annual report. The partnership has endured because of N+S's ability to keep its presentation of the auto insurance provider's message fresh, developing the conceptual and visual theme and overall design, as well as managing production from inception to delivery.

THE PROGRESSIVE CORPORATION 2009 ANNUAL REPORT

Progressive's annual report is its main instrument for communicating with stakeholders, including government agencies. Beyond all the numbers and figures, however, the publication aims to reinforce Progressive's business strategy, maintain the company's commitment to contemporary art as a way of promoting creative thinking, and support the company's position of solving problems through innovation.

Of course, such a goal cannot be achieved alone, or without the crucial element of respect. And that's exactly what creative director Mark Schwartz and photographer Coke O'Neal kept in mind when they brought together twenty–two Progressive employees, twelve contractors, and

one artist to portray seventy–two "everyday people" for the annual report. Their theme? "Respect."

According to Schwartz, the shoot took place over a six–day period in December 2009–amidst snow, freezing rain, and Cleveland's bone–chilling winds. "The foundation of Progressive's customer care philosophy is built upon respect," he says. "Since true respect is earned, the individuals featured in this project were selected for their commitment to their communities, their families, and themselves." O'Neal explored the theme by employing a wooden box–a metaphoric stage to celebrate each person's individuality–and telling a story in each frame.

CREATIVE FIRM: NESNADNY + SCHWARTZ – CLEVELAND, OH, USA

CREATIVE TEAM: MARK SCHWARTZ – CREATIVE DIRECTOR; GREG OZNOWICH – DESIGNER; MARK SCHWARTZ – PHOTOGRAPHER; LANCE RINGEL – WRITER

CLIENT: VASSAR COLLEGE

CREATIVE FIRM: ANDRE MULAS – SURABAYA, INDONESIA
CREATIVE TEAM: ANDRE MULAS – PHOTOGRAPHER/ART DIRECTOR; CHARLES REZANDI – ART DIRECTOR/STYLIST
CLIENT: IN(F)ASION

CREATIVE FIRM: STUDIO JMV LLC – MIAMI, FL, USA
CREATIVE TEAM: JOSE MANUEL VIDAURRE – PHOTOGRA-PHER/DIGITAL ARTIST, STUDIO JMV LLC; NICK MONAHAN – ART DIRECTOR, ME&LEWIS IDEAS INC.; PAUL MEEHAN – CREATIVE STRATEGIST, ME&LEWIS IDEAS INC.; JEFF LEWIS – CREATIVE DIRECTOR, ME&LEWIS IDEAS INC; GREG PLOWE – GLOBAL MARKETING DIRECTOR, SABMILLER
CLIENT: SAB MILLER
URL: HTTP://WWW.JMV-STUDIO.COM

CREATIVE FIRM: MTV NETWORKS – NEW YORK, NY, USA
CREATIVE TEAM: JIM DEBARROS – VP, OFF–AIR CREATIVE; ART STREIBER – PHOTOGRAPHER; RICHARD BROWD – ART DIREC-TOR; KAREN WEISS – PHOTO DIRECTOR/PROJECT MANAGER
CLIENT: MTV

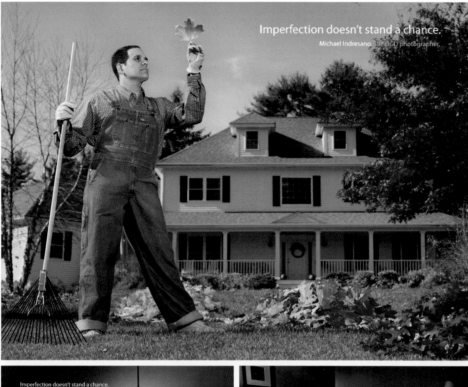

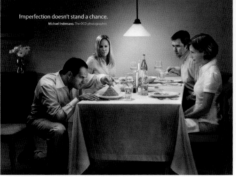

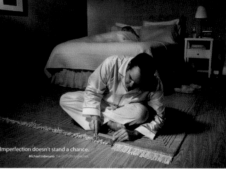

CREATIVE FIRM: MICHAEL INDRESANO PHOTOGRAPHY – BOSTON, MA, USA

CREATIVE TEAM: MICHAEL INDRESANO – PHOTOGRAPHER; MICHELE DOUC-ETTE – PRODUCER; MARC GALLUCCI – CREATIVE DIRECTOR; KEITH MANNING – ART DIRECTOR; PHIL HENSON – COPYWRITER; TUI STARK – STYLIST

CLIENT: MICHAEL INDRESANO PHOTOGRAPHY

URL: WWW.INDRESANO.COM

CREATIVE FIRM: RANDI WOLF DESIGN – GLASSBORO, NJ, USA

CREATIVE TEAM: RANDI WOLF – PHOTOGRAPHER

CLIENT: BOWE SCHOOL P.T.O.

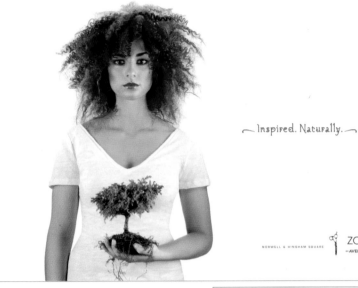

Inspired. Naturally.

zona
NORWELL & HINGHAM SQUARE | AVEDA concept salon

CREATIVE FIRM: MICHAEL INDRESANO PHOTOGRAPHY – BOSTON, MA, USA

CREATIVE TEAM: MICHAEL INDRESANO – PHOTOGRAPHER; MICHELE DOUCETTE – PRODUCER; TIM NEEDHAM – CREATIVE DIRECTOR/COPYWRITER; BETH WICKWIRE – PROP STYLIST; KRISTEN HIGGINS – RETOUCHER

CLIENT: ZONA HAIR SALON/AVEDA

URL: WWW.INDRESANO.COM

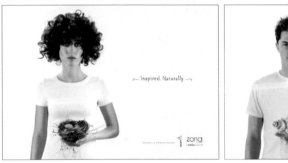

CREATIVE FIRM: STUDIO JMV LLC – MIAMI, FL, USA

CREATIVE TEAM: JOSE MANUEL VIDAURRE – PHOTOGRAPHER/DIGITAL ARTIST, STUDIO JMV LLC; NICK MONAHAN – ART DIRECTOR, ME&LEWIS IDEAS INC.; PAUL MEEHAN – CREATIVE STRATEGIST, ME&LEWIS IDEAS INC.; JEFF LEWIS – CREATIVE DIRECTOR, ME&LEWIS IDEAS INC.; GREG PLOWE – GLOBAL MARKETING DIRECTOR, SABMILLER

CLIENT: SABMILLER

URL: HTTP://WWW.JMV–STUDIO.COM

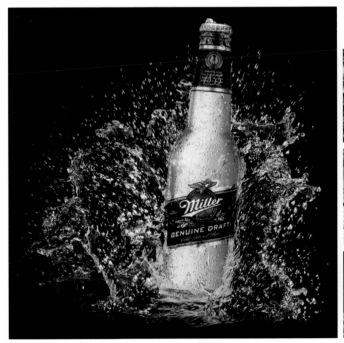

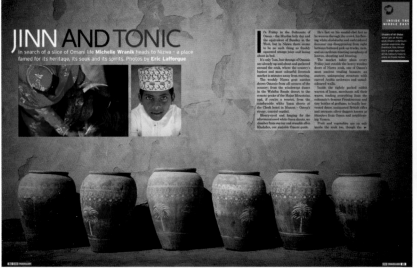

CREATIVE FIRM: EMPHASIS MEDIA LIMITED – NORTH POINT, HONG KONG

CREATIVE TEAM: DAN HAYES – EDITOR; MIKE WESCOMBE – ART DIRECTOR

CLIENT: CNN

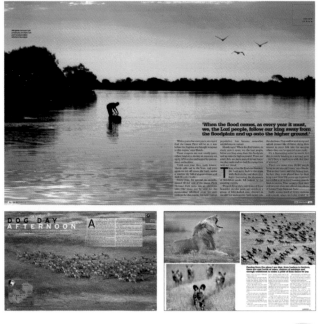

CREATIVE FIRM: EMPHASIS MEDIA LIMITED – NORTH POINT, HONG KONG

CREATIVE TEAM: DAN HAYES – EDITOR; MIKE WESCOMBE – ART DIRECTOR

CLIENT: CNN

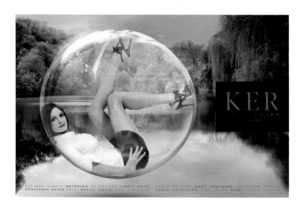

CREATIVE FIRM: CONTEXTO PROPAGANDA LTDA – SAO PAULO, BRAZIL

CREATIVE TEAM: OLAVO ROCHA – CREATIVE DIRECTOR; FABRICIO KASSICK – ART DIRECTOR; OSCAR NESTAREZ – COPYWRITER; AMILCAR PACKER – PHOTOGRAPHER

CLIENT: KER

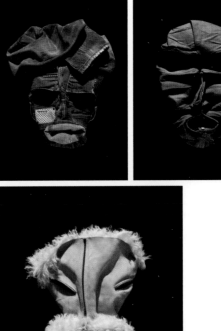

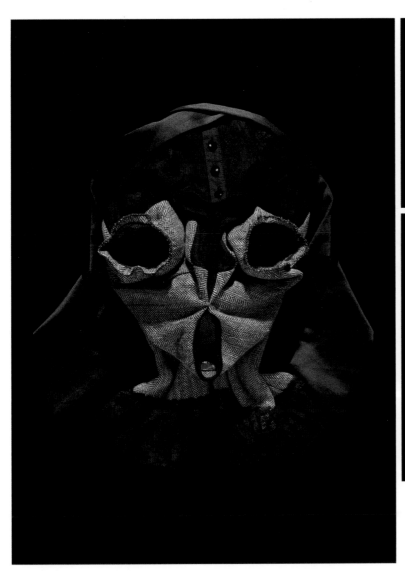

PLATINUM

CREATIVE FIRM: FUTUREBRAND GMBH – HAMBURG, GERMANY

CREATIVE TEAM: GÜNTER SENDLMEIER – CEO/CCO; JONATHAN SVEN AMELUNG – CREATIVE DIRECTOR; JESSICA WATERMANN – ACCOUNT DIRECTOR; BELA BORSODI – PHOTOGRAPHER; HOLGER LENDNER – MANAGING DIRECTOR (YALOOK.COM); JÖRN MIKOWKSY – CHIEF BUYER (YALOOK.COM)

CLIENT: FASHIONWORLD GMBH (A MEMBER OF THE OTTO GROUP)

YALOOK.COM – FASHION FACES

Whoever coined the phrase "Clothes make the man" never dreamed of such a literal interpretation.

For online fashion retailer Yalook.com's Fashion Faces Calendar 2010, agency FutureBrand GmbH devised a striking look as part of the brand launch. Creative director Jonathan Sven Amelung wanted to show a trendy and fashionable target group that buying fashion online could be an experience on par with an offline advisory service. "The challenge and key objective were to raise awareness and establish Yalook.com as a must–have online fashion shop for people who are looking for personality and character," the Hamburg–based Amelung says. "Fine feathers make fine birds, and clothing emphasizes personality and shows people's character and lifestyle."

Amelung "awakened" the clothing of the collection and made the clothes–not the models–the stars of the campaign, enlisting New York photographer Bela Borsodi to artfully fold pieces from the collection into twelve individual "fashion faces." "The garments were not cut or glued, just folded," says Amelung. The resulting anthropomorphic visages certainly do illustrate character–from a Karl Lagerfeld sport coat twisted into a dapper, jewel–eyed male face to a women's blouse reinterpreted as a cross between Darth Vader and Munch's *The Scream*. As the focus of the company's print ads and calendar, the dozen faces became Yalook.com's signature visual and generated buzz for the fledgling brand. The calendar, in fact, proved so popular that demand exceeded supply–but a lucky thousand customers got their copies in time for the New Year.

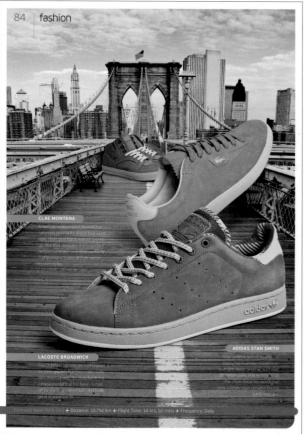

CREATIVE FIRM: AGENCY FISH – LONDON, UK
CLIENT: QATAR AIRWAYS

CREATIVE FIRM: AGENCY FISH – LONDON, UK
CLIENT: QATAR AIRWAYS

TYPOGRAPHY

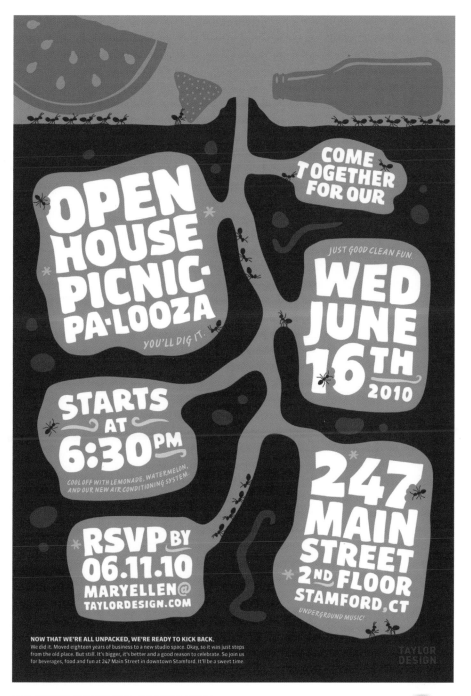

CREATIVE FIRM: TAYLOR DESIGN – STAMFORD, CT, USA
CREATIVE TEAM: DANIEL TAYLOR – CREATIVE DIRECTOR; STEVE HABERSANG – ART DIRECTOR/DESIGNER
CLIENT: TAYLOR DESIGN

CREATIVE FIRM: MARC ATLAN DESIGN, INC. – VENICE, CA, USA
CREATIVE TEAM: MARC ATLAN – CREATIVE DIRECTOR
CLIENT: BARRICADE BOOKS

CREATIVE FIRM: MTV NETWORKS – NEW YORK, NY, USA
CREATIVE TEAM: JEFFREY KEYTON – SVP, DESIGN AND OFF–AIR CREATIVE; JIM DEBARROS – VP, OFF–AIR CREATIVE; LANCE RUSOFF – DESIGN DIRECTOR; FRAN SIZEMORE – COORDINATING PRODUCER
CLIENT: MTV

CREATIVE FIRM: EURO RSCG C&O – PARIS, FRANCE
CREATIVE TEAM: THOMAS HERODIN – ART DIRECTOR; REZA BASSIRI – CREATIVE DIRECTOR
CLIENT: VILLE DE PANTIN

CREATIVE FIRM: EURO RSCG C&O – PARIS, FRANCE
CREATIVE TEAM: EURO RSCG C&O
CLIENT: EURO RSCG C&O
URL: HTTP://WWW.HUBC–O.COM

CREATIVE FIRM: DESIGNAGENTUR WAGNER – MAINZ, GERMANY
CREATIVE TEAM: OLIVER WAGNER – DIPLOM–DESIGNER (FH)
CLIENT: TISCHLEREI »G

CREATIVE FIRM: AMELUNG DESIGN – HAMBURG, GERMANY
CREATIVE TEAM: JONATHAN SVEN AMELUNG – CREATIVE DIRECTOR
CLIENT: IFP DESIGN

GREEN

CREATIVITY AWARDS ANNUAL

CREATIVE FIRM: MARC ATLAN DESIGN, INC. – VENICE, CA, USA
CREATIVE TEAM: MARC ATLAN – CREATIVE DIRECTOR
CLIENT: KJAER WEIS

CREATIVE FIRM: MENDES PUBLICIDADE – BELEM, BRAZIL
CREATIVE TEAM: OSWALDO MENDES – CREATIVITY DIRECTOR; MÁRCIA DE MIRANDA – COPYWRITER; MARIA ALICE PENNA – ART DIRECTOR
CLIENT: STATUS CONSTRUÇÕES

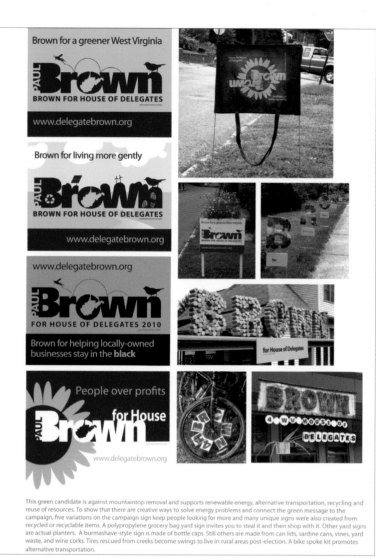

This green candidate is against mountaintop removal and supports renewable energy, alternative transportation, recycling and reuse of resources. To show that there are creative ways to solve energy problems and connect the green message to the campaign, five variations on the campaign sign keep people looking for more and many unique signs were also created from recycled or recyclable items. A polypropylene grocery bag yard sign invites you to steal it and then shop with it. Other yard signs are actual planters. A burmashave-style sign is made of bottle caps. Still others are made from can lids, sardine cans, vines, yard waste, and wine corks. Tires rescued from creeks become swings to live in rural areas post-election. A bike spoke kit promotes alternative transportation.

CREATIVE FIRM: EVE FAULKES DESIGN – MORGANTOWN, WV, USA

CREATIVE TEAM: SIGN FACTORY – PRINTING; EVE FAULKES – DESIGNER; RACHEL SHULER, LAUREN LAMB – PRODUCTION ASSISTANTS

CLIENT: PAUL BROWN FOR WV HOUSE OF DELEGATES`

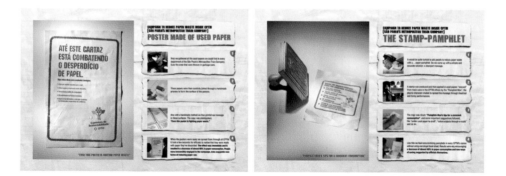

CREATIVE FIRM: CONTEXTO PROPAGANDA LTDA – SAO PAULO, BRAZIL

CREATIVE TEAM: OLAVO ROCHA – CREATIVE DIRECTOR; FABRICIO KASSICK – ART DIRECTOR; OSCAR NESTAREZ – COPY-WRITER; MARCOS LOPES – PHOTOGRAPHER; LAYLA YUKA – PRODUCER

CLIENT: CPTM

ALTERNATIVE MEDIA

ATIVITY AWARDS ANNUAL

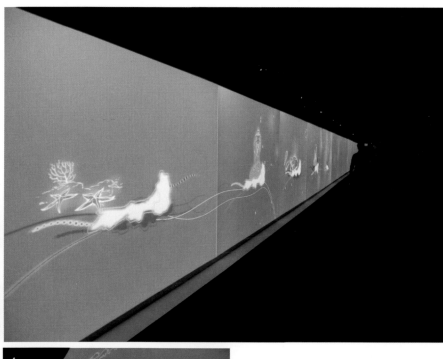

ⓟ PLATINUM

THE DIGITAL GATEWAY AT THE 2010 COMMERCE CENTRE

CREATIVE FIRM: SWITCH INTERACTIVE – VANCOUVER, BC, CANADA

CREATIVE TEAM: CATHERINE WINCKLER, BLAIR POCOCK – CREATIVE DIRECTORS; MYRON CAMPBELL – ART DIRECTOR; GAUTHIER POMPOUGNAC – PROGRAMMER; JAYBE ALLANSON – INTERACTIVE PRODUCER; COLIN CAMPBELL – ENVIRONMENT DESIGN; FELIX HEINEN – PRINT DESIGN; TZANKO TCHANGOV – ANIMATIONS; TERRY FREWER – ORIGINAL MUSIC; TANGIBLE INTERACTION – SENSORS; EVOLUTION – HARDWARE; 3DS – FABRICATION

CLIENT: BC OLYMPIC & PARALYMPIC WINTER GAMES SECRETARIAT

URL: HTTP://WWW.SWITCHINTERACTIVE.COM/THEWALL

The opening ceremonies of the 2010 Winter Olympics in Vancouver stunned the world with its mind–blowing digital pyrotechnics, and developing a similarly memorable experience at Vancouver's 2010 Commerce Centre to welcome VIP and corporate visitors was another tremendous effort. Switch Interactive wove together illustration, animation, exhibit design, music, and the latest interactive technologies to transform a 110–foot long passageway into an innovative, immersive, walk–through experience while reinforcing the message of the Western provinces as "Canada's Pacific Gateway"—not just a mountainous landscape but a creative, innovative, and sustainable place to do business.

"We understood that the solution had to be as much business showcase as it is digital art installation," says creative director Garrett Wagner. "To engage visitors and deliver a one–of–a–kind experience, we literally made the experience 'people powered,'" with no two experiences ever the same. "As visitors move along the passageway, they trigger motion sensors that 'paint' the wall with a total of seventeen animated, illustrated vignettes representing 'sector success' in Western Canada." Switch told the stories of the West's thriving economy and sector–based expertise using such evolutions as a heron bird, signifying wilderness tourism, morphing into the HERON unmanned aircraft, representing aviation.

At its debut in January 2010–the Games opened the following month–the Digital Gateway was among the longest interactive walls in the world, and the journey to get there was long, too. "By building a prototype and conducting extensive on–site testing, we overcame challenges posed by a wall of this length, including aligning the images along all 110 feet, seaming the animations, and synching the sensors, computers, music, and animations," Wagner says. "We also had to find projection solutions for the corridor's low ceiling and narrow width, ultimately choosing fifteen short–throw ceiling–mounted projectors." And for that, Switch skips the gold, silver, and bronze and goes straight for the Platinum.

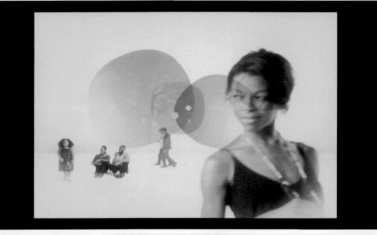

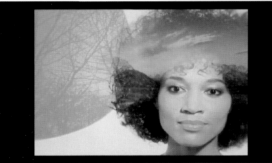

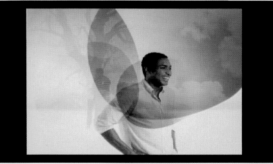

P PLATINUM

CREATIVE FIRM: VH1 – NEW YORK, NY, USA

CREATIVE TEAM: PHIL DELBOURGO – SVP OF BRAND & DESIGN; GARY ENCARNACION – PRODUCER; KESIME BERNARD – CREATIVE DIRECTOR; NIGEL COX–HAGAN – EVP OF CREATIVE & MARKETING; EYEBALL – POST PRODUCTION COMPANY/CREATIVE PARTNER, CREATIVE; LIMORE SHUR – DIRECTOR/DIRECTOR; HYEJIN HWANG – CREATIVE PARTNER/CO–CREATIVE DIRECTOR/CO–DIRECTOR; TALINE GHAZARIAN – PRODUCER; ERIN LEEMAN – LIVE ACTION PRODUCTION MANAGER; JESSE MCGOWAN – DESIGNER/ ANIMATOR; MITCHELL PAONE, HSIANG JU HUNG, CHRIS RO, DARIUS MAGHEN – DESIGNERS; SANDRA ARNDT – STRATEGIST; NEIL STUBER, ELLIOT LIM, DAVID POCULL – ANIMATORS; KYLE JONES – JUNIOR ANIMATOR

CLIENT: CENTRIC

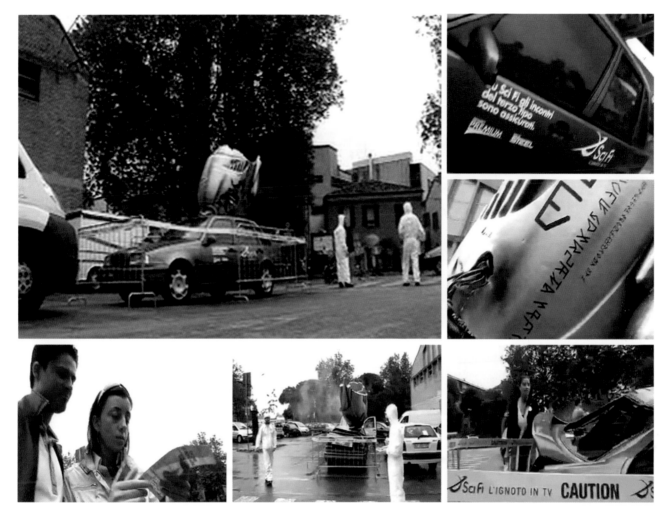

PLATINUM

SCI FI – ALIEN CRASH

CREATIVE FIRM: GRUPPO RONCAGLIA – ROME, ITALY
CREATIVE TEAM: ARNALDO FUNARO – CREATIVE DIRECTOR; ARIBERTO ANASTASI – ART DIRECTOR; ARNALDO FUNARO – COPY
CLIENT: NBC UNIVERSAL GLOBAL NETWORKS ITALIA

The Sci–Fi Channel (now SyFy), which has a branded block on Italy's Steel action and adventure channel, wanted to illustrate the slogan, "The unknown is closer than you can imagine" in an unconventional way in order to increase brand awareness. Gruppo Roncaglia, in conjunction with NBC Universal Italia, presented a realistic–looking marriage of the unknown and the tangible. A clip shows an automobile with its roof and windows completely smashed by a collision with a huge reactor from an alien ship, while a group of scientists gives away some flyers similar to the form used

in Italy to document car accident reports. (One piece of text reads, in translation, "On Sci–Fi, close encounters of the third kind are 'insured'"–which, in Italian, also means "assured."

The design aimed to create a smart and smooth "alien object" that evokes clearly a space ship engine," says the agency. "Another important point was to make the car collision as realistic as possible, and the use of 'alien' type on the engine helped us to suggest that the element really crashed from a spaceship."

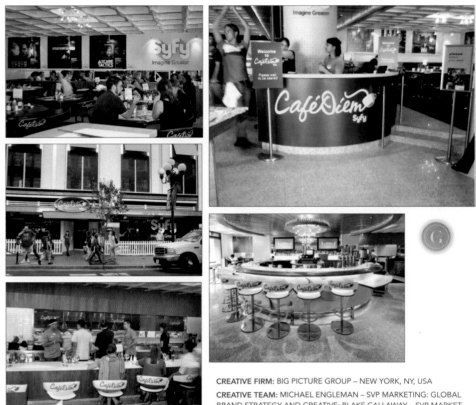

CREATIVE FIRM: BIG PICTURE GROUP – NEW YORK, NY, USA

CREATIVE TEAM: MICHAEL ENGLEMAN – SVP MARKETING: GLOBAL BRAND STRATEGY AND CREATIVE; BLAKE CALLAWAY – SVP MARKETING: BRAND AND INTEGRITY; WILLIAM LEE – CREATIVE DIRECTOR

CLIENT: SYFY

CREATIVE FIRM: SPQR NETWORK – ROME, ITALY

CREATIVE TEAM: MATTEO BETORI – CREATIVE DIRECTOR/ART DIRECTOR; MASSIMO GUERCI – ART DIRECTOR; SARA BINELLO, DANIELE PAPA – COPY

CLIENT: NBC UNIVERSAL GLOBAL NETWORKS ITALIA

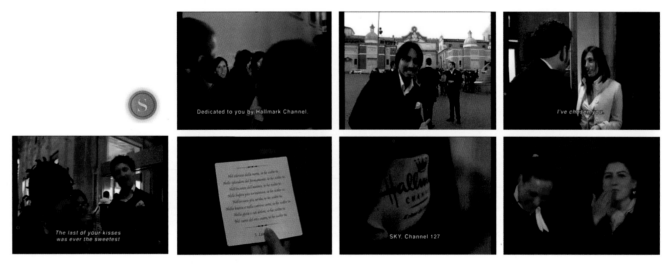

 PLATINUM

ALICE (WHITE RABBIT)

CREATIVE FIRM: FALLON – NEW YORK, NY, USA
CREATIVE TEAM: MICHAEL ENGLEMAN – SVP MARKET-ING: GLOBAL BRAND STRATEGY AND CREATIVE; BLAKE CALLAWAY – SVP MARKETING: BRAND AND INTEGRITY; WILLIAM LEE – CREATIVE DIRECTOR
CLIENT: SYFY
URL: HTTP://THEWHITERABBITINC.COM

Lewis Carroll's Alice's Adventures in Wonderland—also known as Alice in Wonderland—is a decidedly surreal work, and cable network SyFy found it to be an appropriately evergreen source. To market its reimagining of the classic, SyFy's parent company, NBC Universal, tapped Fallon Worldwide to take the story's elements online.

"Our approach was to take consumers down a multimedia rabbit hole of our creation," the agency explains. "Certainly consumers' familiarity with the tale was a strength for us, but how fragmented their memories were of the story and its multiple icons—from the Mad Hatter and Cheshire Cat to the Queen of Hearts and Alice herself—proved to be a challenge." As the White Rabbit remains the most familiar icon, the updated character—in this case, a human with a rabbit head (or a rabbit with a human body)—became the focus of the multimedia adventure: The White Rabbit Experience.

In a twisted act of performance art, the rabbit jumped off computers to the streets of New York, projected larger than life across historic building facades such as FIT, The Maritime Hotel, and the former Union Square Virgin Megastore. The Friday before the show's Sunday night premiere, too, fifty live rabbit–people were unleashed on the city's streets, handing out playing cards naming Alice and the Mad Hatter "Wonderland's Most Wanted" to those brave enough to approach. ("Hundreds of tweets, photos, and videos were posted by people who ran into one of our white rabbits across Manhattan," Fallon notes.) And on Twitter, @WhiteRabbitInc drove people to the website via a digital rabbit trail.

The resulting buzz drove the premiere to better–than–expected ratings expectations, becoming the highest–rated Sunday night on Syfy since 2007.

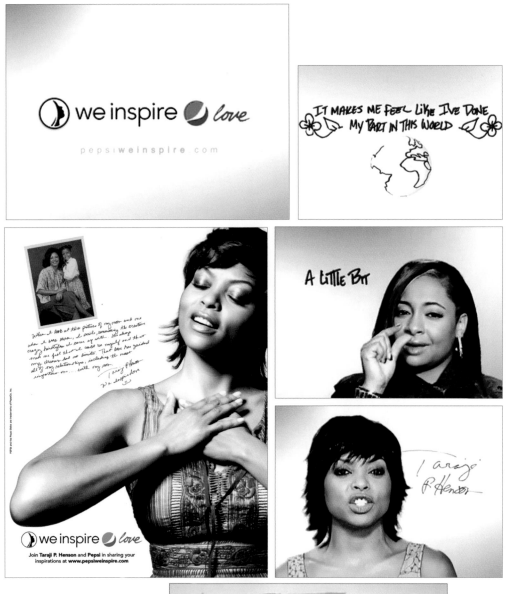

PLATINUM

CREATIVE FIRM: RPM GROUP – NEW YORK, NY, USA

CREATIVE TEAM: FRANK COOPER – SVP, CHIEF CONSUMER ENGAGEMENT OFFICER; LAUREN SCOTT – SENIOR MARKETING MANAGER; LYLETTE PIZARRO – RPM GROUP PARTNER; FRANZ ALIQUO – SENIOR STRATEGIST; RENE MCLEAN – RPM GROUP FOUNDER; ABBY LIPMAN – ACCOUNT EXECUTIVE; ERIKA PRIESTLEY – ASSOCIATE MARKETING MANAGER

CLIENT: PEPSI CO.

URL: HTTP://WWW.PEPSIWEINSPIRE.COM/

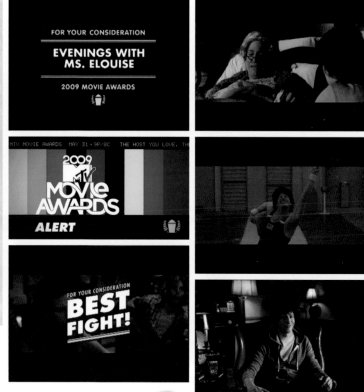

CREATIVE FIRM: BACKYARD PRODUCTIONS, MTV ON–AIR PRO-MOS, MAUDE, MTV OFF–AIR CREATIVE – NEW YORK, NY, USA

CREATIVE TEAM: KEVIN MACKALL, AMY CAMPBELL – CREATIVE DIRECTORS; BRENT STOLLER – EXECUTIVE PRODUCER; AARON STOLLER – DIRECTOR, WRITER, ART DIRECTOR; KRIS WALTER – PRODUCER; JASON KARLEY, AKIVA SHAFFER, ANDY SAMBERG – WRITERS; LIZ EPP – ASSOCIATE PRODUCER; TAMI REIKER – DIRECTOR OF PHOTOGRAPHY; TIFFANY BURCHARD – EDITOR; JORMA TACCONE – MUSIC, SOUND DESIGN; MITCH DORF, STEPHEN DICKSON, JIMMY HITE – AUDIO; THOMAS BERGER – DESIGN DIRECTOR; CHRIS GALLAGHER – ANIMATOR; MARC KLATZKO – MANAGING DIRECTOR, CREATIVE AND MARKETING, MAUDE; DAMION WATERS – INTERACTIVE DESIGNER, MAUDE

CLIENT: MTV

URL: HTTP://WWW.MYMAUDE.COM/MTV/AWARDS/ MA09_160X600_BESTKISS_AWARD.HTML

CREATIVE FIRM: I IMAGINE STUDIO – EVANSTON, IL, USA

CREATIVE TEAM: OLGA WEISS – CREATIVE DIRECTOR; VLAD MOSKVIN – DEVELOPER; ALENA TSIMIS – PRODUCER; LAURENCE MINSKY – COPYWRITER

CLIENT: LAMIN–ART

URL: HTTP://WWW.PEARLESCENCE.COM, GREEN.IIMAGINESTUDIO.COM/?P=1156

CREATIVE FIRM: TRACYLOCKE – DALLAS, TX, USA

CREATIVE TEAM: REGAN HOLLEY – CHIEF CREATIVE OFFICER; ERIC HARRIS – CREATIVE DIRECTOR; CLAY MERRELL – PRINT PRODUCER; BRANDON CRADDOCK, STEPHANIE PAREJA, BRIANA WOLLMAN – ART DIRECTORS; ANTONIO BANOS – COPYWRITER; BRANDIE STEPHAN – ACCOUNT DIRECTOR; CRAIG KUHNER, JACK ANDERSON – PHOTOGRAPHERS

CLIENT: PIZZA HUT

URL: WWW.HITTHEHUT.COM

CREATIVE FIRM: MTVU – NEW YORK, NY, USA

CREATIVE TEAM: ERIC CONTE – VP PRODUCTION; CHRIS MCCARTHY – EXECUTIVE PRODUCER; JOE BUOYE – DIRECTOR OF OPERATIONS; PAUL RICCI – SENIOR PRODUCER; SOPHIA CRANSHAW – SUPERVISING PRODUCER; ANDREA WILLIAMS – WRITER/DIRECTOR; JEFF WOODTON – PRODUCER; JOE ARCIDIACONO – DIRECTOR OF PHOTOGRAPHY; BEN WILLIAMS – EDITOR; JON TROPEA – AUDIO; NOOPUR AGARWAL – DIRECTOR, PUBLIC AFFAIRS; COURTNEY KNOWLES – THE JED FOUNDATION; JASON RZEPKA – VP PRO SOCIAL, PUBLIC AFFAIRS; JANICE GATTI – DIRECTOR, COMMUNICATIONS; CLAUDIA BOJORQUEZ – COORDINATOR PRO SOCIAL, PUBLIC AFFAIRS; PAUL DEGEORGES – SUPERVISING PRODUCER, PRODUCTION ONLINE

CLIENT: MTVU

URL: HTTP://WWW.HALFOFUS.COM/

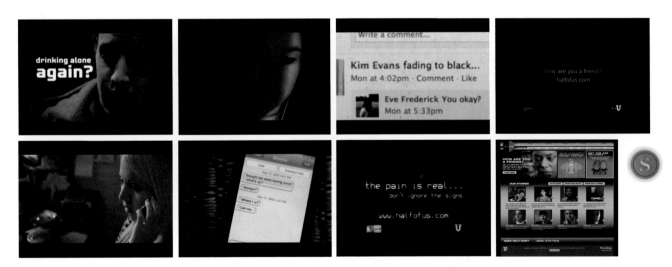

CREATIVE FIRM: PJA ADVERTISING + MARKETING – CAMBRIDGE, MA, USA

CREATIVE TEAM: CHRISTOPHER FRAME – CREATIVE DIRECTOR; DAVE SANDSTEADT, CRISTINA GORDET – ASSOCIATE CREATIVE DIRECTORS; PAUL YOKOTA – SENIOR ART DIRECTOR; ELIZABETH SCHWARTZ – INTERATIVE PRODUCER; KEN DENORSCIA – PRINT PRODUCER

CLIENT: INFOR

URL: HTTP://PRESENTATIONS.AGENCYPJA.COM/PJA/CREATIVITYAWARDS/AM3.PHP

CREATIVE FIRM: DIESTE – DALLAS, TX, USA

CREATIVE TEAM: JAVIER GUEMES – CREATIVE DIRECTOR; ALDO QUEVEDO – CHIEF CREATIVE OFFICER; JAIME HOLCOMBE, MARIO REINOSO – COPYWRITERS; LUIS ENRIQUEZ – ART DIRECTOR; JOHN COSTELLO – EXECUTIVE AGENCY PRODUCER; ALEX DUPLAN – DIRECTOR; PATRICK HAMMON – EDITOR; JOSE SUASTE – COMPOSER

CLIENT: LATINO CULTURAL CENTER

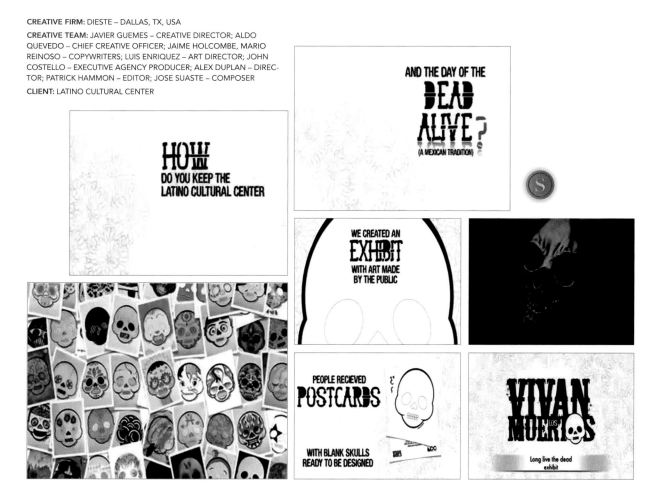

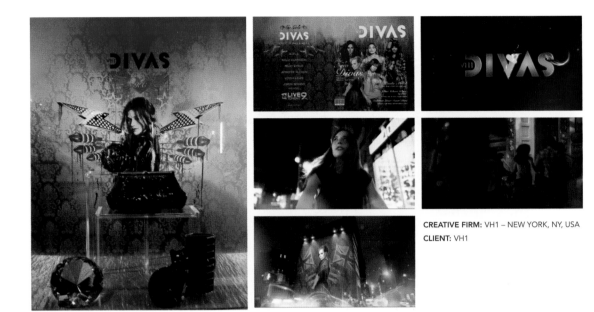

CREATIVE FIRM: VH1 – NEW YORK, NY, USA

CLIENT: VH1

CREATIVE FIRM: DIESTE – DALLAS, TX, USA

CREATIVE TEAM: ALDO QUEVEDO – CHIEF CREATIVE OFFICER; JAVIER GUEMES – CREATIVE DIRECTOR; ALEX WALTUCH, JUAN IGNACIO CHIRINOS – COPYWRITERS; PAM GAMMPER, RODOLFO VARGAS – ART DIRECTORS; PATTY ELMORE – EXECUTIVE AGENCY PRODUCER; BORIS NURKO – AGENCY PRODUCER; CHRIS GIBBSO – EDITOR; GIO – COMPOSER

CLIENT: DIESTE

URL: HTTP://LEAVE09BEHIND.ORG/

The Brief:
Acquire new Rapid Rewards members
IN THE AIRPORTS.

The Solution:
First, create a new form of free media
– the gate boarding monitors.

Second, sign people up in a new way
– via SMS text.

We used boarding monitors
as free media to show
offer video

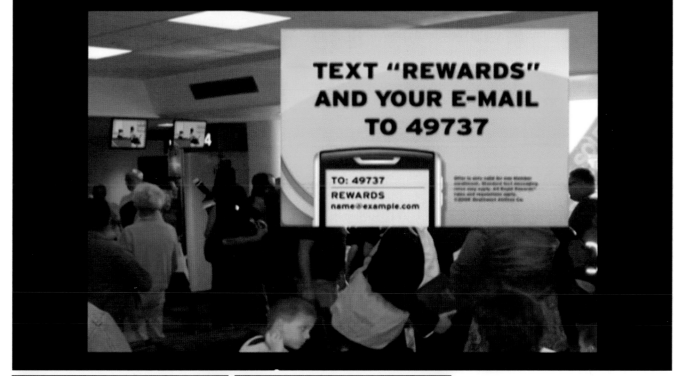

TEXT "REWARDS"
AND YOUR E-MAIL
TO 49737

TO: 49737
REWARDS
name@example.com

The Results:
First year ROI of **295%**
and so successful that
the client has requested
all airport marketing
now include SMS sign-up.

BOOYAH.

Never been done by SWA

1. Use of boarding monitors
 as free media
2. SMS Sign - Up

CREATIVE FIRM: WUNDERMAN – IRVINE, CA, USA
CREATIVE TEAM: ANTHONY DIBIASE – EXECUTIVE CREATIVE DIRECTOR; CRAIG EVANS, SUSIE LIM – CREATIVE DIRECTORS; BEN PETERS – ACD/
COPYWRITER; DAVID BUNNELL – ART DIRECTOR; PIECK PANIKABUTR – SR. INTERACTIVE ART DIRECTOR; RYAN LINDSEY – INTERACTIVE
DESIGNER; BRENT BARBOUR – ACCOUNT DIRECTOR; ERIC UCHIDA – ACCOUNT SUPERVISOR; HEATHER MCCULLOUGH – ACCOUNT EXECUTIVE
CLIENT: SOUTHWEST AIRLINES RAPID REWARDS
URL: HTTP://WWW.OURTHRILLZONE.COM/SOUTHWEST/SMSTEXT/

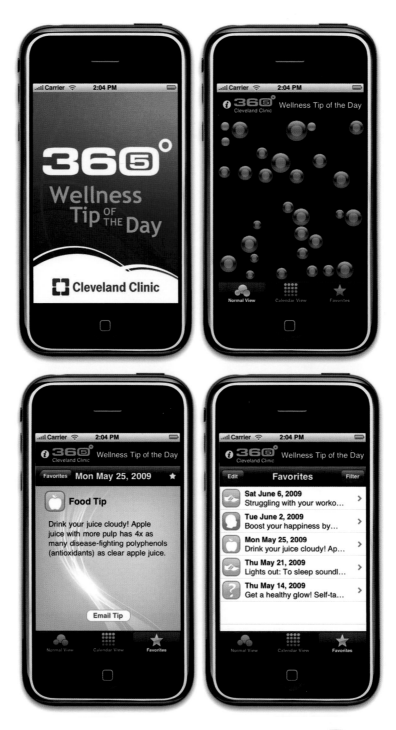

CREATIVE FIRM: BENNETT ADELSON – CLEVELAND, OH, USA
CREATIVE TEAM: CLEVELAND CLINIC WELLNESS ENTERPRISE – 360–5 TEAM
CLIENT: CLEVELAND CLINIC
URL: HTTP://WWW.360–5.COM/FEATURES/DAILYTIP/PAGES/DAILY

NEW MEDIA

PLATINUM

ALICE – WHITE RABBIT

CREATIVE FIRM: FALLON – NEW YORK, NY, USA

CREATIVE TEAM: MICHAEL ENGLEMAN – SVP MARKET-ING: GLOBAL BRAND STRATEGY AND CREATIVE; BLAKE CALLAWAY – SVP MARKETING: BRAND AND INTEGRITY; WILLIAM LEE – CREATIVE DIRECTOR

CLIENT: SYFY

Watch out, Alice–there's a new kind of rabbit hole. To drive viewership for Alice, Syfy's modern–day retelling of the classic tale of Alice in Wonderland, New York agency Fallon focused on the most–remembered character, White Rabbit, as the centerpiece of the campaign.

"We placed rich media banners on promi-nent sites across the web, like USA Today, YouTube, and Gawker," the agency says. These were no ordinary banners, though; the White Rabbit–in the new version, a bizarre human–rabbit hybrid–appeared to literally leap through the webpage, push around page elements, and create gen-eral mischief while beckoning engaged users to follow along. The White Rabbit took viewers on a wild search for through a digital rabbit hole and through a trail of faux microsites for the fictitious Wonder-land Tea Shop and Happy Hearts Casino, eventually arriving at the Alice page at SyFy.com. The campaign's impression rate exceeded expectations, as did the pro-gram itself, drawing a new viewer increase of 28 percent to the newly rebranded network.

CREATIVE FIRM: DEADLINE – LOS ANGELES, CA, USA

CREATIVE TEAM: ERIC KAHN – CREATIVE DIRECTOR, DEADLINE; MATTHEW HOCKMAN – PRODUCER, DEADLINE; EUGENE KIM – DESIGNER, DEADLINE; ERIK HOWARD – TECHNICAL LEAD, DEADLINE

URL: HTTP://WWW.DEAD–LINE.COM/AWARDS/2010/CREATIVITY_UP

CREATIVE FIRM: IAC ADVERTISING – NEW YORK, NY, USA

CREATIVE TEAM: MICHAEL CALLEIA – CREATIVE DIRECTOR; LAURIE SATLER – CUSTOM SOLUTIONS MANAGER; TARA SCOTT – ART DIRECTOR; ALBERTO LANGTON – DESIGNER/FLASH; SHIRIN FLEISCHMAN – ACCOUNT MANAGER; DOMINICK INSANA – STRATEGIC ACCOUNT MANAGER; ANDREA NIELSEN – SALES DEVELOPMENT DIRECTOR

CLIENT: VISA

URL: HTTP://WWW.IACADVERTISING.COM/OMMA/VISA/BANNERGADGET/INDEX.HTML

CREATIVE FIRM: DEADLINE – LOS ANGELES, CA, USA

CREATIVE TEAM: JUSTIN PURTSCHUK – VP DIGITAL MARKETING, DISNEY; MATTHEW HOCKMAN – PRODUCER, DEADLINE; EUGENE KIM – ART DIRECTOR, DEADLINE; JENNA LOLLI – PROJECT COORDINATOR, DEADLINE

CLIENT: WALT DISNEY STUDIOS PICTURE MARKETING

URL: HTTP://WWW.DEAD–LINE.COM/AWARDS/2010/CREATIVITY_WR

CREATIVE FIRM: DEADLINE – LOS ANGELES, CA, USA

CREATIVE TEAM: JUSTIN PURTSCHUK – VP DIGITAL MARKETING, DISNEY; ERIC KAHN – CREATIVE DIRECTOR, DEADLINE; MATTHEW HOCKMAN – PRODUCER, DEADLINE; EUGENE KIM – DESIGNER, DEADLINE

CLIENT: WALT DISNEY STUDIOS PICTURE MARKETING

URL: HTTP://WWW.DEAD–LINE.COM/AWARDS/2010/CREATIVITY_TS

 PLATINUM

CREATIVE FIRM: RPM GROUP – NEW YORK, NY, USA

CREATIVE TEAM: FRANK COOPER – SVP, CHIEF CONSUMER ENGAGEMENT OFFICER; LAUREN SCOTT – SENIOR MARKETING MANAGER; LYLETTE PIZARRO – RPM GROUP PARTNER; FRANZ ALIQUO – SENIOR STRATEGIST; RENE MCLEAN – RPM GROUP FOUNDER; ABBY LIPMAN – ACCOUNT EXECUTIVE; ERIKA PRIESTLEY – ASSOCIATE MARKETING MANAGER

CLIENT: PEPSI CO.

URL: HTTP://WWW.PEPSIWEINSPIRE.COM/

CREATIVE FIRM: RULE29 – GENEVA, IL, USA
CREATIVE TEAM: JUSTIN AHRENS – OWNER/CREATIVE DIRECTOR; TIM DAMITZ – LEAD DESIGNER
CLIENT: NEENAH PAPER
URL: HTTP://WWW.NEENAHPAPERBLOG.COM/

CREATIVE FIRM: BILLUPS DESIGN – CHICAGO, IL, USA
URL: HTTP://WWW.STAIRWELLBLOG.COM

CREATIVE FIRM: WORLD WIDE WEB DOMINATION – CYBERJAYA, SELANGOR, MALAYSIA

CLIENT: LIMKOKWING UNIVERSITY OF CREATIVE TECHNOLOGY

URL: BLOG.LIMKOKWING.COM

CREATIVE FIRM: PJA ADVERTISING + MARKETING – CAMBRIDGE, MA, USA

CREATIVE TEAM: AARON DASILVA – CREATIVE DIRECTOR; JANUARY SPALATRO – ART DIRECTOR; MIKE O'TOOLE – PRESIDENT; PHIL JOHNSON – CEO; DOUG REYNOLDS – INTERACTIVE PRODUCER; MATT MAGEE – INTERACTIVE STRATEGIST

CLIENT: PJA ADVERTISING + MARKETING

URL: HTTP://PRESENTATIONS.AGENCYPJA.COM/PJA/CREATIVITYAWARDS/NM1.PHP

CREATIVE FIRM: RULE29 – GENEVA, IL, USA
CREATIVE TEAM: JUSTIN AHRENS – OWNER/CREATIVE DIRECTOR
CLIENT: LIFE IN ABUNDANCE

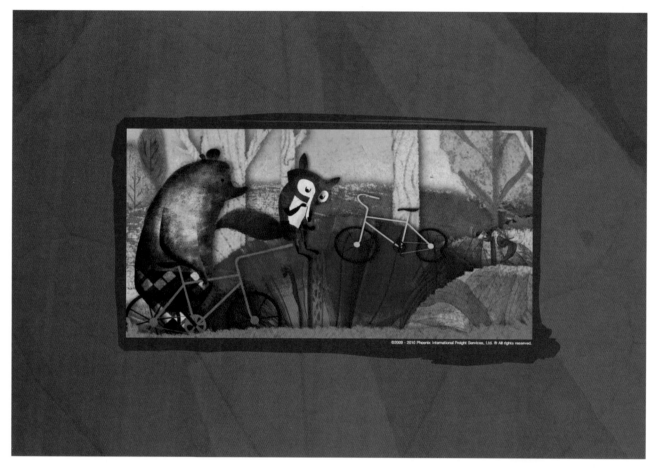

CREATIVE FIRM: HYPELIFE BRANDS – KANSAS CITY, MO, USA
CREATIVE TEAM: CURT CUSCINO – CREATIVE DIRECTOR; KRISTEN HOWDESHELL – ANIMATOR; KEVIN HOWDESHELL – LEAD DESIGNER
CLIENT: PHOENIX INTERNATIONAL
URL: HTTP://WWW.PHOENIXINTL.COM/ECARD/

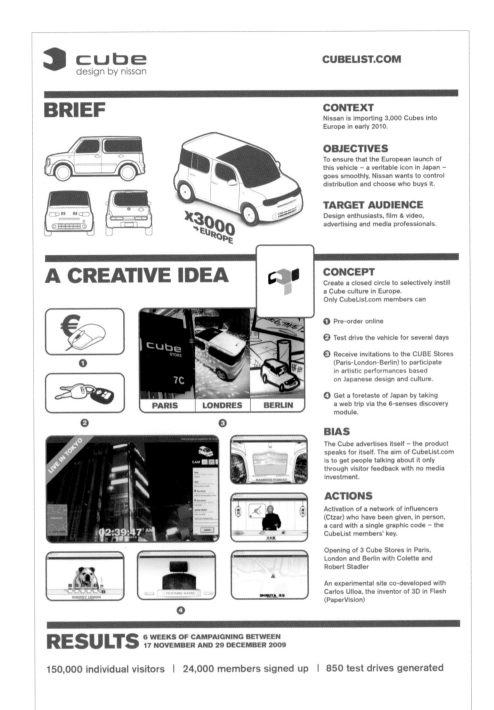

PLATINUM

CREATIVE FIRM: DNA – NEUILLY–SUR–SEINE, FRANCE
CREATIVE TEAM: OLIVIER DELAS – CHIEF CREATIVE OFFICER; VINCENT DRUGUET – DEPUTY CLIENT SERVICE DIRECTOR; JEAN–BAPTISTE BURDIN – CREATIVE DIRECTOR
CLIENT: NISSAN EUROPE
URL: HTTP://DEMO.BISYSTEM.COM/NISSAN_CUBELIST

WIREFRAMES
Widgets libraries and easy to use tools for layout and formatting will help your wireframes come together in no time.

PROTOTYPES
With one-click HTML prototype generation, Axure RP brings your designs to life without writing a single line of code.

SPECIFICATIONS
Specification generation with customizable templates and formatting options will make your job much less painful.

COLLABORATION
Integrated source control helps your team simultaneously on a project and maintain a history for your projects.

CREATIVE FIRM: MEL LIM DESIGN – SAN DIEGO, CA, USA

CREATIVE TEAM: MEL LIM – DESIGN DIRECTOR; JOE KEYLON – SENIOR USER INTERFACE ARTIST

CLIENT: AXURE SOFTWARE SOLUTIONS

CREATIVE FIRM: YUDU PUBLISHING – LONDON, UNITED KINGDOM

URL: WWW.YUDU.COM

CREATIVE FIRM: RPM GROUP – NEW YORK, NY, USA

CREATIVE TEAM: FRANK COOPER – SVP, CHIEF CONSUMER ENGAGEMENT OFFICER; LAUREN SCOTT – SENIOR MARKETING MANAGER; LYLETTE PIZARRO – RPM GROUP PARTNER; FRANZ ALIQUO – SENIOR STRATEGIST; RENE MCLEAN – RPM GROUP FOUNDER; ABBY LIPMAN – ACCOUNT EXECUTIVE; ERIKA PRIESTLEY – ASSOCIATE MARKETING MANAGER

CLIENT: PEPSI CO.

URL: HTTP://WWW.PEPSIWEINSPIRE.COM/

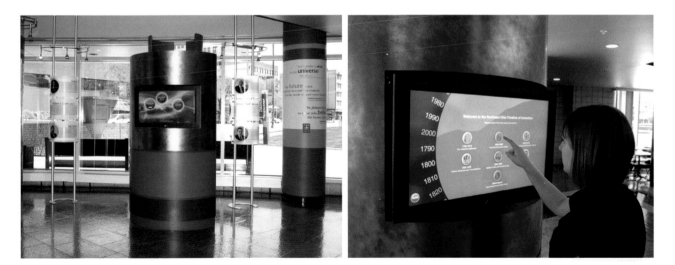

CREATIVE FIRM: KAREN SKUNTA & COMPANY – CLEVELAND, OH, USA

CREATIVE TEAM: KAREN A. SKUNTA – CREATIVE DIRECTOR; FELIX LEE – SR. GRAPHIC DESIGNER, INTERACTIVE; BLUE ROBOT – INTERACTIVE DEVELOPER

CLIENT: CLEVELAND STATE UNIVERSITY NANCE COLLEGE OF BUS.

NEW MEDIA & WEB DESIGN

GREEN DIGITAL

 PLATINUM

CREATIVE FIRM: HYPELIFE BRANDS –
KANSAS CITY, MO, USA

CREATIVE TEAM: CURT CUSCINO – CREATIVE DIRECTOR;
KRISTEN HOWDESHELL – ANIMATOR; KEVIN HOWDESHELL
– LEAD DESIGNER

CLIENT: PHOENIX INTERNATIONAL

URL: HTTP://WWW.PHOENIXINTL.COM/ECARD/

A bear rides a bicycle through an idyllic wooded area on the edge of town. The ursine shares its transportation with various animals, then picnics with squirrels and other animals that share their bounty. Such is the delightful tableau created by HYPELIFE Brands out of Kansas City. "Our goal for this interactive piece was to help Phoenix International, North America's largest privately held, full–service international global logistics provider and freight forwarding organization, bring awareness to the pillars of to their new sustainability

PHOENIX INTERNATIONAL 2009 HOLIDAY E–CARD

program, Phoenix Forward," says principal and creative director Curt Cuscino, "and promote holiday goodwill in an internationally sensitive e–card to be distributed amongst their international employee and client base."

HYPELIFE built the card around Phoenix International's three core pillars: Planet, People, and Prosperity. "For this year's holiday e–card/interactive piece, we set out to develop a narrative around these three pillars of the program, with a story that anyone can understand and relate to independent a particular ethnicity, religion, or geographic location during the holiday season," says Cuscino. "Each of the characters that we developed for this e–card was designed to demonstrate one of these three pillars to the viewer, and also show a community interacting with

each other in a way that benefits everyone positively."

`In line with the program's focus, Phoenix International invested in the creation of this digital promotional piece in an effort to further reduce their paper consumption, rather than printing and sending thousands of holiday cards. Additionally, the card invites viewers to join them in contributing to Habitat for Humanity, and continue sending along the card–for free. "Not only could Phoenix International employees share this with their clients and vendors, but then those clients and vendors could pass the goodwill forward to others, and so on," Cuscino explains.

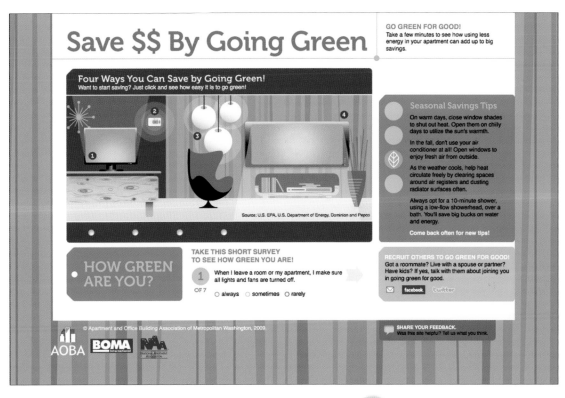

Save $$ By Going Green

GO GREEN FOR GOOD!
Take a few minutes to see how using less energy in your apartment can add up to big savings.

Four Ways You Can Save by Going Green!
Want to start saving? Just click and see how easy it is to go green!

Source: U.S. EPA, U.S. Department of Energy, Dominion and Pepco

Seasonal Savings Tips

On warm days, close window shades to shut out heat. Open them on chilly days to utilize the sun's warmth.

In the fall, don't use your air conditioner at all! Open windows to enjoy fresh air from outside.

As the weather cools, help heat circulate freely by clearing spaces around air registers and dusting radiator surfaces often.

Always opt for a 10-minute shower, using a low-flow showerhead, over a bath. You'll save big bucks on water and energy.

Come back often for new tips!

HOW GREEN ARE YOU?

TAKE THIS SHORT SURVEY TO SEE HOW GREEN YOU ARE!

 1 OF 7 — When I leave a room or my apartment, I make sure all lights and fans are turned off.

○ always ○ sometimes ○ rarely

RECRUIT OTHERS TO GO GREEN FOR GOOD!
Got a roommate? Live with a spouse or partner? Have kids? If yes, talk with them about joining you in going green for good.

facebook twitter

© Apartment and Office Building Association of Metropolitan Washington, 2009.

AOBA BOMA International NAA National Apartment Association

SHARE YOUR FEEDBACK.
Was this site helpful? Tell us what you think.

CREATIVE FIRM: DESIGN NUT, LLC – KENSINGTON, MD, USA
CREATIVE TEAM: BRENT M. ALMOND – DESIGNER; MICHAEL SCHAFER – PROGRAMMER
CLIENT: APARTMENT AND OFFICE BUILDING ASSOCIATION
URL: HTTP://WWW.AOBA–METRO.ORG/GOGREEN/

Ski Challenge - PROVE IT
The first social media iPhone application dedicated to the skiers community. It supports the Nissan Qashqai PROVE IT cross-media winter campaign launched in 45 European ski resorts:

Including :

- Stunning interactive 3D maps of the resorts, turn around, zoom in, zoom out, localize themselves as well as their friends on top of the slopes.

- Social features: share tricks, publish geo-localized photos, videos and events on the application 3D maps and on Facebook, send messages to friends or schedule meetings at the closest mountain top bar with the resort guide application

- With the "Record your run" module, record real-time videos –or photos– of your ski run on the slopes and publish them through Facebook Connect. iPhone users prove their skills and measure up to the whole PROVE IT community!

The most rated participant will be the winner and will have a Qashqai.

> Download

> www.nissan-proveit.com

CREATIVE FIRM: DNA – NEUILLY–SUR–SEINE, FRANCE
CREATIVE TEAM: OLIVIER DELAS – CHIEF CREATIVE OFFI-CER; JEAN BAPTISTE BURDIN – CREATIVE DIRECTOR; MAX VINALL – COPYWRITER; YASUSHI ZONNO – ART DIRECTOR
CLIENT: NISSAN EUROPE
URL: HTTP://DEMO.BISYSTEM.COM/SKICHALLENGE/

CREATIVE FIRM: HSAD – SEOUL, SOUTH KOREA
CLIENT: LG TELECOM

CREATIVE FIRM: HYPELIFE BRANDS –
KANSAS CITY, MO, USA
CREATIVE TEAM: CURT CUSCINO –
CREATIVE DIRECTOR
CLIENT: THE MODEL CONGRESS
URL: HTTP://TINYURL.COM/THEMOD-
CONAPP

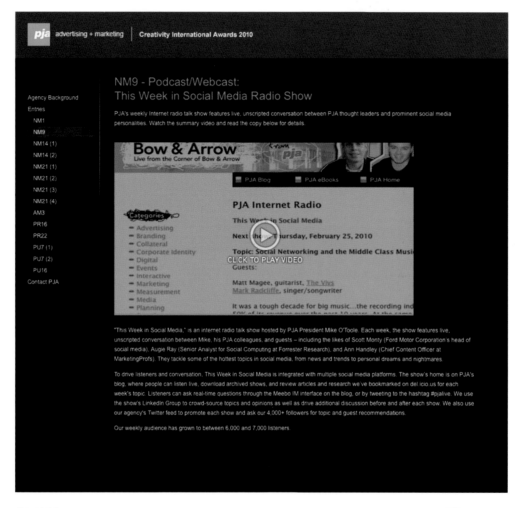

CREATIVE FIRM: PJA ADVERTISING + MARKETING – CAMBRIDGE, MA, USA

CREATIVE TEAM: MIKE O'TOOLE – PRESIDENT; MATT MAGEE – INTERACTIVE STRATEGIST; CHRISTOPHER SCOTT – PRODUCER; AARON DASILVA – CREATIVE DIRECTOR; JANUARY SPALARATRO – ART DIRECTOR

CLIENT: PJA ADVERTISING + MARKETING

URL: HTTP://PRESENTATIONS.AGENCYPJA.COM/PJA/CREATIVITYAWARDS/NM9.PHP

Ski Challenge - PROVE IT

The first social media iPhone application dedicated to the skiers community. It supports the Nissan Qashqai PROVE IT cross-media winter campaign launched in 45 European ski resorts:

Including :

- Stunning interactive 3D maps of the resorts, turn around, zoom in, zoom out, localize themselves as well as their friends on top of the slopes.

- Social features: share tricks, publish geo-localized photos, videos and events on the application 3D maps and on Facebook, send messages to friends or schedule meetings at the closest mountain top bar with the resort guide application

- With the "Record your run" module, record real-time videos –or photos– of your ski run on the slopes and publish them through Facebook Connect. iPhone users prove their skills and measure up to the whole PROVE IT community!

The most rated participant will be the winner and will have a Qashqai.

> **Download**

> **www.nissan-proveit.com**

CREATIVE FIRM: DNA/DIGITAS – NEUILLY–SUR–SEINE, FRANCE

CREATIVE TEAM: PHONEVALLEY – AGENCY; OLIVIER DELAS – CHIEF CREATIVE OFFICER; JEAN–BAPTISTE BURDIN – CREATIVE DIRECTOR; MAX VINALL – COPYWRITER; YASUSHI ZONNO – ART DIRECTOR

CLIENT: NISSAN EUROPE

URL: HTTP://DEMO.BISYSTEM.COM/SKICHALLENGE/

CREATIVE FIRM: PJA ADVERTISING + MARKETING – CAMBRIDGE, MA, USA

CREATIVE TEAM: CHRISTOPHER FRAME – CREATIVE DIRECTOR; DAVE SANDSTEADT, CRISTINA GORDET – ASSOCIATE CREATIVE DIRECTORS; PAUL YOKOTA – SENIOR ART DIRECTOR; ELIZABETH SCHWARTZ – INTERACTIVE PRODUCER

CLIENT: INFOR

URL: HTTP://PRESENTATIONS.AGENCYPJA.COM/PJA/CREATIVITYAWARDS/NM21–4.PHP

CREATIVE FIRM: IAC ADVERTISING – NEW YORK, NY, USA

CREATIVE TEAM: MICHAEL CALLEIA – CREATIVE DIRECTOR; LAURIE SATLER – CUSTOM SOLUTIONS MANAGER; TARA SCOTT – SENIOR DESIGNER; CHRIS COFFEE – ACCOUNT MANAGER; AMY MBAGWU – STRATEGIC ACCOUNT MANAGER; ANDREA NIELSEN – SALES DEVELOPMENT DIRECTOR; AIMEE WARNER – CLIENT SERVICES PROJECT MANAGER, EVI

CLIENT: HEAVEN HILL DISTILLERIES

URL: HTTP://WWW.EVITE.COM/PAGES/INVITE/VIEWINVITE.JSP?INVITEID=UYAJGEMQESFEQHIBPHWT&LI=IQ&SRC=EMAIL&TRK=AEI6

CREATIVE FIRM: PJA ADVERTISING + MARKETING – CAMBRIDGE, MA, USA

CREATIVE TEAM: MIKE O'TOOLE – PRESIDENT; PHIL JOHNSON – CEO; MATT MAGEE – INTERACTIVE STRATEGIST; AARON DASILVA – CREATIVE DIRECTOR; JANUARY SPALATRO – ART DIRECTOR; DOUG ZANGER – HOST

CLIENT: PJA ADVERTISING + MARKETING

URL: HTTP://PRESENTATIONS.AGENCYPJA.COM/PJA/CREATIVITYAWARDS/NM21–3.PHP

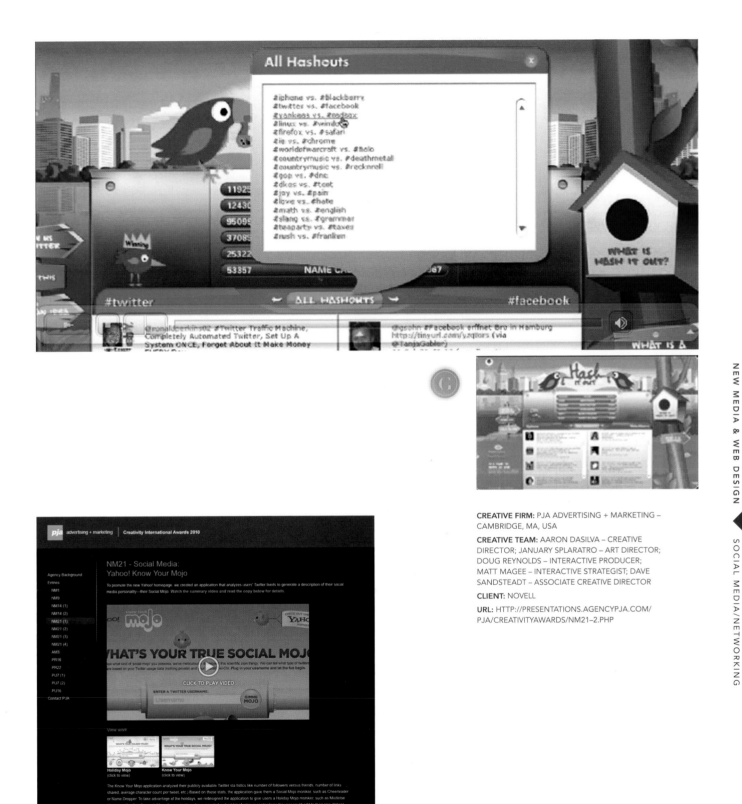

CREATIVE FIRM: PJA ADVERTISING + MARKETING –
CAMBRIDGE, MA, USA

CREATIVE TEAM: AARON DASILVA – CREATIVE
DIRECTOR; JANUARY SPLARATRO – ART DIRECTOR;
DOUG REYNOLDS – INTERACTIVE PRODUCER;
MATT MAGEE – INTERACTIVE STRATEGIST; DAVE
SANDSTEADT – ASSOCIATE CREATIVE DIRECTOR

CLIENT: NOVELL

URL: HTTP://PRESENTATIONS.AGENCYPJA.COM/
PJA/CREATIVITYAWARDS/NM21–2.PHP

CREATIVE FIRM: PJA ADVERTISING + MARKETING – CAMBRIDGE, MA, USA

CREATIVE TEAM: AARON DASILVA – CREATIVE DIRECTOR; DAVE SANDSTEADT – ASSOCI-
ATE CREATIVE DIRECTOR; JANUARY SPLARATRO – ART DIRECTOR; DOUG REYNOLDS
– INTERACTIVE PRODUCER; MATT MAGEE – INTERACTIVE STRATEGIST

CLIENT: YAHOO!

URL: HTTP://PRESENTATIONS.AGENCYPJA.COM/PJA/CREATIVITYAWARDS/NM21–1.PHP

PLATINUM

BIOSHOCK 2

CREATIVE FIRM: ROKKAN – SAN FRANCISCO, CA, USA

CREATIVE TEAM: CHARLES BAE – EXECUTIVE CREATIVE DIRECTOR; MATT BURNISTON – 3D ARTIST; ERROL SCHWARTZ – FLASH DEVELOPER; BRIAN CARLEY – CREATIVE DIRECTOR; RUSSELL SAVAGE – TECHNICAL DIRECTOR; JENNIFER MEEKER – SENIOR INTERACTIVE PRODUCER

CLIENT: 2K GAMES

URL: HTTP://WWW.BIOSHOCK2GAME.COM/EN/

Bioshock was one of the most highly regarded and critically praised first–person shooter video games of all time, and coming up with an equally compelling sequel was a tall order. To market Bioshock 2, 2K Games approached San Francisco's Rokkan agency, which had been with them from the start. "In short, the client wanted something totally badass and a bit frightening," says executive creative director Charles Bae. "There was a lot of pressure and huge expectations from 2K, but having done the original two Bioshock sites, we were well prepared to top those online experiences."

As with most game marketing, the online components were meant to build awareness and most importantly, get people pumped—all without giving away too much. "We worked with 2K to come up with a game site concept that revolved around telling a different side of the story that wasn't necessarily found in the game," Bae says. "We thought it would be cool and different from typical game marketing." Rokkan's winning concept was a unique, metaphoric glimpse into the mind of one of the key characters of the game, the Big Sister, using video, 3D, and photo compositing. The 3D and motion team developed all the elements based on sketches and artwork from the BioShock 2 development team—an unusual creation, as game studios usually prohibit the creation of new assets by an outside vendor.

"Every element we used had to relate to the game's Art Deco period infused with the concept of a failed utopia," explains Bae. "Compositionally, many of the repeating shapes evoke movement that alludes to the utopian/anything–is–possible mentality of the Roaring '20s, as well as the advances in machine tech. This was the creative basis for the entire site."

CREATIVE FIRM: PERSUASIVE GAMES – NEW YORK, NY, USA

CREATIVE TEAM: SOPHIA CRANSHAW – SUPERVISING PRODUCER; DAX MARTINEZ–VARGAS – WRITER/DIRECTOR; JEFF WOODTON – PRODUCER; SUPERFAD – GRAPHICS/ANIMATION; PAUL HAMMER, DAVID PERLICK MOLINARI – AUDIO; STEPHEN FRIEDMAN – EVP & GENERAL MANAGER, MTV; ROSS MARTIN – SVP, MTV 360 DEVELOPMENT AND PRODUCTION; ERIC CONTE – VP OF PRODUCTION, MTVU; PAUL RICCI – SUPERVISING PRODUCER, MTVU; KRISTEN PIETROPOLI – COORDINATING PRODUCER, MTVU; CHRIS MCCARTHY – SVP MTV STRATEGIC DEVELOPMENT/DIGITAL TV NETWORKS; SHANA PETTA – VP MTV360 MARKETING; JASON RZEPKA – VP PRO SOCIAL, PUBLIC AFFAIRS; JANICE GATTI – DIRECTOR, COMMUNICATIONS; NOOPUR AGARWAL – DIRECTOR PUBLIC AFFAIRS, MTV360; CLAUDIA BOJORQUEZ – COORDINATOR PRO SOCIAL, PUBLIC AFFAIRS; PETER NILSSON – VP TECHNOLOGY & OPS, CMN; PAUL DEGEORGES – SUPERVISING PRODUCER, PRODUCTION ONLINE; MARK TICHY – PRODUCER, MTV.COM PRODUCTION; SERAFIN VAZQUEZ – DIRECTOR USER INTERFACE, CMN

CLIENT: MTVU

URL: HTTP://WWW.INDEBTED.COM/THE–GAME/DEBTSKI/

laposte.fr/lre

PLATINUM

TRANSFORMER

CREATIVE FIRM: EURO RSCG C&O – PARIS, FRANCE

CREATIVE TEAM: OLIVIER MOULIERAC, JÉRÔME GALINHA – CREATIVE DIRECTORS; SAMUEL KADZ – CREATIVE DIRECTOR & ART DIRECTOR; GILLES FANUCHI – ART DIRECTOR; CÉCILE EAP – TV PRODUCER; DAVID NICOLAS – DIRECTOR; THE DARK ROOM @ PARTIZAN – PRODUCTION COMPANY; VÉRONIQUE VARLIN, DOUNIA ALNO – AGENCY MANAGERS; THIERRY HERRANT, AGNÈS PRESBERG – LA POSTE MANAGERS; KARIM OURABAH – AGENCY PRODUCER; NUMÉRO 6 – POST-PRODUCTION COMPANY

CLIENT: LA POSTE

URL: HTTP://WWW.YOUTUBE.COM/WATCH?V=TVWHRJIRGP0

Due to the use of the Internet for written exchanges and business transactions, post offices everywhere are hurting. For crucial communications that still must be sent (and received) the old–fashioned way, La Poste, France's main postal operator, created the Electronic Register Letter. La Poste asked Paris agency Euro Rscg C&O to promote this service while putting an emphasis on this high–potential product and position the service as still relevant as a modern mail operator.

Mission accomplished. In the minute–long spot, what appears to be a simple tutorial for how to send a letter via computer

takes a slightly surreal turn as the laptop computer sprouts wings (à la Transformers) and flies off to deliver its message as its startled owner calls after it.

"The challenge was all about the product demonstration," the firm explains. "Here, it is enriched by animations and special effects anchored in a very realistic image. We think that beyond that scenario, the technical performance represents the transformation and the final 'UFO' in a very realistic way."

CREATIVE FIRM: ZED COMMUNICATIONS –
DUBAI, UNITED ARAB EMIRATES

CREATIVE TEAM: ROBERT MITCHELL
– MANAGING DIRECTOR; MANPREET
SEERA – CREATIVE DIRECTOR; REX MUNDO
– COPYWRITER; MOHAMMAD ATIF – WEB
DEVELOPER; ADAM NEILAND, RAJESH
KUMAR – WEB DESIGNERS

CLIENT: ABU DHABI AWARDS

URL: HTTP://WWW.ABUDHABIAWARDS.AE/
NAME.HTM

CREATIVE FIRM: COLENSO BBDO – AUCKLAND, NEW ZEALAND

CREATIVE TEAM: NICK WORTHINGTON – EXECUTIVE CREATIVE DIRECTOR/ART DIRECTOR/COPYWRITER; ANNE BOOTHROYD, LEN
CHEESEMAN – ART DIRECTORS/COPYWRITERS; MICHAEL REDWOOD, ANGELA WATSON – GROUP ACCOUNT DIRECTORS; NIGEL SUT-
TON – AGENCY PRODUCER; ANDERSEN M STUDIO – PRODUCTION COMPANY; LINE AND MARTIN ANDERSEN, ANDERSEN M STUDIO –
DIRECTORS; MIKKEL H. ERIKSEN, INSTRUMENT STUDIO, LONDON – SOUND DESIGN; MARTIN ANDERSEN, ANDERSEN M STUDIO – DOP/
EDITOR; LINE ANDERSEN, ANDERSEN M STUDIO – ANIMATION

CLIENT: NEW ZEALAND BOOK COUNCIL

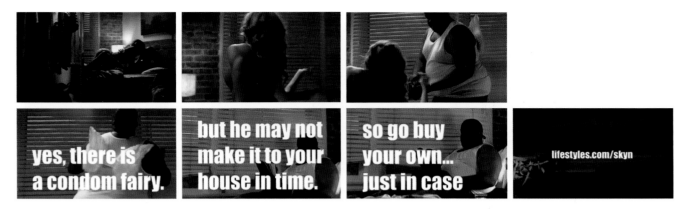

CREATIVE FIRM: AMP AGENCY– BOSTON/BEST* COMPANY EVER, INC. – EL SEGUNDO, CA, USA

CREATIVE TEAM: LAURA MURPHY & EILEEN DOHERTY – DIRECTORS, BEST*; CRISTOFF LANZENBERG – DIRECTOR OF PHOTOGRAPHY; ADAM SVATEK – EDITOR, BEAST, LA; PETER GWINN – CREATIVE DIRECTOR, AMP AGENCY, BOSTON; DIANE CASTRUP – LINE PRODUCER, BEST*; JENNIFER PEEPLES – ACCOUNT SUPERVISOR, AMP AGENCY, BOSTON; BEACON STREET STUDIOS, LA – COMPOSER; NEW HAT, LA – TELECINE

CLIENT: LIFESTYLES CONDOMS

CREATIVE FIRM: ANIDEN INTERACTIVE – HOUSTON, TX, USA

CLIENT: HEWLETT–PACKARD

URL: HTTP://VIMEO.COM/CHANNELS/51835

CREATIVE FIRM: EWEN INDUSTRIES, INC. – NEW YORK, NY, USA

CREATIVE TEAM: PAUL KLEIN – GENERAL ELECTRIC CONSUMER PRODUCTS; SAMUEL EWEN, INTERFERENCE, INC. – CREATIVE DIRECTOR; ROHIT SANG – WRITER; PAUL EWEN – DIRECTOR/ EDITOR; TODD SOMODEVILLA – DIRECTOR OF PHOTOGRAPHY; BECKY MORRISON – PRODUCER; GREG MACDONALD – ANIMATION AND GRAPHICS; LARRY BUKSBAUM – SOUND DESIGN AND AUDIO MIX

CLIENT: INTERFERENCE INC./GE APPLIANCES

URL: HTTP://WWW.YOUTUBE. COM/WATCH?V=N0RVVMGMXCI

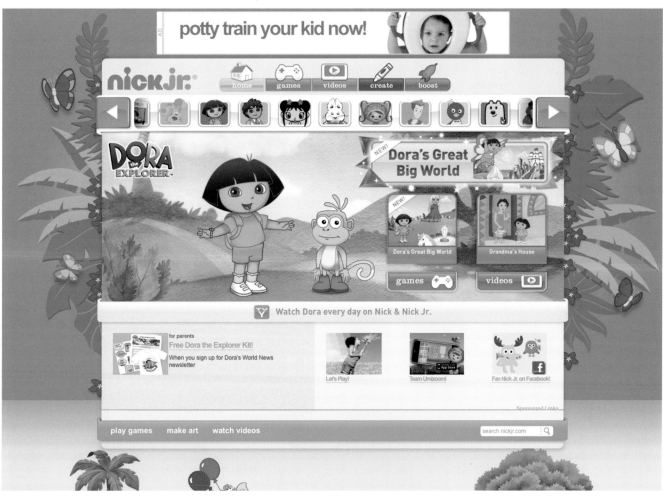

 PLATINUM

CREATIVE FIRM: CRICKET MOON MEDIA – NEW YORK, NY, USA

CREATIVE TEAM: RENATO CASTILHO – DESIGN DIRECTOR; STEVE HERNANDEZ – ART DIRECTOR; ROBERT KOHR – ANIMATION DIRECTOR; JORDANA DRELL – PRODUCTION DIRECTOR; SUSAN GARGIULO – PRODUCER

CLIENT: NICKELODEON KIDS AND FAMILY GROUP

URL: HTTP://WWW.NICKJR.COM/KIDS/DORA–THE–EXPLORER/

CREATIVE FIRM: NICKELODEON KIDS AND FAMILY GROUP – NEW YORK, NY, USA

CREATIVE TEAM: RENATO CASTILHO – DESIGN DIRECTOR; STEVE HERNANDEZ – ART DIRECTOR; ROBERT KOHR – DESIGNER/ANIMATOR; REBECCA ZELO – SR. PRODUCER; KENNETH JOHNSON – PRODUCER; TREVOR THOMPSON – LEAD TECHNOLOGIST; JORDANA DRELL – PRODUCTION DIRECTOR

CLIENT: NICKELODEON KIDS AND FAMILY GROUP

URL: HTTP://WWW.NICKJR.COM/KIDS

CREATIVE FIRM: SINGULARITY DESIGN – PHILADELPHIA, PA, USA

CLIENT: MID–ATLANTIC DAIRY ASSOCIATION

URL: HTTP://WWW.OPERATIONDAIRY.COM

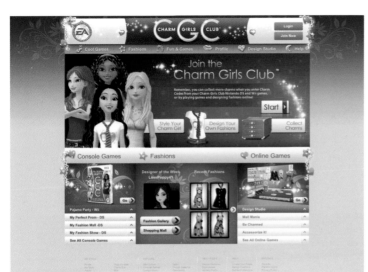

CREATIVE FIRM: DEADLINE – LOS ANGELES,
CA, USA
CLIENT: ELECTRONIC ARTS
URL: HTTP://WWW.CHARMGIRLSCLUB.
COM/HOME.ACTION

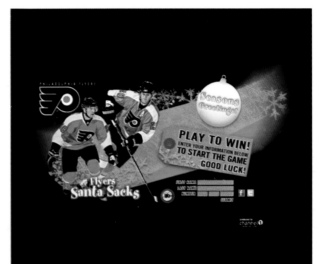

CREATIVE FIRM: CHANNEL 1 MEDIA SOLUTIONS
INC. – TORONTO, ON, CANADA
CREATIVE TEAM: EVAN KARASICK – PRESIDENT
CLIENT: PHILADELPHIA FLYERS
URL: WWW.CHANNEL1MEDIA.COM/NEWFLY-
ERS/2009

CREATIVE FIRM: DEADLINE – LOS
ANGELES, CA, USA
CLIENT: ELECTRONIC ARTS
URL: HTTP://LPSO.COM/

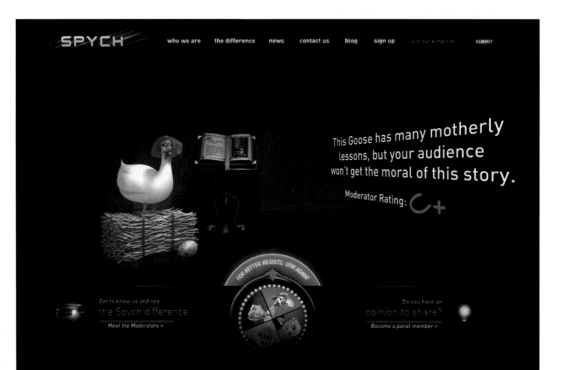

 PLATINUM

SPYCH RESEARCH WEBSITE

CREATIVE FIRM: SINGULARITY DESIGN –
PHILADELPHIA, PA, USA
CLIENT: SPYCH RESEARCH
URL: HTTP://WWW.SPYCHRESEARCH.COM

The last thing market research firm Spych wanted was to be perceived as another boring company. Instead of taking the clinical tack, Philadelphia's Singularity Design developed a brand story around what makes Spych different—complete with familiar characters drawn from archetypes familiar to its Generation X and Millennial audience and representing its competition: Mother Goose, an alien, the "noob," and, finally, the Spych professional.

"We knew the website should be exciting and unique," the agency says, "positioning Spych as an innovative, tech–savvy, passionate company run by young professionals." To get into that mindset, Singularity listed

Spych characteristics as "fun," "friendly," "hip," "professional," "intuitive," "modern," "alive," and "smart" and NOT "corporate," "busy," "dark," "boring," "frustrating to use," "unpredictable," "bland," "static," and "dated."

Singularity used Flash video manipulation with Papervision3D, and also built the site using a Flash–based content management system to deliver the key information and set the brand apart in the eyes of both its prospective clients and its intended demographic. Spych's founder and managing partner Ben Smithee summed up the agency's efforts in patently Gen X/ Millennial language: "You guys seriously rocked it with the site!"

CREATIVE FIRM: PJA ADVERTISING + MARKETING – CAMBRIDGE, MA, USA

CREATIVE TEAM: AARON DASILVA – CREATIVE DIRECTOR; BRIAN BERNIER, DAVE SANDSTEADT – ASSOCIATE CREATIVE DIRECTORS; ELIZABETH SCHWARTZ – INTERACTIVE PRODUCER

CLIENT: NOVELL/MICROSOFT

URL: HTTP://PRESENTATIONS.AGENCYPJA.COM/PJA/CREATIVITYAWARDS/NM14–2.PHP

CREATIVE FIRM: VML – CHICAGO, IL, USA

CREATIVE TEAM: MOLLY E. SPATARA – SENIOR DIRECTOR, INTERNET MARKETING, ACCENTURE; STEVE MCGINNIS – ACCOUNT DIRECTOR, VML

CLIENT: ACCENTURE

URL: HTTP://WWW.ACCENTURE.COM

CREATIVE FIRM: KAREN SKUNTA & COMPANY – CLEVELAND, OH, USA

CREATIVE TEAM: KAREN A. SKUNTA – CREATIVE DIRECTOR; FELIX LEE – SR. GRAPHIC DESIGNER, INTERACTIVE

CLIENT: KAREN SKUNTA & COMPANY

URL: HTTP://WWW.SKUNTA.COM/

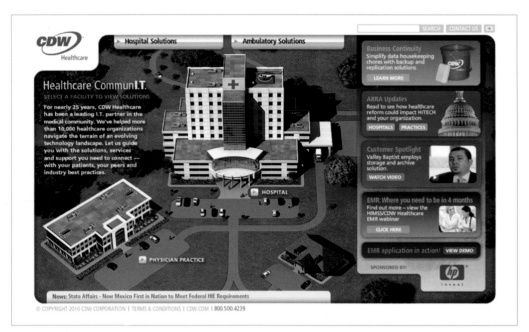

CREATIVE FIRM: STUDIONORTH – NORTH CHICAGO, IL, USA
CLIENT: CDW HEALTHCARE
URL: HTTP://WWW.CDWCOMMUNIT.COM/

CREATIVE FIRM: THE BASEMENT
DESIGN + MOTION – INDIANAPO-
LIS, IN, USA
CLIENT: PRECISE PATH ROBOTICS
URL: HTTP://WWW.PRECISEPATH.
COM/

CREATIVE FIRM: MJE MARKETING SERVICES – SAN DIEGO, CA, USA

CREATIVE TEAM: MARLEE EHRENFELD – CREATIVE DIRECTOR; AARON ISHAEIK – ART DIRECTOR; BRUCE GRESHAM – WEB DEVELOPER

CLIENT: MJE MARKETING SERVICES

URL: MJEMARKETING.COM

CREATIVE FIRM: LUON – OVERIJSE, BELGIUM

CLIENT: EDUCAM

URL: WWW.EDUCAM.BE

CREATIVE FIRM: BLUE–INFINITY – CAROUGE, SWITZERLAND

CLIENT: SWISS INSTITUTE OF BIOINFORMATICS

URL: HTTP://WWW.ISB–SIB.CH/

CREATIVE FIRM: BILLUPS DESIGN – CHICAGO, IL, USA
CREATIVE TEAM: DAVID MCPHERSON – GENERAL MANAGER, HIGHSCHOOLSPORTS.NET
CLIENT: HIGH SCHOOL SPORTS / GANNETT
URL: HTTP://WWW.HIGHSCHOOLSPORTS.NET

CREATIVE FIRM: MSDS – NEW YORK, NY, USA
CLIENT: CORTERA
URL: WWW.CORTERA.COM

CREATIVE FIRM: JPL – HARRISBURG, PA, USA
CLIENT: MODJESKI & MASTERS
URL: HTTP://WWW.MODJESKI.COM/

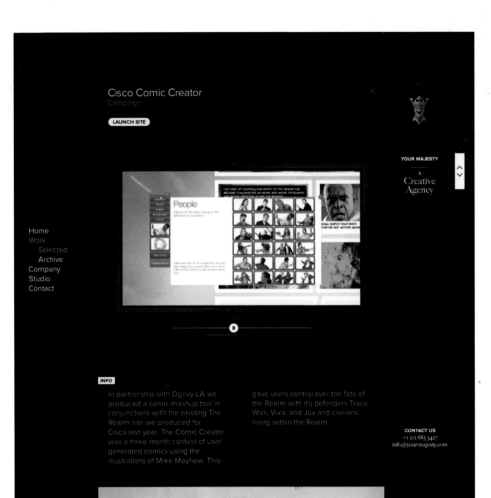

PLATINUM

CREATIVE FIRM: YOUR MAJESTY CO. – NEW YORK, NY, USA
CLIENT: OGILVY & MATHER LA/CISCO SYSTEMS INC.
URL: HTTP://YOUR–MAJESTY.COM/#/WORK/ARCHIVE/
CISCO_COMIC

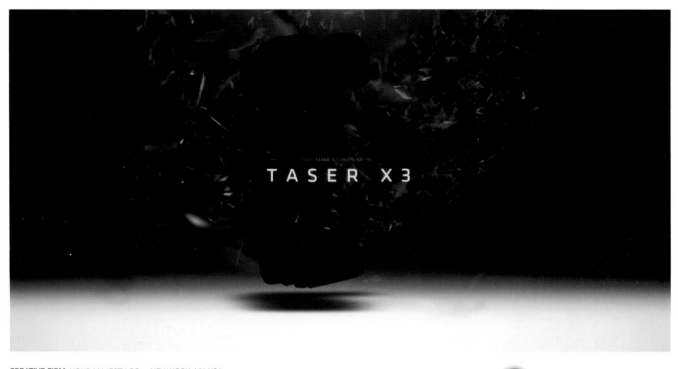

CREATIVE FIRM: YOUR MAJESTY CO. – NEW YORK, NY, USA

CREATIVE TEAM: PETER KARLSSON – ACCOUNT DIRECTOR; JAMES WIDEGREN, JENS KARLSSON – CREATIVE DIRECTORS; HEATHER REDDIG – EXECUTIVE PRODUCER; JONATHAN PETTERSSON, HAROLD SCISSORS – DEVELOPERS; MICHAEL PELTON – 3D; STEPHEN HODDE – SOUND DESIGN

CLIENT: TASER INTERNATIONAL, INC.

URL: HTTP://WWW.TASERX3.COM

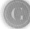

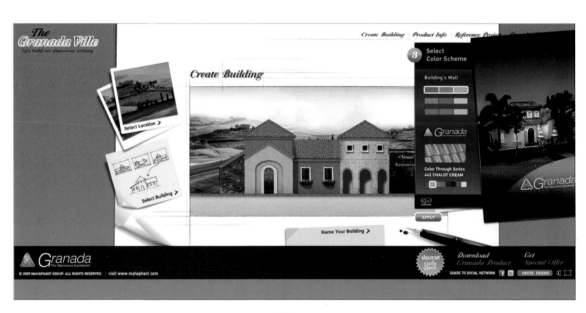

CREATIVE FIRM: THOMAS IDEA CO., LTD. – BANGKOK, THAILAND

CLIENT: MAHAPHANT GROUP

URL: HTTP://WWW.GRANADAROOF.COM

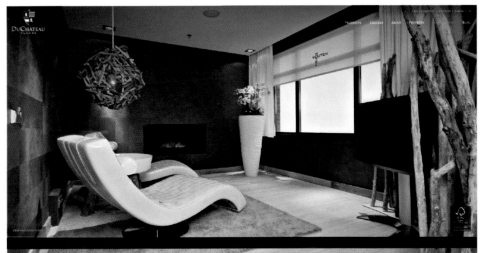

CREATIVE FIRM: JACOB TYLER CREATIVE GROUP – SAN DIEGO, CA, USA

CREATIVE TEAM: LES KOLLEGIAN – CREATIVE DIRECTOR

CLIENT: DUCHATEAU FLOORS

URL: HTTP://WWW.DUCHATEAUFLOORS.COM/

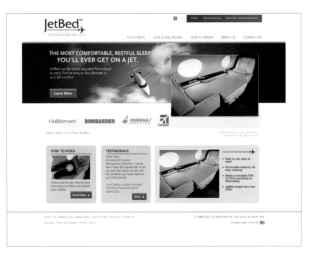

CREATIVE FIRM: JACOB TYLER CREATIVE GROUP – SAN DIEGO, CA, USA

CREATIVE TEAM: LES KOLLEGIAN – CREATIVE DIRECTOR; GORDON TSUJI – ART DIRECTOR; JESS RECHT – DESIGNER

CLIENT: JETBED

URL: HTTP://WWW.JET–BED.COM/INDEX.PHP

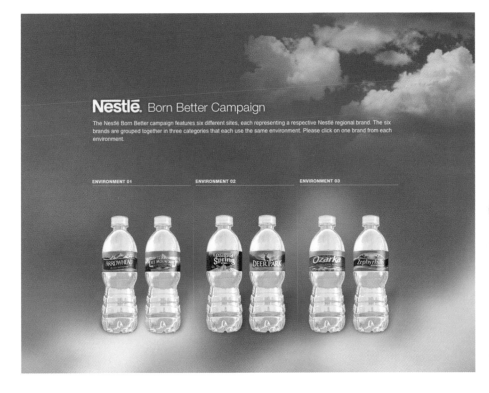

CREATIVE FIRM: YOUR MAJESTY CO. – NEW YORK, NY, USA

CREATIVE TEAM: PETER KARLSSON – ACCOUNT DIRECTOR; JENS KARLSSON – CREATIVE DIRECTOR/ PHOTOGRAPHER; JAMES WIDEGREN, EMIL LANNE – CREATIVE DIRECTORS; CHRISTIAN JOHANSSON – ART DIRECTOR; MARIUS VENN – DESIGNER; KASPER KUIJPERS – DEVELOPER; HEATHER REDDIG – EXECU- TIVE PRODUCER; SARAH KAYDEN – PRODUCER; MICHAEL PELTON – 3D

CLIENT: MCCANN ERICKSON/NESTLE WATERS

URL: HTTP://YOUR–MAJESTY.COM/NESTLE/

CREATIVE FIRM: JACOB TYLER CREATIVE GROUP – SAN DIEGO, CA, USA
CREATIVE TEAM: LES KOLLEGIAN – CREATIVE DIRECTOR; GORDON TSUJI – ART DIRECTOR; JESS RECHT – DESIGNER
CLIENT: LAMKIN GRIPS
URL: HTTP://WWW.LAMKINGRIPS.COM/

CREATIVE FIRM: MJE MARKETING SERVICES – SAN DIEGO, CA, USA
CREATIVE TEAM: MARLEE EHRENFELD – CREATIVE DIRECTOR; AARON ISHAEIK – ART DIRECTOR; BRUCE GRESHAM – WEB DEVELOPER
CLIENT: THE PORT OF SAN DIEGO
URL: THEBIGBAY.COM

CREATIVE FIRM: YOUR MAJESTY CO. – NEW YORK, NY, USA
CREATIVE TEAM: JAMES WIDEGREN – CREATIVE DIRECTOR/DESIGNER; MERTEN SNIJDERS – DEVELOPER
CLIENT: METAPROJECT
URL: HTTP://THEMETAPROJECT.COM/

CREATIVE FIRM: EURO RSCG C&O / HAVAS ENERGIES – PARIS, FRANCE
CLIENT: EDF
URL: HTTP://ACTIVITES.EDF.COM/EDF–DANS–LE–MONDE/TOUTES–
NOS–ACTIVITES–EN–3D–41412.HTML

CREATIVE FIRM: WORLD WIDE WEB DOMINATION –
CYBERJAYA, SELANGOR, MALAYSIA
CLIENT: LIMKOKWING UNIVERSITY OF CREATIVE
TECHNOLOGY
URL: WWW.LIMKOKWING.NET

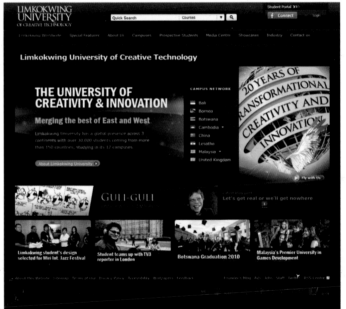

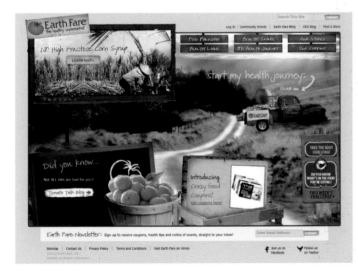

CREATIVE FIRM: BOSTON INTERACTIVE – CHARLESTOWN, MA, USA
CREATIVE TEAM: CHUCK MURPHY – FOUNDER & CEO; JIM KELLER – VP OF INTER-
ACTIVE SERVICES; JACLYN ROTH – CREATIVE DIRECTOR; SCOTT NOONAN – CHIEF
TECHNOLOGY OFFICER; VIRGINIA THOMSON – USER EXPERIENCE ARCHITECT;
LEWIS GOULDEN, MIKE REYNOLDS – SENIOR DEVELOPERS; SARA STROPE – INTER-
ACTIVE PRODUCER
CLIENT: EARTH FARE
URL: HTTP://WWW.EARTHFARE.COM

CREATIVE FIRM: ROKKAN – SAN FRANCISCO, CA, USA
CREATIVE TEAM: CHARLES BAE – EXECUTIVE CREATIVE DIRECTOR; FAISAL RAMADAN – LEAD FLASH DEVELOPER; ADIL HASHEM,
AKEEM PHILBERT – CMS TEAM; MEGAN WARD, VINCENT AU – INFORMATION ARCHITECTURE; JESSICA ALTUS – PROJECT MANAGER
CLIENT: 2K GAMES
URL: HTTP://2KGAMES.COM

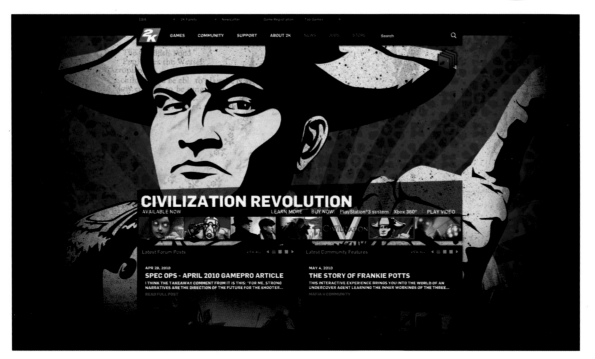

CREATIVE FIRM: JACOB TYLER CREATIVE GROUP – SAN DIEGO, CA, USA
CREATIVE TEAM: LES KOLLEGIAN – CREATIVE DIRECTOR; GORDON
TSUJI – ART DIRECTOR; JESS RECHT – DESIGNER
CLIENT: BONFIRE HEALTH
URL: HTTP://WWW.BONFIREHEALTH.COM/

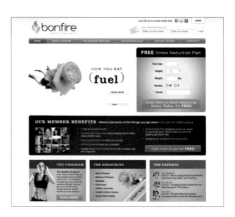

CREATIVE FIRM: YOUR MAJESTY CO. – NEW YORK, NY, USA
CREATIVE TEAM: PETER KARLSSON – ACCOUNT DIRECTOR; JENS KARLSSON,
JAMES WIDEGREN – CREATIVE DIRECTORS; CHRISTIAN JOHANSSON – ART
DIRECTOR; ERIK JONSSON – DESIGNER; HEATHER REDDIG – EXECUTIVE
PRODUCER; SARAH KAYDEN – PRODUCER; CALEB JOHNSTON, JONATHAN
PETTERSSON, KASPER KUIJPERS, BRIAN STEGALL, HOLGER STORM, MERTEN
SNIJDERS – DEVELOPERS
CLIENT: STRAWBERRY FROG/TRUENORTH FRITO–LAY
URL: HTTP://YOUR–MAJESTY.COM/#/WORK/ARCHIVE/TRUENORTH

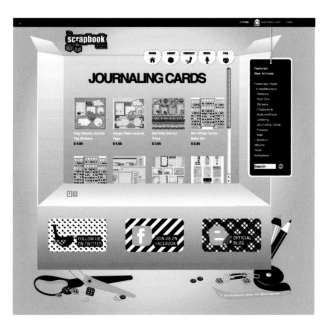

CREATIVE FIRM: QUIRK – SINGAPORE
CLIENT: THE SCRAPBOOK CARTON
URL: HTTP://WWW.THESCRAPBOOKCARTON.COM/

CREATIVE FIRM: ORGANIC, INC. – SAN FRANCISCO, CA, USA
CLIENT: BANK OF AMERICA
URL: HTTP://HOMELOANS.BANKOFAMERICA.COM/EN/
HOME–LOAN–EXPERIENCE/START.HTML

CREATIVE FIRM: FAHRENHEIT STUDIO – LOS ANGELES, CA, USA
CREATIVE TEAM: ROBERT WEITZ, DYLAN TRAN – CREATIVE
DIRECTORS; MELINDA SMITH – COPYWRITER; PATRICK
O'CONNOR – EDITOR; JIM THOBURN – PROGRAMMER;
SOLSPACE – DEVELOPER
CLIENT: BAKER AVENUE ASSET MANAGEMENT
URL: HTTP://WWW.BAKERAVE.COM

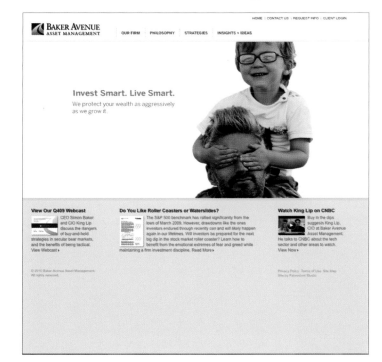

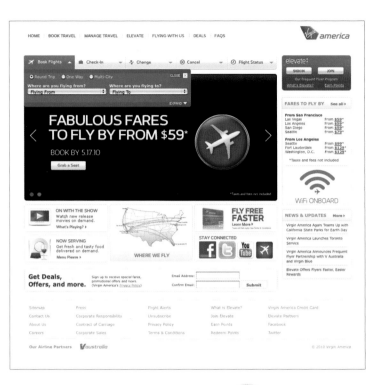

CREATIVE FIRM: ROKKAN – SAN FRANCISCO, CA, USA

CREATIVE TEAM: CHUNG NG – DIRECTOR OF USER EXPERIENCE; ANNIE WONG – UX DIRECTOR; EMILY TONG – INFORMATION ARCHITECT; CHARLES BAE – EXECUTIVE CREATIVE DIRECTOR; DINA CASTRO–LINDNER – SENIOR DESIGNER; NICOLE RANNOU – PROJECT MANAGER

CLIENT: VIRGIN GROUP LTD.

URL: HTTP://WWW.VIRGINAMERICA.COM/VA/HOME.DO

CREATIVE FIRM: BAILEY BRAND CONSULTING – PLYMOUTH MEETING, PA, USA

CLIENT: TWININGS USA

URL: HTTP://WWW.TWININGSUSA.COM/

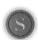

CREATIVE FIRM: ORGANIC, INC. – SAN FRANCISCO, CA, USA

CLIENT: BANK OF AMERICA

URL: HTTP://PROMOTIONS.BANKOFAMERICA.COM/ONCAMPUS/ THEMORRISCODE/

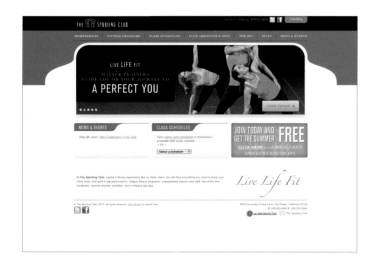

CREATIVE FIRM: JACOB TYLER CREATIVE GROUP – SAN DIEGO, CA, USA

CREATIVE TEAM: LES KOLLEGIAN – CREATIVE DIRECTOR; GORDON TSUJI – ART DIRECTOR; JESS RECHT – DESIGNER

CLIENT: THE SPORTING CLUB

URL: HTTP://WWW.THESPORTINGCLUB.COM/

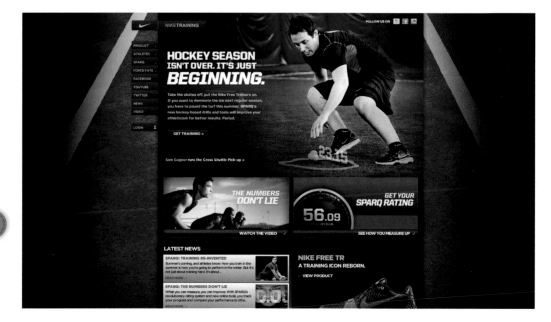

CREATIVE FIRM: ORGANIC, INC. – SAN FRANCISCO, CA, USA

CLIENT: NIKE CANADA

URL: HTTP://WWW.NIKE.COM/NIKEOS/P/NIKETRAINING/EN_CA/

CREATIVE FIRM: KNOCK INC. – MINNEAPOLIS, MN, USA

CREATIVE TEAM: KNOCK INC. – DESIGN FIRM; TODD PAULSON – CREATIVE DIRECTOR; SARA NELSON – DESIGN DIRECTOR; KAT TOWNSEND – DESIGNER; DAN ARMSTRONG – WRITER; ADRIAN SUAREZ – WEBSITE PROGRAMMING

CLIENT: NAMCO BANDAI

URL: WWW.KLONOAGAME.COM

CREATIVE FIRM: NICKELODEON KIDS AND FAMILY GROUP – NEW YORK, NY, USA

CREATIVE TEAM: RENATO CASTILHO – DESIGN DIRECTOR; ANNA TSALOPOULOS – ART DIRECTOR; ALLISON GARBER – SR. DESIGNER; JASMINE WILSON – DESIGNER; STEPHEN MASSONI – SITE DIRECTOR; ROBERT OSTERGAARD – EDITORIAL DIRECTOR; SUSAN SOBOTA – DESIGNER

CLIENT: NICKELODEON KIDS AND FAMILY GROUP

URL: HTTP://WWW.NICKJR.COM/

CREATIVE FIRM: FALLON – NEW YORK, NY, USA

CREATIVE TEAM: MICHAEL ENGLEMAN – SVP MARKETING: GLOBAL BRAND STRATEGY AND CREATIVE; BLAKE CALLAWAY – SVP MARKETING : BRAND AND INTEGRITY; WILLIAM LEE – CREATIVE DIRECTOR

CLIENT: SYFY

URL: HTTP://THEWHITERABBITINC.COM/

CREATIVE FIRM: NICKELODEON KIDS AND FAMILY GROUP – NEW YORK, NY, USA

CREATIVE TEAM: RENATO CASTILHO – DESIGN DIRECTOR; ELLIOT TAUB – SR. DESIGNER; WANCHEN LIN – DESIGNER; ABBY PECORIELLO – SITE DIRECTOR; HILARY BROMBERG – PRODUCTION DIRECTOR

CLIENT: NICKELODEON KIDS AND FAMILY GROUP

URL: HTTP://WWW.PARENTSCONNECT.COM/

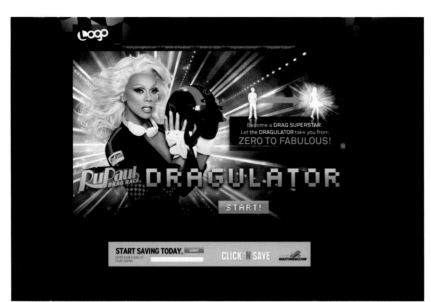

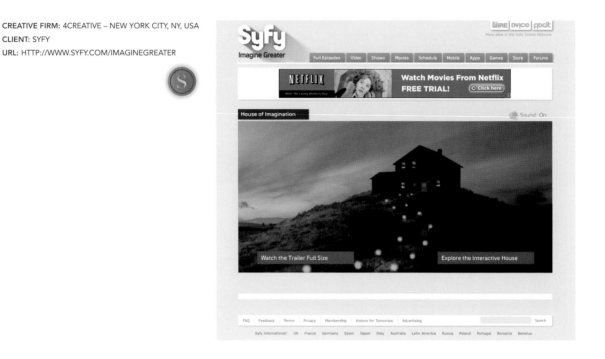

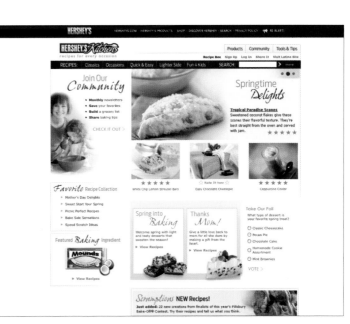

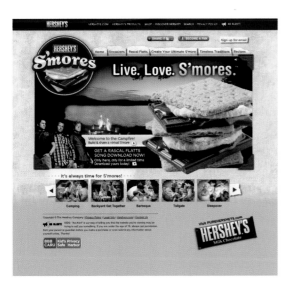

CREATIVE FIRM: JPL – HARRISBURG, PA, USA
CLIENT: THE HERSHEY COMPANY
URL: HTTP://WWW.HERSHEYS.COM/RECIPES/

CREATIVE FIRM: JPL – HARRISBURG, PA, USA
CLIENT: THE HERSHEY COMPANY
URL: HTTP://WWW.PURESMORES.COM

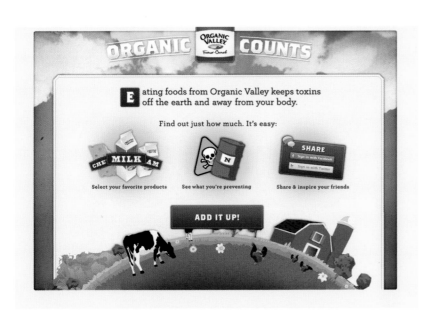

CREATIVE FIRM: PLANET PROPAGANDA – MADISON, WI, USA
CREATIVE TEAM: DANA LYTLE – CREATIVE DIRECTOR; BEN HIRBY – CREATIVE DIRECTOR; MARCUS TRAPP, TRENT SIMON, NATHAN LENZ – INTERACTIVE DEVELOPERS; ZACK SCHULZE – INTERACTIVE DESIGNER; ANDY BRAWNER, ANGIE SCOTLAND – COPYWRITERS; SARAH BRATNOBER, GREG BRICKL – CLIENTS
CLIENT: ORGANIC VALLEY
URL: WWW.ORGANICVALLEY.COOP/ORGANICCOUNTS

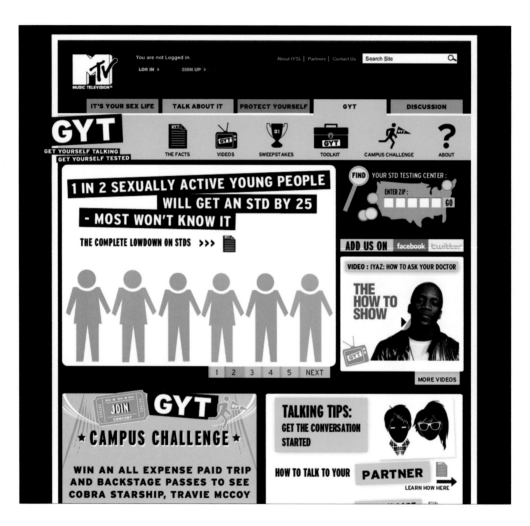

PLATINUM

CREATIVE FIRM: COHESIVE C EATIVE – NEW YORK, NY, USA
CLIENT: MTV
URL: WWW.GYT09.ORG

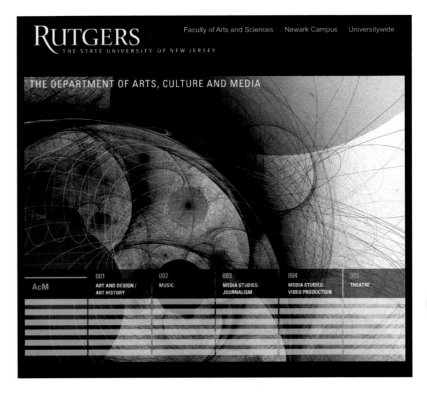

CREATIVE FIRM: JUNO STUDIO
CREATIVE TEAM: JUN LI – ART DIRECTOR/DESIGNER
CLIENT: RUTGERS UNIVERSITY
URL: HTTP://ACM.NEWARK.RUTGERS.EDU/

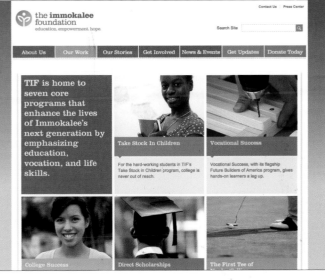

CREATIVE FIRM: BLUE CODA, INC. – CAMBRIDGE, MA, USA
CLIENT: MASSACHUSETTS SENIOR CARE
URL: HTTP://WWW.MASENIORCARE.ORG/

CREATIVE FIRM: POCCUO – WASHINGTON DC, USA
CREATIVE TEAM: PHILLIP ZELNAR – DESIGNER; MA-
SON KESSINGER – DEVELOPER; CHRIS MAIER – WRITER
CLIENT: THE IMMOKALEE FOUNDATION
URL: HTTP://WWW.IMMOKALEEFOUNDATION.ORG

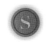

CREATIVE FIRM: 36 BRANDING – PASADENA, CA, USA
CLIENT: LIBERTY HILL FOUNDATION
URL: HTTP://WWW.LIBERTYHILL.ORG

CREATIVE FIRM: VISION INTERNET – SANTA MONICA, CA, USA
CLIENT: TOWN OF CHAPEL HILL, NC
URL: WWW.CI.CHAPEL–HILL.NC.US

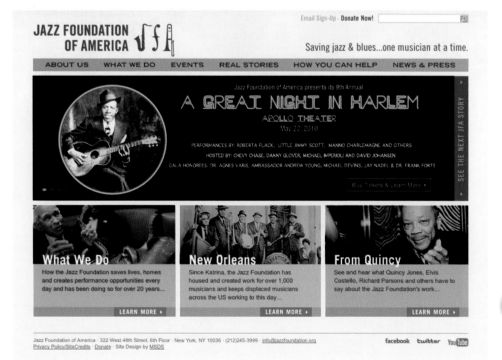

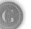

CREATIVE FIRM: MSDS – NEW YORK, NY, USA
CLIENT: JAZZ FOUNDATION
URL: WWW.JAZZFOUNDATION.ORG

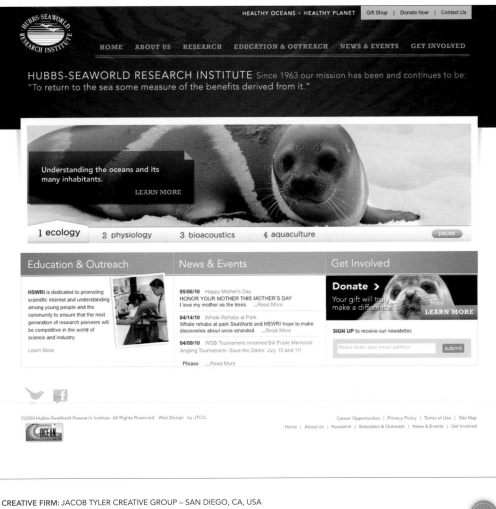

CREATIVE FIRM: JACOB TYLER CREATIVE GROUP – SAN DIEGO, CA, USA
CREATIVE TEAM: LES KOLLEGIAN – CREATIVE DIRECTOR; GORDON TSUJI – ART DIRECTOR; JESS RECHT – DESIGNER
CLIENT: HUBBS–SEAWORLD RESEARCH INSTITUTE
URL: HTTP://HSWRI.ORG/

CREATIVE FIRM: POCCUO – WASHINGTON DC, USA
CREATIVE TEAM: MASON KESSINGER – DESIGNER/DEVELOPER; CHRIS MAIER – WRITER
CLIENT: FOOD & WATER WATCH
URL: HTTP://WWW.FOODANDWATERWATCH.ORG/FOOD/GLOBAL–GROCE

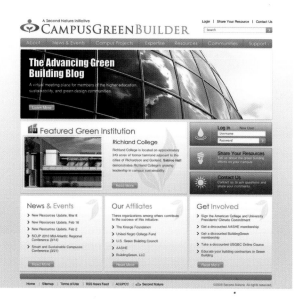

CREATIVE FIRM: VISION INTERNET – SANTA MONICA, CA, USA
CLIENT: TOWN OF PRESCOTT VALLEY, AZ
URL: WWW.PVAZ.NET

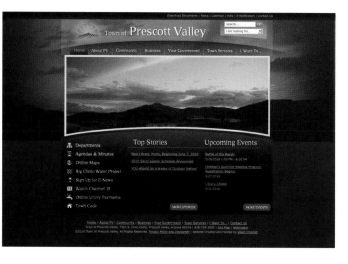

CREATIVE FIRM: BLUE CODA, INC. – CAMBRIDGE, MA, USA
CLIENT: SECOND NATURE
URL: HTTP://WWW.CAMPUSGREENBUILDER.ORG/

CREATIVE FIRM: VISION INTERNET – SANTA MONICA, CA, USA
CLIENT: CITY OF NEWPORT BEACH, CA
URL: WWW.NEWPORTBEACHCA.GOV

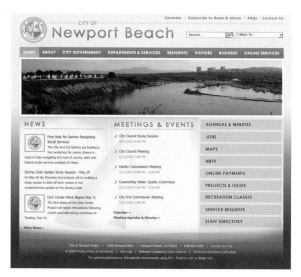

CREATIVE FIRM: VISION INTERNET – SANTA MONICA, CA, USA
CLIENT: CITY OF BURBANK
URL: WWW.CI.BURBANK.CA.US

CREATIVE FIRM: WETHERBEE CREATIVE & WEB
LLC – DERRY, NH, USA
CLIENT: MORE THAN WORDS
URL: HTTP://WWW.MTWYOUTH.ORG

CREATIVE FIRM: VISION INTERNET – SANTA MONICA, CA, USA
CLIENT: CITY OF SANTA CRUZ
URL: WWW.CITYOFSANTACRUZ.COM

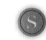

CREATIVE FIRM: POCCUO – WASHINGTON DC, USA
CREATIVE TEAM: PHILLIP ZELNAR – DESIGNER
CLIENT: OCEANA
URL: HTTP://WWW.OCEANA.ORG

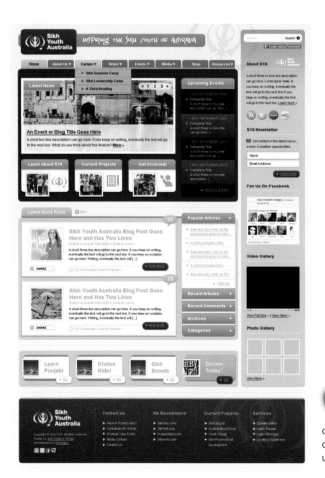

CREATIVE FIRM: JUST CREATIVE DESIGN – NEWCASTLE, AUSTRALIA
CLIENT: SIKH YOUTH AUSTRALIA
URL: HTTP://WWW.SIKHYOUTHAUSTRALIA.COM/

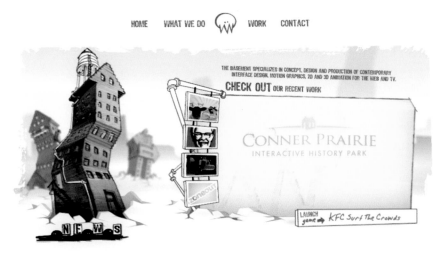

 PLATINUM

CREATIVE FIRM: THE BASEMENT DESIGN + MOTION –
INDIANAPOLIS, IN, USA
CLIENT: THE BASEMENT DESIGN + MOTION
URL: HTTP://WWW.THEBASEMENT.TV

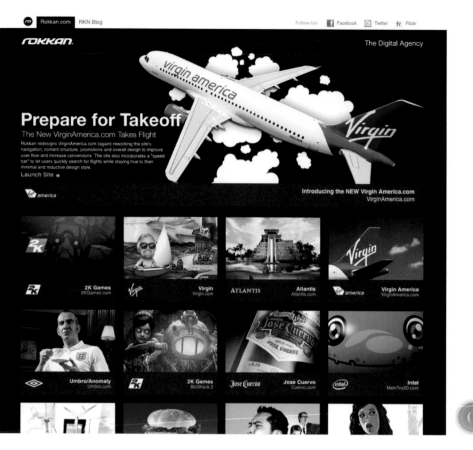

CREATIVE FIRM: ROKKAN – SAN FRANCISCO, CA, USA

CLIENT: ROKKAN

URL: HTTP://ROKKAN.COM

CREATIVE FIRM: ANIDEN INTERACTIVE – HOUSTON, TX, USA

CREATIVE TEAM: BRANDON WHITE – MULTIMEDIA MANAGER; BRET STOUT – CREATIVE DIRECTOR; DARREN EDGE – DESIGNER; DAVID CHIEN – EXPERIENCE DIVISION MANAGER; HELEN PINA – MARKETING MANAGER; JODY COCHRAN, TIFA CHEN, TREVOR FARELLA – DESIGNERS; JUNE SUGG – ART DIRECTOR; MARK PULDA – VICE PRESIDENT OF PRODUCTION

CLIENT: ANIDEN INTERACTIVE

URL: WWW.ANIDEN.COM

CREATIVE FIRM: BLUEZOOM – GREENSBORO, NC, USA
CLIENT: BLUEZOOM
URL: WWW.BLUEZOOM.BZ

CREATIVE FIRM: SINGULARITY DESIGN – PHILADELPHIA, PA, USA
CLIENT: SINGULARITY DESIGN
URL: HTTP://WWW.SINGULARITYDESIGN.COM/2009HOLIDAYS/

CREATIVE FIRM: VISION INTERNET – SANTA MONICA, CA, USA
CLIENT: POWAY CENTER FOR THE PERFORMING ARTS
URL: WWW.POWAYCENTER.COM

CREATIVE FIRM: SGIS – FORT LAUDERDALE, FL, USA

CREATIVE TEAM: REBECCA AMESBURY – VICE PRESIDENT, MARKETING AND COMMUNICATION; ARIANA TORO, MELISSA GARCIA – COPYWRITERS; BRETT CLIMAN – MULTIMEDIA DESIGNER

CLIENT: SGIS

URL: HTTP://WWW.SGIS.COM

CREATIVE FIRM: MTV NETWORKS CREATIVE SERVICES – NEW YORK, NY, USA

CREATIVE TEAM: SCOTT WADLER – SVP, DESIGN; CHERYL FAMILY – SVP, EDITORIAL DIRECTOR; ALAN PERLER – VP, PRODUCTION; NICK GAMMA – DESIGN DIRECTOR; ANTHONY CARLUCCI – DESIGNER; RICHARD TANCIN, MARK MALABRIGO – SENIOR PRODUCERS; TORY MAST – COPYWRITER; BARBARA CRAWFORD – PROJECT MANAGER; REALITY DIGITAL – BACKEND DEVELOPMENT; DAVID FELTON – CREATIVE DIRECTOR

CLIENT: MTV NETWORKS

URL: HTTP://MAINEVENTS.MTVN.COM/GENIUS_BANK/

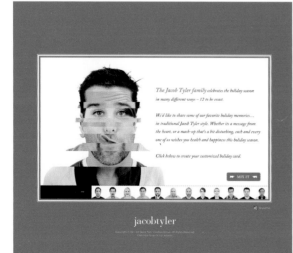

CREATIVE FIRM: JACOB TYLER CREATIVE GROUP – SAN DIEGO, CA, USA

CREATIVE TEAM: LES KOLLEGIAN – CREATIVE DIRECTOR; GORDON TSUJI – ART DIRECTOR; JONATHAN MARSHALL – COPYWRITER; ADAM ROOP – PROGRAMMING

CLIENT: SELF (JACOB TYLER CREATIVE GROUP)

URL: HTTP://WWW.JACOBTYLER.COM/HAPPYHOLIDAYS/

FILM & VIDEO

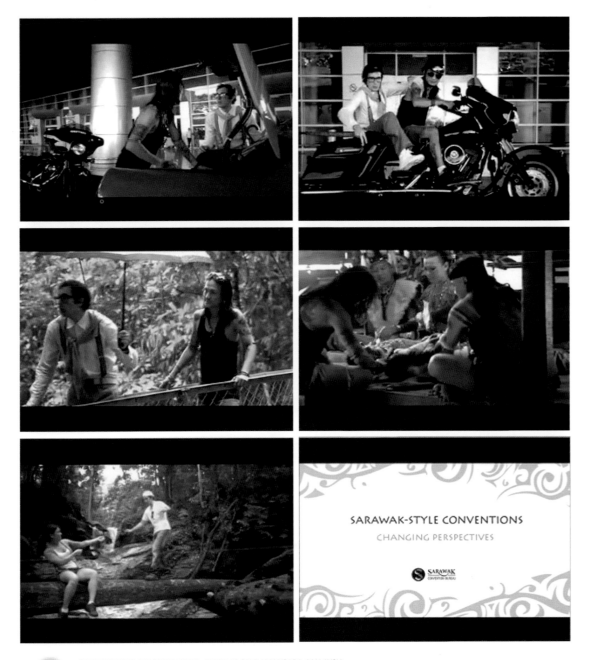

SARAWAK-STYLE CONVENTIONS

CHANGING PERSPECTIVES

CREATIVE FIRM: MAGIC MAKERS – BANDAR SRI DAMANSARA, MALAYSIA
CLIENT: SARAWAK CONVENTION BUREAU
URL: WWW.SARAWAKCB.COM

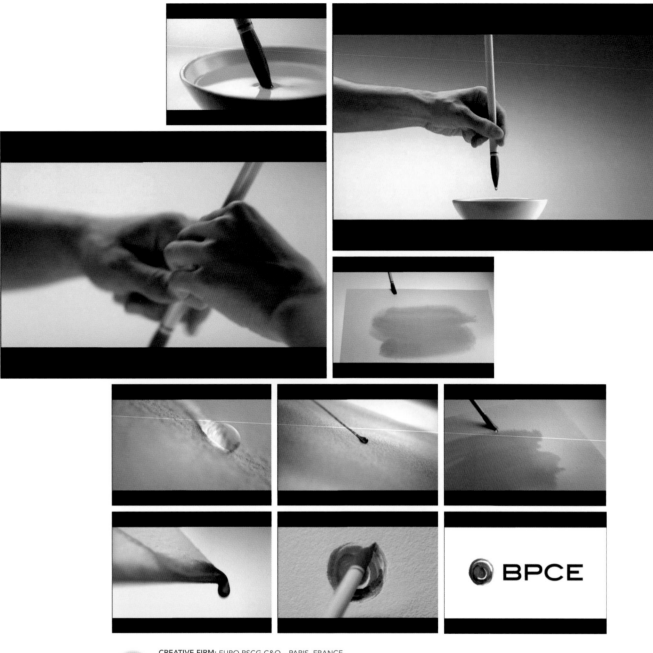

CREATIVE FIRM: EURO RSCG C&O – PARIS, FRANCE

CREATIVE TEAM: REZA BASSIRI – CREATIVE DIRECTOR; FRANCESCA MUND – ART DIRECTOR

CLIENT: BPCE GROUP

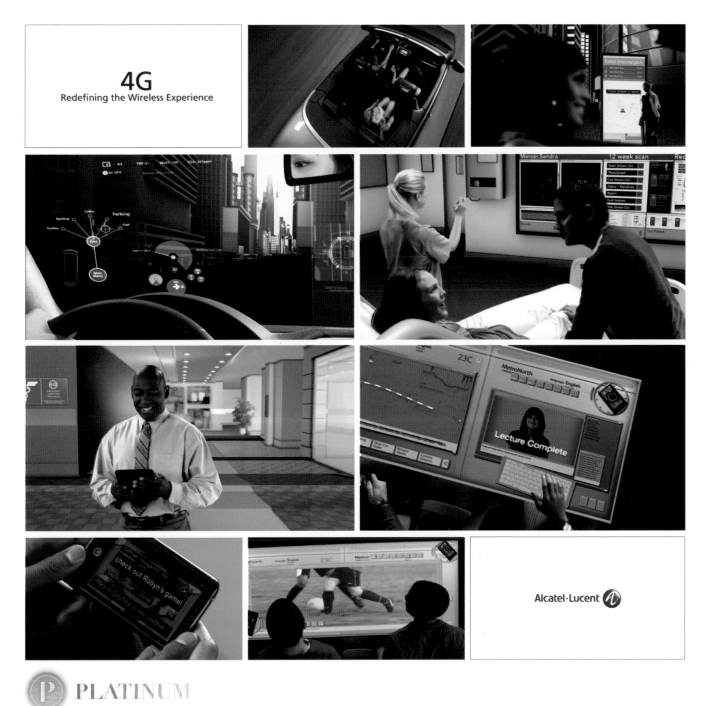

4G
Redefining the Wireless Experience

Alcatel·Lucent

PLATINUM

CREATIVE FIRM: BANFIELD–SEGUIN LTD. – OTTAWA, ON, CANADA
CLIENT: ALCATEL LUCENT

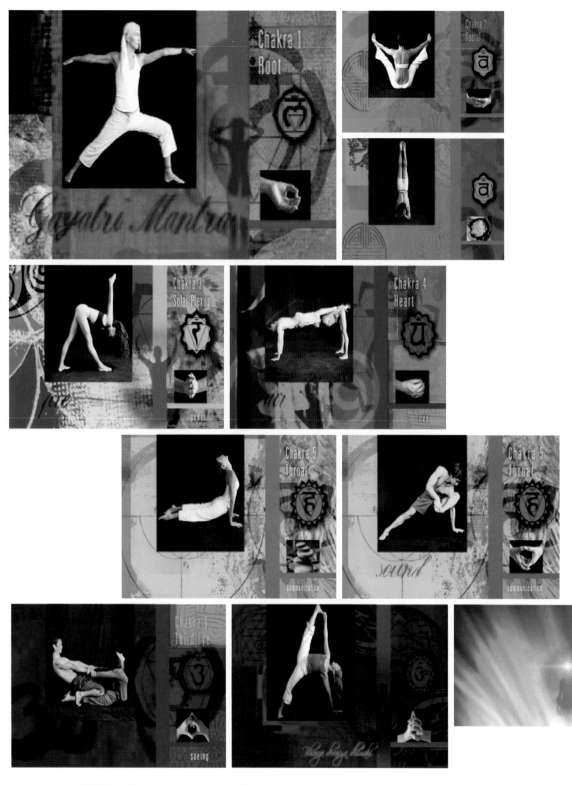

CREATIVE FIRM: GREEN RABBIT DESIGN STUDIO, INC. – SCOTTSDALE, AZ, USA
CREATIVE TEAM: GREEN RABBIT DESIGN STUDIO, INC. – DESIGN FIRM
URL: HTTP://WWW.GREENRABBIT.COM/GAYATRI.HTML

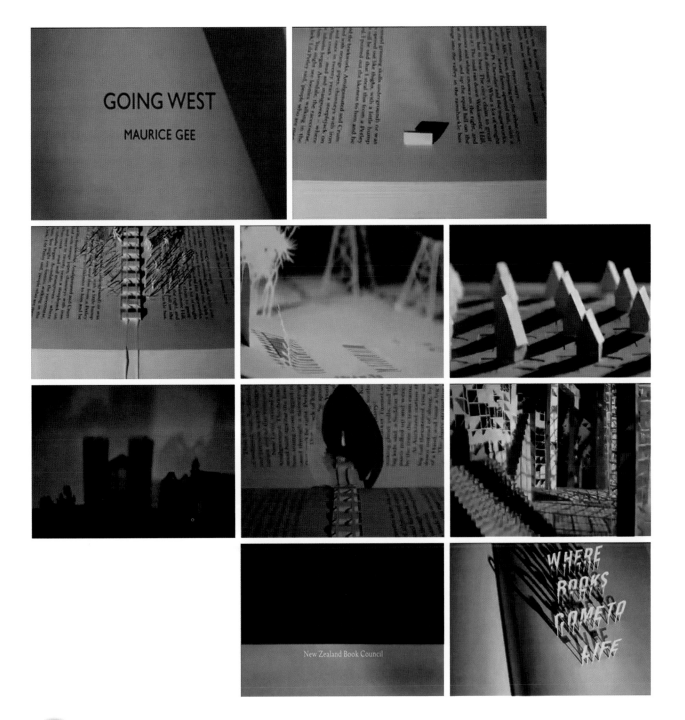

 PLATINUM

GOING WEST

CREATIVE FIRM: COLENSO BBDO – AUCKLAND, NEW ZEALAND

CREATIVE TEAM: NICK WORTHINGTON – EXECUTIVE CREATIVE DIRECTOR/ART DIRECTOR/COPYWRITER; ANNE BOOTHROYD, LEN CHEESEMAN – ART DIRECTORS/ COPYWRITERS; MICHAEL REDWOOD, ANGELA WATSON – GROUP ACCOUNT DIRECTOR; NIGEL SUTTON – AGENCY PRODUCER; ANDERSEN M STUDIO – PRODUCTION COMPANY; LINE AND MARTIN ANDERSEN, ANDERSEN M STUDIO – DIRECTOR; MIKKEL H. ERIKSEN, INSTRUMENT STUDIO, LONDON – SOUND DESIGN; MARTIN ANDERSEN, ANDERSEN M STUDIO – DOP/EDITOR; LINE ANDERSEN, ANDERSEN M STUDIO – ANIMATION

CLIENT: NEW ZEALAND BOOK COUNCIL

No Nudity. No Gratuitous Violence. No Kittens on Rollerskates. No Kids doing dumb stuff. Just a book. Brought to life. That caught the imagination of the on–line community and spread through 942 blogs, 2,182 tweets, 29,134 pages and 670,000 views on YouTube to become New Zealand's No 3 all time favourited film and animation.

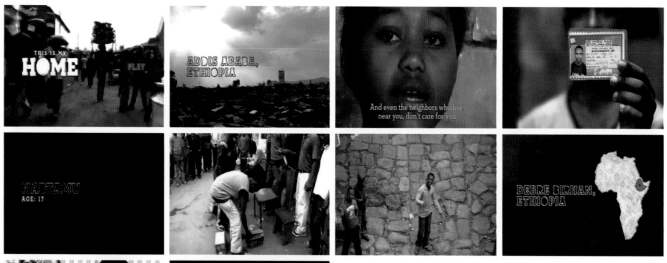

CREATIVE FIRM: RULE29 – GENEVA, IL, USA
CREATIVE TEAM: JUSTIN AHRENS – OWNER/CREATIVE DIRECTOR
CLIENT: LIFE IN ABUNDANCE
URL: WWW.LIAINT.ORG

CREATIVE FIRM: TEXAS TECH UNIVERSITY COMMUNICATIONS AND MARKETING DEPARTMENT – LUBBOCK, TX, USA

CREATIVE TEAM: KEVIN JONES – COORDINATOR OF 3D ANIMATION; JACKY DELGADO – MEDIA COORDINATOR; SHANNON ADAMS – COORDINATOR OF GRAPHIC DESIGN; KALEY DANIEL – DIRECTOR OF COMMUNICATIONS & MARKETING

CLIENT: TEXAS TECH UNIVERSITY LIBRARY'S 3D ANIMATION LAB

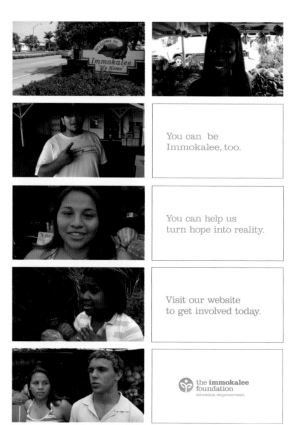

CREATIVE FIRM: POCCUO – WASHINGTON DC, USA
CREATIVE TEAM: CHRIS MAIER – WRITER; ELIOT BRODSKY – DIRECTOR
CLIENT: THE IMMOKALEE FOUNDATION
URL: HTTP://VIMEO.COM/6129500

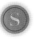

ⓟ PLATINUM

CREATIVE FIRM: THE BASEMENT DESIGN + MOTION – INDIANAPOLIS, IN, USA
CLIENT: THE BASEMENT DESIGN + MOTION
URL: HTTP://70.32.94.43/EMAIL/JACOB/

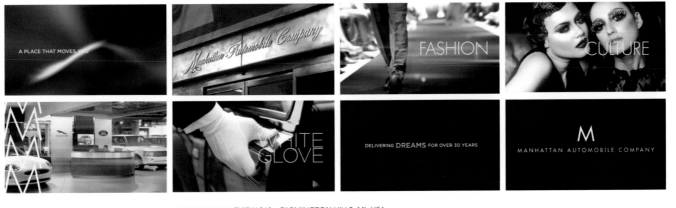

CREATIVE FIRM: EVIEW 360 – FARMINGTON HILLS, MI, USA
CREATIVE TEAM: WAEL BERRACHED – CREATIVE OFFICER; DARIAN RAWSON – EDITOR
CLIENT: MANHATTAN AUTOMOBILE COMPANY
URL: HTTP://VIMEO.COM/9475206

CREATIVE FIRM: PLANET PROPAGANDA – MADISON, WI, USA
CREATIVE TEAM: DANA LYTLE – CREATIVE DIRECTOR; NATE THEIS – DIRECTOR; ADAM BLUMA – DESIGNER; ANDY BRAWNER – COPYWRITER/MUSIC
CLIENT: RISHI TEA

CREATIVE FIRM: PLANET PROPAGANDA – MADISON, WI, USA
CREATIVE TEAM: KEVIN WADE – CREATIVE DIRECTOR/DESIGNER/COPYWRITER; NATE THEIS – DIRECTOR/DESIGNER/ANIMATOR/COPYWRITER
CLIENT: BRAND P

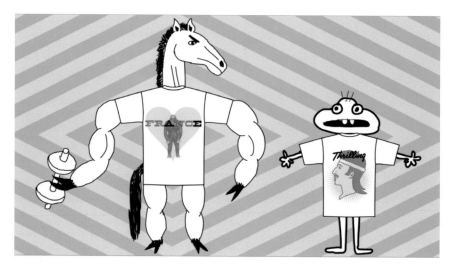

 PLATINUM

2009 CMT MUSIC AWARDS OPEN

CREATIVE FIRM: CMT – NEW YORK, NY, USA

CREATIVE TEAM: DAVID BENNETT – ART DIRECTOR; JEFF NICHOLS, LESLIE LEGARE – CREATIVE DIRECTORS; BEN FRANK – DESIGNER; JIM PARKER – SOUND DESIGN; EMILIE SCHNICK – PROJECT MANAGER

CLIENT: CMT

MTV–at least back in the '80s–is synonymous with cutting–edge music and even quicker visual cuts. The 2009 CMT Music Awards carried on that tradition for its opening sequence. "We decided on a full frontal assault on as many of the five senses as possible," says CMT, which produced the opening in house. "It is a blitzkrieg of sight and sound like never before seen by the CMT audience, featuring pulsating logos, dynamic color washes, quick cuts of motorized stills of people partying their asses off, trails of electricity weaving in and around…it was almost too much." But not quite: "Too much is exactly what it needed to be."

Of course, there's the part where the awards are handed out, live performances remind everyone what it's all about, and the host hawks his latest project, but the aim of the opening is to set the stage for viewers at home. "Each year, it gets harder to be bigger, louder, and awesomer than before," says CMT. "And while we always do it well, it ain't easy." To set the tone, the theme of the 2009 show was "Live + Loud." ("Just in case anyone thought our awards show might be tape delayed and hushed.") Believe it or not, CMT says the biggest challenge in creating this "show appetizer" was making it loud enough and with enough "live" energy to "blow people's faces off." Yee–ha.

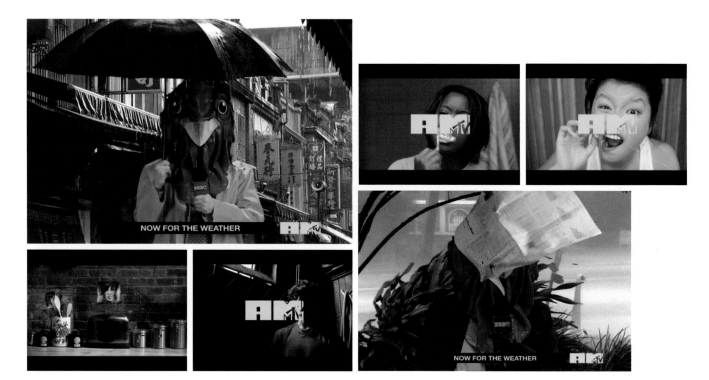

CREATIVE FIRM: MTV ON–AIR DESIGN – NEW YORK, NY, USA

CREATIVE TEAM: JEFFREY KEYTON, ROMY MANN – CREATIVE DIRECTORS; DAVID MCELWAINE – DESIGN DIRECTOR/WRITER; CROBIN – SENIOR DESIGNER/WRITER/DIRECTOR/EDITOR; CHRIS GALLAGHER – ANIMATOR; ROSS JEFFCOAT – PRODUCER; ED DAVID – DIRECTOR OF PHOTOGRAPHY; KIMIE KIMURA–HEANEY – LINE PRODUCER

CLIENT: MTV

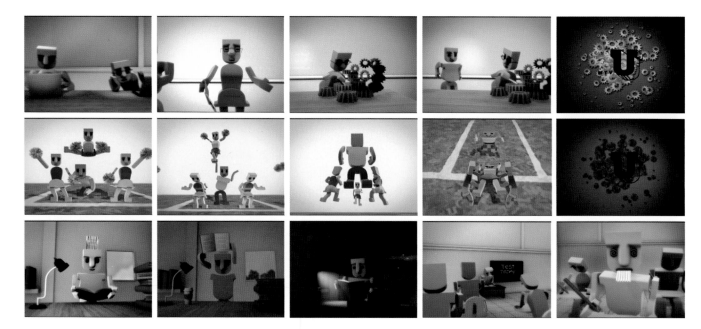

CREATIVE FIRM: MTV ON–AIR PROMOS – NEW YORK, NY, USA

CREATIVE TEAM: KEVIN MACKALL, AMY CAMPBELL – CREATIVE DIRECTORS; SOPHIA CRANSHAW – SUPERVISING PRODUCER; MICHAEL ROBINSON – ANIMATION/GRAPHICS; BRIAN HORGAN – ANIMATION/CHARACTER RIGGING; DANIEL WEHR – MUSIC; JEFF WOODTON – PRODUCTION MANAGER; RICHARD POWELL – LIGHTING/RENDERING

CLIENT: MTVU

CREATIVE FIRM: NICKELODEON PRESCHOOL BRAND CREATIVE – NEW YORK, NY, USA

CREATIVE TEAM: MATTHEW DUNTEMANN – CREATIVE DIRECTOR; LIZA STEINBERG – EDITORIAL DIRECTOR; ELANA BAUMGARTEN – WRITER; FRIENDS WITH YOU – DESIGNER; FARREL ALLEN – DIRECTOR OF ON AIR PROMOS; JEFFREY BLACKMAN – VP OF PRODUCTION; ADAM ABADA – EDITOR; CARLY SALAMAN – PRODUCER; JENNIFER CAST – ART DIRECTOR; ANNETTE FERRARA – SENIOR PROJECT MANAGER; KIM SHEA – PRODUCTION MANAGER; KELLY FENTRESS – PROJECT ASSISTANT; JESSICA RISHEL – PRODUCTION ASSISTANT

CLIENT: NICKELODEON

CREATIVE FIRM: LOGO – NEW YORK, NY, USA

CREATIVE TEAM: RODGER BELKNAP – CREATIVE DIRECTOR/VP HEAD OF CREATIVE; ELIZABETH SHIM – DESIGN DIRECTOR; PATRICK HOSMER, ALEC DONOVAN – ANIMATORS; DAVID PELICK MOLINARI – MUSIC; LAURYN SIEGEL, CARLY USDIN – PRODUCERS

CLIENT: LOGO

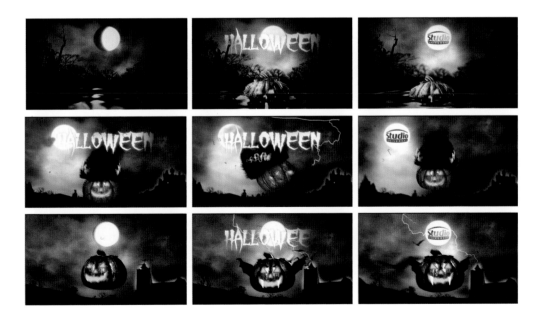

CREATIVE FIRM: NBC UNIVERSAL GLOBAL NETWORKS ITALIA – ROME, ITALY

CLIENT: NBC UNIVERSAL GLOBAL NETWORKS ITALIA

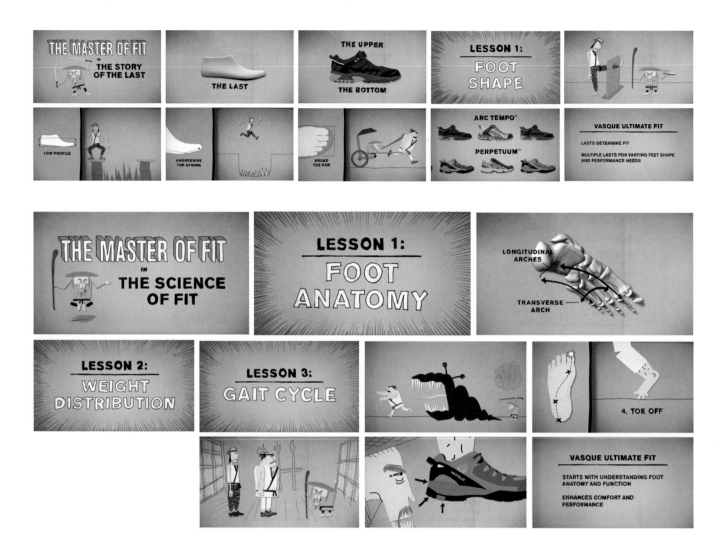

ⓅPLATINUM

CREATIVE FIRM: PLANET PROPAGANDA – MADISON, WI, USA
CREATIVE TEAM: NATE THEIS – DIRECTOR/DESIGNER/ANIMATOR; KRIS KLUTHE – DESIGNER/ANIMATOR; ANDY BRAWNER – COPYWRITER; MARCUS TRAPP – VOICEOVER; MIKE KROL – MUSIC
CLIENT: VASQUE

VASQUE MASTER OF FIT

Who is the Master of Fit? Planet Propaganda discovered (okay, created) this Yoda/Chuck Norris/Mr. Miyagi hybrid to host and narrate a training video for shoe company Vasque. "The project started out as a way to help shop kids understand the science and technology Vasque puts into their superior trail–running shoes," says director/animator/designer Nate Theis. Turning a dry subject into something fun, the Madison, Wis., agency was certain that humor would actually make the science stick better. "It's that whole 'sugar helps the medicine go down' thing," Theis says.

Making fairly technical information about the shoe development process not only understandable but interesting led to the conception of The Master of Fit. "He's

this grizzled, crabby Zen master guy who happens to know everything there is to know about feet, shoes, and fit," Theis explains. "Even though he comes off a little crazy and delusional (ok, a lot crazy and delusional), he clearly knows his stuff. He humiliates his pupils in the video yet still manages to be endearing." Vasque was on board with the idea from the beginning, but keeping the talent in check was the biggest knot to untie. "If anything was challenging, it was getting The Master to settle down long enough to actually drop some shoe knowledge," Theis says. "We had so much fun with his sadistic tendencies that we'd forget we had a job to do."

TV & RADIO

CREATIVITY AWARDS ANNUAL

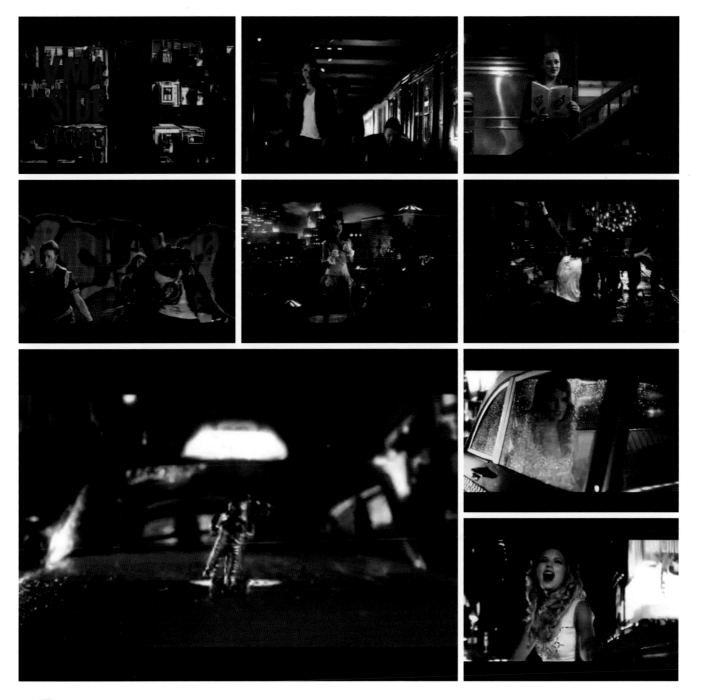

CREATIVE FIRM: MTV ON–AIR PROMOS – NEW YORK, NY, USA

CREATIVE TEAM: KEVIN MACKALL, AMY CAMPBELL – CREATIVE DIRECTORS; BRENT STOLLER – EXECUTIVE PRODUCER; SEYI PETER–THOMAS – WRITER/DIRECTOR/ART DIRECTOR; KRIS WALTER – PRODUCER; ELIZABETH EPP – ASSOCIATE PRODUCER; ERICSON CORE – DIRECTOR OF PHOTOGRAPHY; BRANDON BOUDREAUX – EDITOR; BRITT MYERS – AUDIO; CALEB EVERITT – GRAPHICS; SHAUN HARRISON – ANIMATOR; CLICK 3X – VISUAL EFFECTS

CLIENT: MTV

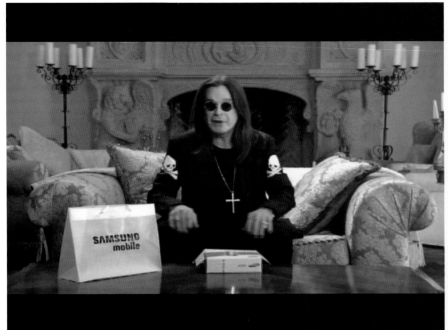

CREATIVE FIRM: MWW GROUP – DALLAS, TX, USA

CREATIVE TEAM: COLIN SELIKOW, VINCE COOK, BOB PRICE – CREATIVE DIRECTORS; MATT BLITZ – PRODUCER; TRENT BUTERBAUGH, MELANIE MCCORD, SARAH THORP, LIN

CLIENT: SAMSUNG MOBILE

CREATIVE FIRM: WIZZDESIGN° – CLICHY, FRANCE

CREATIVE TEAM: FRANÇOIS BRUN – PRODUCER; WIZZDESIGN° – PRODUCTION COMPANY; REMI DEVOUASSOUD – DIRECTOR; JEROME LOZANO – EDITOR; MARCEL PARIS – ADVERTISING AGENCY; FREDERIC TEMIN – CREATIVE DIRECTOR; ANNE DE MAUPEOU – CREATIVE DIRECTOR; PIERRE MARCUS – AGENCY PRODUCER; REMI DEVOUASSOUD – ANIMATION; THIERRY OIGNON – ANIMATION; FLAME ARTIST – MICHA SHER; WIZZ – POST PRODUCTION; WAM – 2ND POST PRODUCTION COMPANY; QUEEN – SAVE ME – MUSIC

CLIENT: FIAT

URL: WWW.WIZZ.FR

CREATIVE FIRM: MTV ON–AIR PROMOS – NEW YORK, NY, USA

CREATIVE TEAM: KEVIN MACKALL, AMY CAMPBELL, JOSEPH ORTIZ – CREATIVE DIRECTORS; EVAN SILVER – WRITER/DIRECTOR/ART DIRECTOR; JESSICA BOROVAY – PRODUCER; DAVE GORN – DIRECTOR OF PHOTOGRAPHY; BRAD TURNER – EDITOR; DAVE HNATIUK, DAVE HUSTON – AUDIO; RICHARD BROWD – GRAPHICS; DAVID WEINSTOCK – TYPE DESIGN

CLIENT: MTV

CREATIVE FIRM: PUBLICIS/THE BASEMENT DESIGN + MOTION – INDIANAPOLIS, IN, USA

CLIENT: PUBLICIS/CONNER PRAIRIE

URL: HTTP://VIMEO.COM/4514248

CREATIVE FIRM: TAYLOR JAMES – LONDON, UNITED KINGDOM

CREATIVE TEAM: GLOBAL HUE – AGENCY; TAYLOR JAMES – CGI & VISUAL EFFECTS/DIRECTOR; FLYNN PRODUCTIONS – LIVE ACTION PRODUCTION; BERMUDA TOURISM – CLIENT

CLIENT: BERMUDA TOURISM

CREATIVE FIRM: MTV ON–AIR PROMOS – NEW YORK, NY, USA

CREATIVE TEAM: KEVIN MACKALL, AMY CAMPBELL, JOSEPH ORTIZ – CREATIVE DIRECTORS; BRENT STOLLER – EXECUTIVE PRODUCER; HOWARD GRANDISON, EVAN SILVER – WRITERS/DIRECTORS; KRIS WALTER – PRODUCER; THOMAS BERGER, ANTHONY ANNANDONO – ART DIRECTORS; JOE ARCIDIACONO, DAVE GORN – DIRECTORS OF PHOTOGRAPHY; BRAD TURNER – EDITOR; DAVE HNATIUK – AUDIO; CLICK 3X – VISUAL EFFECTS

CLIENT: MTV

CREATIVE FIRM: MTV ON–AIR PROMOS – NEW YORK, NY, USA

CREATIVE TEAM: KEVIN MACKALL, AMY CAMPBELL, JOSEPH ORTIZ – CREATIVE DIRECTORS; BRENT STOLLER – EXECUTIVE PRODUCER; EVAN SILVER – WRITER/DIRECTOR/ART DIRECTOR; SEAN LINEHAN – PRODUCER; CARLOS VERON – DIRECTOR OF PHOTOGRAPHY; DAVE HNATIUK – SOUND DESIGN; ERIK AULI – EDITOR; SHAY GRABOWSKI – GRAPHICS; CLICK 3X – VISUAL EFFECTS

CLIENT: MTV

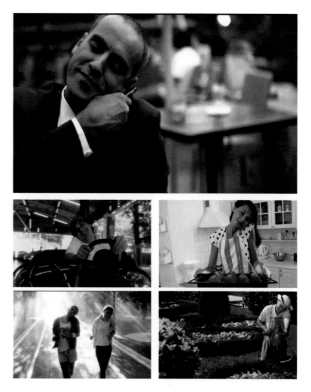

CREATIVE FIRM: NICKELODEON – NEW YORK, NY, USA

CREATIVE TEAM: JAY SCHMALHOLZ – CREATIVE DIRECTOR; ANTHONY GELSOMINO – EXECUTIVE PRODUCER; ROBYN BROWN – ASSOCIATE PRODUCER; LAURA VON IDERSTEIN – SENIOR MANAGER; NICK WAKEFIELD – PRODUCER

CLIENT: DREAMWORKS

CREATIVE FIRM: BRUKETA&ZINIC OM – ZAGREB, CROATIA

CREATIVE TEAM: MOE MINKARA – CREATIVE DIRECTOR/COPYWRITER; DANIEL VUKOVIC – COPYWRITER; GOGA GOLIK – ART DIRECTOR; SARKE – PRODUCER; LEVIAN BAKHIA – DIRECTOR; HELENA ROSANDIC – ACCOUNT DIRECTOR

CLIENT: NAR MOBILE

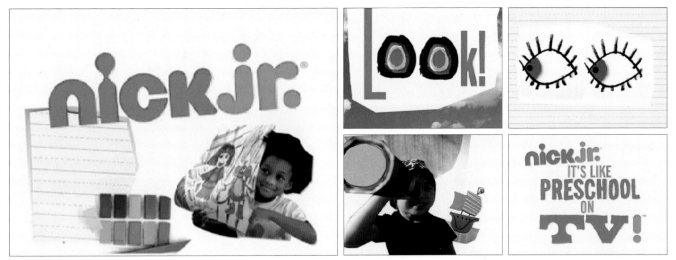

CREATIVE FIRM: NICKELODEON PRESCHOOL BRAND CREATIVE – NEW YORK, NY, USA

CREATIVE TEAM: JESSICA MCCADDEN – PRODUCER; FARREL ALLEN – DIRECTOR OF ON AIR PROMOS; LIZA STEINBERG – EDITORIAL DIRECTOR; ELANA BAUMGARTEN, MATTHEW PERRAULT – WRITERS; MATTHEW DUNTEMANN – CREATIVE DIRECTOR; JENNIFER CAST – ART DIRECTOR; KURT HARTMAN – ANIMATOR; LAURIE ROSENWALD – DESIGNER; JEFFREY BLACKMAN – VP OF PRODUCTION; ANNETTE FERRARA – SENIOR PROJECT MANAGER; KIM SHEA – PRODUCTION MANAGER; JESSICA RISHEL – PRODUCTION ASSISTANT

CLIENT: NICKELODEON

CREATIVE FIRM: NICKELODEON – NEW YORK, NY, USA

CREATIVE TEAM: JAY SCHMALHOLZ – CREATIVE DIRECTOR; ANTHONY GELSOMINO – EXECUTIVE PRODUCER; ROBYN BROWN – ASSOCIATE PRODUCER; LAURA VON IDERSTEIN – SENIOR MANAGER

CLIENT: PARAMOUNT

CREATIVE FIRM: NICKELODEON – NEW YORK, NY, USA

CREATIVE TEAM: JAY SCHMALHOLZ – CREATIVE DIRECTOR; ANTHONY GELSOMINO – EXECUTIVE PRODUCER; ROBYN BROWN – ASSOCIATE PRODUCER; LAURA VON IDERSTEIN – SENIOR MANAGER; RICK ORLANDO – PRODUCER

CLIENT: DREAMWORKS

CREATIVE FIRM: PLANET PROPAGANDA – MADISON, WI, USA
CREATIVE TEAM: DAVID TAYLOR – CREATIVE DIRECTOR/DESIGNER; NATE THEIS – DIRECTOR/ANIMATOR; ANDY BRAWNER – COPYWRITER
CLIENT: ACR

CREATIVE FIRM: NBC UNIVERSAL GLOBAL NETWORKS ITALIA – ROME, ITALY
CLIENT: NBC UNIVERSAL GLOBAL NETWORKS ITALIA

THE UNKNOWN IS CLOSER THAN YOU CAN IMAGINE.

CREATIVE FIRM: MTVU – NEW YORK, NY, USA
CREATIVE TEAM: ERIC CONTE – VP PRODUCTION; CHRIS MCCARTHY – EXECUTIVE PRODUCER; JOE BUOYE – SENIOR DIRECTOR OF OPERATIONS; JAMES COHAN – DIRECTOR OF POST PRODUCTION; ALAN CLARY – PRODUCER
CLIENT: HARRY POTTER

 PLATINUM

CREATIVE FIRM: NICKELODEON PRESCHOOL BRAND CREATIVE – NEW YORK, NY, USA

CREATIVE TEAM: JENNIFER TREUTING – PRODUCER; FARREL ALLEN – DIRECTOR OF ON AIR PROMOS; MATTHEW DUNTEMANN – CREATIVE DIRECTOR; KURT HARTMAN, CHRISTOPHER PAPA – ANIMATORS; MELINDA BECK – DESIGNER; JEFFREY BLACKMAN – VP OF PRODUCTION; ANNETTE FERRARA – SENIOR PROJECT MANAGER; KIM SHEA – PRODUCTION MANAGER; JESSICA RISHEL – PRODUCTION ASSISTANT

CLIENT: NICKELODEON

CREATIVE FIRM: CMT – NEW YORK, NY, USA

CREATIVE TEAM: JEFF NICHOLS, LESLIE LEGARE – CREATIVE DIRECTORS; DAVID BENNETT – ART DIRECTOR; EMILIE SCHNICK – PROJECT MANAGER; TRAVIS FRADY, NORA GAFFNEY – PRODUCERS; MALCOLM FRANCIS, JIM PARKER – SOUND DESIGN; NAILGUN – DESIGNER

CLIENT: CMT

CREATIVE FIRM: TEENNICK – NEW YORK, NY, USA

CREATIVE TEAM: DAVID CHUSTZ – VP, BRAND CREATIVE; MATTHEW PER-REAULT – CREATIVE DIRECTOR; LISANDRO PEREZ–REY – PRODUCER

CLIENT: TEENNICK

CREATIVE FIRM: NICKTOONS – NEW YORK, NY, USA

CREATIVE TEAM: TERRY MCCORMICK – CREATIVE DIRECTOR; MICHELLE KRATCHMAN – ART DIRECTOR; JON MCNALLY – PRODUCER

CLIENT: NICKTOONS

CREATIVE FIRM: NICKELODEON PRESCHOOL BRAND CREATIVE – NEW YORK, NY, USA

CREATIVE TEAM: KIMBERLY CHALMERS – PRODUCER; FARREL ALLEN – DIRECTOR OF ON AIR PROMOS; MATTHEW DUNTEMANN – CREATIVE DIRECTOR; CHRISTOPHER PAPA – ANIMATOR; DAVE HEISS – ANIMATOR; MELINDA BECK – DESIGNER; JEFFREY BLACKMAN – VP OF PRODUCTION; LINDSEY FELTY – PROJECT MANAGER; STEVE PUCCIARELLI, KIM SHEA – PRODUCTION MANAGERS; KELLY FENTRESS – PROJECT ASSISTANT; JESSICA RISHEL – PRODUCTION ASSISTANT

CLIENT: NICKELODEON

CREATIVE FIRM: TROLLBACK – NEW YORK, NY, USA

CREATIVE TEAM: JAY SCHMALHOLZ, MATTHEW DUNTEMANN – CREATIVE DIRECTORS; GALIA MOORS – EDITOR; CHRISTINA AUGUSTINOS – EXECUTIVE PRODUCER; LIZ WILLIAMS – PRODUCER; TROLLBACK – DESIGNER; KATINA STERGAKOS, DIANA CHU – PROJECT MANAGERS; SHANELLE COLLINS, TARA POWER – LINE PRODUCERS; ERICA OTTENBERG – COPYWRITER; MICHAEL PECORIELLO – SENIOR COPYWRITER; ROY HARTER – AUDIO MIXER; BRIAN LUCY, TONI–ANN LAGANA – PRODUCTION ASSISTANTS

CLIENT: NICKELODEON

CREATIVE FIRM: TROLLBACK – NEW YORK, NY, USA

CREATIVE TEAM: JAY SCHMALHOLZ, MATTHEW DUNTEMANN – CREATIVE DIRECTORS; GALIA MOORS – EDITOR; CHRISTINA AUGUSTINOS – EXECUTIVE PRODUCER; LIZ WILLIAMS – PRODUCER; BRIAN LUCY, TONI–ANN LAGANA – PRODUCTION ASSISTANTS; TARA POWER, SHANELLE COLLINS – LINE PRODUCER; DIANA CHU – PROJECT MANAGER; KATINA STERGAKOS – PROJECT MANAGER; ERICA OTTENBERG – COPYWRITER; MICHAEL PECORIELLO – SENIOR COPYWRITER; TROLLBACK – DESIGNER; ROY HARTER – AUDIO MIXER

CLIENT: NICKELODEON

CREATIVE FIRM: MTVU – NEW YORK, NY, USA

CREATIVE TEAM: ERIC CONTE – VP PRODUCTION; CHRIS MCCARTHY – EXECUTIVE PRODUCER; JOE BUOYE – DIRECTOR OF OPERATIONS; DAN LUTZ, MIKE STYPULKOSKI – PRODUCERS; JAMES COHAN – DIRECTOR OF POST PRODUCTION

CLIENT: NIKE

URL: HTTP://WWW.MTVU.COM/TAG/THE–NIKE–HUMAN–RACE/

CREATIVE FIRM: MTV ON–AIR DESIGN – NEW YORK, NY, USA

CREATIVE TEAM: JEFFREY KEYTON, ROMY MANN – CREATIVE DIRECTORS; THOMAS BERGER – DESIGN DIRECTOR; PAMELA BRILL – SUPERVISING PRODUCER; KRIS WALTER – LINE PRODUCER; CLICK 3X – EDIT & ANIMATION

CLIENT: MTV

CREATIVE FIRM: TROLLBACK – NEW YORK, NY, USA

CREATIVE TEAM: JAY SCHMALHOLZ, MATTHEW DUNTEMANN – CREATIVE DIRECTORS; CHRISTINA AUGUSTINOS – EXECUTIVE PRODUCER; LIZ WILLIAMS – PRODUCER; GALIA MOORS – EDITOR; TROLLBACK – DESIGNER; KATINA STERGAKOS – PROJECT MANAGER; ERICA OTTENBERG – COPYWRITER; MICHAEL PECORI-ELLO – SENIOR COPYWRITER; TARA POWER, SHANELLE COLLINS – LINE PRODUCERS; DIANA CHU – PROJECT MANAGER; ROY HARTER – AUDIO MIXER; TONI–ANN LAGANA, BRIAN LUCY – PRODUCTION ASSISTANTS

CLIENT: NICKELODEON

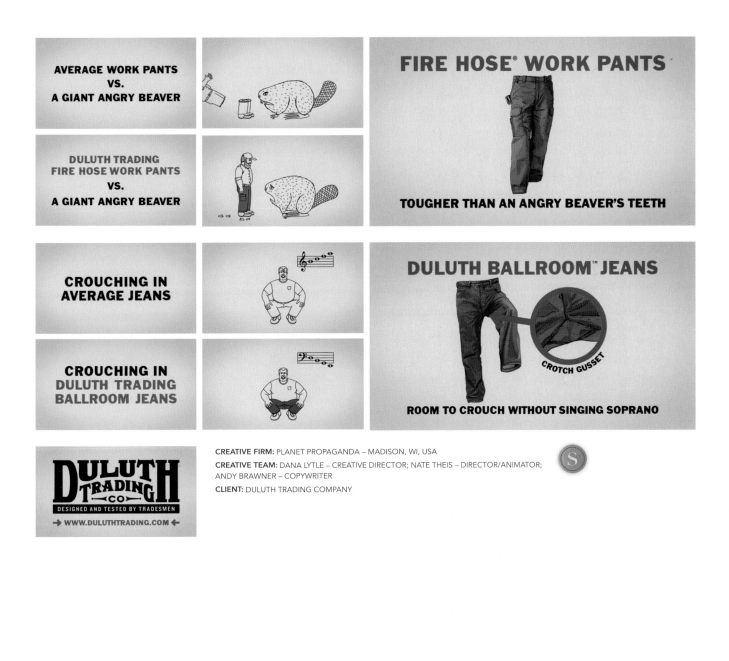

CREATIVE FIRM: PLANET PROPAGANDA – MADISON, WI, USA
CREATIVE TEAM: DANA LYTLE – CREATIVE DIRECTOR; NATE THEIS – DIRECTOR/ANIMATOR; ANDY BRAWNER – COPYWRITER
CLIENT: DULUTH TRADING COMPANY

CREATIVE FIRM: TROLLBACK – NEW YORK, NY, USA
CREATIVE TEAM: JAY SCHMALHOLZ – CREATIVE DIRECTOR; CHRISTINA AUGUSTINOS – EXECUTIVE PRODUCER; ANDREW HARRISON, MATTHEW DUNTEMANN – CREATIVE DIRECTORS; JENNIFER BRYSON, KATHERINE KENNEDY – PRODUCERS; SCOTT DUNCAN – DIRECTOR; TARA POWER – LINE PRODUCER; ROY HARTER – AUDIO MIXER; KATINA STERGAKOS, LINDSAY FELTY, RUTH HORN – MANAGERS; TROLLBACK – DESIGNER
CLIENT: NICKELODEON

CREATIVE FIRM: WIZZDESIGN° – CLICHY, FRANCE

CREATIVE TEAM: WIZZDESIGN° – PRODUCTION; FRANÇOIS BRUN – PRODUCER; GUILLAUME COMBES – ARTISTIC RESEARCH; MAUD DARDEAU, MATTHIEU JAVELLE – ARTISTS/ILLUSTRATORS FOR SUMO; FOGGY NOTION, DANIEL GOTESSON – ARTISTS/ILLUSTRATORS FOR HULA; EDIK KATYKHIN – ARTIST/ILLUSTRATOR FOR YOGA; IRINA DAKEVA, CLEMENT DOZIER – DIRECTORS; WIZZ PARIS – POST PRODUCTION; CEDRIC HERBET – POST PRODUCTION DIRECTOR; MATTHIEU CAULET – COMPOSITING; SEBASTIEN FILINGER, MATTHIEU WOTHKE, CLEMENT SOULMAGNON, GARY LEVESQUE, CORENTIN ROUGE – 2D GRAPHIC ARTISTS FOR SUMO; PHILIPPE VALETTE – 2D GRAPHIC ARTIST FOR SUMO, YOGA, HULA; DAVID DEVAUX, NICOLAS HU, BRUNO MAYOR, LISA PACLET, BRUNO SALAMONE, OERD VAN CUIJLENBORG – 2D GRAPHIC ARTISTS FOR HULA, YOGA; OGILVY PARIS – AGENCY; CHRIS GARBUTT – EXECUTIVE CREATIVE DIRECTOR; ANTOANETA METCHANOVNA – ART DIRECTOR; ARNAUD VANHAEL, BENJAMIN BREGEAULT – COPYWRITERS; LAURE BAYLE, DIANE DE BRETTEVILLE – TV PRODUCTION; DANA EDELMAN – MUSIC COMPOSER FOR SUMO; MILE23MUSIC US NY, CENDRINEIGE PARIS – MUSIC CO EDITORS FOR SUMO; MATHIEU LAFONTAINE, JASON BRANDO CICIOLA – MUSIC COMPOSOR FOR YOGA; DIDIER TOVELS – MUSIC COMPOSOR FOR HULA

CLIENT: MATTEL

URL: WWW.WIZZ.FR

CREATIVE FIRM: EURO RSCG C&O – PARIS, FRANCE

CREATIVE TEAM: OLIVIER MOULIERAC, JÉRÔME GALINHA – CREATIVE DIRECTORS; SYLVAIN LOURADOUR – COPYWRITER; SILKE NEUMANN – ART DIRECTOR; EMMANUELLE RONSLIN – AGENCY PRODUCER; VIRGINIE MELDENER – TV PRODUCER; 75 – PRODUCTION COMPANY; VINCENT LOBELLE – DIRECTOR; JEAN–MARC HULEUX, LUCILE DRÉANO – AGENCY MANAGERS; AURÉLIE MARTZEL, FABRICE MOREAU – INPES COMMUNICATION MANAGERS

CLIENT: INPES

half men and half demons serving humanity

half men and half demons serving humanity

Super-heroes ready to explode
on your TV screen

half men and half demons serving humanity

- Are we talking all night?
I am sleeping to death

PLATINUM

CREATIVE FIRM: NBC UNIVERSAL GLOBAL NETWORKS
ITALIA – ROME, ITALY
CLIENT: NBC UNIVERSAL GLOBAL NETWORKS ITALIA

COMICS ON SCI FI

The Sci–Fi Channel (now SyFy) is worldwide, including as a branded programming block on the Italian action and adventure channel Steel. To promote a segment dedicated to some of comics' most iconic superheroes, NBC Universal Global Networks Italia graphically communicated the intimate relationship between the narrative and visual expression. "Our challenge was to get away from the usual reproduction of comics on screen, or comic strips with moving images inside," says creative manager Monica Ciarli, "and then decided to show how a comic hero can become an animated hero on screen." By using the actual characters across media from black–and–white sketches on paper to their blockbuster movie counterparts, Ciarli literally thought outside the box and stylistically explored how characters can leap off the page and onto the screen.

CREATIVE FIRM: 4CREATIVE – NEW YORK, NY, USA

CREATIVE TEAM: MICHAEL ENGLEMAN – SVP MARKETING: GLOBAL BRAND STRATEGY AND CREATIVE; KATE LEONARD – HEAD OF PRODUCTION; JOE LOSKYWITZ, TOM TAGHOLM – CREATIVE DIRECTORS; BRETT FORAKER – DIRECTOR; SHANANNE LANE – EXECUTIVE PRODUCER; OLIVIA BROWNE – BUSINESS DIRECTOR; ROBERTS JONES – PRODUCER; TINO SCHAEDLER – PRODUCTION DESIGNER; LARRY FONG – DIRECTOR OF PHOTOGRAPHY; ADAM RUDD – EDITOR; RICH MARTIN – SOUND DESIGN AND COMPOSER; LIZ GAFFNEY – LINE PRODUCER; MIGUEL E. RODRIGUEZ – PRODUCTION COORDINATOR

CLIENT: SYFY

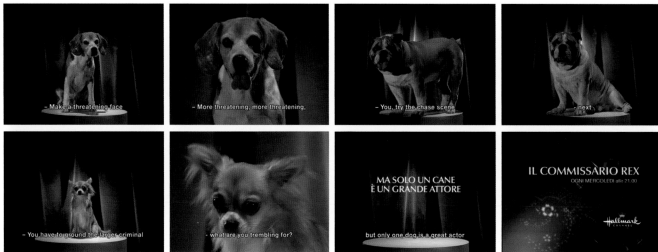

CREATIVE FIRM: NBC UNIVERSAL GLOBAL NETWORKS ITALIA – ROME, ITALY

CLIENT: NBC UNIVERSAL GLOBAL NETWORKS ITALIA

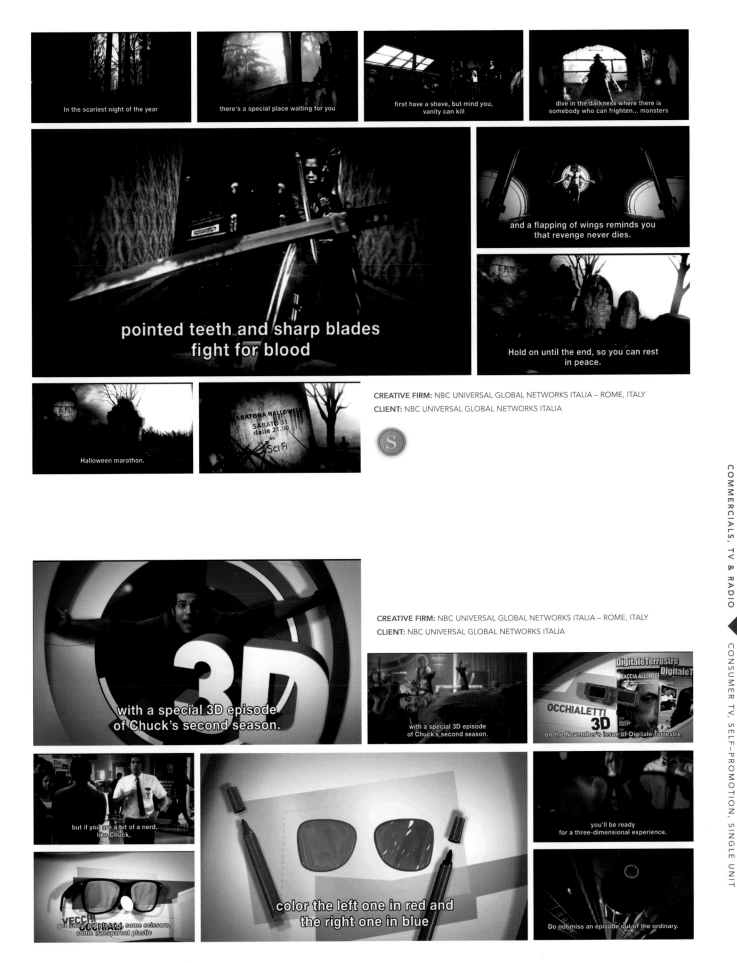

In the scariest night of the year

there's a special place waiting for you

first have a shave, but mind you, vanity can kill

dive in the darkness where there is somebody who can frighten... monsters

pointed teeth and sharp blades fight for blood

and a flapping of wings reminds you that revenge never dies.

Hold on until the end, so you can rest in peace.

Halloween marathon.

CREATIVE FIRM: NBC UNIVERSAL GLOBAL NETWORKS ITALIA – ROME, ITALY
CLIENT: NBC UNIVERSAL GLOBAL NETWORKS ITALIA

with a special 3D episode of Chuck's second season.

with a special 3D episode of Chuck's second season.

on the November's issue of Digitale Terrestre.

CREATIVE FIRM: NBC UNIVERSAL GLOBAL NETWORKS ITALIA – ROME, ITALY
CLIENT: NBC UNIVERSAL GLOBAL NETWORKS ITALIA

but if you are a bit of a nerd, like Chuck,

you'll be ready for a three-dimensional experience.

get some glasses, some scissors, some transparent plastic

color the left one in red and the right one in blue

Do not miss an episode out of the ordinary.

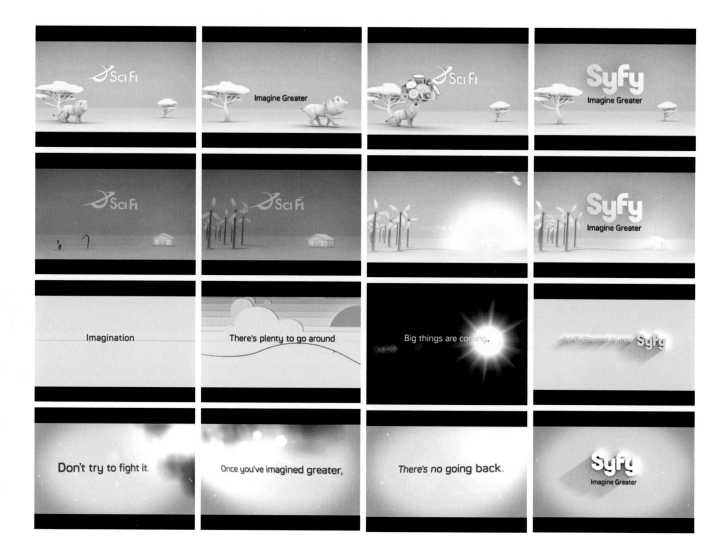

CREATIVE FIRM: SYFY – NEW YORK, NY, USA
CREATIVE TEAM: MICHAEL ENGLEMAN – SVP MARKET-
ING: GLOBAL BRAND STRATEGY AND CREATIVE; JOE
LOSKYWITZ – CREATIVE DIRECTOR; BL:ND – DESIGN/
ANIMATION; KATE LEONARD – DIRECTOR OF ON–AIR; BEN
COCHRAN – COPYWRITER; BRIAN EVERETT – PRODUCER;
KARI SHACKELTON – PROJECT MANAGER
CLIENT: SYFY

P PLATINUM

I TO Y

What if words could be transformed by the power of a lion's roar, blown away by wind turbines that sprout from the earth, or moved to dance through animated type treatments—all with the tagline, "Imagine Greater"? Such imaginative scenarios were exactly how the Sci Fi Channel went about announcing its new name, SyFy, to viewers. The "I to Y" campaign, a thoughtful, multi–pronged creative effort, heralded the brand evolution through a series of animation–based spots—each introducing viewers to the new look and feel of Syfy.

The spots avoided the obvious thematic choices, such as aliens, instead focusing on well–known things from everyday life.

Set in Syfy's signature brand environment, each narrative in the "Transformation" series featured evocative animation and meticulously selected music in order to communicate the magical yet playful nature of Syfy. The "Word Play" spots featured carefully crafted, poetic copy brought to life by a breath of simple animation. Short, sweet, and created completely in–house, the spots garnered attention and acclaim while acquainting audiences with Syfy's new editorial voice and custom font, Syfy Sans.

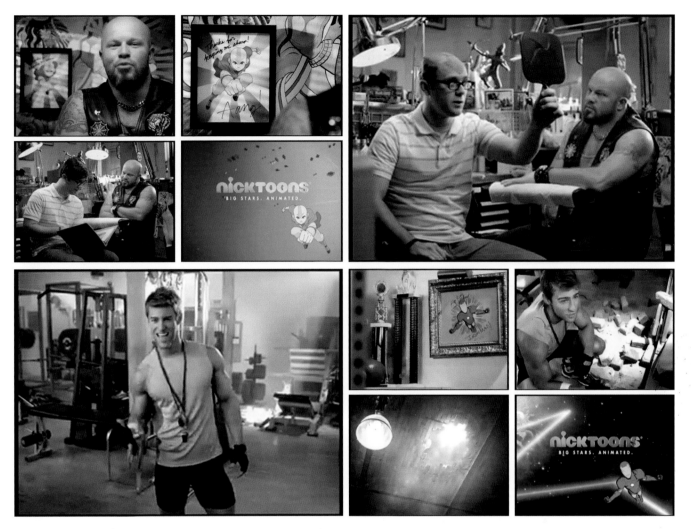

CREATIVE FIRM: CURIOUS PICTURES – NEW YORK, NY, USA

CREATIVE TEAM: TERRY MCCORMICK – CREATIVE DIRECTOR; MICHELLE KRATCHMAN – ART DIRECTOR; CURIOUS PICTURES – CREATIVE FIRM

CLIENT: NICKTOONS

CREATIVE FIRM: ROGER – NEW YORK, NY, USA

CREATIVE TEAM: TERRY MCCORMICK – CREATIVE DIRECTOR; MICHELLE KRATCHMAN – ART DIRECTOR; VICKY STEWART – PRODUCER; ROGER – CREATIVE FIRM

CLIENT: NICKTOONS

CREATIVE FIRM: MEKANISM – NEW YORK, NY, USA

CREATIVE TEAM: DAVID CHUSTZ (TEENNICK) – VP, BRAND CREATIVE; MATTHEW PERREAULT (TEENNICK) – CREATIVE DIRECTOR; JASON HARRIS – PRESIDENT/EXECUTIVE PRODUCER; DAVE CLARK, RORY HANRAHAN – DIRECTORS; LISANDRO PEREZ–REY (TEENNICK) – PRODUCER

CLIENT: TEENNICK

CREATIVE FIRM: ROGER – NEW YORK, NY, USA

CREATIVE TEAM: TERRY MCCORMICK – CREATIVE DIRECTOR; MICHELLE KRATCHMAN – ART DIRECTOR; VICKY STEWART – PRODUCER; ROGER – CREATIVE FIRM

CLIENT: NICKTOONS

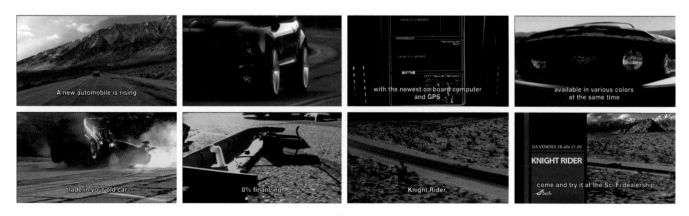

CREATIVE FIRM: NBC UNIVERSAL GLOBAL NETWORKS ITALIA – ROME, ITALY

CLIENT: NBC UNIVERSAL GLOBAL NETWORKS ITALIA

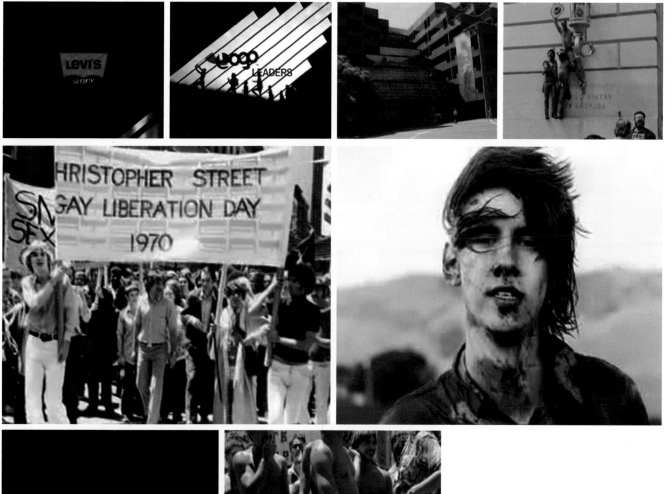

PLATINUM

CREATIVE FIRM: LOGO – NEW YORK, NY, USA

CREATIVE TEAM: COURTNEY POWELL – DIRECTOR/EDITOR/PRODUCER; GARRETT WAGNER – CREATIVE DIRECTOR; DANIELLE STACK – ANIMATOR; TONY BEKO – CINEMATOGRAPHER; ELIZABETH SHIM – DESIGN DIRECTOR; BRETT WOLFSON – LINE PRODUCER; STEPHEN HERMANN – SOUND DESIGNER; AMY WIGLER – VICE PRESIDENT OF INTEGRATED MKTG; RODGER BELKNAP – CREATIVE DIRECTOR/VP HEAD OF CREATIVE

CLIENT: LEVI'S

CREATIVE FIRM: LOGO – NEW YORK, NY, USA

CREATIVE TEAM: RODGER BELKNAP – CREATIVE DIRECTOR/ VP HEAD OF CREATIVE; GARRETT WAGNER – VP PROMOS & EDITORIAL DIRECTOR; ELIZABETH SHIM – DESIGN DIRECTOR; BRETT WOLFSON – LINE PRODUCER; TANYA GIZZARELLI – PRODUCTION ASSISTANT; DEBORAH GAR REICHMAN – DIRECTOR/WRITER/PRODUCER; KENNETH KRUEGER – DESIGNER/ANIMATOR; JUNG IN YUN – ANIMATOR; ANA VESELIC – EDITOR; JONATHAN TANZER – DIRECTOR OF PHOTOGRAPHY; RALPH KELSEY – AUDIO

CLIENT: LOGO

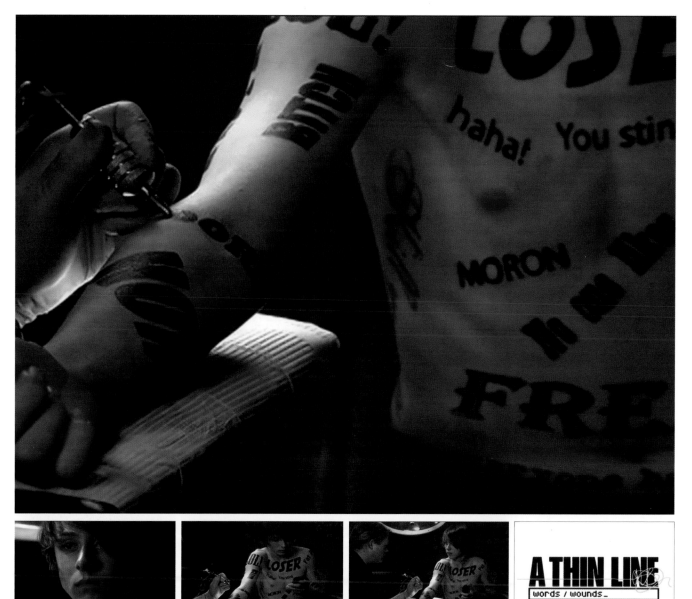

A THIN LINE
words / wounds_

athinline.org

PLATINUM

CREATIVE FIRM: MTV ON–AIR PROMOS – NEW YORK, NY, USA

CREATIVE TEAM: KEVIN MACKALL, AMY CAMPBELL – CREATIVE DIRECTORS; BRENT STOLLER – EXECUTIVE PRODUCER; PATRICK CUMMINGS – WRITER/ART DIRECTOR; JOEL SCHUMACHER – DIRECTOR; SEAN LINEHAN – PRODUCER; JERRY RISIUS – DIRECTOR OF PHOTOGRAPHY; AYELET LEIBOVITCH – EDITOR; PAUL GOLDMAN – AUDIO

CLIENT: MTV

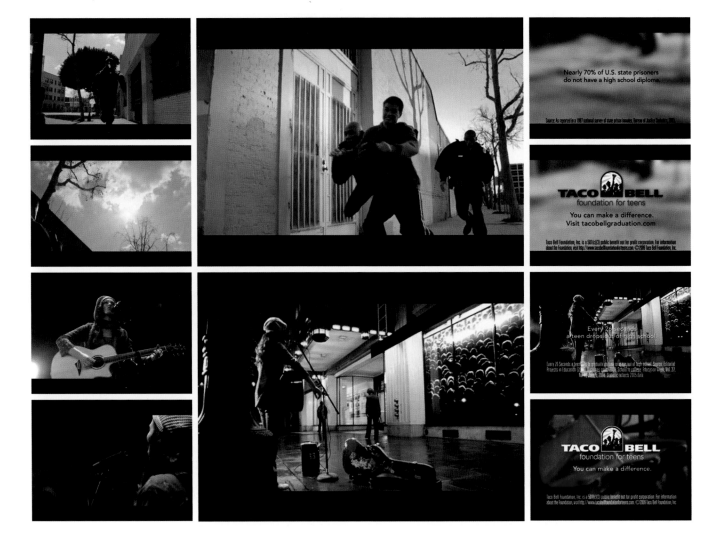

 PLATINUM

CREATIVE FIRM: DIESTE – DALLAS, TX, USA

CREATIVE TEAM: CARLOS TOURNE – CHIEF CREATIVE OFFICER; ROBERTO SAUCEDO – CREATIVE DIRECTOR; IGNACIO ROMERO, SAUL DOMINGUEZ – COPYWRITERS; JESUS ACOSTA – ART DIRECTOR; ANGEL LA RIVA – AGENCY PRODUCER; JIM ZOOLALIAN – DIRECTOR

CLIENT: TACO BELL

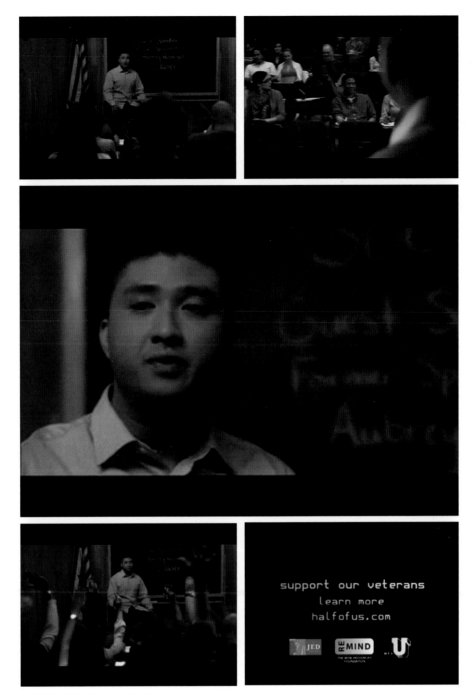

support our veterans
learn more
halfofus.com

CREATIVE FIRM: MTV ON–AIR PROMOS – NEW YORK, NY, USA

CREATIVE TEAM: KEVIN MACKALL, AMY CAMPBELL – CREATIVE DIRECTORS; SOPHIA CRANSHAW – WRITER/DIRECTOR; ANDREA WILLIAMS – WRITER; JEFF WOODTON – PRODUCER; JON HOKANSON – DIRECTOR OF PHOTOGRAPHY; GREGORY KENNEY, CORYANDER FRIEND – ART DIRECTORS; GALA VERDUGO – EDITOR; JON TROPEA – AUDIO; NOOPUR AGARWAL – DIRECTOR, MTV PUBLIC AFFAIRS; COURTNEY KNOWLES – THE JED FOUNDATION; RENE BARDORF – BOB WOODRUFF FOUNDATION

CLIENT: MTVU, THE JED FOUNDATION, BOB WOODRUFF FOUNDATION

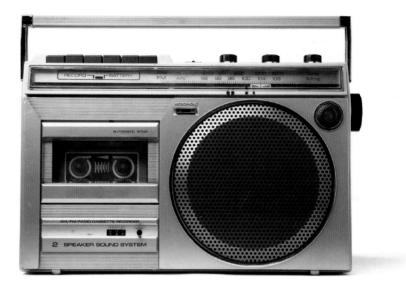

CATEGORY: RADIO, SINGLE UNIT

CREATIVE FIRM: DIESTE – DALLAS, TX, USA

CREATIVE TEAM: ALDO QUEVEDO – CHIEF CREATIVE OFFICER; CARLOS TOURNE – EXECUTIVE CREATIVE OFFICER; PATY MARTINEZ, FLOR LEIBASCHOFF – CREATIVE DIRECTORS; FLOR LEIBASCHOFF, ERNESTO FERNANDEZ, ALEX REIDER – COPYWRITERS; PATY MARTINEZ, ALE TORRES – ART DIRECTORS; JOHN COSTELLO – AGENCY PRODUCER

CLIENT: 7–ELEVEN

CATEGORY: RADIO, SINGLE UNIT

CREATIVE FIRM: CLEAR CHANNEL CREATIVE SERVICES GROUP – ATLANTA, GA, USA

CREATIVE TEAM: COLIN COSTELLO – ASSOCIATE CREATIVE DIRECTOR; CHRISTINA O'FLAHERTY, JASON PHELPS – WRITERS

CLIENT: BRYANT PARK

CATEGORY: RADIO, SINGLE UNIT

CREATIVE FIRM: CLEAR CHANNEL CREATIVE SERVICES GROUP – ATLANTA, GA, USA

CREATIVE TEAM: COLIN COSTELLO – WRITER; JJ FOXX – PRODUCER; LIZ SMITH – CREATIVE DIRECTOR

CLIENT: AD COUNCIL/IRAQ & AFGHANISTAN VETERANS OF AMERICA

CATEGORY: RADIO, SINGLE UNIT

CREATIVE FIRM: CLEAR CHANNEL CREATIVE SERVICES GROUP – ATLANTA, GA, USA

CREATIVE TEAM: JJ FOXX – ASSOCIATE CREATIVE DIRECTOR; JILL BELLOMA – WRITER; FORREST MARTIN – PRODUCER

CLIENT: MYRECORDCLEARED.COM

CATEGORY: RADIO, SINGLE UNIT

CREATIVE FIRM: MULTICARE HEALTH SYSTEMS – SEATTLE, WA, USA

CLIENT: MULTICARE HEALTH SYSTEMS

URL: MULTICARE.ORG

CATEGORY: RADIO, SINGLE UNIT

CREATIVE FIRM: MULTICARE HEALTH SYSTEMS – SEATTLE, WA, USA

CLIENT: MULTICARE HEALTH SYSTEMS

URL: MULTICARE.ORG

CATEGORY: RADIO, CAMPAIGN

CREATIVE FIRM: CLEAR CHANNEL CREATIVE SERVICES GROUP – ATLANTA, GA, USA

CREATIVE TEAM: JJ FOXX – ASSOCIATE CREATIVE DIRECTOR; CHRISTINA O'FLAHERTY – WRITER; JASON PHELPS – WRITER/PRODUCER

CLIENT: CLEAR CHANNEL CREATIVE SERVICES GROUP

CATEGORY: RADIO, SELF–PROMOTION, SINGLE UNIT

CREATIVE FIRM: CLEAR CHANNEL CREATIVE SERVICES GROUP – ATLANTA, GA, USA

CREATIVE TEAM: JILL BELLOMA, DAVE SAVAGE, JASON PHELPS – WRITERS; VITO GORINAS – WRITER/PRODUCER; LIZ SMITH – CREATIVE DIRECTOR

CLIENT: ROCKSTAR RADIO WADV

CATEGORY: RADIO, SELF–PROMOTION, SINGLE UNIT

CREATIVE FIRM: MULTICARE HEALTH SYSTEMS – SEATLLE, WA, USA

CREATIVE TEAM: MARTHA CRAIG – WRITER

CLIENT: MULTICARE HEALTH SYSTEMS

URL: MULTICARE.ORG

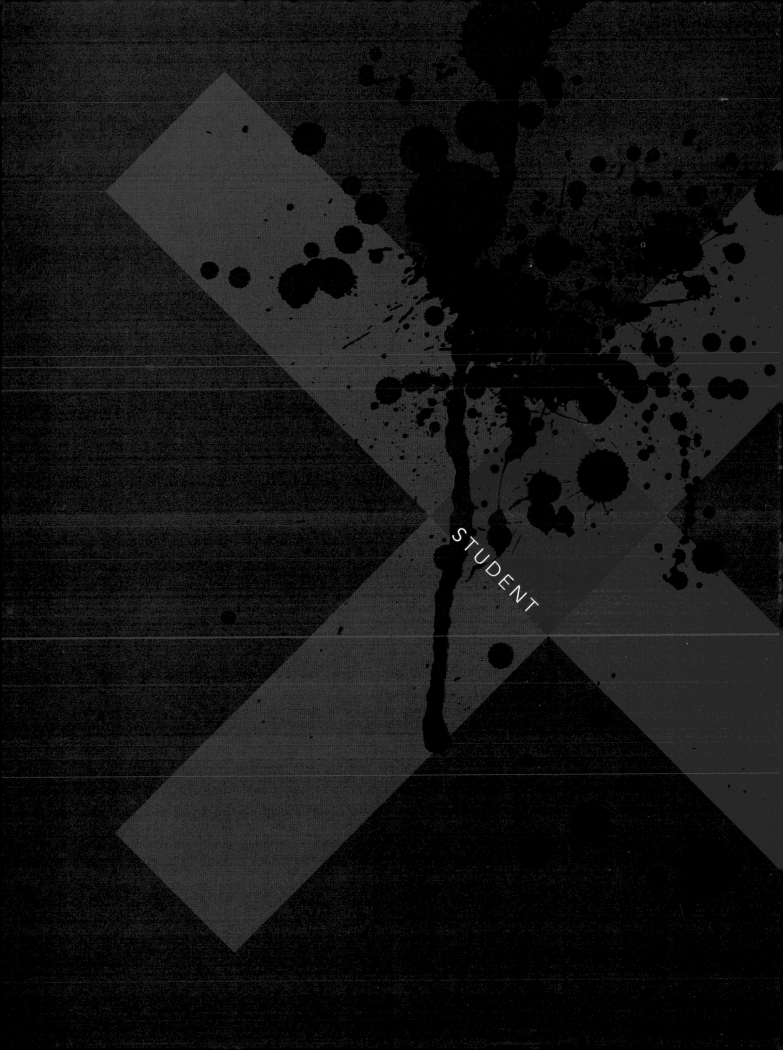

STUDENT

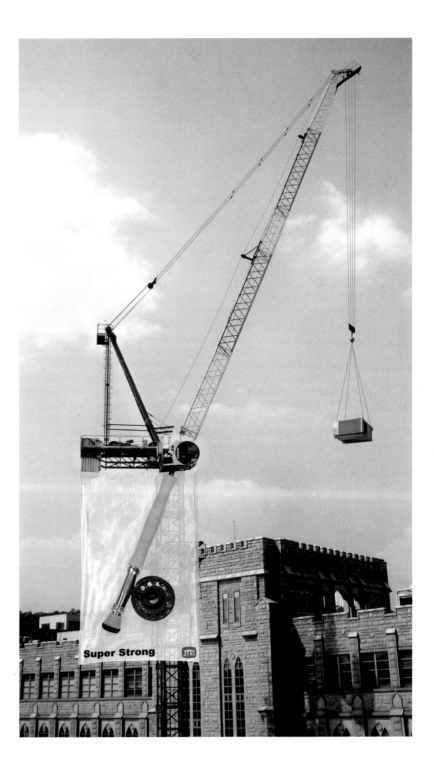

 PLATINUM

SUPER STRONG FISHING RODS

CATEGORY: BILLBOARDS, SINGLE UNIT
SCHOOL: SEOUL, SOUTH KOREA
CREATIVE TEAM: JOO HONG KIM – ART DIRECTOR;
SEUNG–WOO LEE, CHANG HYUN KIM – COPYWRITERS,
MIJOO PARK – ART DIRECTOR

Talk about a hook! Forget Moby Dick—can your fishing rod hoist building materials? For a billboard for a fishing rod, Mijoo Park sought to illustrate its durability by attaching it to a crane hoist, and lifted its exposure in the process. "We decided to advertise the brand through a billboard in order for it to gain maximum exposure," Park says. "Moreover, the ad can lighten up the stiff atmosphere of a construction site in an urban setting." The effect is stunning, reeling in the viewer.

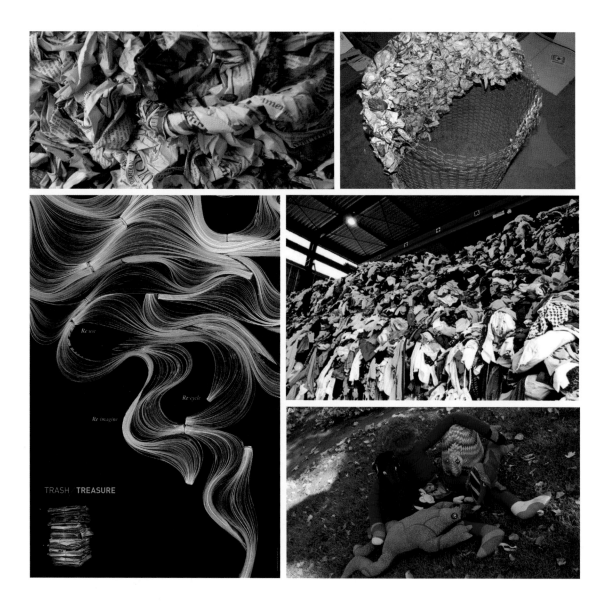

Ⓟ PLATINUM

TRASH/TREASURE

CATEGORY: CORPORATE IDENTITY PROGRAM, CAMPAIGN
SCHOOL: PRATT INSTITUTE – NEW YORK, NY, USA
CREATIVE TEAM: WOOJIN LEE – ART DIRECTOR/COPY-WRITER/DESIGNER/PHOTOGRAPHER; JOHN CHAICH – COPYWRITER; ALISA ZAMIR – INSTRUCTOR/PROFESSOR

What happens to that which we throw away? Pratt Institute student Woojin Lee turned it into a corporate identity program. Assigned to evaluate a social cause and devise a total brand look for it, Lee chose for her subject a new creative recycling movement, which she dubbed Trash/Treasure. "The design objective was to engage the audience and to demonstrate the objective of my 'movement,' she says. "Trash/Treasure focuses on creating art from trash or reused, recycled materials, so I created my art from trash."

For Lee, manipulating old newspapers and magazines to create the art in the poster was "a discovery process using form, color, shape, and scale." She also designed the project's own unique font for the cover design of the brochure. Still, working with such an elemental material in a marketable context was a bit daunting. "My biggest challenge was delivering my own artwork through a commercial medium," Lee says. "The message had to be understandable and easily engage in public. In order to do that, the theme had to be intimate and personal, but not too much."

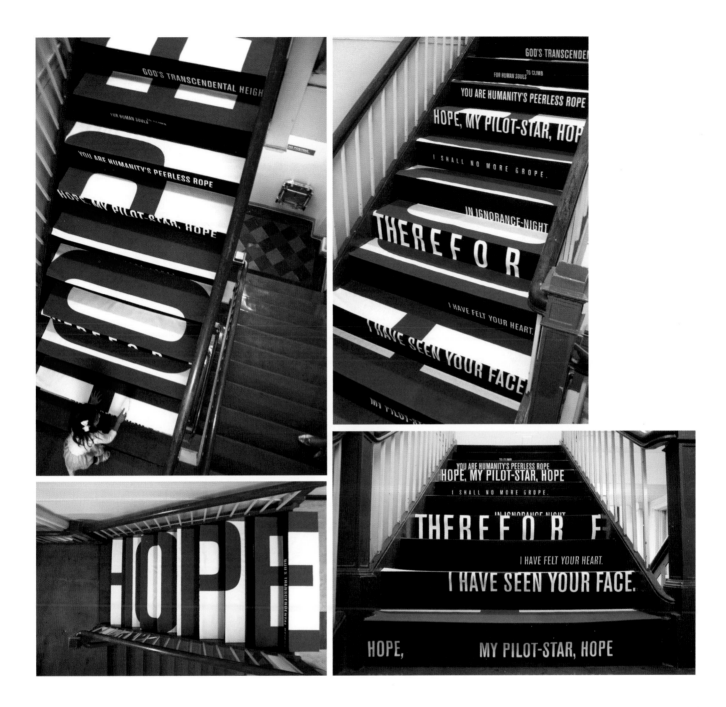

PLATINUM

CATEGORY: ENVIRONMENTAL GRAPHICS, SINGLE UNIT

SCHOOL: SCHOOL OF THE ART INSTITUTE OF CHICAGO – CHICAGO, IL, USA

CREATIVE TEAM: YOUNGHA PARK – DESIGNER; SURABHI GHOSH – INSTRUCTOR

HOPE BY SRI CHINMOY – POEM INSTALLATION

Aspiring designer Youngha Park created an environmental graphic designed to take its observers elsewhere–both physically and spiritually. "The project was about locating myself and the audience by placing my artwork in a specific site," says the School of the Art Institute student. "This staircase installation is a reinterpretation of a poem, Hope, by the Indian spiritual leader Sri Chinmoy." With ten lines of the poem corresponding to each of the ten steps from bottom to top, Park says, "The staircase itself symbolizes a meaning of the content–that hope can make human souls climb God's transcendental height."

CATEGORY: BRANDING, CAMPAIGN
CREATIVE TEAM: KOTA KOBAYASHI –
GRAPHIC DESIGNER

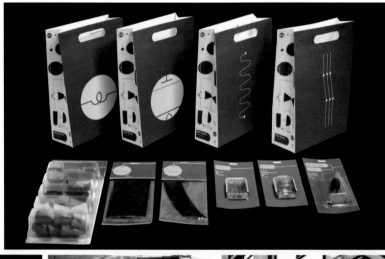

CATEGORY: CORPORATE IDENTITY PROGRAM, CAMPAIGN
SCHOOL: SCHOOL OF VISUAL ARTS – NEW YORK, NY, USA
CREATIVE TEAM: ERIN KIM – STUDENT

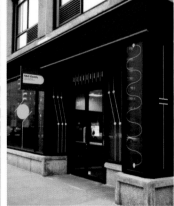

A new point of view

CATEGORY: ANNUAL REPORTS

SCHOOL: DREXEL UNIVERSITY GRAPHIC DESIGN PROGRAM, AWCOMAD – PHILADEL-PHIA, PA, USA

CREATIVE TEAM: NICOLE BONAVITACOLA – STUDENT DESIGNER AND ILLUSTRATOR; JODY GRAFF – INSTRUCTOR

CATEGORY: BRANDING, CAMPAIGN

CREATIVE TEAM: KOTA KOBAYASHI – GRAPHIC DESIGNER

CATEGORY: BRANDING, CAMPAIGN

SCHOOL: KIRA SEA DESIGN – NEW YORK, NY, USA

STUDENT PRINT

goodmeats goodseafood

goodproduce gooddeli

goodbakery goodwine & beer

CATEGORY: CORPORATE IDENTITY PROGRAM, CAMPAIGN

SCHOOL: UNIVERSITY OF BALTIMORE – BALTIMORE, MD, USA

CREATIVE TEAM: SIMON FONG – MFA INTEGRATED DESIGN STUDENT; ED GOLD – INSTRUCTOR

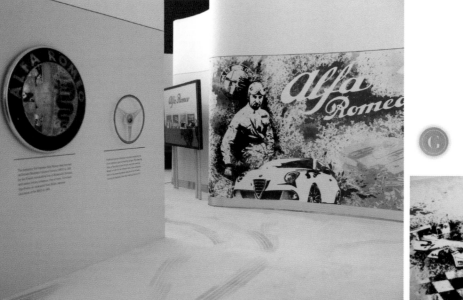
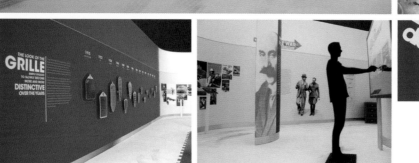

CATEGORY: ENVIRONMENTAL GRAPHICS, SINGLE UNIT

SCHOOL: DREXEL UNIVERSITY GRAPHIC DESIGN PROGRAM, AWCOMAD – PHILADELPHIA, PA, USA

CREATIVE TEAM: ALEX BOENISCH – STUDENT DESIGNER; E. JUNE ROBERTS–LUNN – INSTRUCTOR

PRINT STUDENT

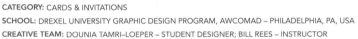

CATEGORY: CARDS & INVITATIONS

SCHOOL: DREXEL UNIVERSITY GRAPHIC DESIGN PROGRAM, AWCOMAD – PHILADELPHIA, PA, USA

CREATIVE TEAM: DOUNIA TAMRI–LOEPER – STUDENT DESIGNER; BILL REES – INSTRUCTOR

CATEGORY: CARDS & INVITATIONS

SCHOOL: DREXEL UNIVERSITY GRAPHIC DESIGN PROGRAM, AWCOMAD – PHILADELPHIA, PA, USA

CREATIVE TEAM: CAITLIN GUENDELSBERGER – STUDENT DESIGNER; MICOLE RONDINONE – STUDENT PHOTOGRAPHER; BILL REES – INSTRUCTOR

CATEGORY: ENVIRONMENTAL GRAPHICS, SINGLE UNIT

SCHOOL: DREXEL UNIVERSITY GRAPHIC DESIGN PROGRAM, AWCOMAD – PHILADELPHIA, PA, USA

CREATIVE TEAM: DANNI SINISI – STUDENT DESIGNER; E. JUNE ROBERTS–LUNN – INSTRUCTOR

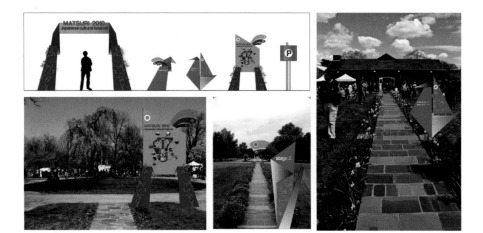

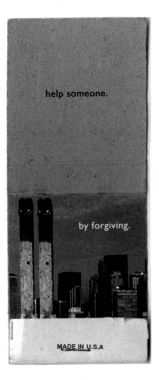

CATEGORY: ENVIRONMENTAL GRAPHICS, SINGLE UNIT

SCHOOL: DREXEL UNIVERSITY GRAPHIC DESIGN PROGRAM, AWCOMAD – PHILADELPHIA, PA, USA

CREATIVE TEAM: KARINA YOSHIMITSU – STUDENT DESIGNER; AMY REES – INSTRUCTOR

CATEGORY: POSTER, SINGLE UNIT

SCHOOL: SCHOOL OF VISUAL ARTS – NEW YORK, NY, USA

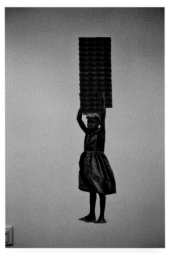

CATEGORY: POSTER, SINGLE UNIT

SCHOOL: GEORGIA STATE UNIVERSITY – ATLANTA, GA, USA

CREATIVE TEAM: BARRON BIROS

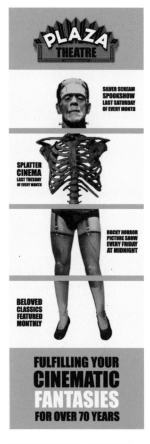

CATEGORY: POSTER, SINGLE UNIT

SCHOOL: SWEATHEART INTERNATIONAL – GYEONGGI–DO, SOUTH KOREA

CREATIVE TEAM: DONG IK LEE – CREATIVE DIRECTOR; MIN JOON CHO – ART DIRECTOR; JIN SIK OH – COPYWRITER

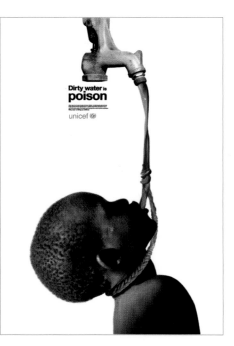

CATEGORY: POSTER, SINGLE UNIT

SCHOOL: EWHA WOMENS' UNIVERSITY – SEOUL, SOUTH KOREA

CREATIVE TEAM: YOUNG HEE KWON

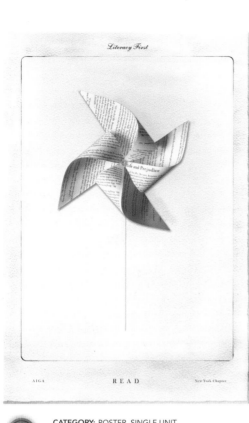

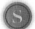 **CATEGORY:** POSTER, SINGLE UNIT
SCHOOL: KIRA SEA DESIGN – NEW YORK, NY, USA

 CATEGORY: POSTER, SINGLE UNIT
SCHOOL: ACADEMY OF ART UNIVERSITY – SAN FRANCISCO, CA, USA

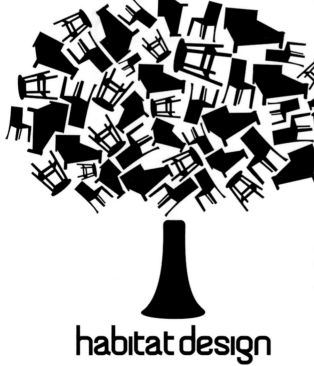

habitat design

CATEGORY: LOGOS & TRADEMARKS

SCHOOL: DREXEL UNIVERSITY GRAPHIC DESIGN PROGRAM, AWCOMAD – PHILADELPHIA, PA, USA

CREATIVE TEAM: JEREMY BLOOM – STUDENT DESIGNER; E. JUNE ROBERTS–LUNN – INSTRUCTOR

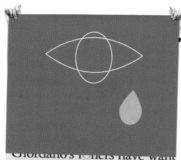

CATEGORY: POSTER, CAMPAIGN
SCHOOL: SCHOOL OF VISUAL ARTS – NEW YORK, NY, USA
CREATIVE TEAM: ERIN KIM – STUDENT

CATEGORY: POSTER, CAMPAIGN
SCHOOL: SCHOOL OF VISUAL ARTS – NEW YORK, NY, USA
CREATIVE TEAM: ERIN KIM – STUDENT

CATEGORY: POSTER, CAMPAIGN

SCHOOL: PRATT INSTITUTE – NEW YORK, NY, USA

CREATIVE TEAM: WOOJIN LEE – ART DIRECTOR/DESIGNER/ILLUSTRATOR/
COPYWRITER; GRAHAM HANSON – INSTUCTOR/PROFESSOR

CATEGORY: POSTER, CAMPAIGN

SCHOOL: PRATT INSTITUTE – NEW YORK, NY, USA

CREATIVE TEAM: JAEEUN CHUNG – ART DIRECTOR/DESIGNER/COPYWRITER

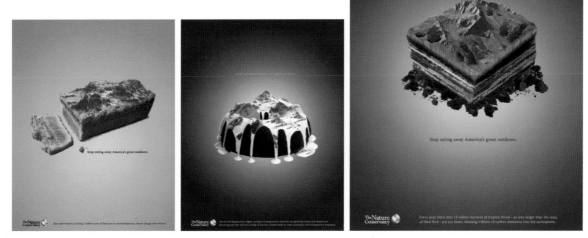

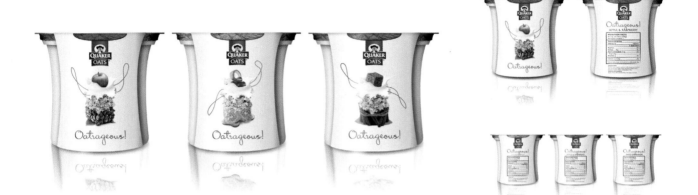

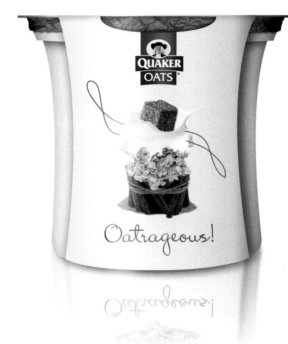

PLATINUM

CATEGORY: FOOD & BEVERAGE PACKAGING
SCHOOL: GWORKSHOP – QUITO, ECUADOR
CREATIVE TEAM: JOSÉ LUIS GARCÍA EGUIGUREN – PACK-AGING DESIGNER

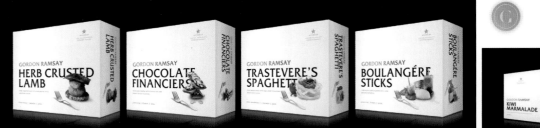

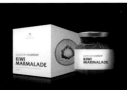

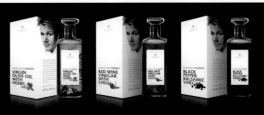

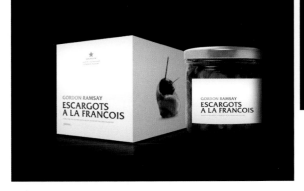

CATEGORY: FOOD & BEVERAGE PACKAGING

SCHOOL: GWORKSHOP – QUITO, ECUADOR

CREATIVE TEAM: JOSÉ LUIS GARCÍA EGUIUREN – MASTER IN PACKAGING DESIGN

CATEGORY: FOOD & BEVERAGE PACKAGING

SCHOOL: DREXEL UNIVERSITY GRAPHIC DESIGN PROGRAM, AWCOMAD – PHILADELPHIA, PA, USA

CREATIVE TEAM: APRIL MORALBA – STUDENT DESIGNER; MARK WILLIE – INSTRUCTOR

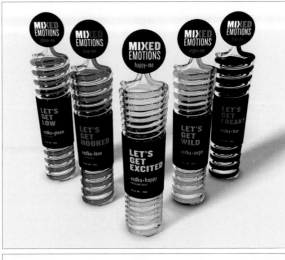

CATEGORY: FOOD & BEVERAGE PACKAGING

SCHOOL: GWORKSHOP – QUITO, ECUADOR

CREATIVE TEAM: JOSÉ LUIS GARCÍA EGUI-UREN – MASTER IN PACKAGING DESIGN

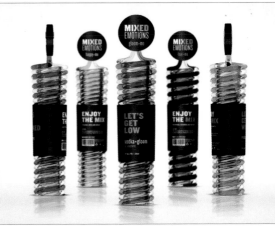

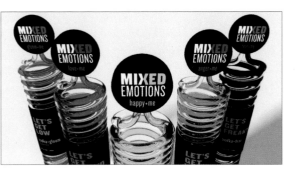

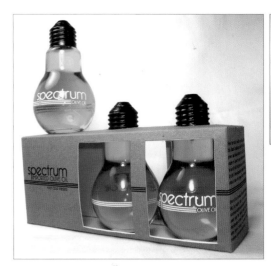

CATEGORY: FOOD & BEVERAGE PACKAGING

SCHOOL: GEORGIA STATE UNIVERSITY – ATLANTA, GA, USA

CREATIVE TEAM: BARRON BIROS

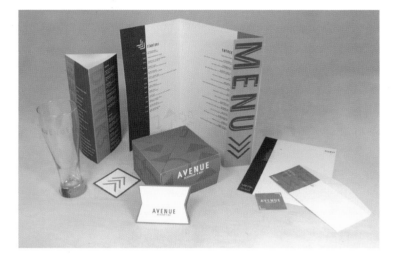

CATEGORY: FOOD & BEVERAGE PACKAGING

SCHOOL: DREXEL UNIVERSITY GRAPHIC DESIGN PROGRAM, AWCOMAD – PHILADELPHIA, PA, USA

CREATIVE TEAM: KATHRYN HALL – STUDENT DESIGNER; MARK WILLIE – INSTRUCTOR

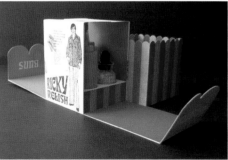

CATEGORY: FOOD & BEVERAGE PACKAGING

SCHOOL: DREXEL UNIVERSITY GRAPHIC DESIGN PROGRAM, AWCOMAD – PHILADELPHIA, PA, USA

CREATIVE TEAM: DOROTHY LUN – STUDENT DESIGNER; JODY GRAFF – INSTRUCTOR

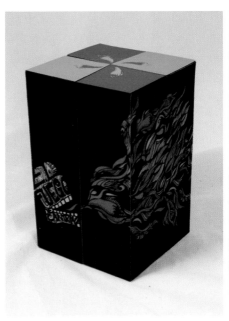

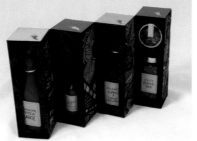

CATEGORY: FOOD & BEVERAGE PACKAGING

SCHOOL: DREXEL UNIVERSITY GRAPHIC DESIGN PROGRAM, AWCOMAD – PHILADELPHIA, PA, USA

CREATIVE TEAM: ERIKA GALLAGHER – STUDENT DESIGNER AND ILLUSTRATOR; SANDY STEWART – INSTRUCTOR

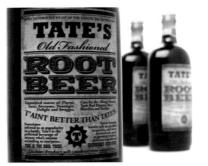

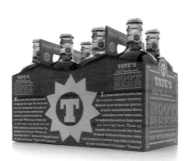

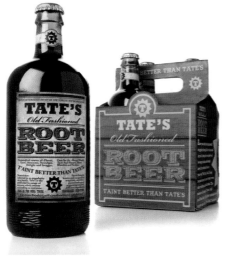

CATEGORY: FOOD & BEVERAGE PACKAGING

CREATIVE TEAM: KOTA KOBAYASHI – GRAPHIC DESIGNER; JAMES KINNEY – ART DIRECTOR/COPY WRITER

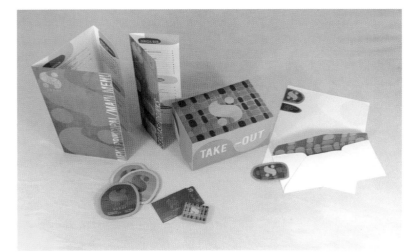

CATEGORY: FOOD & BEVERAGE PACKAGING

SCHOOL: DREXEL UNIVERSITY GRAPHIC DESIGN PROGRAM, AWCOMAD – PHILADELPHIA, PA, USA

CREATIVE TEAM: KARINA YOSHIMITSU – STUDENT DESIGNER; MARK WILLIE – INSTRUCTOR

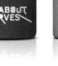

CATEGORY: HEALTH & BEAUTY PACKAGING
SCHOOL: GWORKSHOP – QUITO, ECUADOR
CREATIVE TEAM: JOSÉ LUIS GARCÍA EGUIUREN

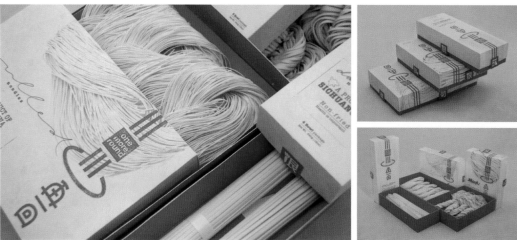
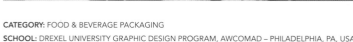

CATEGORY: FOOD & BEVERAGE PACKAGING
SCHOOL: DREXEL UNIVERSITY GRAPHIC DESIGN PROGRAM, AWCOMAD – PHILADELPHIA, PA, USA
CREATIVE TEAM: DOROTHY LUN – STUDENT DESIGNER; JODY GRAFF – INSTRUCTOR

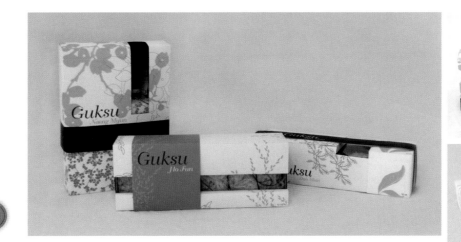

CATEGORY: FOOD & BEVERAGE PACKAGING

SCHOOL: DREXEL UNIVERSITY GRAPHIC DESIGN PROGRAM, AWCOMAD – PHILADELPHIA, PA, USA

CREATIVE TEAM: DOUNIA TAMRI–LOEPER – STUDENT DESIGNER/ILLUSTRATOR; JODY GRAFF – INSTRUCTOR

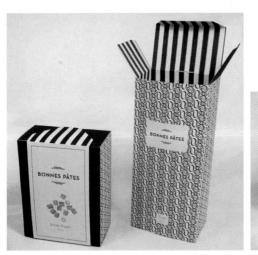

CATEGORY: FOOD & BEVERAGE PACKAGING

SCHOOL: DREXEL UNIVERSITY GRAPHIC DESIGN PROGRAM, AWCO-MAD – PHILADELPHIA, PA, USA

CREATIVE TEAM: DANNI SINISI – STUDENT DESIGNER; SANDY STEWART – INSTRUCTOR

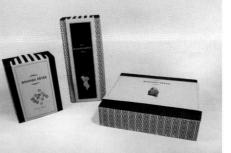

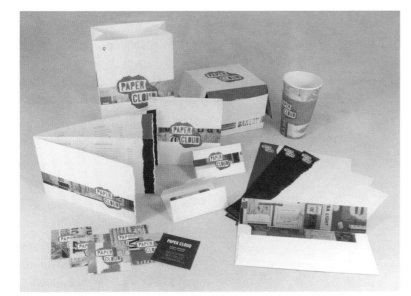

CATEGORY: FOOD & BEVERAGE PACKAGING

SCHOOL: DREXEL UNIVERSITY GRAPHIC DESIGN PROGRAM, AWCO-MAD – PHILADELPHIA, PA, USA

CREATIVE TEAM: JENNIFER CHOY – STUDENT DESIGNER; MARK WILLIE – INSTRUCTOR

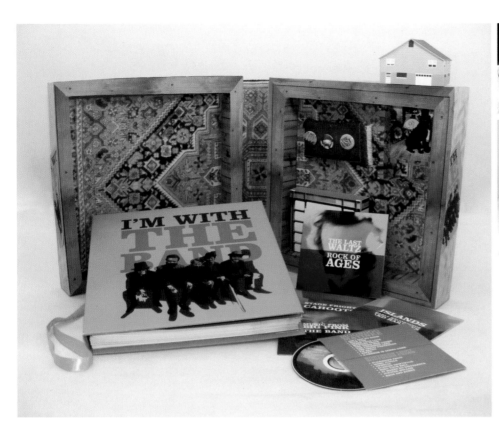

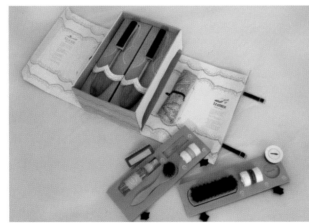

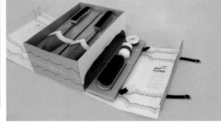

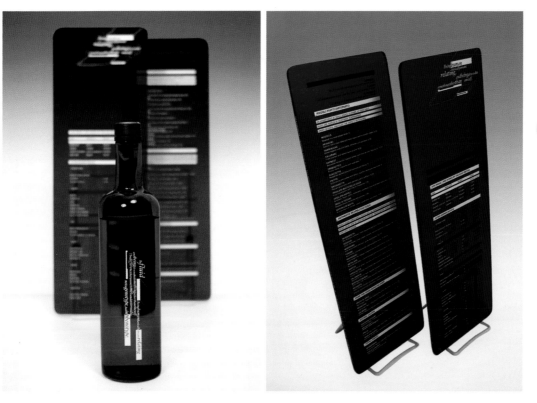

CATEGORY: MENUS & WINE LISTS

SCHOOL: PRATT INSTITUTE – NEW YORK, NY, USA

CREATIVE TEAM: WOOJIN LEE – ART DIRECTOR/DESIGNER; TOM DOLLE – INSTRUCTOR/ PROFESSOR

CATEGORY: MENUS & WINE LISTS

SCHOOL: DREXEL UNIVERSITY GRAPHIC DESIGN PROGRAM, AWCOMAD – PHILADELPHIA, PA, USA

CREATIVE TEAM: MEGHAN PALAGYI – STUDENT DESIGNER; MARK WILLIE – INSTRUCTOR

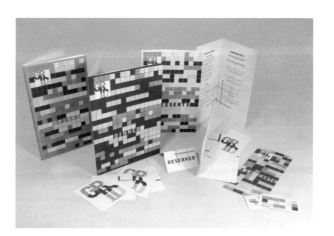

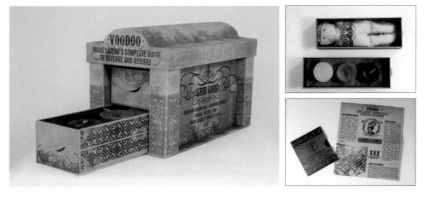

CATEGORY: RETAIL PACKAGING

SCHOOL: DREXEL UNIVERSITY GRAPHIC DESIGN PROGRAM, AWCOMAD – PHILADELPHIA, PA, USA

CREATIVE TEAM: CAITLIN GUENDELSBERGER – STUDENT DESIGNER; SANDY STEWART – INSTRUCTOR

STUDENT PACKAGING

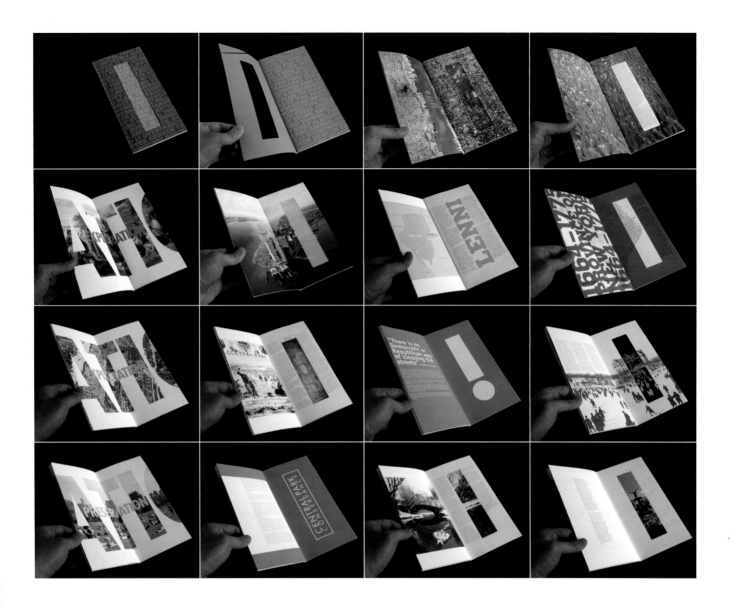

PLATINUM

CENTRAL PARK AWARENESS BOOK

CATEGORY: BOOK DESIGN, INTERIOR

SCHOOL: SCHOOL OF THE ART INSTITUTE OF CHICAGO – CHICAGO, IL, USA

CREATIVE TEAM: YOUNGHA PARK – DESIGNER; DANIEL MORGENTHALER – INSTRUCTOR

New York's Central Park is one of the most visited public spaces in the world, and School of the Art Institute student Youngha Park chose it for an assignment where the aim was to design a book conveying the history of a place and reflecting the theme of "Exploration, Exploitation, and Preservation." The richly illustrated booklet, with its varying layers of bold graphics, vintage illustrations, and vividly colored nature photographs, is a dramatic, yet playful, multilayered introduction to America's favorite park. "By creating this book," the Chicago student says, "I wanted to convey awareness of significance of public environment relating to nature and culture."

PLATINUM

CATEGORY: BOOK DESIGN, JACKET OR COVER, SERIES

SCHOOL: SCHOOL OF VISUAL ARTS – NEW YORK, NY, USA

CREATIVE TEAM: GENEVIEVE WILLIAMS – ADVISOR/INSTRUCTOR/CREATIVE DIRECTOR; DEAEUN KIM – ART DIRECTOR/PACKAGE DESIGN; NICOLE FISCHETTI, APRIL SHARP, ERIN KIM, ERICA CHUNG – ART DIRECTORS

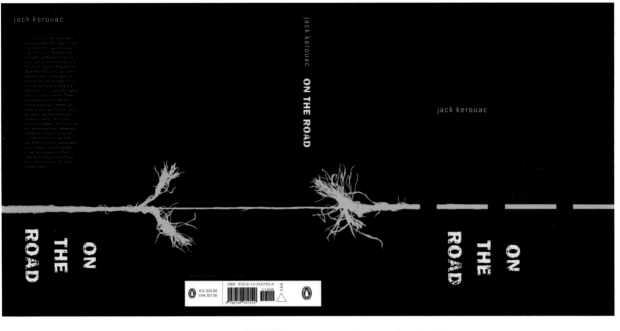

CATEGORY: BOOK DESIGN, JACKET OR COVER, SINGLE UNIT
SCHOOL: DREXEL UNIVERSITY GRAPHIC DESIGN PROGRAM, AWCOMAD – PHILADELPHIA, PA, USA
CREATIVE TEAM: DOROTHY LUN – STUDENT DESIGNER AND ILLUSTRATOR; E. JUNE ROBERTS–LUNN – INSTRUCTOR

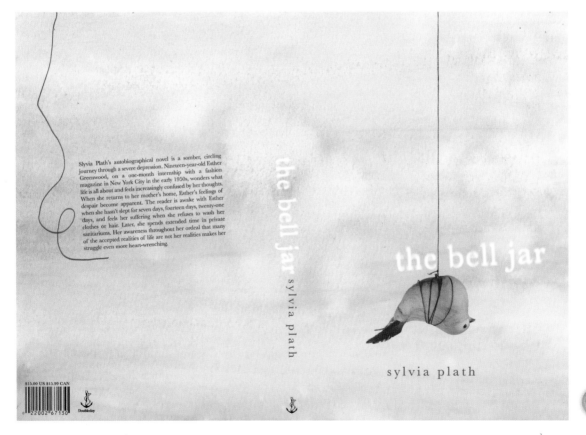

CATEGORY: BOOK DESIGN, JACKET OR COVER, SINGLE UNIT
SCHOOL: DREXEL UNIVERSITY GRAPHIC DESIGN PROGRAM, AWCOMAD – PHILADELPHIA, PA, USA
CREATIVE TEAM: CAITLIN GUENDELSBERGER – STUDENT DESIGNER AND PHOTOGRAPHER; E. JUNE ROBERTS–LUNN – INSTRUCTOR

CATEGORY: BOOK DESIGN, JACKET OR COVER, SINGLE UNIT

SCHOOL: DREXEL UNIVERSITY GRAPHIC DESIGN PROGRAM, AWCOMAD – PHILADELPHIA, PA, USA

CREATIVE TEAM: CAITLIN GUENDELSBERGER – STUDENT DESIGNER AND ILLUSTRATOR; E. JUNE ROBERTS–LUNN – INSTRUCTOR

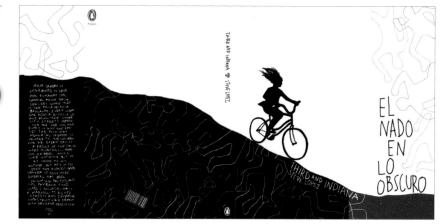

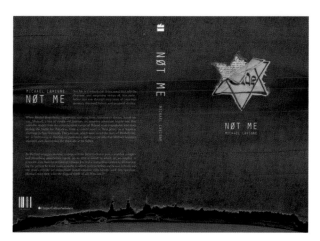

CATEGORY: BOOK DESIGN, JACKET OR COVER, SINGLE UNIT

SCHOOL: DREXEL UNIVERSITY GRAPHIC DESIGN PROGRAM, AWCOMAD – PHILADELPHIA, PA, USA

CREATIVE TEAM: BRIELLE WEINSTEIN – STUDENT DESIGNER; E. JUNE ROBERTS–LUNN – INSTRUCTOR

CATEGORY: BOOK DESIGN, INTERIOR

SCHOOL: PRATT INSTITUTE – NEW YORK, NY, USA

CREATIVE TEAM: WOOJIN LEE – ART DIRECTOR/ EDITORIAL DESIGNER/PHOTOGRAPHER; TOM DOOLE – INSTRUCTOR/PROFESSOR

STUDENT PUBLICATIONS

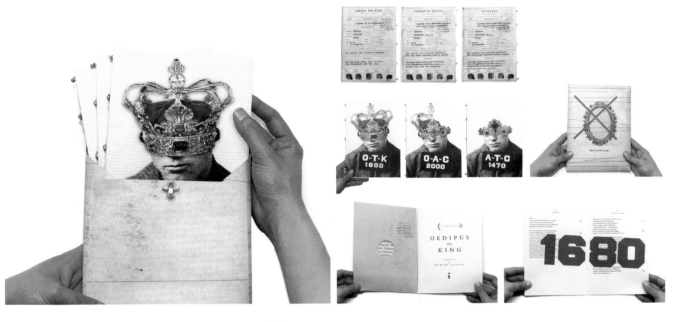

CATEGORY: BOOK DESIGN, JACKET OR COVER, SERIES
SCHOOL: SCHOOL OF VISUAL ARTS – NEW YORK, NY, USA
CREATIVE TEAM: ERIN KIM – STUDENT

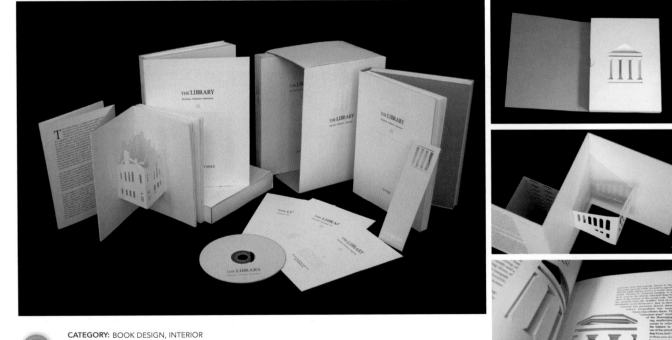

CATEGORY: BOOK DESIGN, INTERIOR
SCHOOL: DREXEL UNIVERSITY GRAPHIC DESIGN PROGRAM, AWCOMAD – PHILADELPHIA, PA, USA
CREATIVE TEAM: CAITLIN GUENDELSBERGER – STUDENT DESIGNER; SANDY STEWART – INSTRUCTOR

CATEGORY: BOOK DESIGN, INTERIOR

SCHOOL: DREXEL UNIVERSITY GRAPHIC DESIGN PROGRAM, AWCOMAD – PHILADELPHIA, PA, USA

CREATIVE TEAM: ERIKA GALLAGHER – STUDENT DESIGNER; MARK WILLIE – INSTRUCTOR

CATEGORY: BOOK DESIGN, INTERIOR

SCHOOL: SCHOOL OF VISUAL ARTS – NEW YORK, NY, USA

CREATIVE TEAM: ERIN KIM – STUDENT

CATEGORY: BOOK DESIGN, INTERIOR

SCHOOL: DREXEL UNIVERSITY GRAPHIC DESIGN PROGRAM, AWCOMAD – PHILADELPHIA, PA, USA

CREATIVE TEAM: BRIELLE WEINSTEIN – STUDENT DESIGNER; JACK CLIGGETT – INSTRUCTOR

CATEGORY: BOOK DESIGN, INTERIOR
SCHOOL: KIRA SEA DESIGN – NEW YORK, NY, USA

CATEGORY: BOOK DESIGN, INTERIOR
SCHOOL: DREXEL UNIVERSITY GRAPHIC DESIGN PROGRAM, AWCOMAD – PHILADELPHIA, PA, USA
CREATIVE TEAM: MARIEL FITZGERALD – STUDENT DESIGNER; E. JUNE ROBERTS–LUNN – INSTRUCTOR

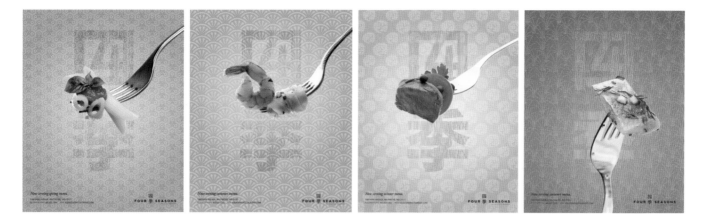

CATEGORY: MAGAZINE AD, CONSUMER, CAMPAIGN

SCHOOL: UNIVERSITY OF BALTIMORE – BALTIMORE, MD, USA

CREATIVE TEAM: SIMON FONG – MFA INTEGRATED DESIGN STUDENT; ED GOLD – INSTRUCTOR

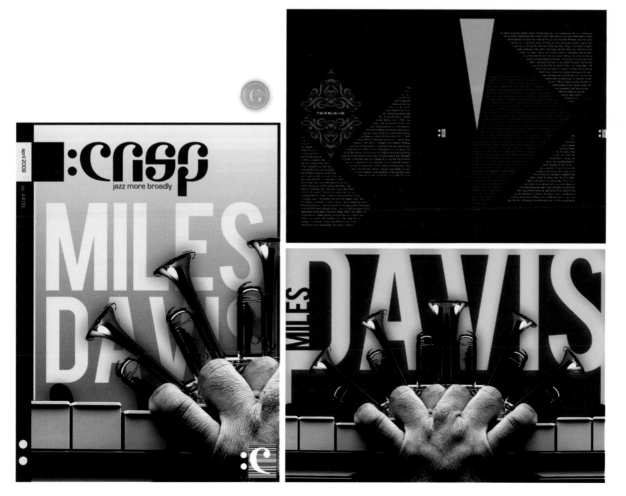

CATEGORY: MAGAZINE DESIGN, COMPLETE

SCHOOL: DREXEL UNIVERSITY GRAPHIC DESIGN PROGRAM, AWCOMAD – PHILADELPHIA, PA, USA

CREATIVE TEAM: JEREMY BLOOM – STUDENT DESIGNER AND ILLUSTRATOR; SANDY STEWART – INSTRUCTOR

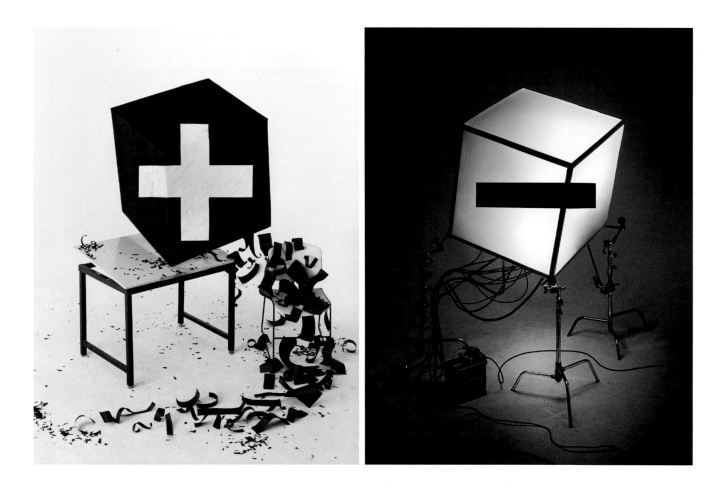

CATEGORY: PHOTOGRAPHY, MAGAZINE, CAMPAIGN OR SERIES
SCHOOL: RIT – ROCHESTER, NY, USA
CREATIVE TEAM: DENIS DEFIBAUGH – PROFESSOR; LORRIE FREAR – PROFESSOR

POSITIVE/NEGATIVE MAGAZINE

Over forty students at Rochester Institute of Technology regularly collaborate on a full–size, 100–page magazine. The exceptional efforts put forth by three different programs to produce +/– Magazine is unique throughout academia.

"+/– Magazine's mission is to present stories that express either a positive or negative perspective on politics, social, scientific, and cultural issues," says RIT instructor Denis Defibaugh. "The goal of the magazine is to provide a forum for students to express their opinions on topical subjects through design, photography and text. In this process the students gained skills to edit, write, illustrate, layout, and produce a magazine in eight weeks." Each photographer/designer team is responsible for concepting the story and providing a positive or negative viewpoint through the story and photo

illustration. "The magazine staff sets the design and text style and edits the subject matter for equal parts positive and negative story topics," Defibaugh adds. Printed at RIT's Printing Applications Lab and bound locally, the magazines are distributed free to students.

Defibaugh cites having forty students from three classes–Editorial Photography, Editorial Design, and Print Media's New Media Team Project–creating a unified direction for the magazine's look as the primary challenge, but strives for balance every step of the way, right down to the cover. "Positive/negative Magazine is unusual because a plus and minus symbol represent the title of the magazine," he says. "Each icon is incorporated into the cover photographs, with the positive symbol on the cover and negative symbol on the back."

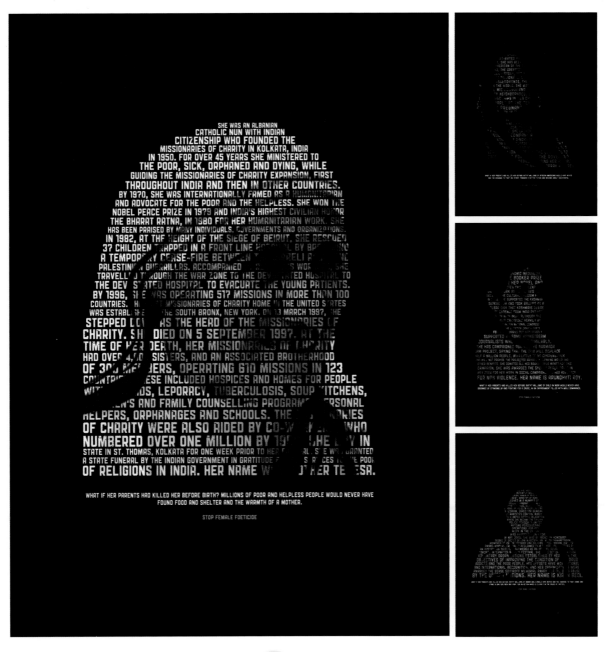

WHAT IF HER PARENTS HAD KILLED HER BEFORE BIRTH? MILLIONS OF POOR AND HELPLESS PEOPLE WOULD NEVER HAVE FOUND FOOD AND SHELTER AND THE WARMTH OF A MOTHER.

STOP FEMALE FOETICIDE

CATEGORY: TYPOGRAPHY, ADVERTISEMENT

SCHOOL: UNIVERSITY OF BEDFORDSHIRE – NEW DELHI, INDIA

CREATIVE TEAM: RITWICK DAS – ART DIRECTOR/COPYWRITER

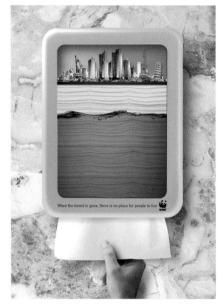
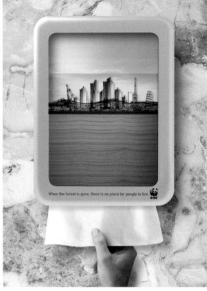
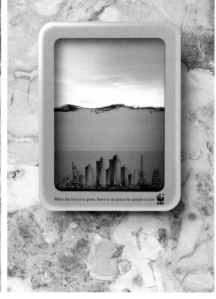

CATEGORY: GREEN ADVERTISING, SINGLE UNIT
SCHOOL: BRAINBOX – SEOUL, SOUTH KOREA
CREATIVE TEAM: YONGJOON KIM – CREATIVE DIRECTOR;
DONGJUN SHIN – ART DIRECTOR; EUNHYE JOO – DESIGNER

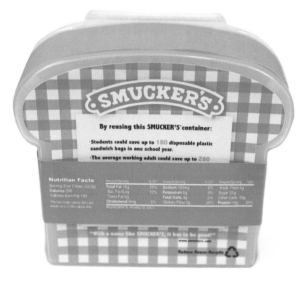

CATEGORY: GREEN PACKAGING OR ANTI–PACKAGING
SCHOOL: GEORGIA STATE UNIVERSITY – ATLANTA, GA, USA
CREATIVE TEAM: BARRON BIROS; SARAH KIM; LAUREN WIGINTON

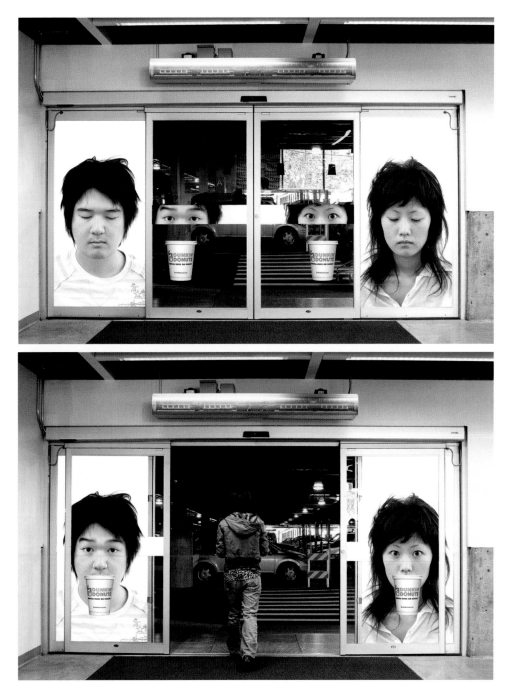

 PLATINUM

CATEGORY: AMBIENT MEDIA, SINGLE UNIT

SCHOOL: SCHOOL OF VISUAL ARTS – NEW YORK, NY, USA

CREATIVE TEAM: KENJI AKIYAMA – ART DIRECTOR/COPY-WRITER; FRANK ANSELMO – INSTRUCTOR

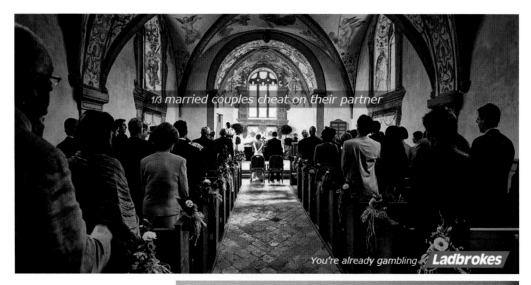

1/3 married couples cheat on their partner

You're already gambling **Ladbrokes**

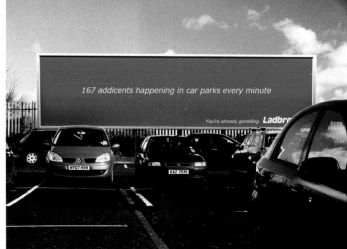

167 addicents happening in car parks every minute

You're already gambling **Ladbr**

Ⓟ PLATINUM

CATEGORY: INTEGRATED CAMPAIGN

SCHOOL: UNIVERSITY OF THE ARTS LONDON – DAEGU, SOUTH KOREA

CREATIVE TEAM: TAE JAY LEE – ART DIRECTOR/COPY-WRITER/DIRECTOR

YOU'RE ALREADY GAMBLING.

You can bet on anything—the weather tomorrow, the odds that Prince Charles will become king in 2013—and people do. Students at University of the Arts in London came up with a fully integrated campaign for Ladbrokes, the largest betting company in the United Kingdom, to appeal to those who weren't already laying their bets. To raise the image of Ladbrokes by making gambling more acceptable, T.J. Lee, the student who also served as the director, art director, and copywriter, focused on the infinitesimal odds present in daily life.

A billboard announces that there are 167 accidents in parking lots every

minute, inviting the reader to consider one's good—or bad—fortune at the moment with the tagline, "You're already gambling." A saucy television spot emphasizes luck—or, one might say, getting lucky—and thus establishes a winning streak starting with the viewer's own conception. Using humor, whimsical music, and fast–moving graphic animation, the video depicts the race of a sperm to an egg and the, er, payoff: "Odds of your birth 300 million:1. You've already won the lottery." According to Lee, the goal was to "expand Ladbrokes' client base and firmly establish the company as THE place to go to when you think of placing a bet."

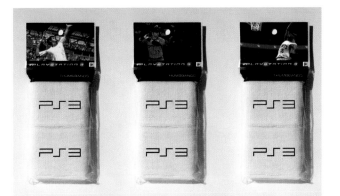

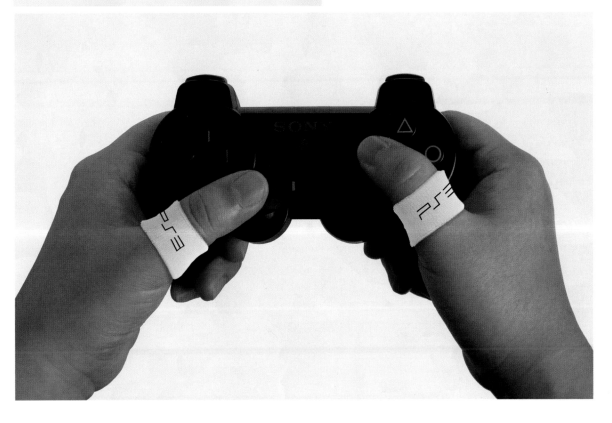

PLATINUM

CATEGORY: GUERILLA MARKETING, SINGLE UNIT
SCHOOL: SCHOOL OF VISUAL ARTS – NEW YORK, NY, USA
CREATIVE TEAM: KENJI AKIYAMA – ART DIRECTOR/COPY-WRITER; FRANK ANSELMO – INSTRUCTOR

THUMBBANDS

Playing a sport—even on a handheld device—can give you quite a workout. School of Visual Arts student Kenji Akiyama took the play seriously (or maybe it's the opposite) in creating an image for PlayStation sports games that would capture the excitement in a new and interesting way. "It's a game!" he says. "It's sports!"

Akiyama reimagined the terrycloth wristbands familiarly seen on athletes as tiny sweatbands for PlayStation players' thumbs. Once he figured it out, he says, it was easy, but coming up with the concept in the first place made him break a sweat. "The idea is always the challenge," he says.

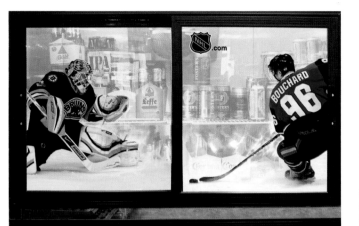

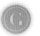

CATEGORY: AMBIENT MEDIA, SINGLE UNIT

SCHOOL: SCHOOL OF VISUAL ARTS – NEW YORK, NY, USA

CREATIVE TEAM: KENJI AKIYAMA – ART DIRECTOR/COPY-WRITER; FRANK ANSELMO – INSTRUCTOR

CATEGORY: AMBIENT MEDIA, SINGLE UNIT

SCHOOL: SCHOOL OF VISUAL ARTS – NEW YORK, NY, USA

CREATIVE TEAM: JANG CHO – ART DIREC-TOR; JACK MARIUCCI – INSTRUCTOR; BOB MACKALL – INSTRUCTOR

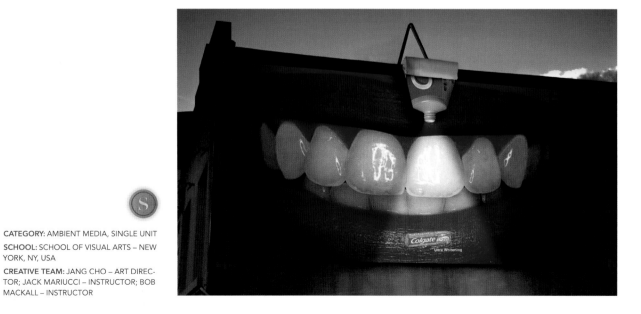

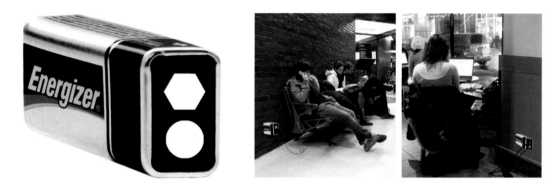

CATEGORY: AMBIENT MEDIA, SINGLE UNIT

SCHOOL: SCHOOL OF VISUAL ARTS – NEW YORK, NY, USA

CREATIVE TEAM: KENJI AKIYAMA – ART DIRECTOR/COPYWRITER; FRANK ANSELMO – INSTRUCTOR

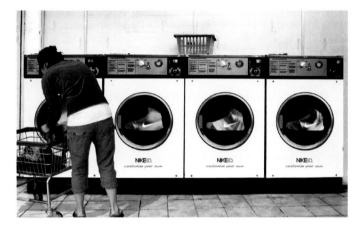

CATEGORY: AMBIENT MEDIA, SINGLE UNIT

SCHOOL: SCHOOL OF VISUAL ARTS – NEW YORK, NY, USA

CREATIVE TEAM: KENJI AKIYAMA – ART DIRECTOR/COPYWRITER; FRANK ANSELMO – INSTRUCTOR

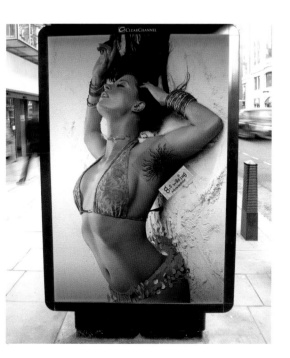

CATEGORY: GUERILLA MARKETING, SINGLE UNIT

SCHOOL: UNIVERSITY OF THE ARTS LONDON – DAEGU, SOUTH KOREA

CREATIVE TEAM: TAE JAY LEE – ART DIRECTOR/ COPYWRITER

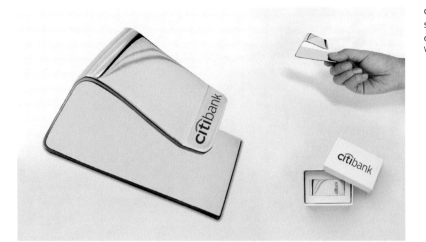

CATEGORY: GUERILLA MARKETING, SINGLE UNIT
SCHOOL: SCHOOL OF VISUAL ARTS – NEW YORK, NY, USA
CREATIVE TEAM: KENJI AKIYAMA – ART DIRECTOR/COPY-WRITER; FRANK ANSELMO – INSTRUCTOR

CATEGORY: GUERILLA MARKETING, SINGLE UNIT
SCHOOL: SCHOOL OF VISUAL ARTS – NEW YORK, NY, USA
CREATIVE TEAM: KENJI AKIYAMA – ART DIRECTOR/COPYWRITER; FRANK ANSELMO – INSTRUCTOR

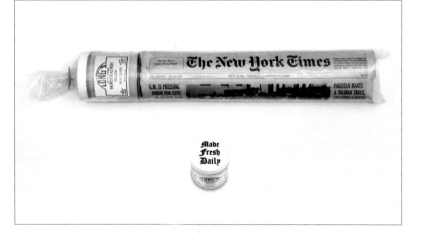

CATEGORY: GUERILLA MARKETING, SINGLE UNIT
SCHOOL: SCHOOL OF VISUAL ARTS – NEW YORK, NY, USA
CREATIVE TEAM: KENJI AKIYAMA, SUNGKWON HA – ART DIREC-TOR/COPYWRITER; FRANK ANSELMO – INSTRUCTOR

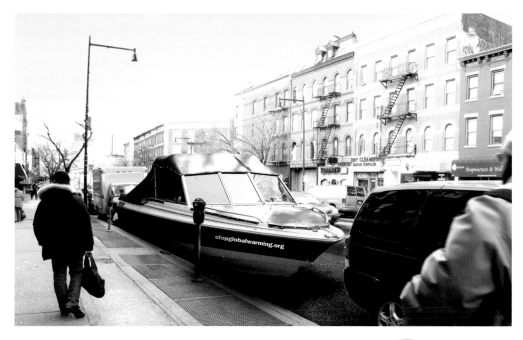

CATEGORY: GUERILLA MARKETING, SINGLE UNIT
SCHOOL: SCHOOL OF VISUAL ARTS – NEW YORK, NY, USA
CREATIVE TEAM: KENJI AKIYAMA – ART DIRECTOR/COPYWRITER; FRANK ANSELMO – INSTRUCTOR

CATEGORY: GUERILLA MARKETING, SINGLE UNIT
SCHOOL: SCHOOL OF VISUAL ARTS – NEW YORK, NY, USA
CREATIVE TEAM: KENJI AKIYAMA – ART DIRECTOR/COPYWRITER; FRANK ANSELMO – INSTRUCTOR

STUDENT ALTERNATIVE MEDIA

CATEGORY: GUERILLA MARKETING, SINGLE UNIT
SCHOOL: SCHOOL OF VISUAL ARTS – NEW YORK, NY, USA
CREATIVE TEAM: KENJI AKIYAMA – ART DIRECTOR/COPY-WRITER; FRANK ANSELMO – INSTRUCTOR

CATEGORY: GUERILLA MARKETING, SINGLE UNIT
SCHOOL: SCHOOL OF VISUAL ARTS – NEW YORK, NY, USA
CREATIVE TEAM: KENJI AKIYAMA – ART DIRECTOR/COPY-WRITER; FRANK ANSELMO – INSTRUCTOR

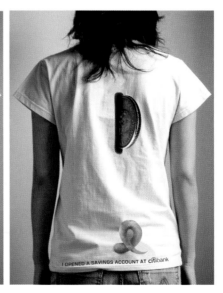

Sneaker Funeral is a campaign meant to give Adidas Originals a marketing advantage by getting people who aren't already looking for a new pair of sneakers to bury their old shoes. By making the funeral into a social rewarding event we get them to do this in public. When the funeral is over there's no turning back. It's death by social media. And once the old shoes are gone people are going to be in need of new pair of sneakers.

CATEGORY: WEBSITE, CONSUMER
SCHOOL: BERGHS SCHOOL OF COMMUNICATION – STOCKHOLM, SWEDEN
CREATIVE TEAM: CHRISTIAN HAMMAR – ART DIRECTOR; HENRIK BOHMAN – COPYWRITER

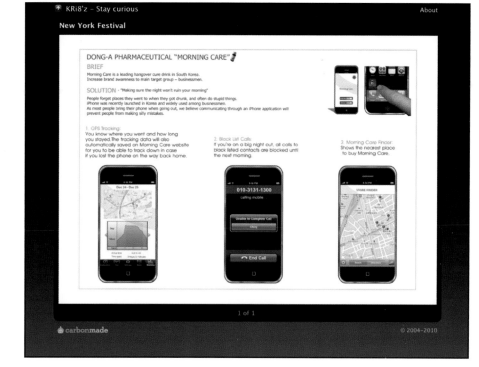

CATEGORY: MOBILE APPLICATIONS
SCHOOL: UNIVERSITY OF THE ARTS LONDON – DAEGU, SOUTH KOREA
CREATIVE TEAM: TAE JAY LEE – ART DIRECTOR/COPYWRITER

PLATINUM

CATEGORY: SHOW OPENINGS/IDS/TITLES

SCHOOL: DREXEL UNIVERSITY GRAPHIC DESIGN PRO-GRAM, AWCOMAD – PHILADELPHIA, PA, USA

CREATIVE TEAM: KANYA ZILLMER – STUDENT DESIGNER; JOSH GDOVIN – INSTRUCTOR

THE SCIENCE OF SLEEP FILM TITLE SEQUENCE

The title sequence of a movie can set the tone for the next two hours. Kanyz Zillmer, a student at Drexel University, chose to take a primitive, collage–inspired approach for the opening to the Michel Gondry film The Science of Sleep, which tells the story of a man who cannot distinguish his dreams from reality. "I wanted to intro-duce the audience to the film via a dream sequence that incorporates both surreal elements as well as actual photos of the film's main characters," says Zillmer. "Each scene in the opening piece represents themes that appear within the context of the film."

Using handmade elements such as hand–cut paper, cotton balls, and actual handwritten letters give the motion piece a hypnagogic feel perfect for the awake/asleep theme of the film as well as the quirky essence of the story. In creating the titles–a requirement of an undergraduate motion course–Zillmer faced the challenge of keeping the animation smooth through-out the minute–long sequence while manipulating multiple elements, including a walking stuffed horse, simultaneous-ly. "Considerable time was spent watching real horses walk across my screen to come up with this effect," she says.

CATEGORY: SHOW OPENINGS/IDS/TITLES

SCHOOL: DREXEL UNIVERSITY GRAPHIC DESIGN PROGRAM, AWCOMAD – PHILADELPHIA, PA, USA

CREATIVE TEAM: ALEX VOORHEES – STUDENT DESIGNER; JOSH GDOVIN – INSTRUCTOR

CATEGORY: SHOW OPENINGS/IDS/TITLES

SCHOOL: DREXEL UNIVERSITY GRAPHIC DESIGN PROGRAM, AWCOMAD – PHILADEL-PHIA, PA, USA

CREATIVE TEAM: KANYA ZILLMER – STUDENT DESIGNER; JOSH GDOVIN – INSTRUCTOR

CATEGORY: SHOW OPENINGS/IDS/TITLES

SCHOOL: DREXEL UNIVERSITY GRAPHIC DESIGN PROGRAM, AWCOMAD – PHILADELPHIA, PA, USA

CREATIVE TEAM: ALEX VOORHEES – STUDENT DESIGNER; JOSH GDOVIN – INSTRUCTOR

STUDENT

FILM & VIDEO

CATEGORY: AUDIO–VISUAL PRESENTATION
SCHOOL: KYUNG CHUL SHIN– YONGIN, SOUTH KOREA
CREATIVE TEAM: KYUNG CHUL SHIN

CATEGORY: SHOW OPENINGS/IDS/TITLES
SCHOOL: DREXEL UNIVERSITY GRAPHIC DESIGN PROGRAM, AWCOMAD – PHILADELPHIA, PA, USA
CREATIVE TEAM: CAITLIN LEMAIRE – STUDENT DESIGNER; JOSH GDOVIN – INSTRUCTOR

CATEGORY: DEMO/PRESENTATION VIDEO
SCHOOL: LEE JIN HA – DAEGU, SOUTH KOREA
CREATIVE TEAM: LEE JIN HA

FILM & VIDEO STUDENT

Odds of your birth 300million : 1

You've already won the lottery

Ladbrokes

PLATINUM



SPERM

CATEGORY: CORPORATE TV, SINGLE UNIT

SCHOOL: UNIVERSITY OF THE ARTS LONDON – DAEGU, SOUTH KOREA

CREATIVE TEAM: TAE JAY LEE – DIRECTOR/ART DIRECTOR/COPYWRITER

You can bet on anything–the weather tomorrow, the odds that Prince Charles will become king in 2013–and people do. Students at University of the Arts in London came up with a fully integrated campaign for Ladbrokes, the largest betting company in the United Kingdom, to appeal to those who weren't already laying their bets. To raise the image of Ladbrokes by making gambling more acceptable, T.J. Lee, the student who also served as the director, art director, and copywriter, focused on the infinitesimal odds present in daily life.

A billboard announces that there are 167 accidents in parking lots every minute, inviting the reader to consider one's

good–or bad–fortune at the moment with the tagline, "You're already gambling." A saucy television spot emphasizes luck–or, one might say, getting lucky–and thus establishes a winning streak starting with the viewer's own conception. Using humor, whimsical music, and fast–moving graphic animation, the video depicts the race of a sperm to an egg and the, er, payoff: "Odds of your birth 300 million:1. You've already won the lottery." According to Lee, the goal was to "expand Ladbrokes' client base and firmly establish the company as THE place to go to when you think of placing a bet."

p2

STUDENT TV & RADIO

Do you still me?

ring brands **to life**

ith digital publications

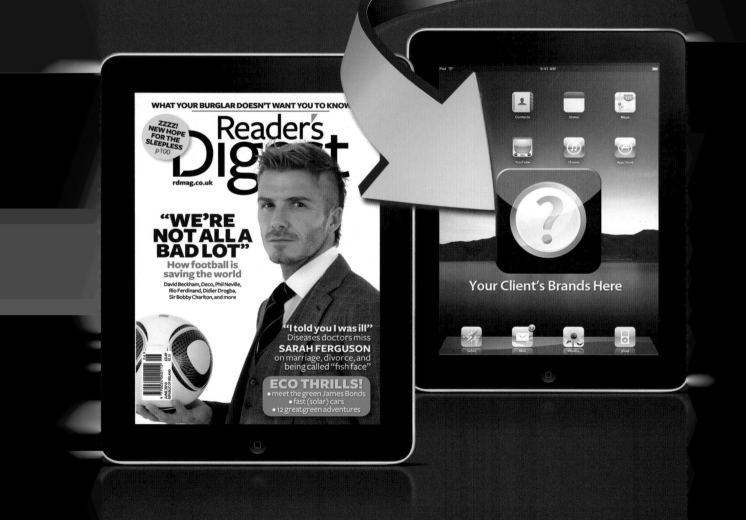

se the impact of your message & increase engagement with the

Create **web, iPad & iPhone**
versions of your client's brochures, magazines, catalogs & more

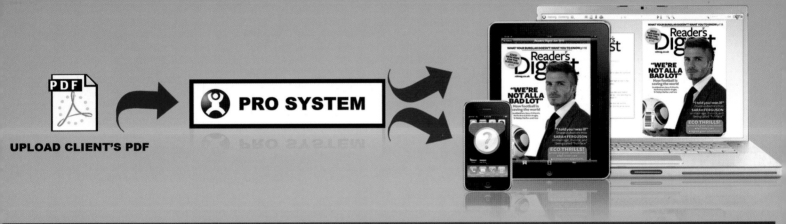

UPLOAD CLIENT'S PDF

PRO SYSTEM

Create publications for Web & iPad
www.yudupro.com

CREATIVE FIRM

INDEX

INDEX

INDEX

INDEX

INDEX

INDEX

CLIENT

INDEX